Stanley Kubrick
Drama & Shadows:
Photographs 1945–1950
Rainer Crone

Prologue by Jeff Wall

Φ

Cinematography: A Prologue
by Jeff Wall

Photography has established itself as one of the great art forms of the western tradition (and now beyond the western tradition). Therefore it includes, absorbs, or contains all the criticisms or critiques made by artists contemplating it with the intention of making something new and good in the medium. As we have recognized it as a major form, we are also recognizing its similarities to other major forms such as painting. We are no longer so concerned with distinguishing photography from the other arts in order to affirm its own unique validity.

When you look at a painting you feel—and this is one of the magical things about painting—that it is always "present time." The picture is always occurring right in front of you whenever you come and look at it. You never have the sense that what was painted has already happened somehow and that the painting is a record of it, a notation of its moment of existence. This is, of course, an illusion, but that illusion is the central achievement of the arts and there is something joyful in it.

I think that photography has the capacity to disclose that feeling as well, despite the fact that it is normally thought of as doing just what painting doesn't do—providing a record of the momentary existence of something, something that may likely cease to exist before the photograph made of it does. That is the way Roland Barthes, for example, saw photographs: as mementos. Photography will always have that quality but it does not have to be limited to it or dominated by it, at least in the hands of artists.

I never agreed with Susan Sontag when she argued that photography devours its subjects and turns everything and everyone into a consumable, a commodity. I think that kind of political language in relation to an art form is usually exaggerated, often for political reasons that don't necessarily have anything to do with the art form as such. Sontag's views might be relevant to a critique of the institutions of journalism, but journalism and photography are not identical. It is easy to get confused on that because photography is so useful to the media. Nevertheless, photography cannot be simply identified with its institutional employment. For that reason, I don't see a political or cultural reason to "subvert" photography.

I have always used the term "cinematography" for my work because I felt that getting involved with performers, sets, and so on—all that artifice—could open doors for me as an artist. In the 1960s and 1970s, I loved the look of films such as Ingmar Bergman's *Persona*, photographed by Sven Nykvist; Pier Paolo Pasolini's *Accatone*, with cinematography by Tonino Delli Colli; and John Huston's *Fat City*, shot by Conrad Hall—as well as Stanley Kubrick's films *Lolita*, *Dr. Strangelove*, and *Barry Lyndon*, each done by a different cameraman.

A motion-picture film is really a long strip of material on which many photographs are printed. The images are projected at such a speed that we cannot perceive them properly and think we are looking at "moving pictures." But we are, in fact, looking at a large number of still photographs, and looking at them in a very peculiar way. That suggested to me that what is normally called "cinematography" is something that can result in a still photograph; it didn't have to result exclusively in what we call a "film." "Cinematography" was, for me, a way to move some steps away from the model of reportage that was still dominant when I began my work in the 1970s, and so I started using the term to describe to myself what I wanted to do.

"Cinematography" also suggests that there is no dominant style in photography. It easily includes reportage or documentary but is not dominated by it. There are many examples of films that move from one mode to another—back again, and then back again, but in a different way, and so on. The cinematographer does not have to choose between "fact" and "fiction"—two terms I find most tiresome when posed one against the other, as they so often are by people who believe they are saying something significant about photography.

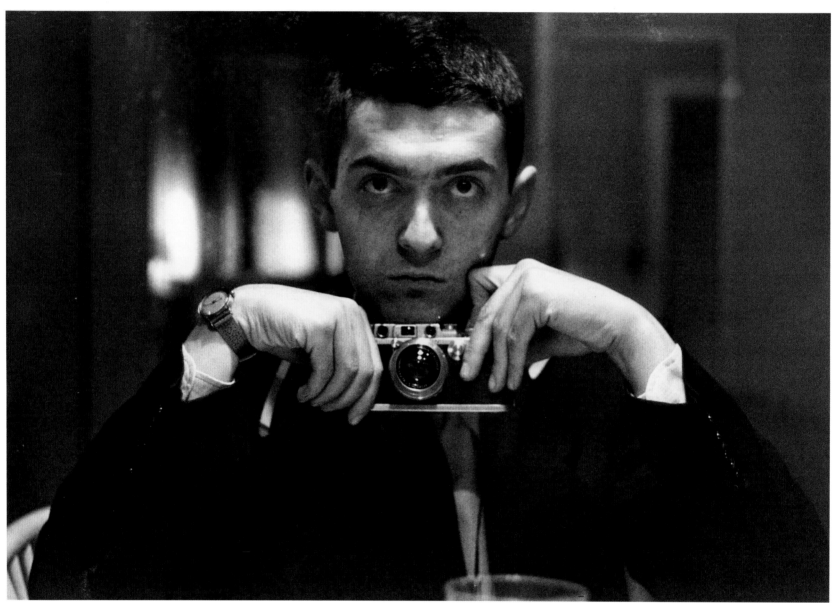

Stanley Kubrick takes a self-portrait, 1940s.

Contents

Foreword

It has long been agreed that Stanley Kubrick ranks among cinema's most seminal figures. Over the course of his career, Kubrick paved new ways in a variety of film genres, including the epic (*Paths of Glory*), the antiwar parable (*Full Metal Jacket*), the horror spectacle (*The Shining*), the psychedelic dystopia (*A Clockwork Orange*), the picaresque costume film (*Barry Lyndon*), the science-fiction fantasy (*2001: A Space Odyssey*), and the psycho-erotic drama (*Eyes Wide Shut*).

It was with great surprise that I discovered, a little more than ten years ago, an important, revelatory aspect of this eminent artist's work that had never before been critically or historically evaluated: a unique body of photographs that Kubrick produced for *Look* magazine between 1945 and 1950 that provides a vital photo-historical context for a postwar American culture just beginning to emerge from the shadows of European tradition.

Kubrick's *Look* photos appeared in the magazine in various formats and croppings, although only roughly 20 percent of a total 12,000 archived negatives were finally published. Buried in the midst of lesser-quality photo-essays, advertisements, and other visual distractions, Kubrick's images were never before judged for their unique visionary quality, formal liberty, or thematic significance. I feel privileged to be able to present to the public this part of unwritten visual history.

The discovery of Kubrick's photographic oeuvre dates back to a graduate seminar I conducted on the director's films in 1993 at the Institute of Art History of Ludwig Maximilian University in Munich. At that time Kubrick's early photos were seemingly untraceable and there were no related publications, yet—a discovery that provoked intense research. Assuming that Kubrick himself had archived his own negatives, I contacted the filmmaker in England. Astonishingly, Kubrick told me that neither negatives nor vintage prints were ever in his possession. He emphasized that he didn't even hold the copyrights to his photography, as he had been employed at *Look* as a staff photographer. Kubrick himself encouraged me to try to find the negatives, even though he had no idea of their whereabouts.

The research that I then conducted with a team of students was focused on seeking out available back issues of the magazine. An exhibition based on Kubrick's 1940s-era *Look* photos was consequently organized in 1999 by the International Center for Curatorial Studies (ICCARUS)—a program I had established in Munich—and proceeded to tour to Paris, Cologne, and Berlin. Within a few years, the research was extended and the sensational original negatives finally tracked down in a cold-storage facility in Ohio owned by the Library of Congress, and in the archives of the Museum of the City of New York, which had been in possession of two-thirds of Kubrick's negatives since *Look* donated them in 1952. The photographs had been untouched and unresearched since that time.

Once liberated from their documentary background, the photographs express Kubrick's mature visual intelligence, which clearly pay homage to the great names of photo history, including Alfred Stieglitz, Edward Steichen, Alexander Rodchenko, and László Moholy-Nagy. These images also display a precociously developed autonomous approach to the photo-essay that puts Kubrick—despite his tender age at the time of their shooting—in the company of Walker Evans, Henri Cartier-Bresson, Robert Frank, Diane Arbus, Louis Faurer, and, indeed, William Eggleston.

This book does not intend to draw the innumerable connections between Kubrick's photographic style and his movies, as this is something that the film historian Thomas Allen Nelson has done formidably in the first chapter of his 1982 book *Kubrick and the Aesthetics of Contingency*. I am certain, however, that the literary, dramaturgic, and cinematic techniques pioneered by the Russian Formalists and Eastern and Central European poets and linguists do shed light on Kubrick's highly sophisticated photographic and cinematographic vision, as I explain in my essay "Kubrick's Kaleidoscope: Epic Pictures as Parables" (p. 7).

I am confident that the careful study of Kubrick's photography as a historically unique phenomenon and as a precedent to his cinematography will confirm and possibly alter the critical perception of this great artist from the second half of the twentieth century.

—*Rainer Crone*

Kubrick's Epic Pictures as Parables
by Rainer Crone

Photographs do not just copy nature but metamorphose it. . . . The formative tendency, then, does not have to conflict with the realistic tendency. Quite the contrary, it may help substantiate and fulfill it—an interaction of which the nineteenth-century realists could not possibly be aware. Contrary to what Proust says, the photographer sees things in his "own soul."

And yet Proust is right in relating the photographic approach to a state of alienation. Even though the photographer who acknowledges the properties of his medium rarely, if ever, shows the emotional detachment which Proust ascribes to him, he cannot freely externalize his inner vision either. What counts is the "right" mixture of his realist loyalties and formative endeavors—a mixture, that is, in which the latter, however strongly developed, surrender their independence to the former. As Lewis Mumford puts it: the photographer's "inner impulse, instead of spreading itself in subjective fantasy, must always be in key with outer circumstances."

Siegfried Kracauer, Theory of Film: The Redemption of Physical Reality[1]

In a world defined by photographs, humanity is conditioned by a pictorial universe. Modern life is built around a more or less conscious filtering of fragmentary reality. Often the sheer mass of images breeds indifference and a reduction of their individual value to redundancy. But sometimes, when faced directly with a truly striking photographic image, we can still stand in awe of the way it confronts our individual state of being with a fascinating "other." Photography at its best becomes a kind of reality check of our own experiences and emotions in the presented reality mirror of the picture frame.

In Stanley Kubrick's photographs—shot in the years immediately after World War II—we are not confronted with an ambition to portray a historical era. Transcending the then-current mode of WPA-style documentary image making, Kubrick's photography created not only visual archives of the time but also social critiques that expressed his intuitive mind and subversive sense of humor. Each of his amazingly thought-out pictures is a conscious challenge to the viewer's own perception, pushing the potentials of representation and the photographic medium. Kubrick developed this singular quality in his photographs and applied it through all of his films—each of which can be read as a sequence of perfectly composed still photographs.

The issue of objectivity as a photographic paradox was raised with the birth of the medium. At its inception, when portraits were still manually retouched, photography was used as an apparently "documentary" tool that attempted to manipulate representation and, through it, the public. A telling example of such early propaganda is the heroic presentation of the "Wild West," its natives, and their landscapes—an idealized and already nostalgic picture taking that was in fact an inverted

procedure of "land-taking" by appropriation and industrialization. In this phenomenon of active photo documentation, we can detect inherent values of a dialectical notion of reality within the medium of photography. On the one hand, photography is based on actual, circumstantial facts, as observed through the camera lens; on the other hand, it reveals a more or less personally arranged interpretation of "reality" by the individual photographer or by the magazine editor who often decided to present the pictures cropped and altered according to the needs of the publication. Thus, the camera as a simulation of Cartesian consciousness remains a questionable tool—even more confusingly so when dealing with its products that have turned into "art."

While Kubrick's work as a director is widely agreed to be brilliant and he is counted among the few twentieth century cinematic masters, there is another aspect to his oeuvre that goes underrecognized: Kubrick was first and foremost a cinematographer and photographer. The photo historian Hubertus von Amelunxen recently discussed Kubrick's uniquely photographic eye:

While photography conveys the impression of a past present, the framed still shot of a film seems to grasp the conflict of time with the image of the future. The filmic image is the illusion of a given time, the photographic image, on the contrary, offers the certainty of a spent moment in time. . . . Kubrick's photographs construct the gaze in decay. . . . [His] photo essays excel by presenting continuously a gaze into the space or by spatializing the gaze as it were, in contributing to them photographic vectors of imaginary or real viewpoint. The guidance of the gaze owes to a perspectivally precise adjustment of the pictorial elements within a picture frame, the reading of which reveals the picture of the photograph as a narrative construction."[2]

Kubrick's unique photographic perspective presents the viewer with a defamiliarizing or alienating process that helps to access the narratological construction of the image as a parable for the present. The cultural theorist Siegfried Kracauer points out in his seminal *Theory of Film* (1960) that the dialectical relationship between the formative impulses and the realistic, ethical intentions of the photographic medium ultimately results in a hermeneutic ambiguity:

If film grows out of photography, the realistic and formative tendencies must be operative in it also. Is it by sheer accident that the two tendencies manifested themselves side by side immediately after the rise of the medium? As if to encompass the whole range of cinematic endeavours at the outset, each went the limit in exhausting its own possibilities. Their prototypes were Lumière, a strict realist, and Méliès, who gave free rein to his artistic imagination. The films they made embody, so to speak, thesis and antithesis in a Hegelian sense.[3]

The major difference between Kubrick and his photographic contemporaries is readily apparent in his conscious arrangement of scenes for dramaturgic purposes—his cinematography, as it were, focusing on shaping reality as an individual idea of truth. At an early age, Kubrick revealed himself to be a genuinely modern photo-artist who artfully articulated the shifting artistic paradigms of the twentieth century. He knew that any obvious, teleological-evolutionary way of explaining the world had become obsolete. Positivism, the great friend of photography in its early days in the nineteenth century, had also lost its validity. The late critic Susan Sontag noted in her series of essays *On Photography* the fear and disdain that early photographers such as William Henry Fox Talbot, Berenice Abbott, and Henri Cartier-Bresson had for "pictorial" or "artificial" photography— all of which led to "pious avowals of respect for things-as-they-are." Sontag continues:

To insist, as Abbott does, that realism is the very essence of photography does not, as it might seem, establish the superiority of one particular procedure or standard, does not necessarily mean that photo-documents *(Abbott's word) are better than pictorial photographs. Photography's commitment to realism can accommodate any style, any approach to subject matter. Sometimes it will be defined more narrowly, as the making of images which resemble, and inform us about, the world.*[4]

Kubrick did not claim a unique or even objective truth. Consequently, his photographs can hardly be considered "documents." On the contrary, they manifest Kubrick's own ideas about the world—an approach to photography that Sontag notes is particularly American in outlook. In distinction to European photography, which tended to "praise or aim at neutrality," in America "pictures got taken not only to show what should be admired but to reveal what needs to be confronted, deplored—and fixed up. American photography implies a more summary, less stable connection with history, and a relation to geographic and social reality that is both more hopeful and more predatory."[5]

Kubrick's most important artistic device lies in the very ambiguity of image making itself. Kubrick himself revealed his love of ambiguity in a rare early interview:

It has always seemed to me that really artistic, truthful ambiguity—if we can use such a paradoxical phrase—is the most perfect form of expression, for a number of reasons. One: nobody likes to be told anything; nobody likes to be told the truth of what's happening. And, perhaps even more important than that, nobody knows what is true or what is happening. I think that a really perfect ambiguity is something which means several things, all of which might be true, and which, at the same time, move the audience, emotionally, in the general direction you want

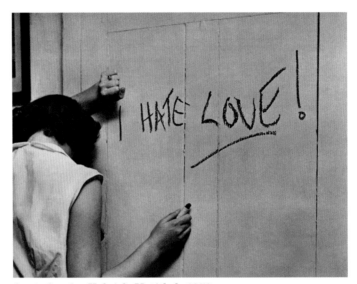

fig. 1: *Stanley Kubrick*, Untitled, *1950.*

them to be moving. So, I think that, conversely, the literal, plain, clear statement is, in its own way, a false statement and never has the power that a perfect ambiguity might."[6]

A close descriptive analysis of a few of Kubrick's paradigmatic photographs clarifies his seemingly paradoxical view on issues of realism and subjectivism in photography. His singularly impressive and self-conceived photo-essay called "First Loves of Teenagers" clearly reveals his embrace of ambiguity in action. This series of deliberately staged images tells the viewer about the pleasures and pitfalls of love, using irony and humor. An experience of "first love" would be unthinkable without pathos and its related clichés. Kubrick even touched on the piquant subject of love between a young girl and a much older man—a theme that found a sequel twelve years later, when Humbert Humbert would meet his sweet temptation on-screen in the film version of Vladimir Nabokov's *Lolita* (1962).

A photo from this series—loosely titled I Hate Love (fig. 1)— shows a young woman with short dark hair and a white sleeveless shirt seen from behind in three-quarter profile as she leans her head against her left arm on a white door. This gesture of desperation gives her an overpowering presence that fills the left third of the image, while the center is dominated by dramatic graffiti spelling out "I HATE *LOVE*!" This paradoxical statement, written by the girl with a lipstick that she still holds in her right hand, has all the characteristic traits of a spontaneous manifesto that could serve as a summary of the central issue of postwar society's ambiguous attitude. This passionate gesture contrasts with the resigned position of the girl's right arm and hand with its still-open lipstick, which rests a little below the graffiti on the door in an attitude that seems to

question her self-destructive doubts about herself and her status in society.

The whole scenario reads as an incarnation of adolescent turmoil, with its mixed feelings of passion and despair—something every onlooker over the age of fifteen has gone through. The fact that the girl is shown from behind—thus concealing her individual traits—further serves to paraphrase a stylistic technique, the *repoussoir*, that is designed to contrast the simplistic, linear reception of the subject and enhance the viewer's process of identification with the scene. Kubrick stages a genuinely human experience through the narrative gesture of the girl's emotional and physical outburst in the form of the lipstick graffiti, which serves as a signifying witness of an action in the immediate past. We are confronted in this image with the staged gesture of the present as a seemingly hopeless resignation to the pain of the past.

The ambiguity of this image points to the cerebral artistic technique that Kubrick was able to construct at the young age of twenty-two. Susan Sontag reminds us of the conceptual sources we have to consider in order to evaluate the full creative concept the young filmmaker had already developed at this point:

Photography's commitment to realism does not limit photography to certain subjects, as more real than others, but rather illustrates the formalist understanding of what goes on in every work of art: reality is, in Viktor Shklovsky's word, de-familiarized. . . . *To claim that photography must be realistic is not incompatible with opening up an even wider gap between image and reality, in which the mysteriously acquired knowledge (and the enhancement of reality) supplied by photographs presumes a prior* alienation from *or devaluation of* reality.[7]

The German dramatist Bertolt Brecht—a prominent figure in the American theatrical and theoretical scene at the time since the successful New York premiere of his *Threepenny Opera* in 1933—would have marveled at Kubrick's use of the girl's hands in this pictorial photograph, as it relates to what he termed the *Gestus*, or an overriding physical attitude that can express as much as words in a dramatic context.

Kubrick's canny use of the *Gestus* marked him as a modern, indeed, avant-garde photographer—even if in certain instances such physical attitudes remained visually and phenomenologically a conceptual device that was overshadowed by the powerful curiosities of narratological circumstances, hence offered only subliminally to the viewer.

Just how much influence the central and eastern European avant-garde poets, filmmakers, and visual artists of the 1920s and 1930s had on the mind of the young Kubrick has never been touched on by his biographers, but he is known to have not only studied the infamous success of *The Threepenny Opera* and Brecht's theories of epic theater, but also carefully studied at the Museum of Modern Art eastern European Constructivist photography and cinema and read about their theoretical implications in the writings of the Russian Formalists in general and filmmaker and theorist Vsevolod Pudovkin[8] in particular. Already as a teenager he frequented exhibitions and was an obsessive attendee of the Museum of Modern Art's highly selective and sophisticated program of avant-garde films.

Through this self-created cultural education, Kubrick would have come to understand the essence of Brecht's theory of drama, which was that a truly modern narrative must avoid the Aristotelian premise that each individual spectator be made to believe what is happening on the stage is reality. Brecht was convinced that if members of the audience really felt that the emotions of heroes of the past—whether Oedipus, Lear, or Hamlet—could equally have been their own, then the basic idea that human nature is a result of changing historical conditions would automatically be invalidated. Brecht therefore argued that the theater should not seek to make its audience believe in the presence of the characters on the stage—should not make it identify with them—but should, rather, follow the method of the epic poet's art. Under ideal circumstances, the audience would realize that what it saw on the stage was merely an account of past events that it should watch with critical detachment. Hence, "epic" (narrative, nondramatic) theater is based on detachment, on what Brecht termed the *Verfremdungseffekt*, or alienation effect. This effect is generated through a number of devices that remind the spectator that what is onstage is a demonstration of human behavior in a scientific spirit rather than with an illusion of reality. In other words, the theater is only a theater and not the world itself.

Brecht's use of alienation was meant to stimulate the audience's attention not only to the formative ends of the play but also to the social and political content of the stories being told. Brecht frequently used the *Gestus* as a basic instrument for alienating the audience from an intimate or empathic identification with the development of the story; indeed, the *Gestus* was a tool for heightened significance, a punctuation mark of sorts that denoted a rigidly applied signifying process. Brecht's techniques were carried over from the Russian Formalists of the late teens and early 1920s and instantaneously spread out to drama, cinema, and photography. The idea of cinematic montage so influentially promoted and proposed in theory and praxis by Pudovkin and his much younger and more popular compatriot Sergei Eisenstein was substantially based on the Formalist's ideas of defamiliarization and estrangement. In his 1998 study *Brecht and Method*, literary critic Fredric Jameson points out that Brecht's use of imagery that could simultaneously signify two very different states—say terror and romance—serves to estrange the viewer's very ideas about "natural" emotions, culture, commerce, and society at large. He goes on to write:

It is superposition and an estrangement which not only makes us grasp the specific narrative element in a new and transformed light, but also charges our conceptions of what a simple physical gesture is, and what counts as a historical event at the same time.[9]

In Brecht's dramaturgical universe, Jameson goes on to say, a simple hand motion—the signifying *Gestus*—can "count as a fateful historical act, with momentous and irreversible consequences," whether it comes from a king or a shopkeeper, or maybe even both. By developing a gestural language that compressed meaning into motion, Brecht was able to relay heightened and everyday meaning at the same time. "You can read these sentences best by completing those specific physical movements that correspond to them," Brecht once said of his own writings.[10]

Jameson goes on to warn, however, that the *Gestus* is not always reliable in its implication of significance:

Thus the identity between the "stylized" and the "natural" is already a way of differentiating them; nor is one's instinctive feeling that Gestus marks some radical simplification of the movements or the action—that "formidable erosion of contours" Gide qoted Nietzsche as recommending—always reliable. One could imagine excessive complication as a decorative emphasis equally calculated to arrest the attention and invite closer scrutiny . . . it is important to note first the peculiar and even paradoxical relationship of such narrative concepts to philosophical abstraction as such: a relationship which will go a long way towards accounting for our difficulty in defining gestus in any hard-and-fast way, even though it is probably readily comprehensible to the layman.[11]

Brecht's methods of defamiliarization as described by Jameson call attention to the dramaturgic photo techniques that Kubrick intuitively applied to his photo-essays of the late 1940s and early 1950s, which were in bold opposition to the documentarist mode so popular at the time.

Kubrick's pictorial approach to photography was evident from the beginning. While still a high-school student, the nascent director gave himself professional "assignments"—studies of subjects taken from his Bronx environment. He joined the student paper as a photographer and published photos of a few school highlights, each stamped with his "official trademark": *Stan Kubrick—Photo. 1414 Shakespeare Ave. N.Y.C.*

The inception of his real career, however, coincided with the death of president Franklin D. Roosevelt on 12 April 1945. On his way to school, Kubrick saw a newsstand displaying papers whose front pages bore thick black letters announcing "F.D.R. DEAD." He quickly assessed the theme and obviously had a very precise idea in mind. He proceeded to persuade the vendor to

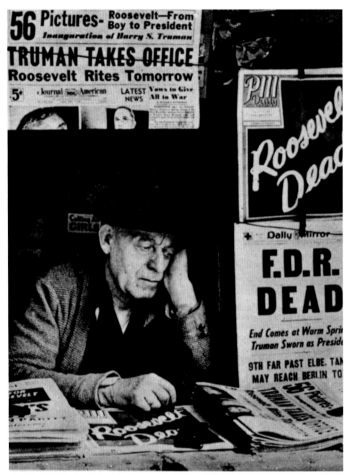

fig. 2: Stanley Kubrick, Untitled, *April 1945.*

look very sad, resting his chin on his hand, thus signifying with a gesture the surrounding headlines (fig. 2).[12] Even in this very first, seemingly straight documentary photograph, Kubrick reveals himself as a conscientious manipulator of desired emotional and social effects—a natural director of the *Gestus* in his subjects. This rather subversive take would become the hidden trademark of his photographic approach. He played the undercover agent of his own worldview while delivering statements of intersubjective value.

Kubrick presented the "F.D.R. DEAD" picture to the photo editor of *Look* magazine the same day and sold it for ten dollars more than he was offered by a competing magazine. His first contribution was published in June 1945. The *Look* team quickly realized Kubrick's talent and gave him assignments for photo stories about daily life in the city. In 1946, soon after his high-school graduation, Kubrick was hired as a staff photographer. He had just turned seventeen. Kubrick's newly found financial security left space for artistic creation and provided great oppor-

tunities for the ambitious young man. Greenwich Village had become a haven for many returning GIs who could not or did not want to adapt to bourgeois American life. In May 1946, Kubrick moved there with Toba Metz, his high-school sweetheart and new bride, and the two enjoyed mingling with the city's bohemian circles of poets, actors, and artists.

Kubrick, like his Beat generation, was always on the road. But his artistic experiences and visual enterprises were always backed by *Look*. He was sent out by the magazine to report on contemporary social life—its glamorous stars, art openings, film premieres, and sporting events. He executed all his assignments with great predilection, reporting on jazz events, such as the famous jazz funerals of New Orleans or the appearances of jazz legends in New York nightclubs. (Next to chess, the movies, and photography, jazz was a reigning interest in Kubrick's teenage life. He even made it as a successful drummer in his high-school jazz band.)

Apart from reporting on glamorous people and events, Kubrick had the ambition to produce sociological studies. He traveled to Chicago to create a portrait of the midwestern metropolis, which was published with the title "Chicago, City of Extremes" (1949), and produced a series on life in an orphanage (1948). One theme that continually fascinated Kubrick was people in in-between states, whether waiting at a dentist's office (1946) or riding the New York subway (1947)— a popular topos for photographers such as Walker Evans, although Kubrick had no previous knowledge of Evans's famous photo study, which would only be published in 1962.[13]

Kubrick's directing talent was further tested when he started photographing psychological studies in 1950. Using students and actors to people his scenarios, Kubrick staged photo series with names like "What Every Teenager Should Know about Dating," "What Teenagers Should Know about Love," and even the quite theatrical mise-en-scène "Jealousy: A Threat to Marriage" (fig. 3). Complete with staged lighting and dramatic gestures, Kubrick's sociological studies were always presented as epic stories, and at times even as Brechtian parables.

In the 11 May 1948 issue of *Look*, Kubrick presented a major story on campus life at New York's Columbia University, which at that point of time presented itself as not only a haven for European intellectuals of every stripe but also the focal point of American political, scientific, and economic discourse owing to its conception of the atomic bomb.

Kubrick shot 380 photographs for this chronicle of modern life as observed in a world-famous multiracial university. Looking at the vast material Kubrick brought together in these simultaneously pictorial and documentary photographs, it becomes instantly clear that his effort goes far beyond an ordinary photo-essay. Kubrick instead beautifully demonstrates the technique of parable, one of literature's central notions and a Brechtian device of alienation.

fig. 3: Stanley Kubrick, Untitled, *1950.*

Fredric Jameson, who defines parables as "short anecdotes, which suggest pointed lessons that the reader must deduce," notes:

Here, too, a dual or two-level structure is persistent, in which an empirical starting point, observation or Einfall *is cancelled and taken up into some more vivid form in which the gesture of the demonstration is retained. . . . The narrative is not empirical: it includes with it the* You see? *and the* Do you understand now? *Implicitly it corrects a mistaken opinion, an all-too-comprehensible popular misconception; but what it replaces the latter with is no longer an opinion, exactly (we must come back to the function of this word in Brecht, whose third play begins, as has been noted, with the offer to buy the protagonist's "opinions"). If we can tell its story or narrative, in other words, that is a kind of proof, and it is better than the opinion: the narrative articulates the conceptual position, and thereby proves that it can have historical evidence—it is an alternative form of argument, implicitly as valid as the abstract philosophical.*[14]

One photograph that Kubrick took during his two-week stay at Columbia particularly reveals his attention to parable and ambivalent readings. The young photographer's interest in the complexity of human relations and sociopolitical observation is amply illustrated in a photo staged in the university's physics department that depicts scientists testing a material (fig. 4). As if looking onto a stage, the viewer is confronted with a strange metal frame flanked by two twisted columns and featuring an

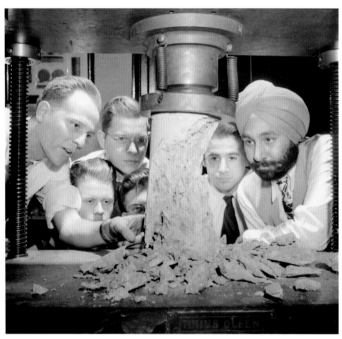

fig. 4: Stanley Kubrick, Untitled, *June 1948.*

impressive metallic cylinder at top center. This metallic device, equipped with four large springs, has clearly just exerted enormous pressure on a cement cylinder. The smashed remains are spread in a regular circle around the center—a pictorial demonstration that the pure philosophical notion of matter and its possibilities is the core issue and final measure for the newly conceived Einsteinian universe.

The most interesting aspect of this picture, though, is Kubrick's arrangement of the six onlooking scientists. Although Kubrick's camera is installed at eye level, thus tracking their perspective, not one of them glances at the lens. The carefully composed framing presents an almost decorative arrangement of the scientists; the one seen at the very left even points his left finger at the destroyed column. All of this hints at an elaborate staging on Kubrick's part that is characteristic of his photographic conception.

The photo's "explosive" meaning, however, only becomes apparent in a second, closer reading of the physicists. At the left of the frame is a group of three men, all Caucasian, with similarly cut blond to brunet hair, who represent the hierarchy that exists in any university. The pointing man, likely a professor, appears to be the eldest and holds his head higher than the other bespectacled man, who stands above a young student with boyish looks; a fourth man is concealed by the experiment's remains in the center. At right is a dark-haired man with bold eyebrows—hinting, perhaps, to a Mediterranean or Middle Eastern background—and on the very right a bearded

Indian wearing a Sikh turban. By presenting them all united in fascination over this apparently unique experiment, Kubrick illustrates an academic utopia of content-driven, bias-free research: a claim that Columbia had written on its flags but, sadly, too often failed to implement in reality (as Kubrick's pictorial separation of racial sides subtly indicates).

The same issue of *Look* that featured these sensational photographs of the life at an "American Elite University" also published an entire column paying homage to the nineteen-year-old "veteran photographer" Stanley, crowned by his photograph. Kubrick's colleagues expressed their respect for his professional approach, noting that he showed no signs of fear when confronted with all those venerable gray-haired professors during his two-week assignment. "Like any experienced photographer, Stanley knew exactly what he wanted." His colleagues—among them the successful former Farm Security Administration photographer Arthur Rothstein, the director of *Look*'s photo department—even formed a "Bringing-Up-Stanley-Club," expressing their concern for his well-being and plying him with daily trivia. The article closes unmistakably: "The young fellow may go on forgetting his keys. But photographically, Stanley doesn't need any help in bringing himself up."[15]

Around the same time, Kubrick also produced a series on campus life at the University of Michigan, one of America's oldest universities, which admitted women as early as 1870. By presenting a scene of a female student lighting the cigarette of her boyfriend, Kubrick accentuates the school's early acceptance of women—a rather unusual gesture, given women's gender roles during the 1940s and 1950s in the United States.

Kubrick might not have asked for help directly, but he liked the company of successful avant-garde photographers and artists in Greenwich Village like Diane Arbus, who played an important role in his bohemian education.[16] Arbus had started out as a fashion photographer together with her husband, Allan, staging startling images for magazines like *Harper's Bazaar*. By the mid-1950s, though, she began to follow her own artistic visions, using the same Graflex camera Kubrick worked with and shooting life at the fringe of society. Fascinated by psychological margins and the visualization of borderline states of mind, Arbus certainly left a lasting impression on the young Kubrick. While Weegee basked in sensation, Arbus explored the inner abysses, presenting extraordinary portraits of transvestites in underwear, the Jewish giant with his bewildered parents, and twins who were barely discernible as identical.[17]

Kubrick also learned to marvel at life's paradoxes, only in a much subtler way. In one photo, for instance, he shows what looks at first to be a house of horror but is in reality a manufacturer of artificial legs (fig. 5)—a business that was, after the war, rather profitable. Instead of indulging in the spectacle of humans with surrogate body parts, Kubrick presents a sort of absurd cabaret in a complex triadic composition. He shows

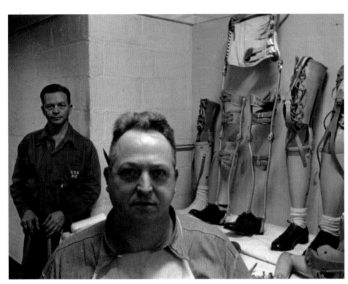

fig. 5: Stanley Kubrick, Untitled, *ca. 1950*

artificial legs lined up on a shelf on the left side. A frontal portrait of a man with receding hairline and a pen behind his right ear, indicating that he is the head of the company, dominates the center foreground of the image. On the left is a soldier who leans against the wall, holding crutches. His legs are cropped.

Kubrick managed to realize his personal vision within the boundaries of the given commercial context. Each picture bears a disruption of sorts, a certain ambivalence that the critic Roland Barthes came to call the *punctum*[18]: an element that strikes the beholder and challenges the initial perception of an image. Kubrick's multiple meanings also lead to an invitation to the viewer to make up his or her own mind about a work. As Jameson has written:

Ultimately Brecht seems, rather, concerned with leaving [the interpretive] process open, and allowing the audience to have its own opinion and to frame its own moral, all the while attempting to suggest strongly—nay, even insist—that it cannot not do so.[19]

Kubrick himself claimed in 1961—at a time when he was already fully developed as a filmmaker—that:

The point of view [the work] is conveying has to be completely entwined with a sense of life as it is, and has to be got across through a subtle injection into the audience's consciousness. The ideas have to be discovered by the audience, and their thrill in making the discovery makes those ideas all the more powerful.[20]

So, in the end, the reader and viewer of these unique pictures is invited to unfold the epic panorama within the *Gestus* of Kubrick's staged parables, composed so subtly by the artist.

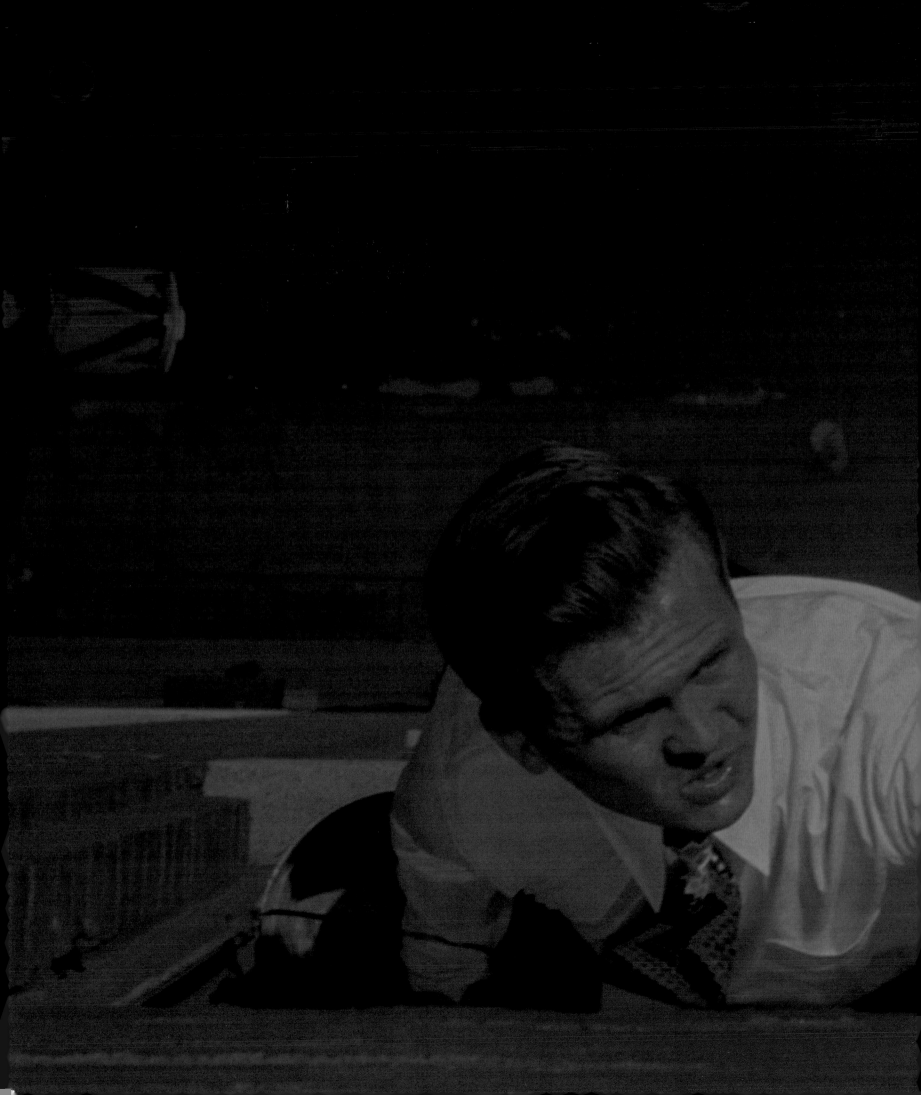

Metropolitan Life

Studies in the Subway 1946

It takes a technically skilled photographer to take a sharp and evenly lit picture in the New York subway without the aid of a flash or any other external source of light. Long exposure times require a steady hand, and, with the train rattling in its tracks, the only time pictures can be taken is during the short intervals when it is stopped at a station. Moreover, Kubrick did not just want to take pictures of passengers; he also did not want them to notice that they were being photographed.

The method he used to maintain control over composition and details during these covert photo shoots was remembered by G. Warren Schloat Jr., a reporter who worked with Kubrick at the time: "Stanley operated the shutter of his camera, which hung in plain view from his neck by leather harness, from a switch hidden in his pocket. The switch was connected to the camera's shutter by wires he had placed up his sleeve. Thus equipped, he could look at and talk to a passenger sitting next to him and at the same time snap a photo of a person sitting across the aisle without detection." Kubrick perfected this technique by hiding the wire in a brown paper bag with a hole in the bottom through which he operated his camera.

As the prime destination for immigrants entering the US, New York was always a heterogeneous conglomeration of communities, cultures, and religions. As a result, its subway was the most densely and diversely populated space in the world. Unlike Walker Evans, the influential documentary photographer who created anonymous portraits of passengers in the subway some years earlier (published only in 1966 in the now-legendary book *Many Are Called*), Kubrick attempted to combine many different characteristics in one picture. While his images speak of the people's diversity, they also possess a common existential touch that goes beyond documentary photography to reach an almost theatrical quality. The subway becomes a stage where life is in limbo, its scenes transformed into allegories of hope and expectation.

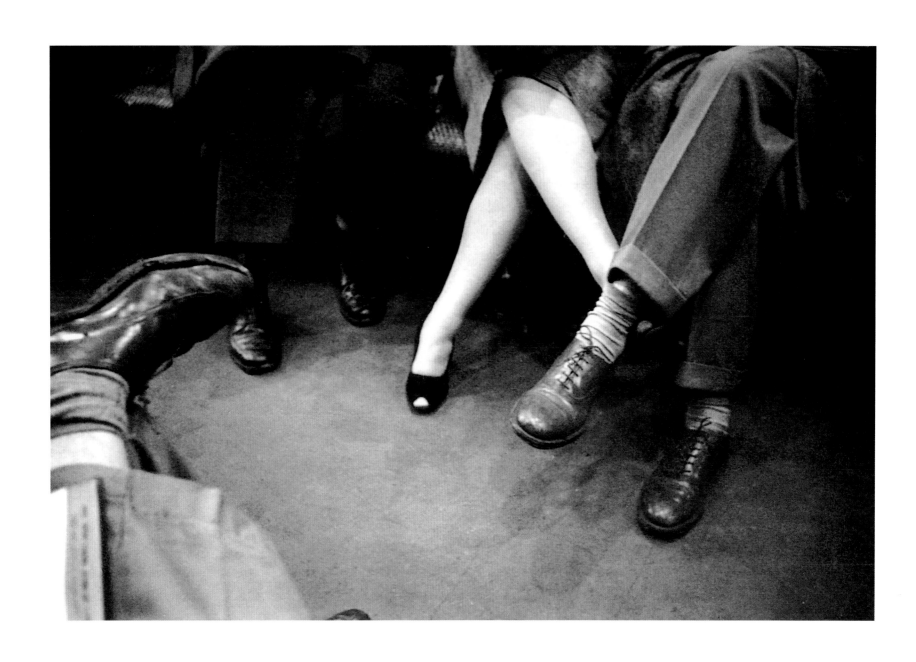

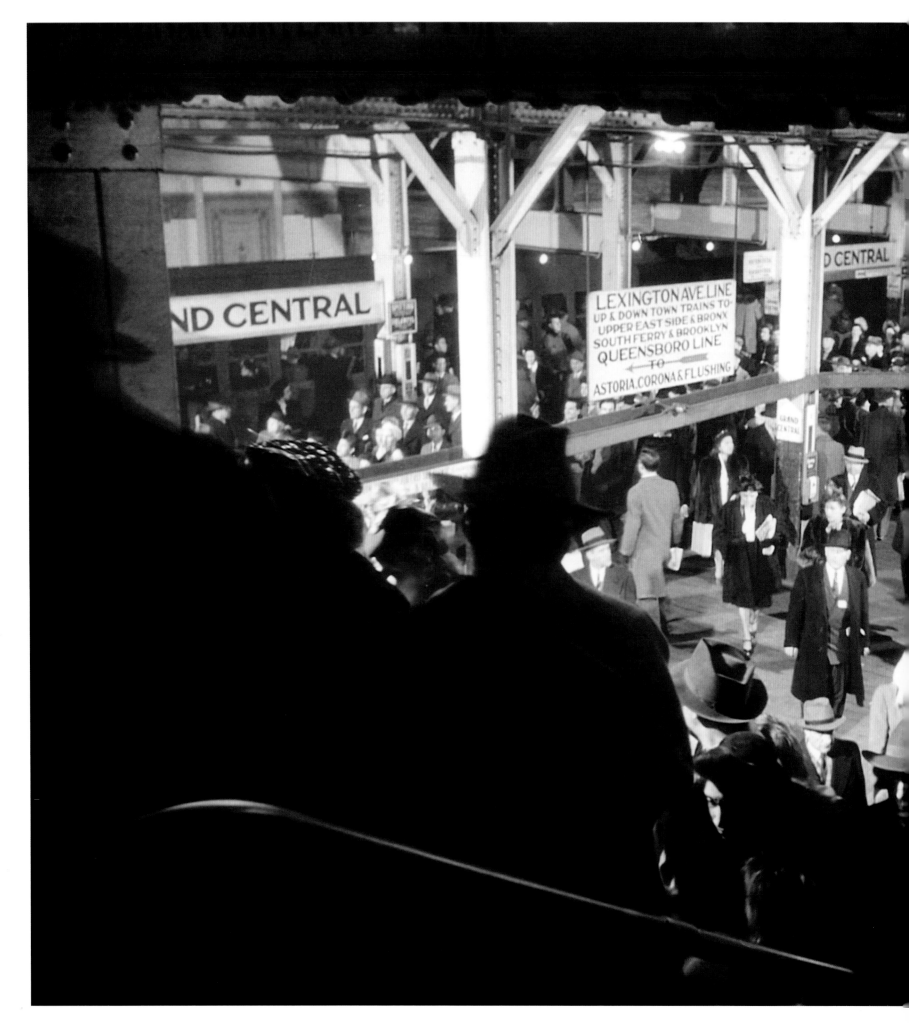

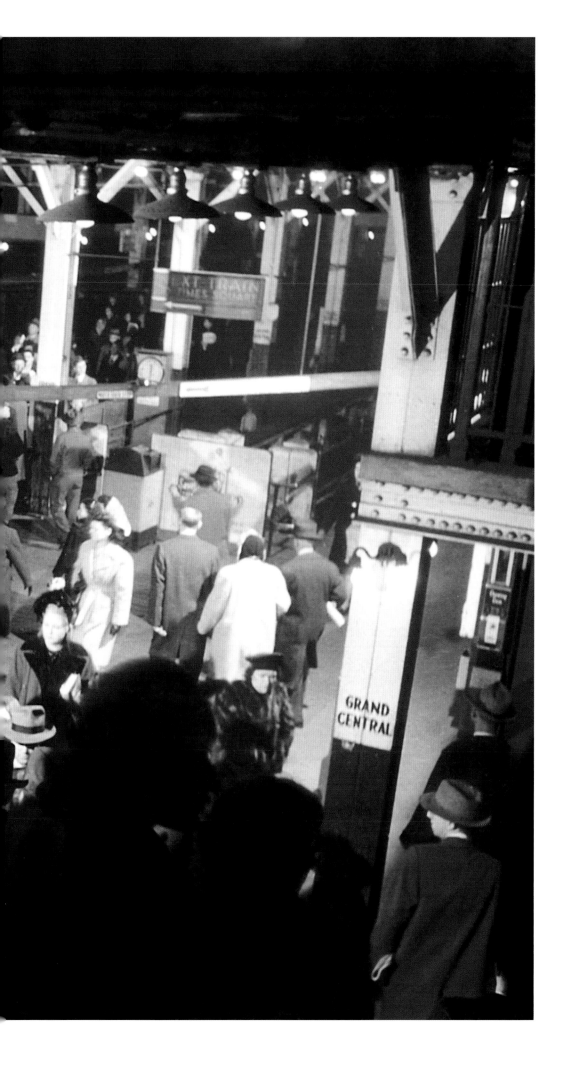

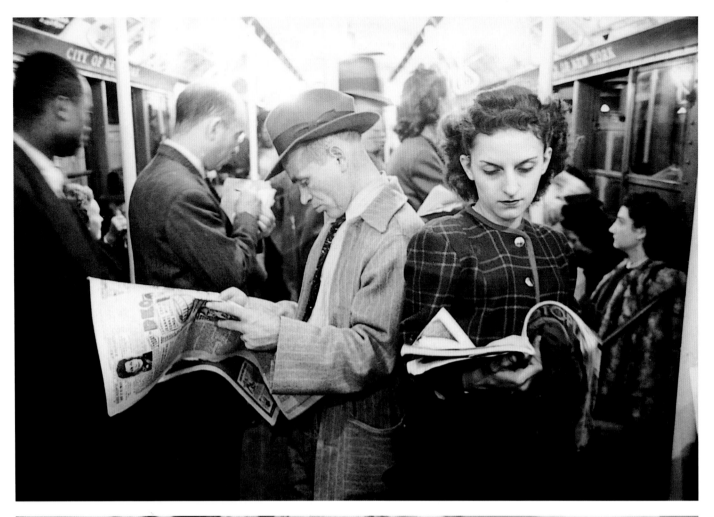

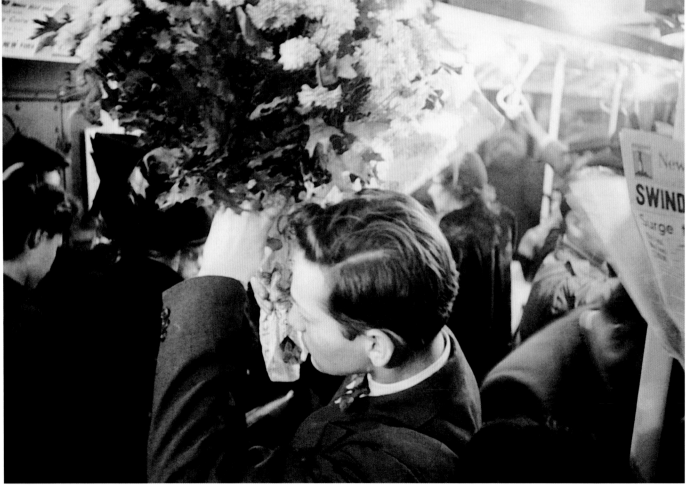

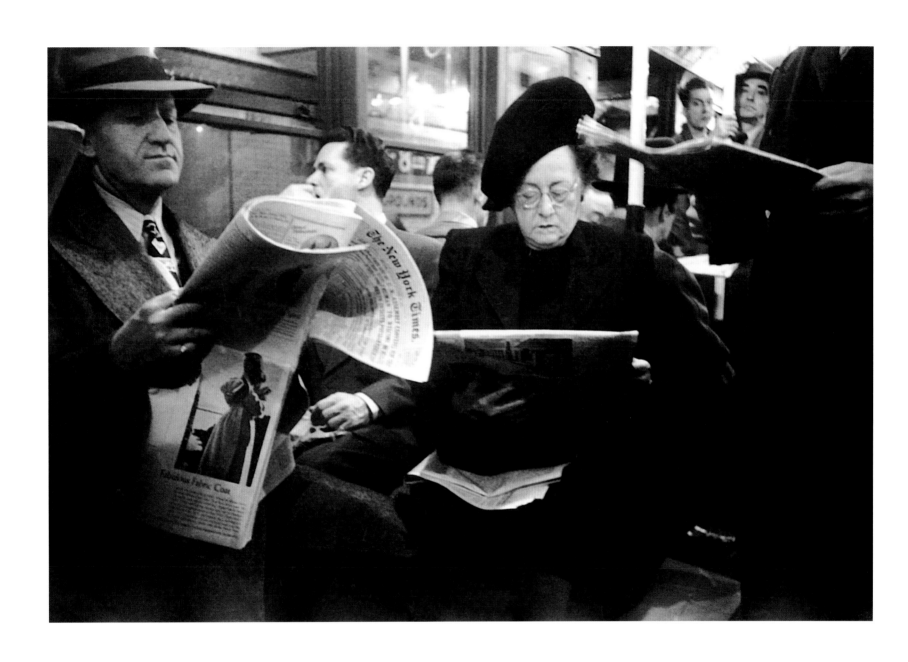

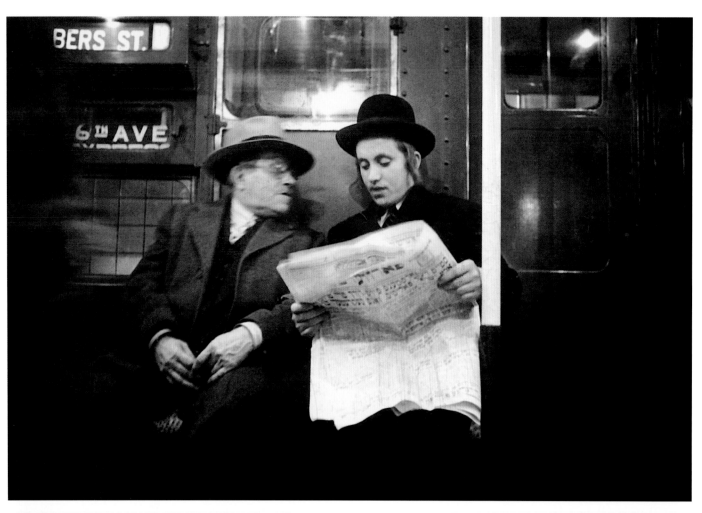

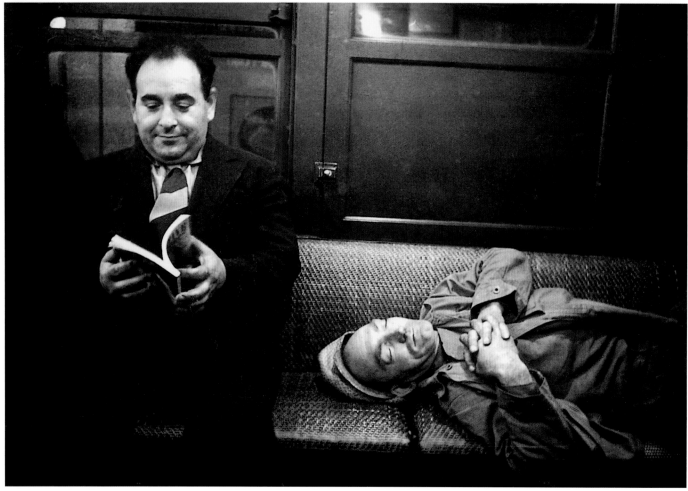

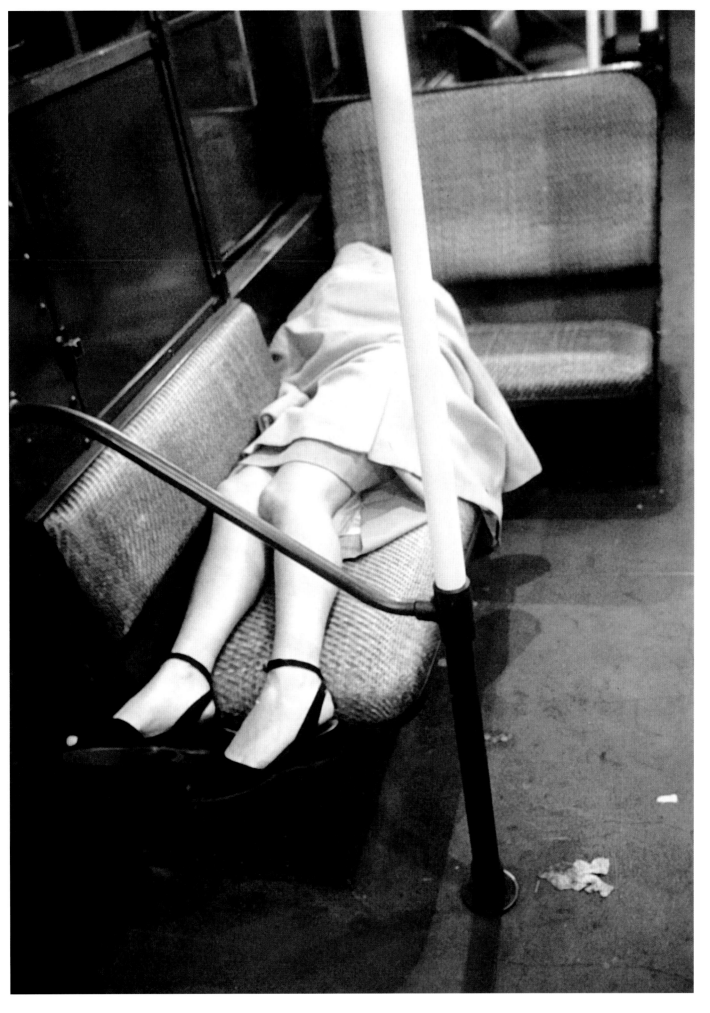

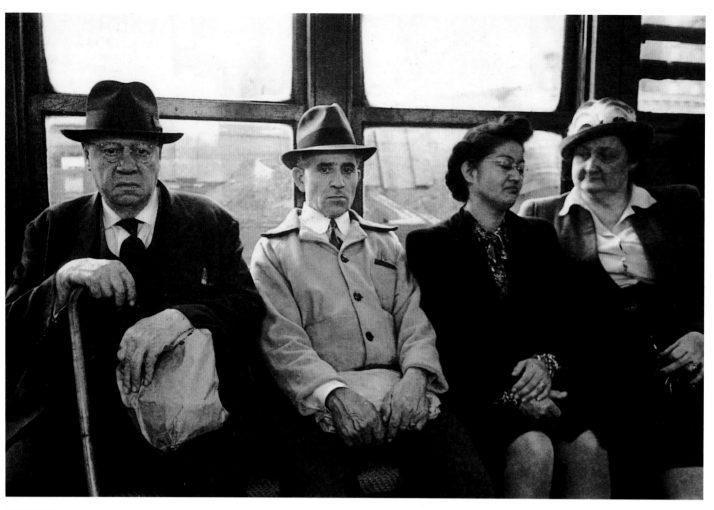

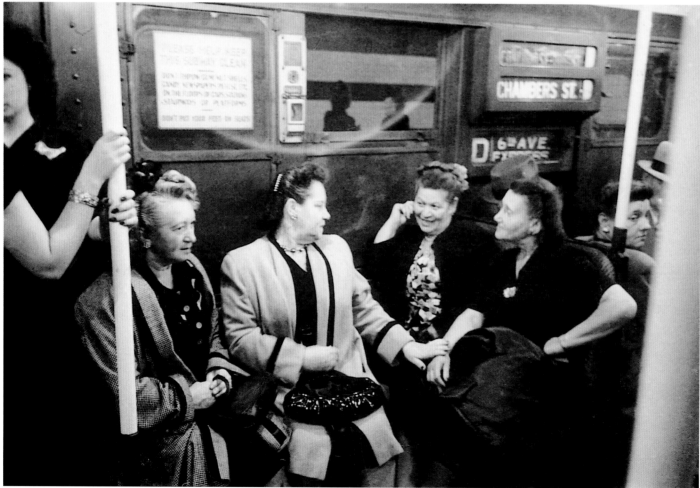

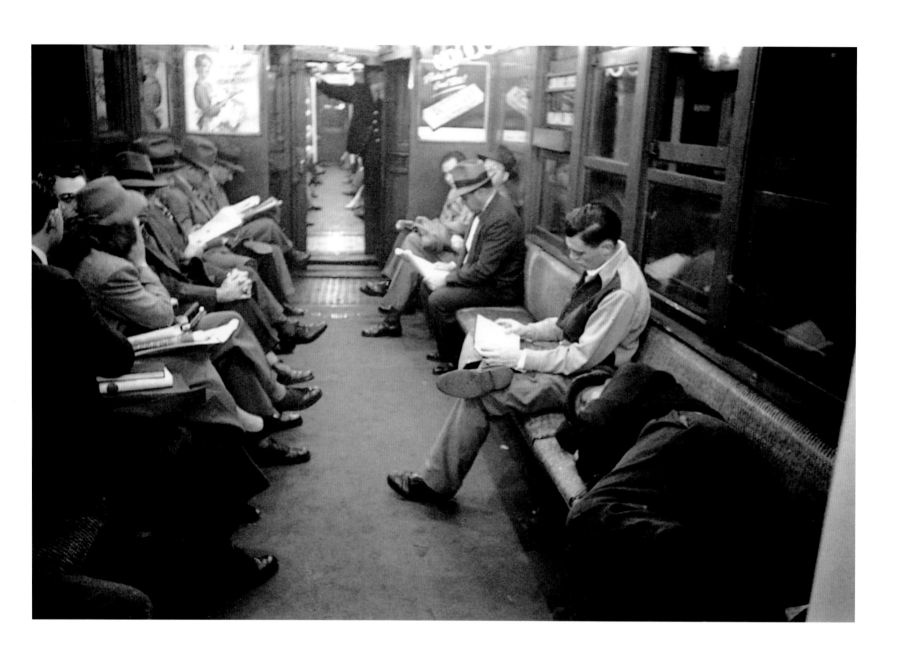

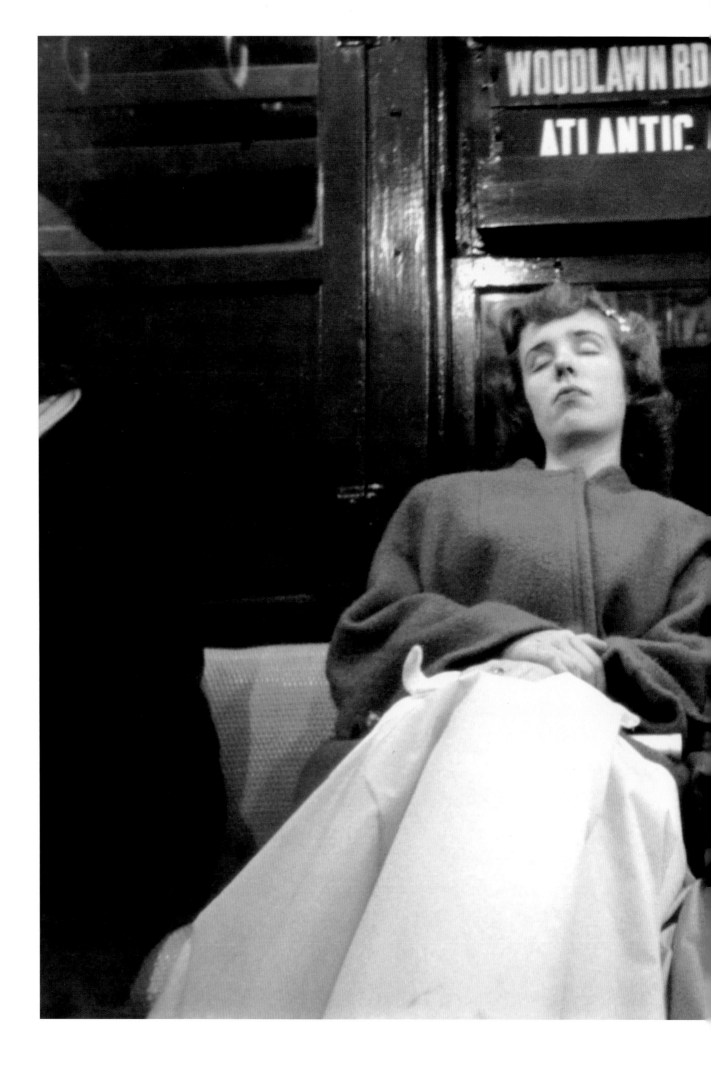

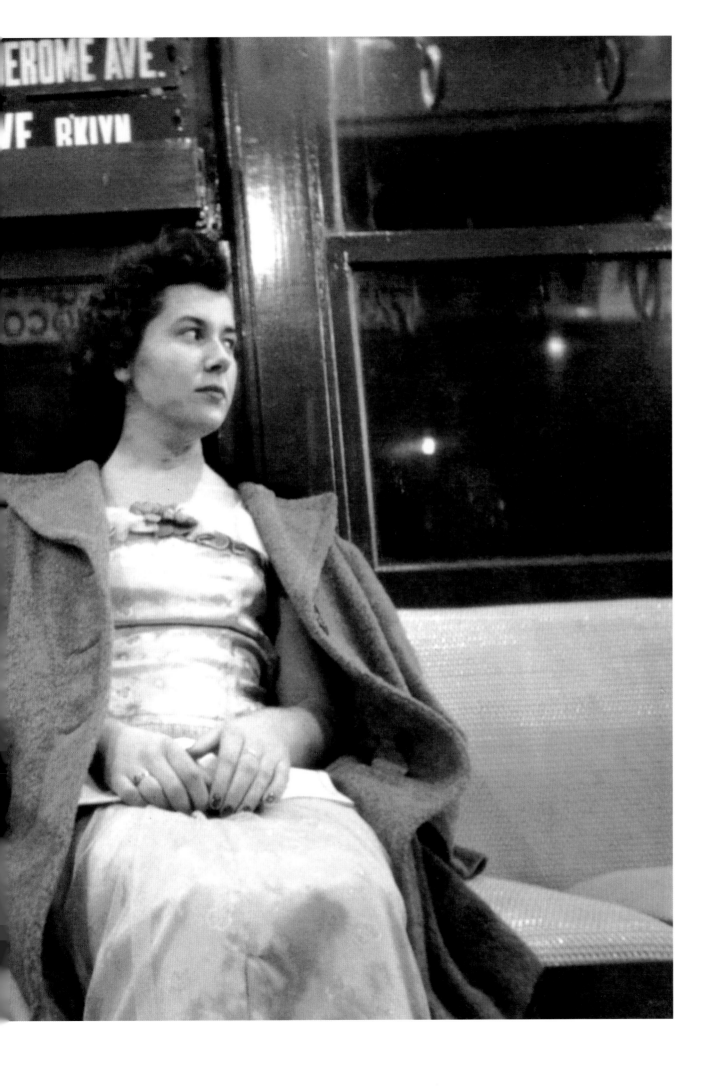

Chicago
City of Social Contrasts January 1949

"America's most baffling metropolis—the city where everything's done in opposite ways—that's Chicago," reads the opening phrase to Kubrick's photo-essay on Chicago. The midwestern metropolis had risen in about one hundred years from an Indian village to the fourth-largest city in the world. The result, according to the legendary Chicago columnist Irving Kupcinet, was "some of the lushest living ever known—and a wake of human derelicts." Kubrick's portrait of this city of nearly four million inhabitants focuses largely on character studies that represent the city's diverse social strata. One image shows an old man struck by the consequences of postwar hardness; wrapped in a black winter coat, he sits in a vacant lot eating a sandwich surrounded by the debris of a torn-down brick townhouse. By taking the portrait from an unusually low camera angle, however, Kubrick seems to enthrone his destitute subject, thus generating immediate empathy in the viewer.

In another photograph portraying a black woman cooking dinner for her large family, Kubrick chooses to shoot from above, allowing for a view into the pots and pans that are arranged chaotically on her stove. The picture is characterized by Kubrick's treatment of light and shadow, which do not serve any informational function but underline a dramaturgic purpose that arouses the viewer's attention.

Such portraiture was distinct from the mode of photography conceived during the 1930s by the Farm Security Administration program to document social injustice for public archives. Rather than create an illusionistic realism, Kubrick produced pictures that were staged and manipulated according to his perception of a particular scene or situation. In this way, his photographic method could be compared to Bertolt Brecht's "epic theater," which shattered the illusion of realism in traditional theater by replacing emotion with reason and objectivity.

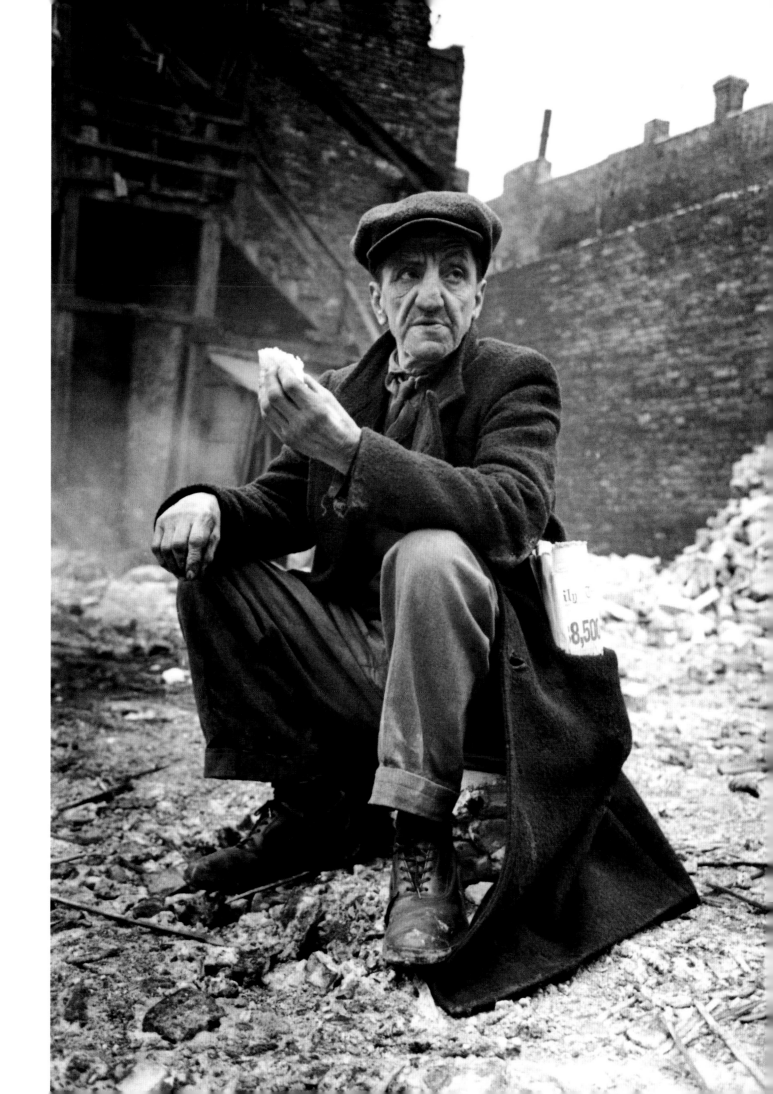

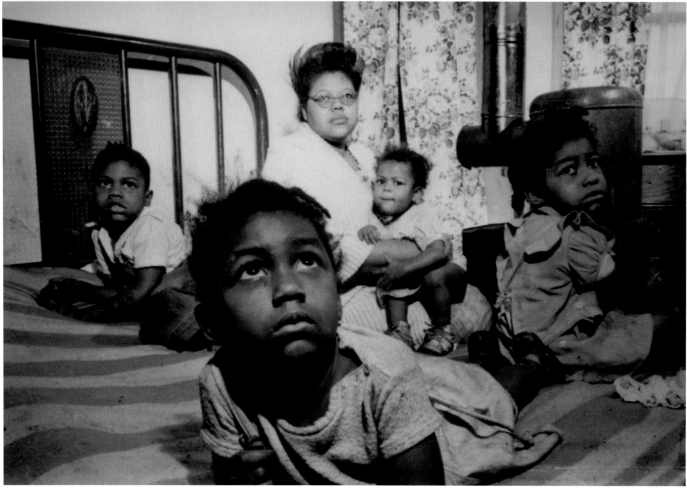

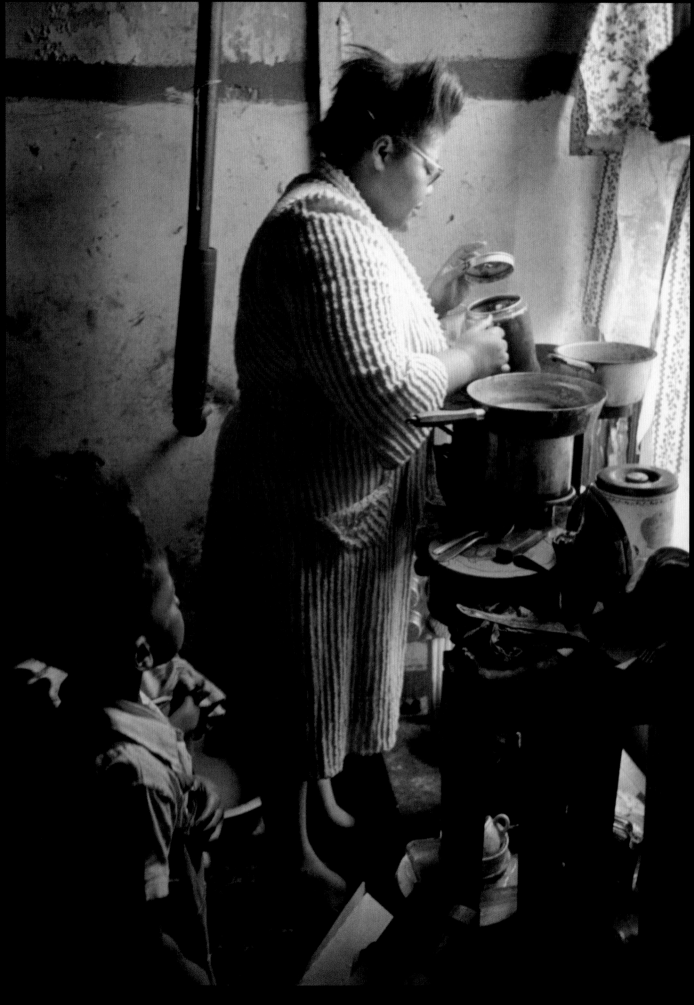

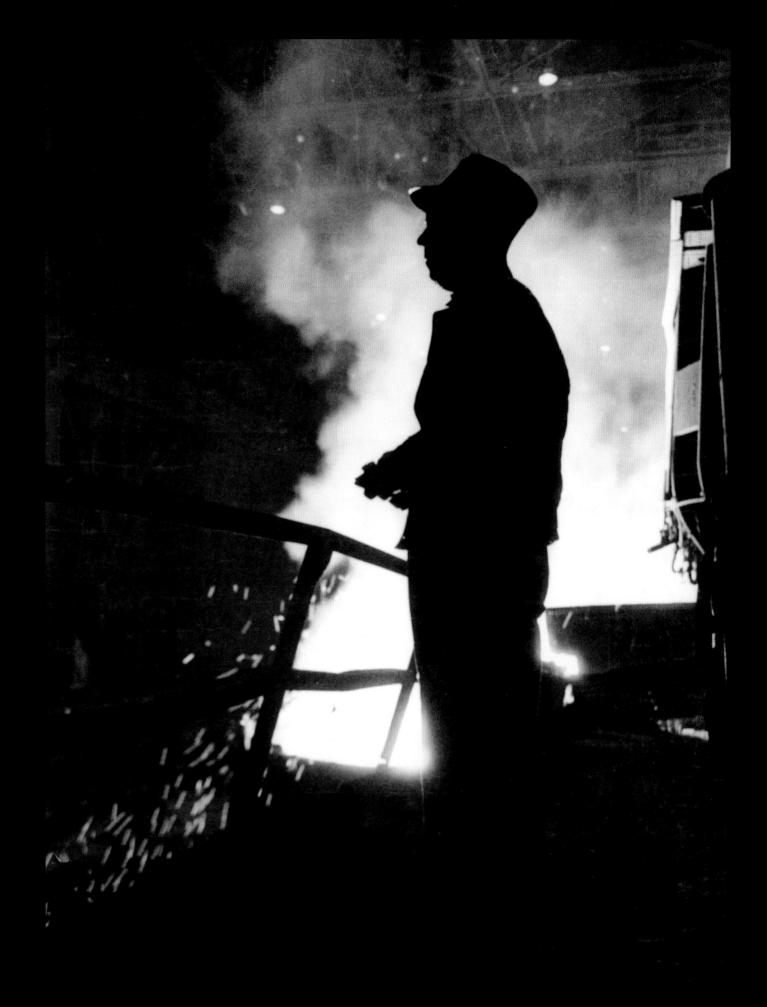

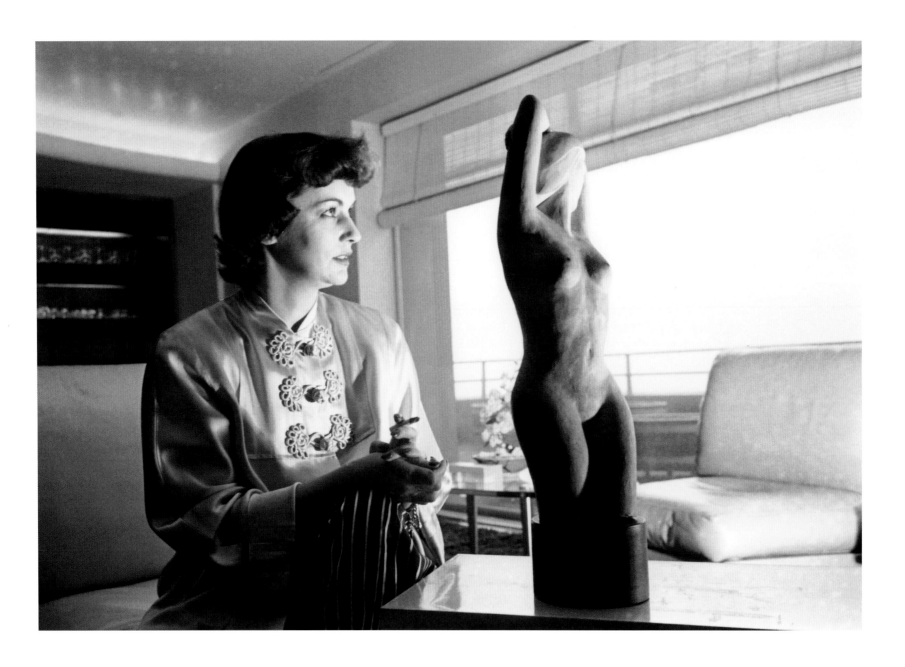

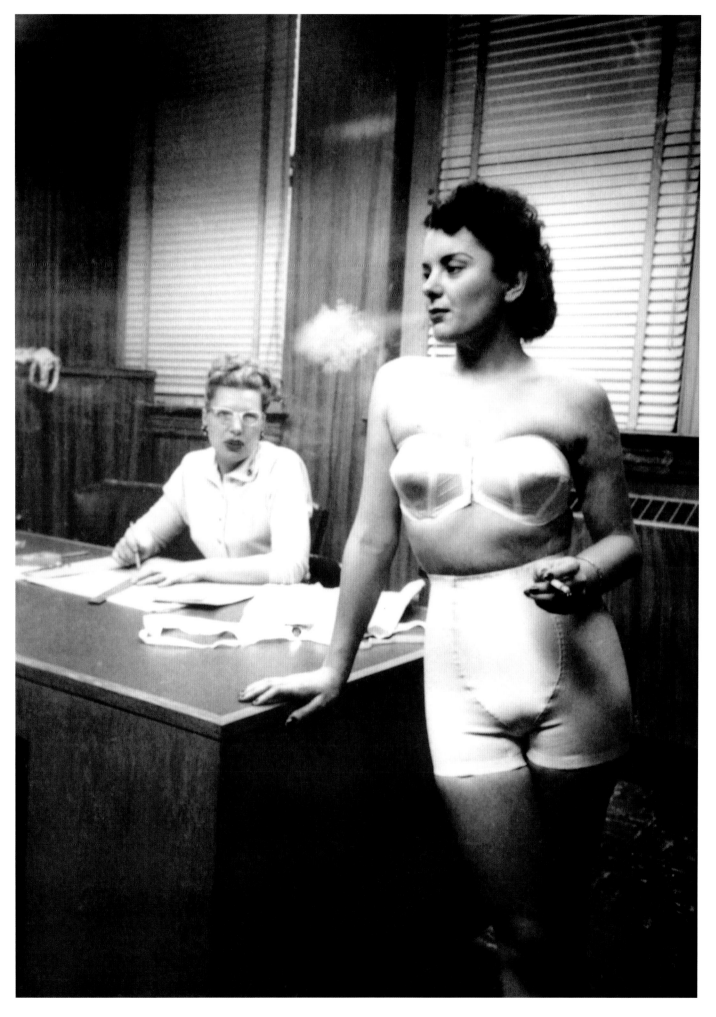

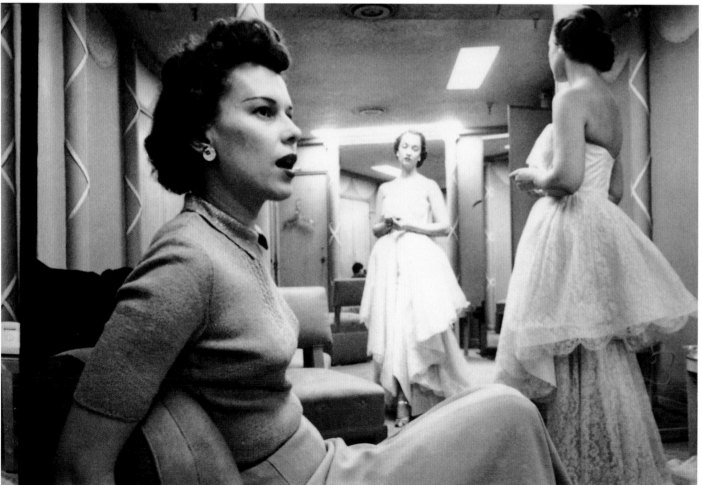

Chicago: City of Social Contrasts 39

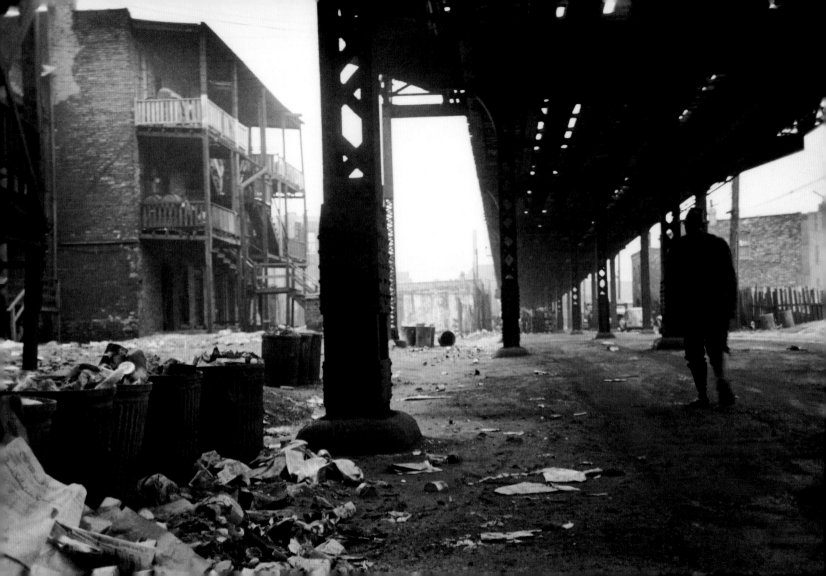

Myths of a Paddy Wagon October 1948

"Paddy" is a nickname for the Irish, derived from the Gaelic name Pádraic, or Patrick. As most policemen in New York at the time were of Irish descent, this slightly derogatory term was also applied to the vehicle used to transport prisoners.

Kubrick's photo-essay on the "World's Most Escape-Proof Paddy Wagon" reflects his attempt to achieve cinematic effects using the means of still photography—using croppings and close-ups and accentuating contrasts of light and shadow—while also maintaining a documentary matter-of-factness. Instead of following potential examples like the popular film noir genre that translated the gangster movies of the 1930s into a mood and point of view that reflected the existential fear, pessimism, and suspicion of the postwar period, Kubrick endeavored to find his own artistic language. Despite his early fascination with the crime-scene photography of Weegee, Kubrick tried to keep a more formal distance when photographing a similar subject.

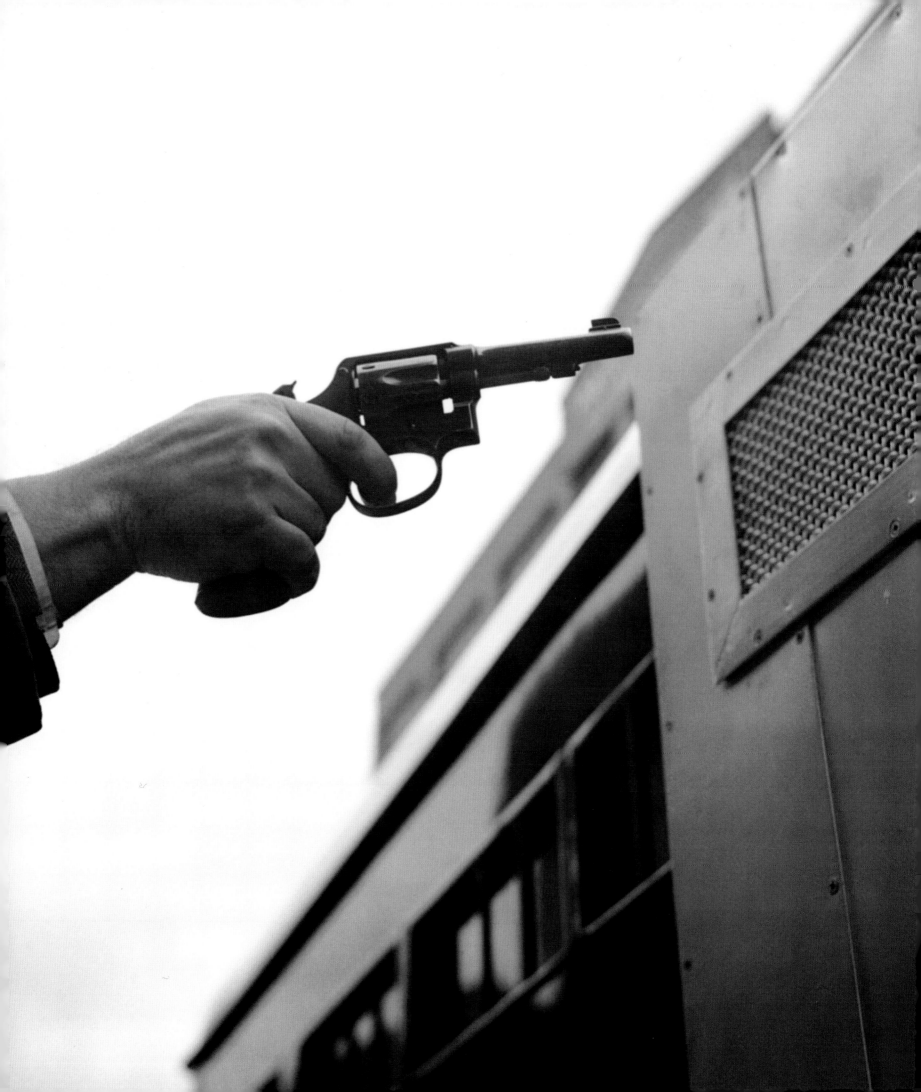

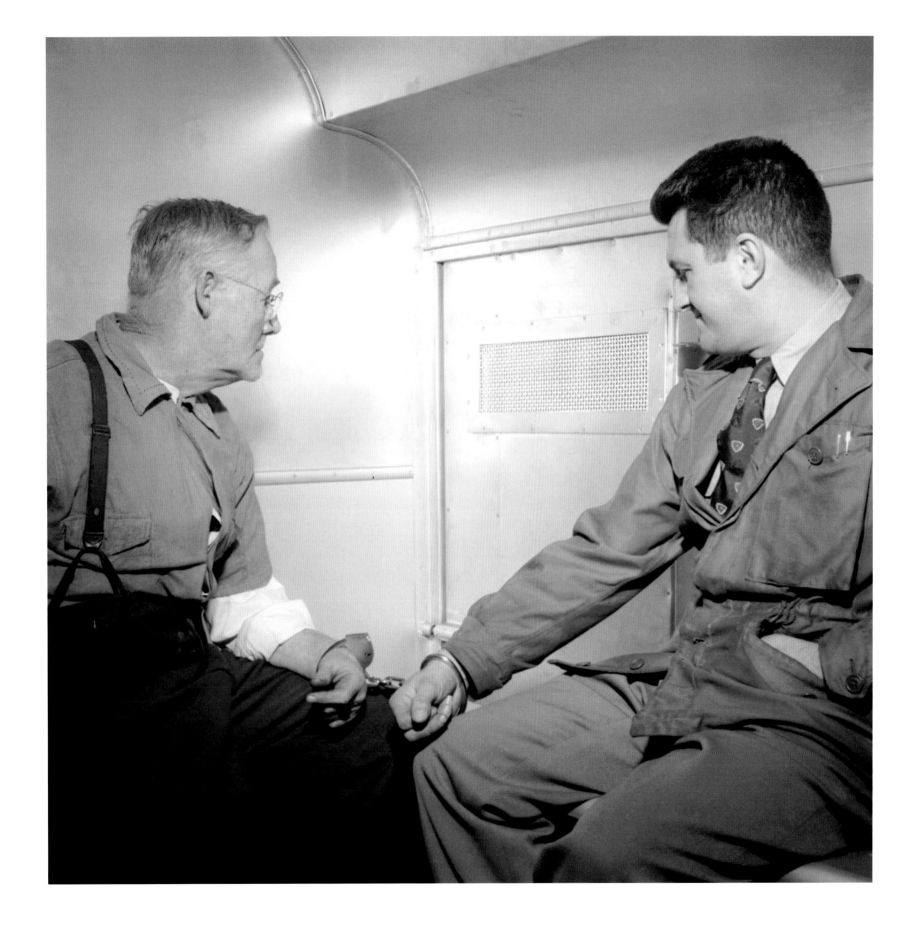

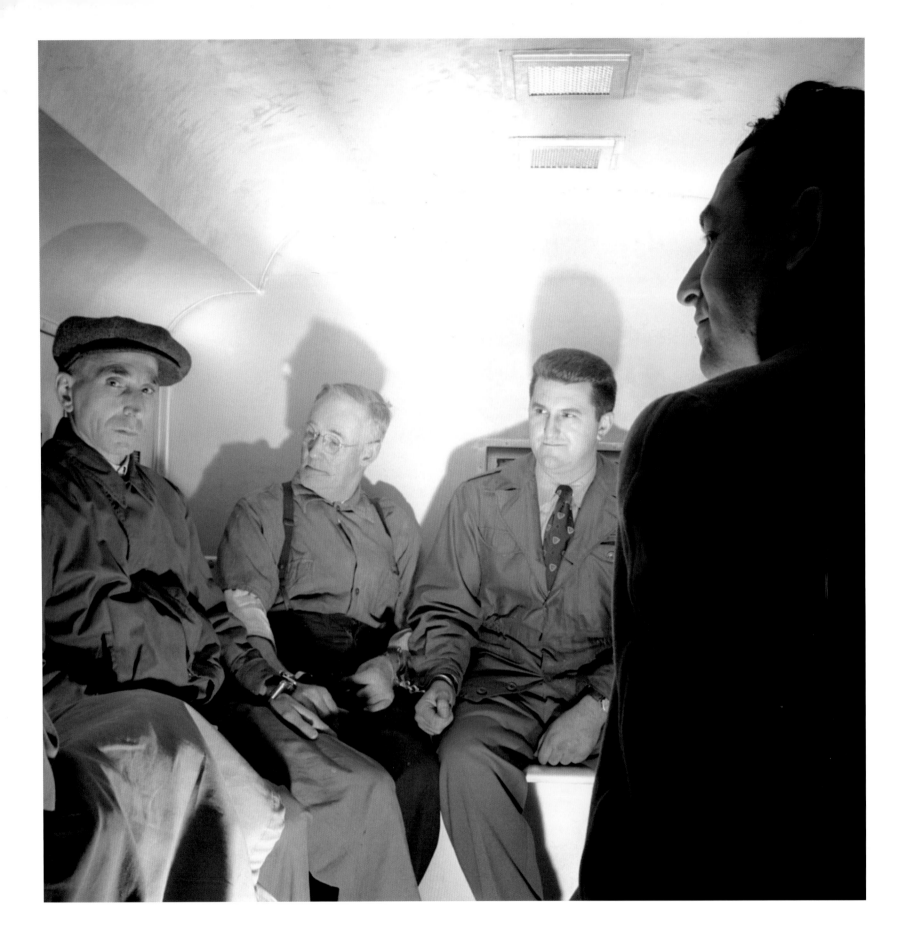

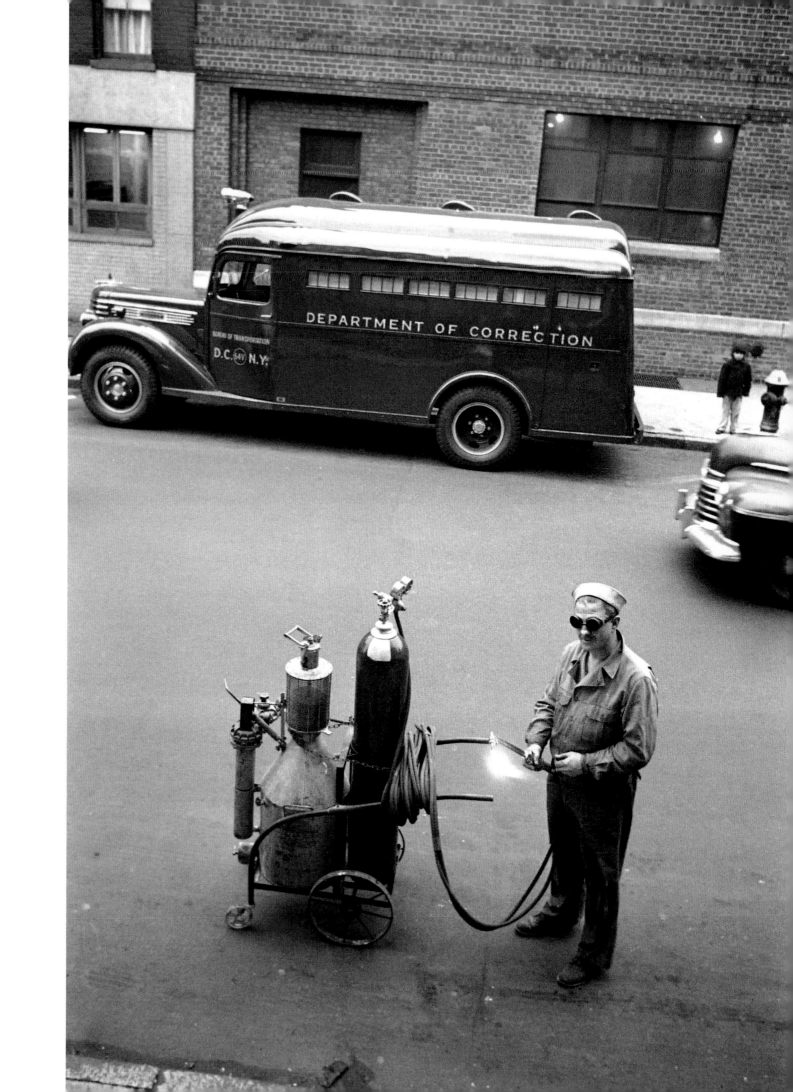

Johnny Grant's Adventures Reporting for Radio in New York August 1946

Johnny Grant—the legendary television broadcaster and "ceremonial mayor" of Hollywood—started his flamboyant career as a buzzing radio reporter in 1940s New York. Kubrick followed Grant around town on his assignments for New York's WINS radio, where he had made a name for himself during World War II with a special daily show for the servicemen on military duty. Grant extended his broadcast fame into the postwar years with high-profile news stories of local and international importance.

Kubrick's study of this promising reporter's daily beat, however, humorously focuses on more trivial matters. It shows how Grant is always right on the spot, approaching his subject as dangerously or—in case of interviewing scantily dressed women—admirably close, without a care as to whether his stories are appropriately "airable." In the funniest pictures, Grant tries to interview such unlikely subjects as animals, little babies, or even totally inanimate objects. Kubrick portrays Grant as an intelligent, energetic, and free-spirited person with a comic talent who—like himself—transcends the boundaries of official assignments to follow his own ideas.

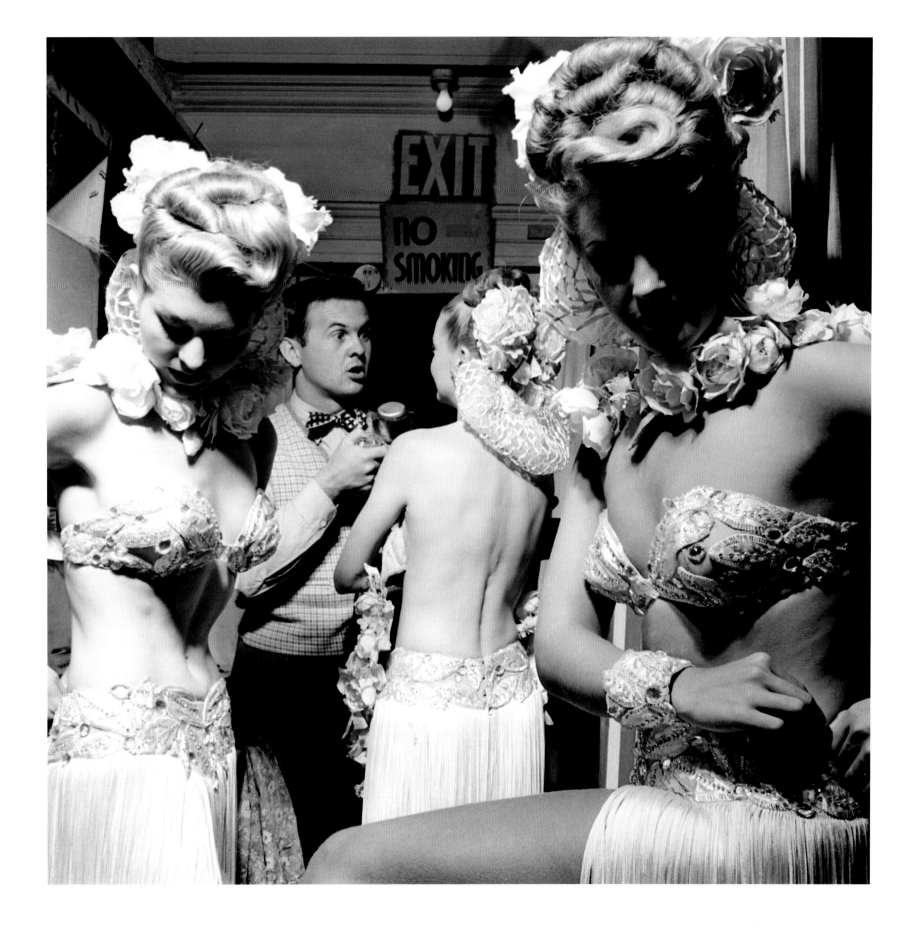

53

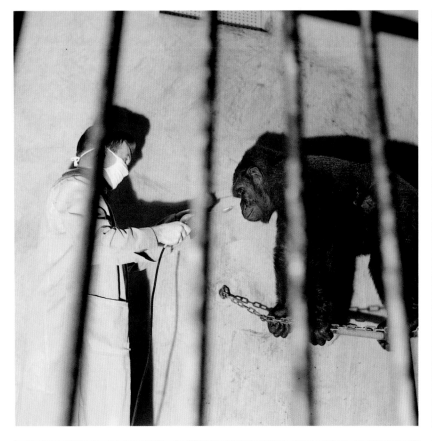
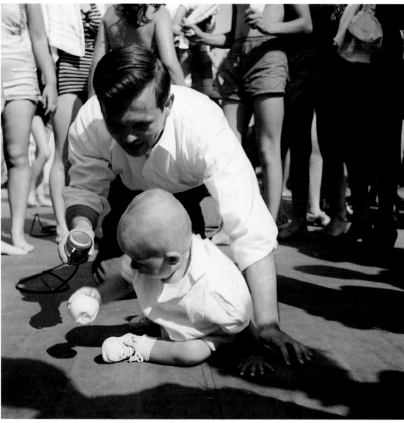
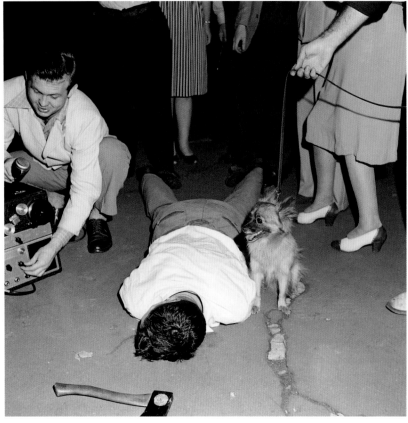
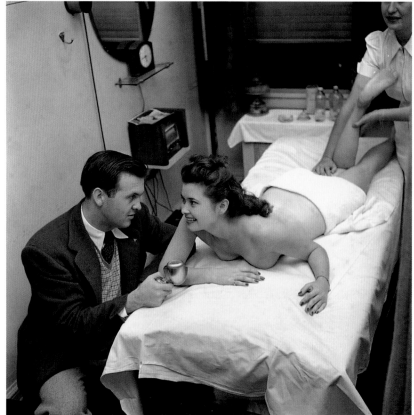

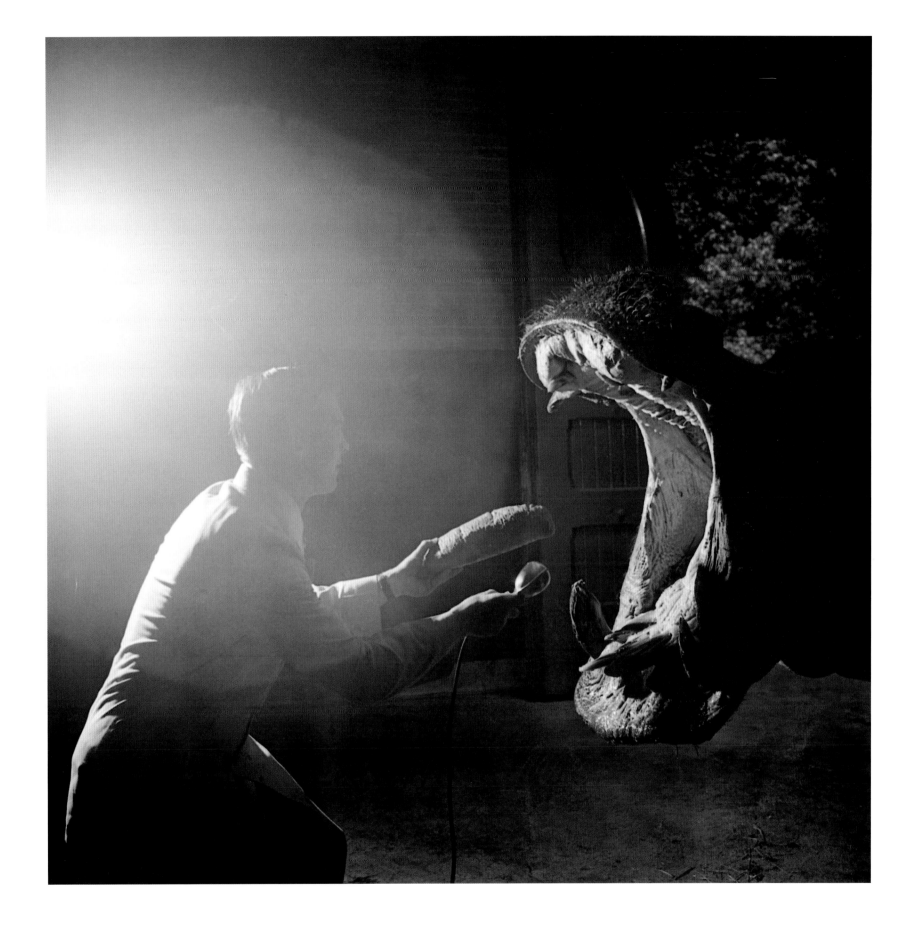

A Tale of a Shoe-Shine Boy October 1947

Kubrick's photo story about a Brooklyn shoe-shine boy draws us into the daily life of Mickey, a handsome and self-confident twelve-year-old who selflessly works after school to help support his ten younger brothers and sisters. Kubrick dramaturgically opens his photo study with a half-figure portrait of the skinny blond boy posing in front of a decorative circus poster—a method of establishing Mickey's character that is taken directly from the narrative structure of Hollywood films. Although Kubrick was just nineteen years old when he shot this story, he clearly already understood the visual language of cinema.

By starring a young unknown boy from a lower social class rather than a celebrity, Kubrick provides not only a view into the boy's life and social circumstances—turning the unknown figure of Mickey into a strong dramatic character—he also gives us a portrait of the city. He captures emotionally moving scenes of Mickey tending to a flock of homing pigeons on the roof of his apartment building, which overlooks the East River and the Brooklyn Bridge.

In this final sequence of photos that are structured to imply the boy's attempts to transcend the daily fight for survival, Kubrick uses the birds as a signifier of both freedom and message carrying when they are released into the sky. Another image showing Mickey climbing a fence bears a similar association to this drive toward liberation.

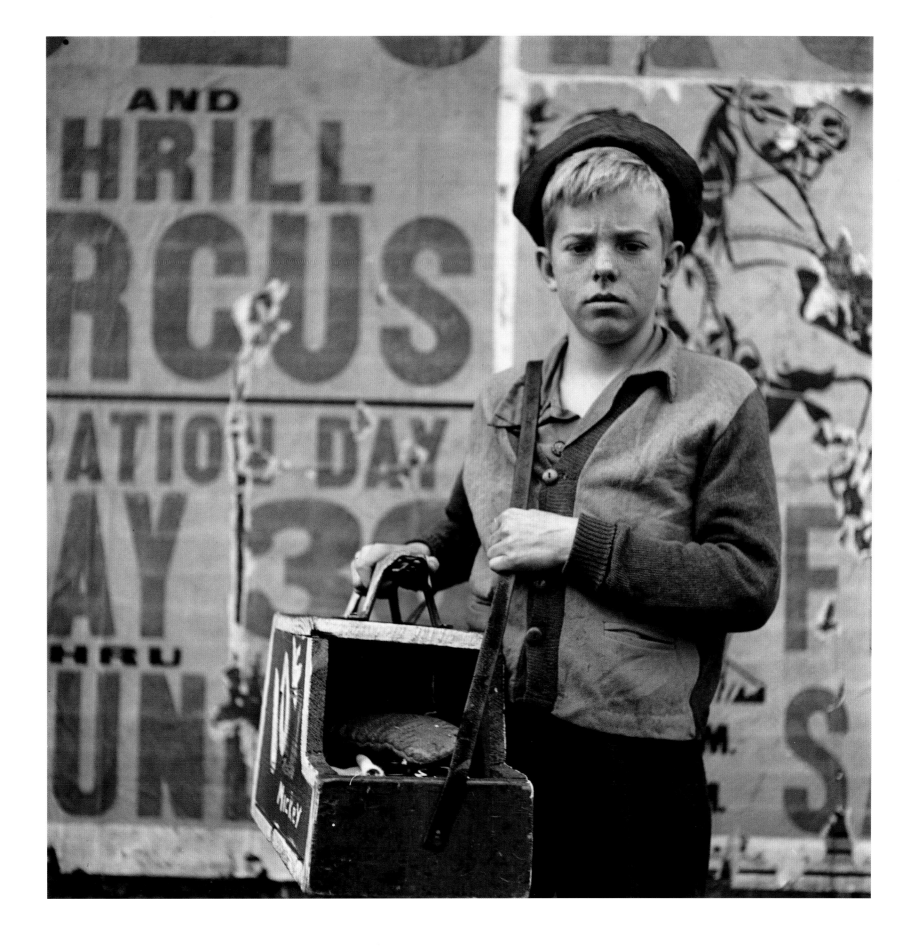

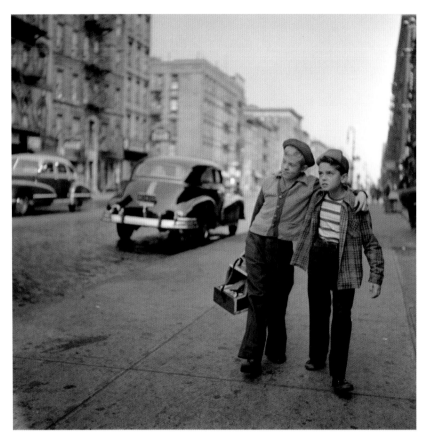
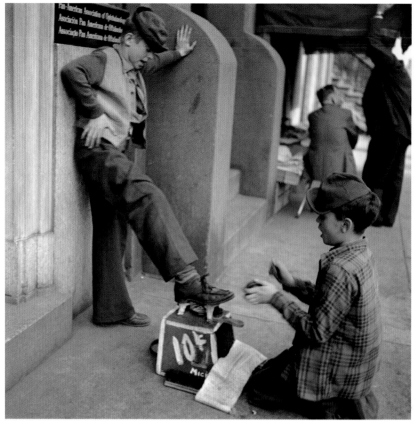
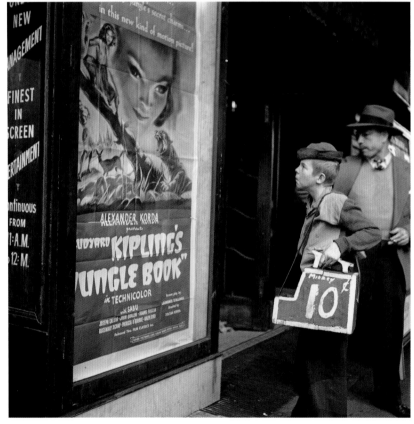
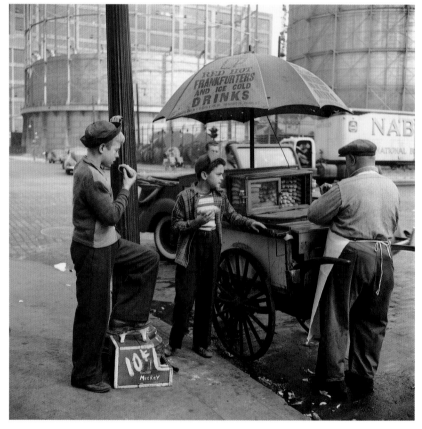

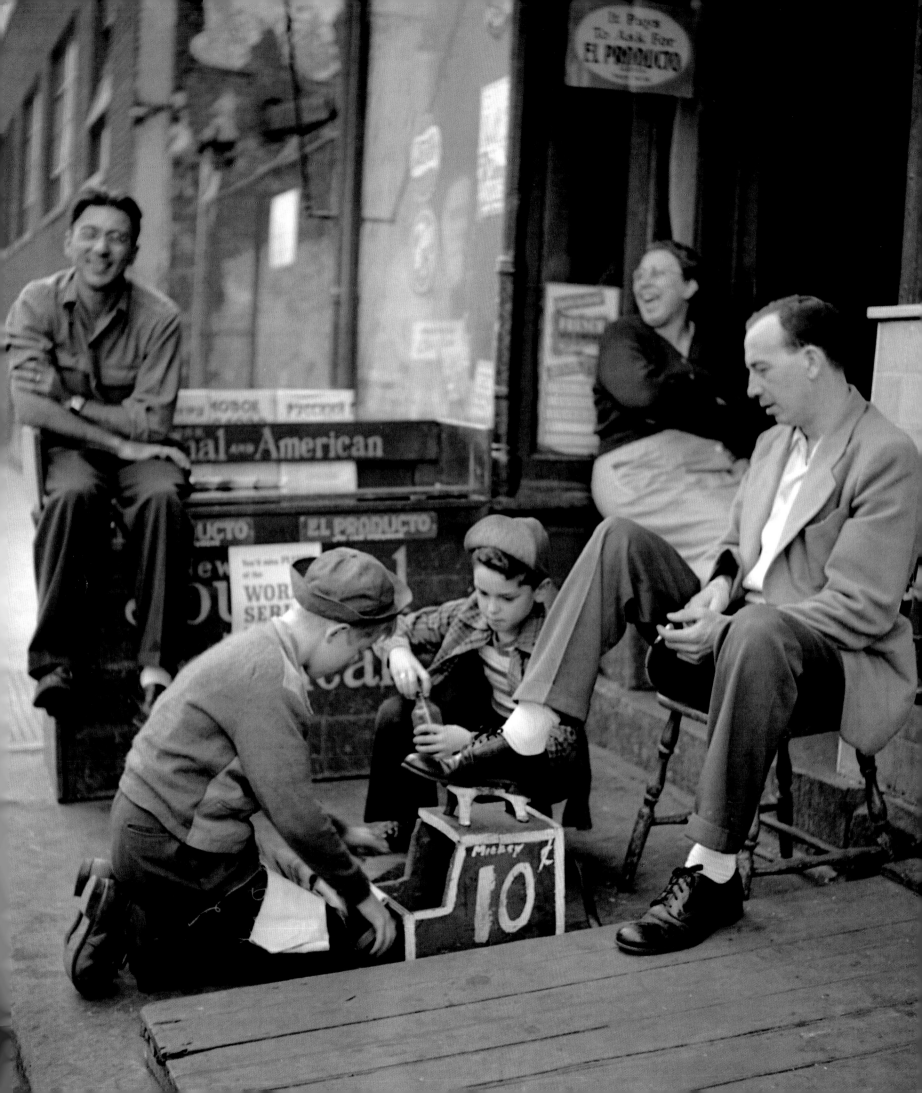

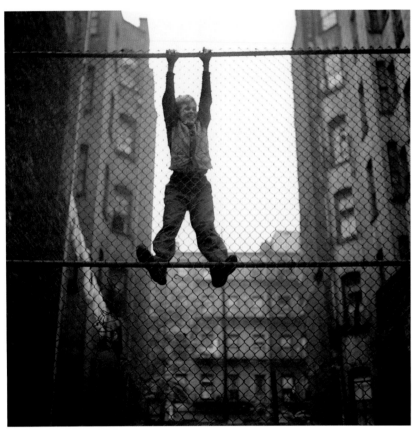

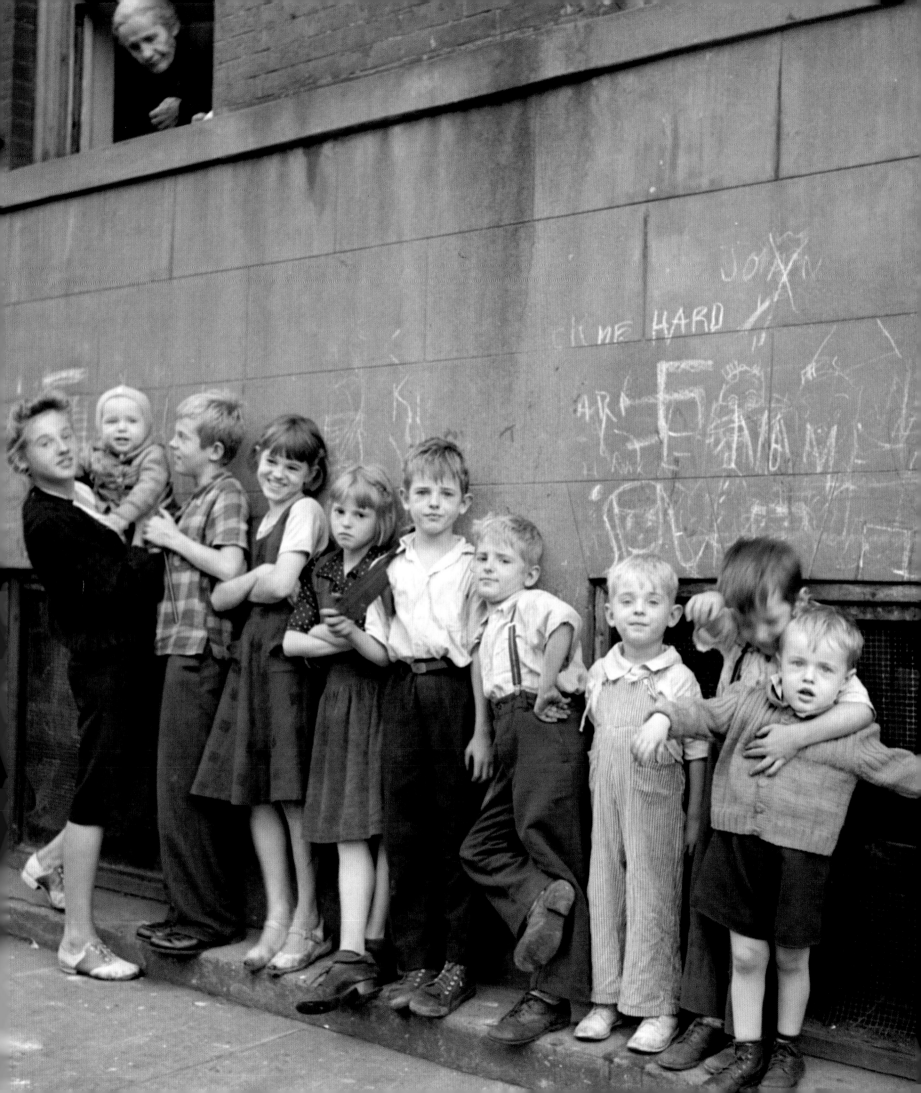

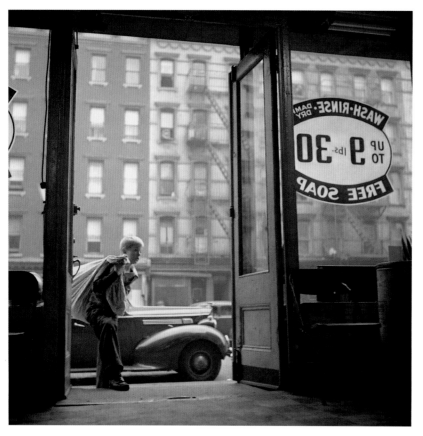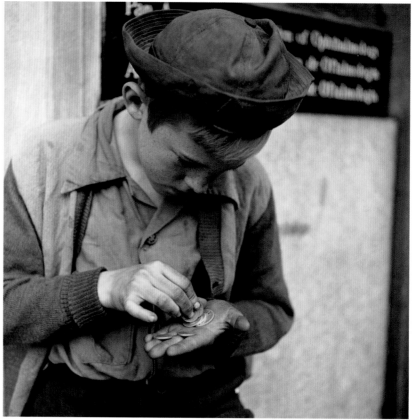

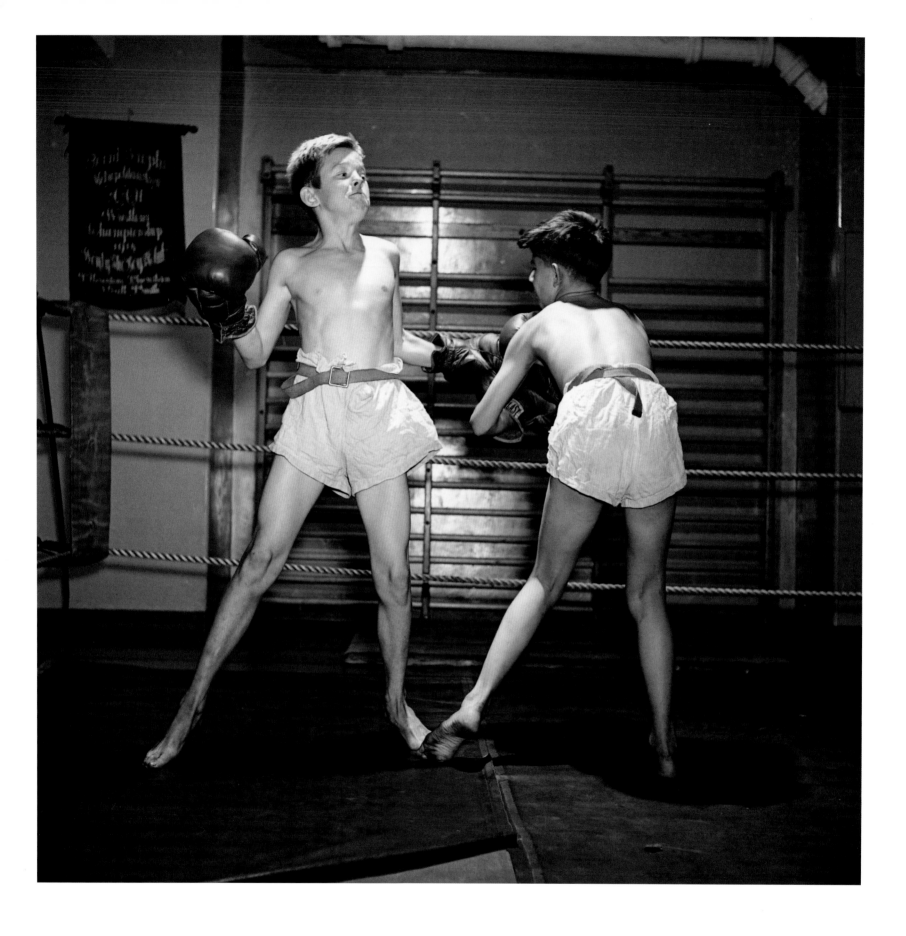

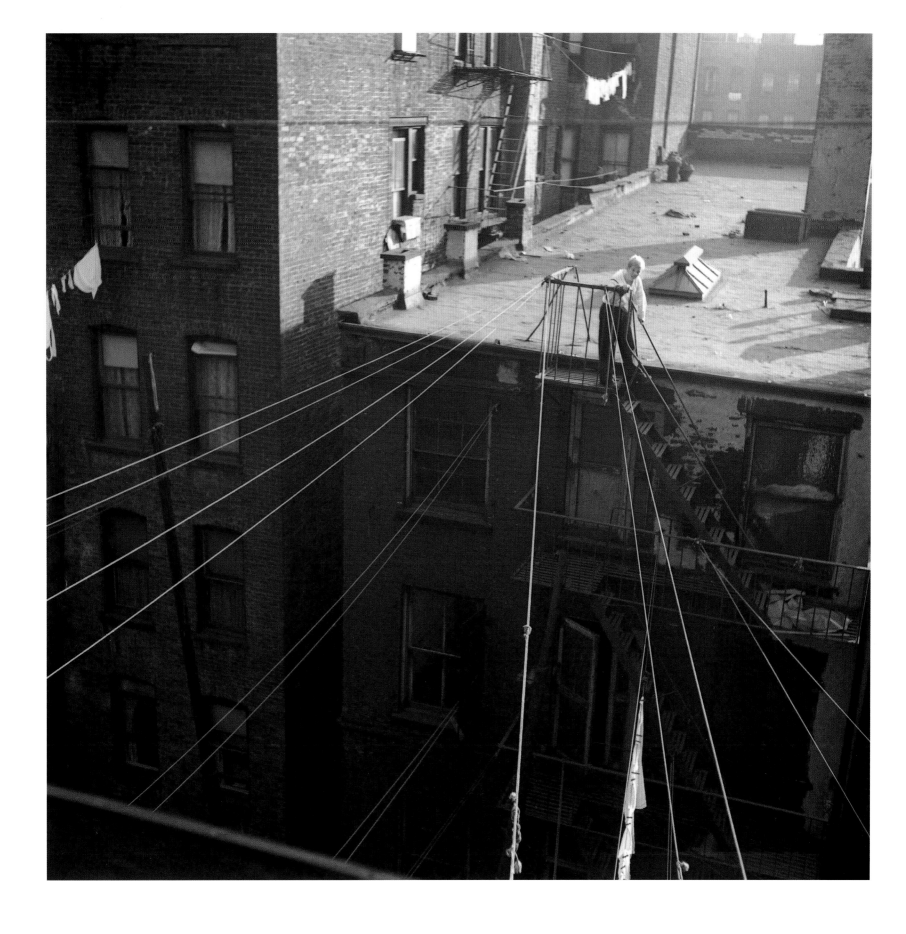

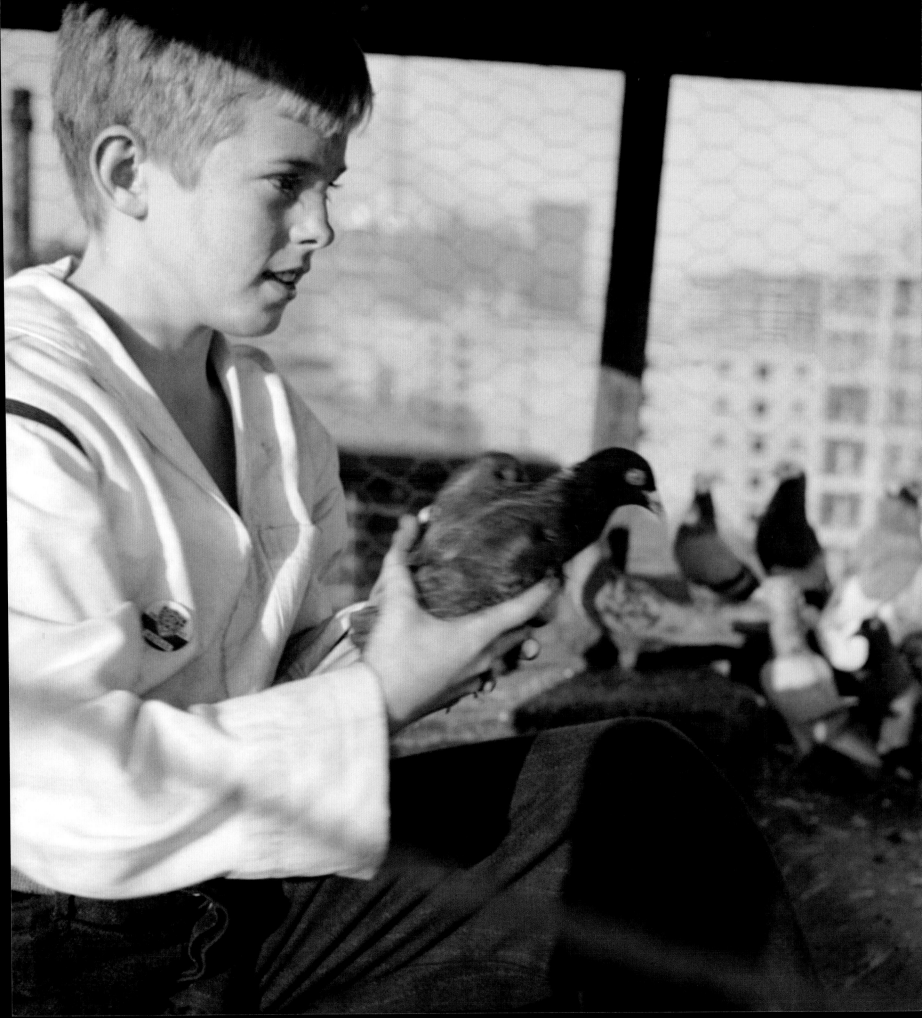

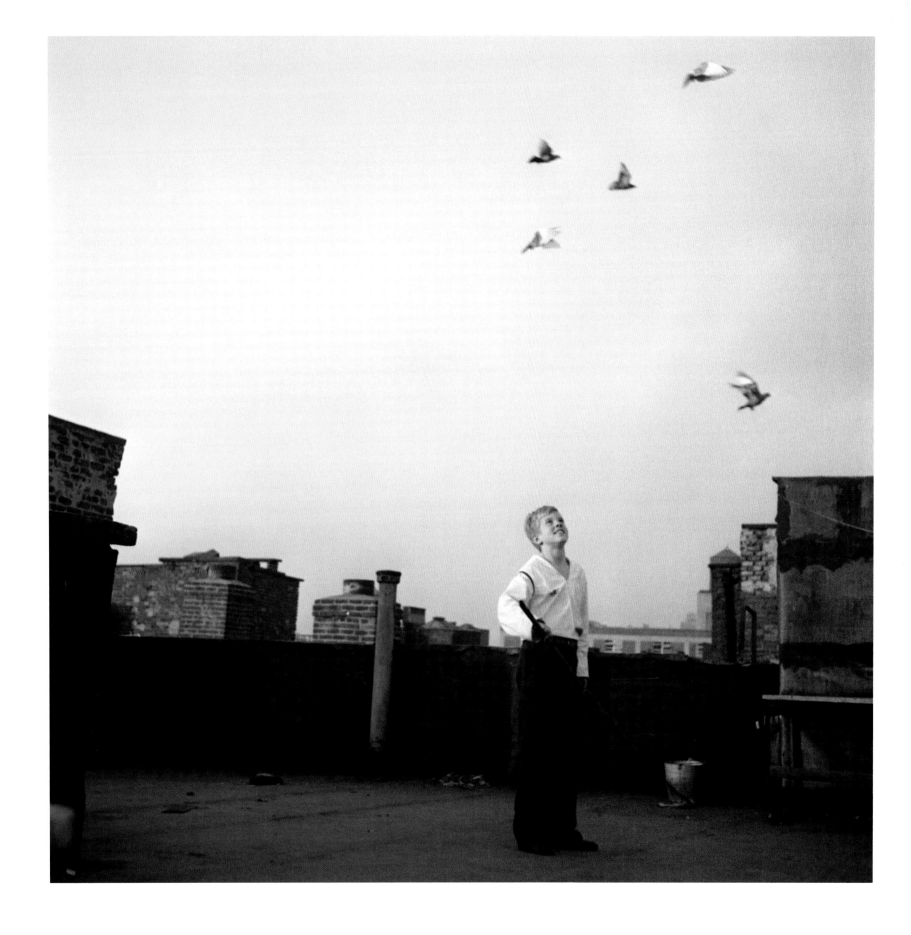

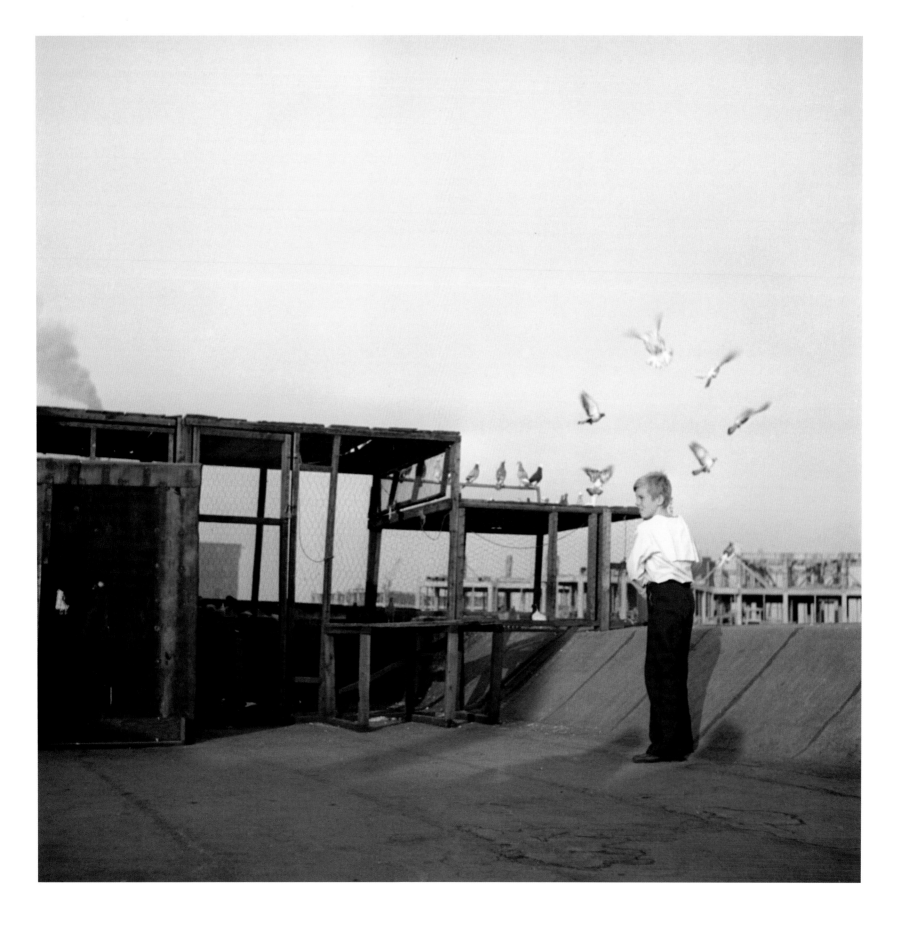

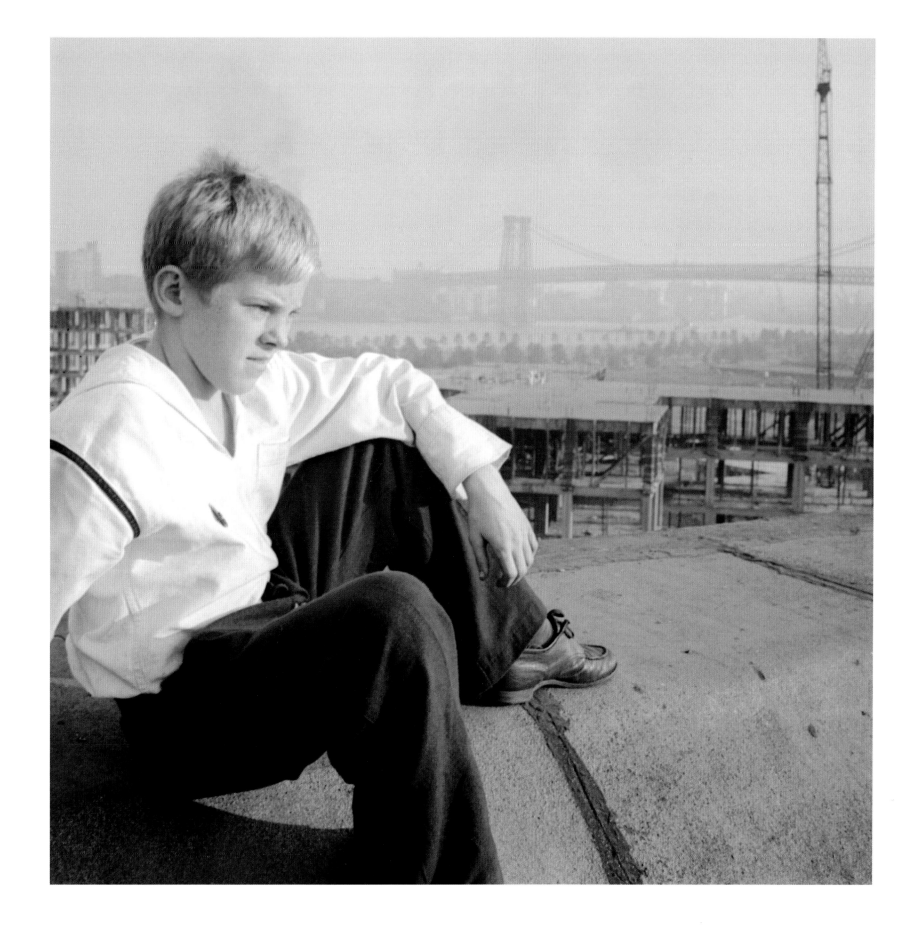

Kids Fighting in the Street July 1946

The American poet Wallace Stevens once said about the photographer Helen Levitt, who dedicated her art almost exclusively to the children of New York, that her "extraordinary gift is to perceive in a transient split second, and in the most ordinary of places—the common city street—the richly imaginative, various, and tragically tender moments of ordinary human existence."

The same could be said of Kubrick. A playful scrap between two boys, while a younger boy looks on, is set against the bleak background of a derelict inner-city street. Unlike Lewis Hine, another twentieth-century photographer whose subjects were the children of New York—in his case, deeply impoverished child laborers—Kubrick chooses not to comment on the stark reality of the boys' social milieu. Instead, he positions his story somewhere between Levitt and Hine and invites the viewer to participate in the boys' rough-and-tumble game, conjuring up universal childhood memories.

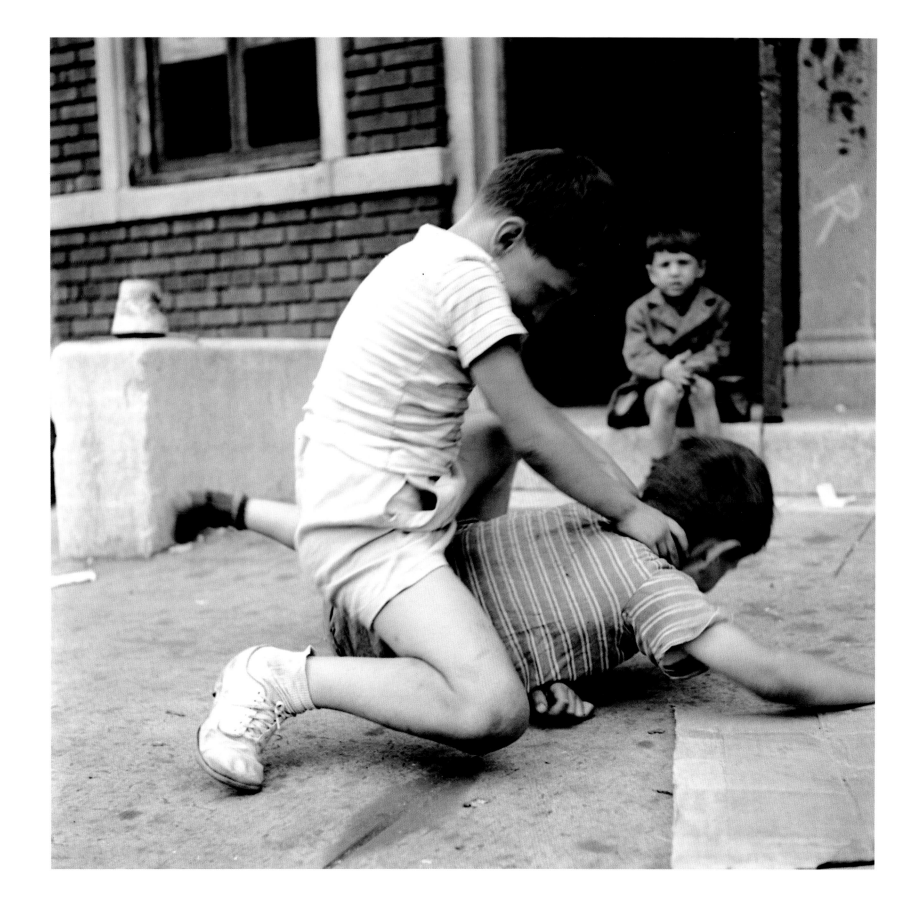

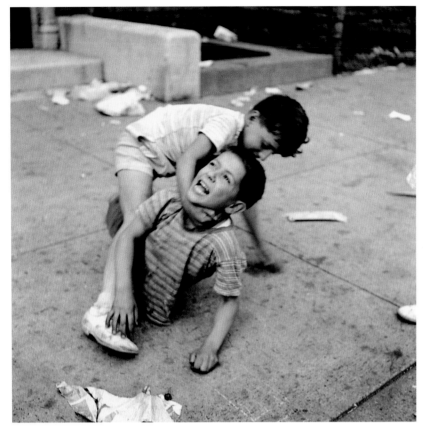
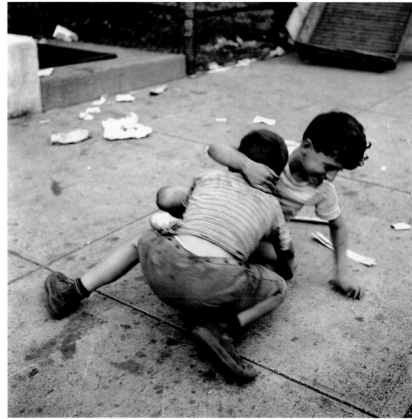
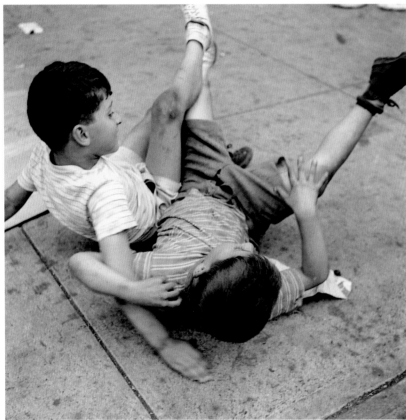
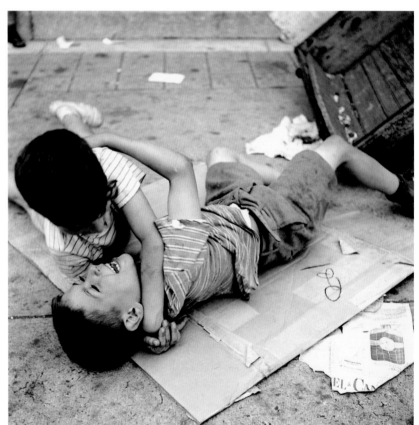

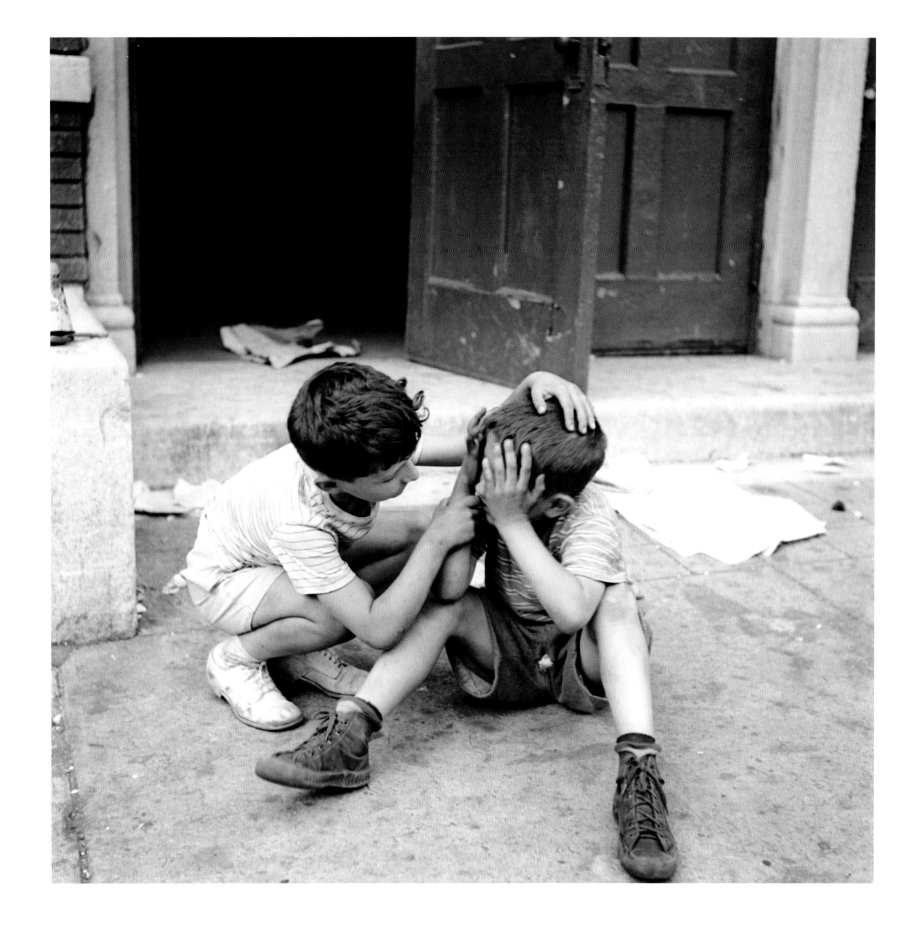

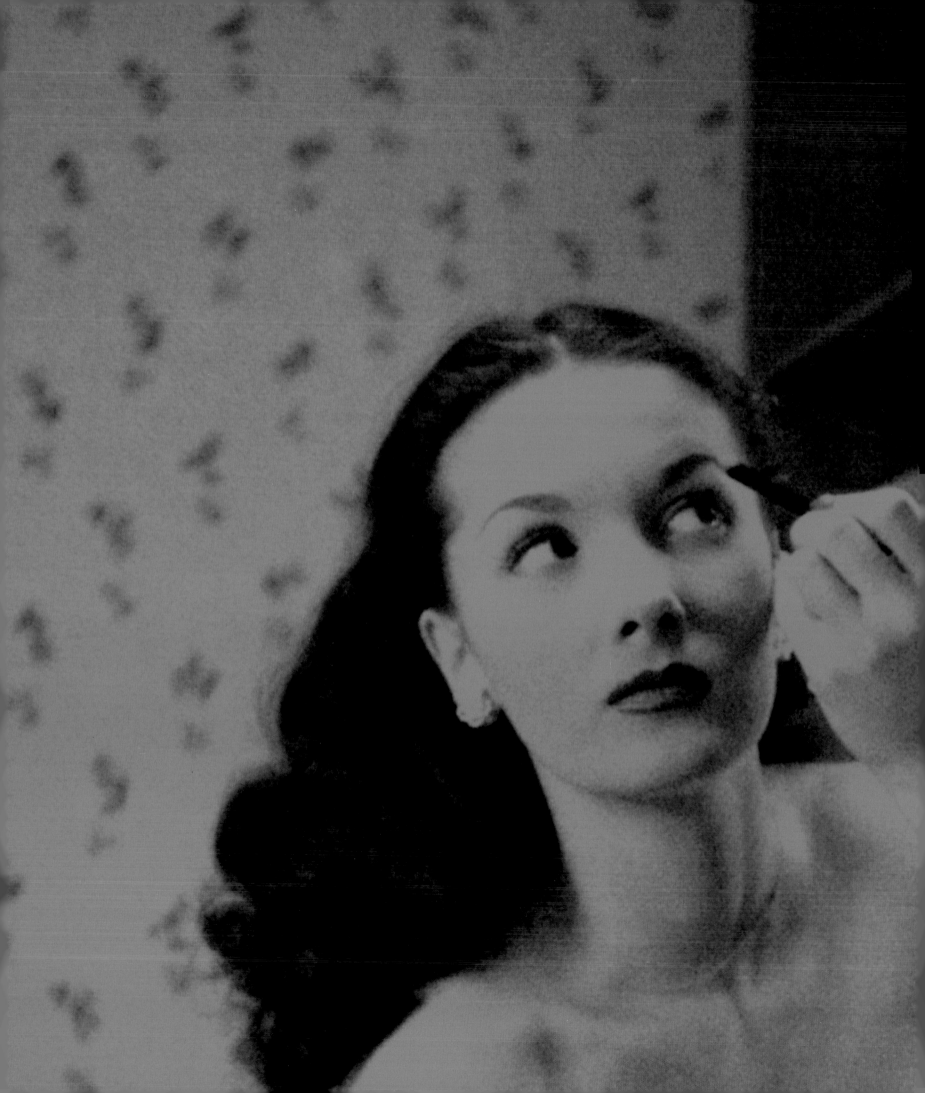

Entertainment

The World's Biggest Spectacle
A Circus Run by a Family March 1948

When Kubrick reported on what was then the biggest circus in the world, there seemed to be no limit to his imagination—as if he wanted to showcase the scope of his talent. Against the background of the postwar period's cultural awakening and the Ringling family's own rise from obscurity, Kubrick portrays the protagonists of the exotic and absurd world of the circus.

Sons of a German immigrant, the six Ringling brothers founded their circus in 1884. From its modest beginnings, the enterprise rose to become unique in the show-business world by the end of the 1880s. Amateur "artistes" themselves, the brothers became managers—most prominent among them John Ringling (1866–1936), who originally performed as a clown and later took over the circus, but also founded railway lines and a bank, eventually becoming an oilman, a real-estate developer, and a patron of the arts. When Kubrick shot this story, it cost twenty-thousand dollars a day to run the circus. With its 1,400 employees, 900 animals, 46 tents, and tons of equipment, the operation directed by John Ringling North, the forty-four-year-old nephew of John Ringling, was almost as self-sufficient as a small town.

Kubrick did not just seek to depict certain aspects of life at the circus; he created nothing short of a *commedia humana*, capturing a tremendous variety of human self-presentation. The daring perspectives seen in these images indicate that Kubrick must have been familiar with Constructivist and Bauhaus photography—both of which he would have had access to at the Museum of Modern Art. The young photographer was clearly striving to find an adequate stylistic representation for the fantastic world of the circus, where the usually separate realities of man and beast collide and where performers defy the laws of gravity. Such themes would have a profound hold on Kubrick's imagination when they underwent a complex cinematographic elaboration in *2001: A Space Odyssey*, which visualizes the stages of intelligence between animals, humans, and some form of higher being.

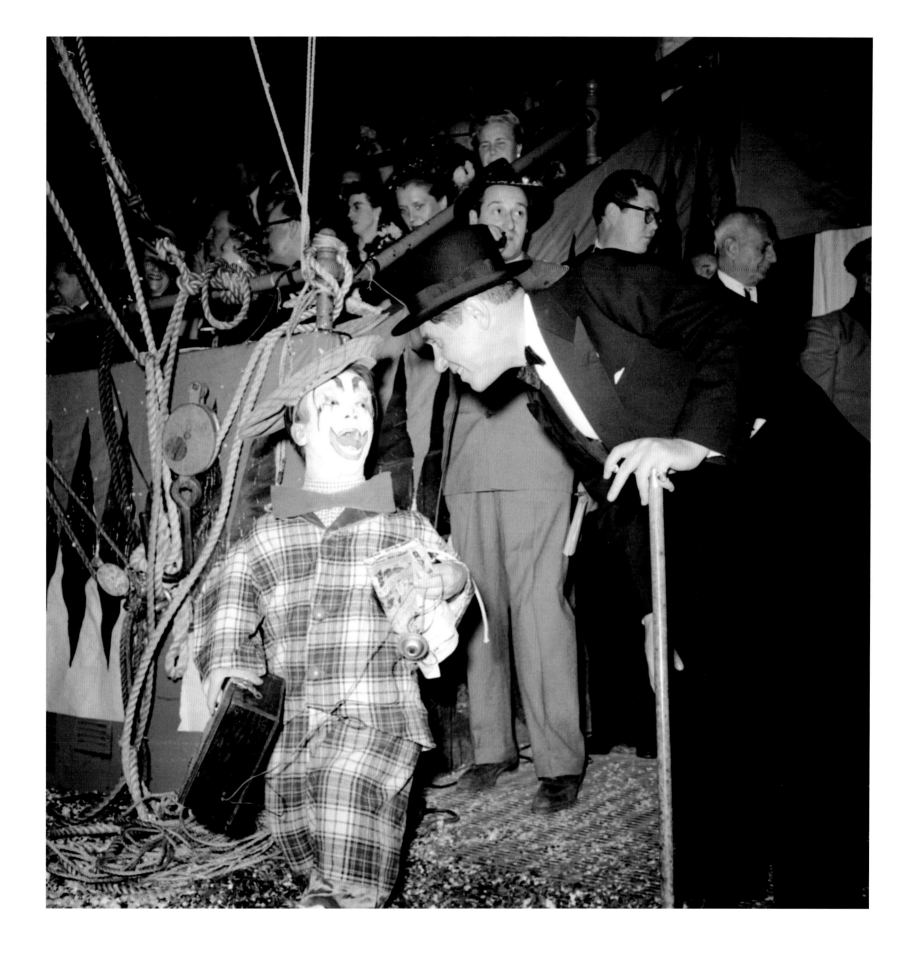

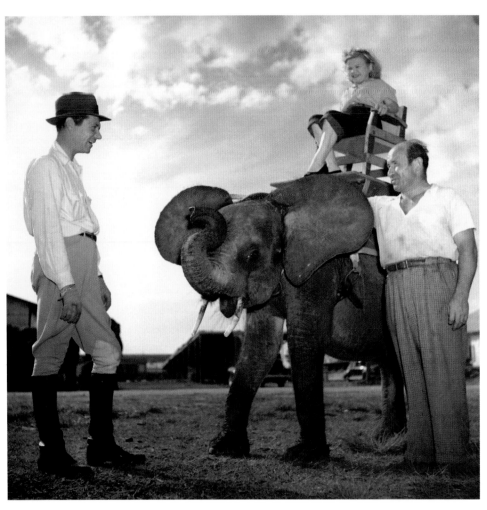

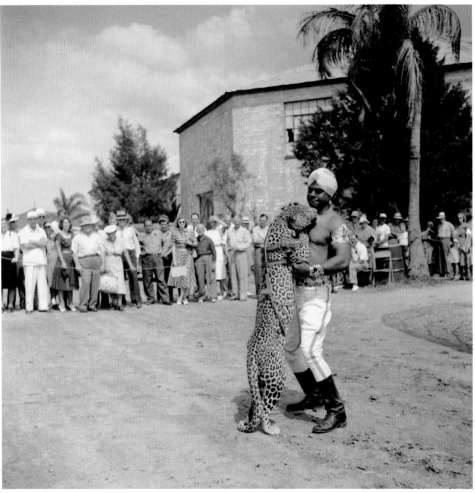

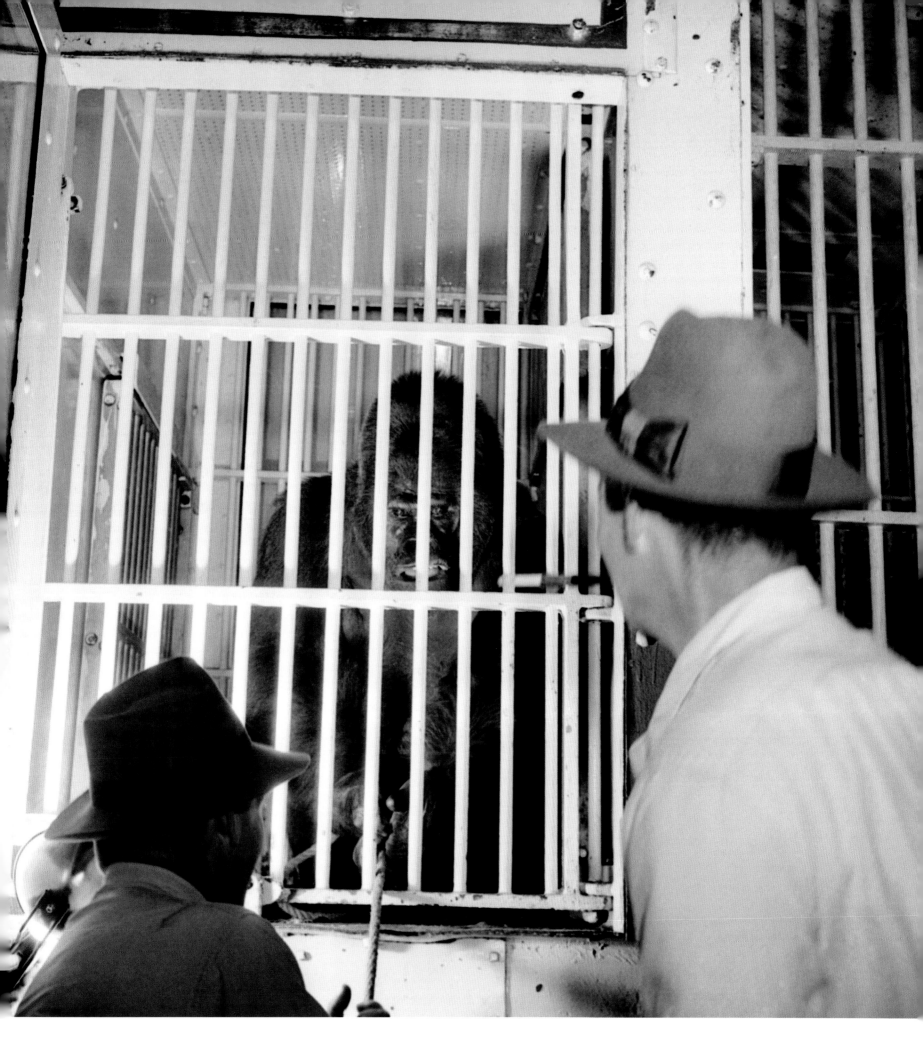

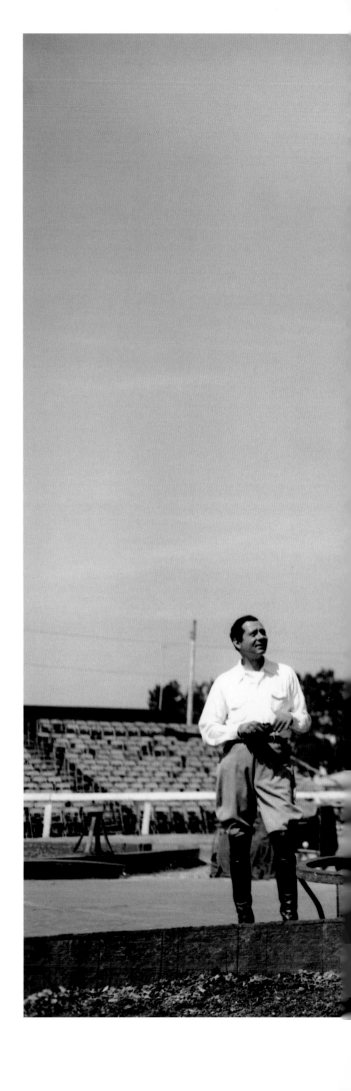

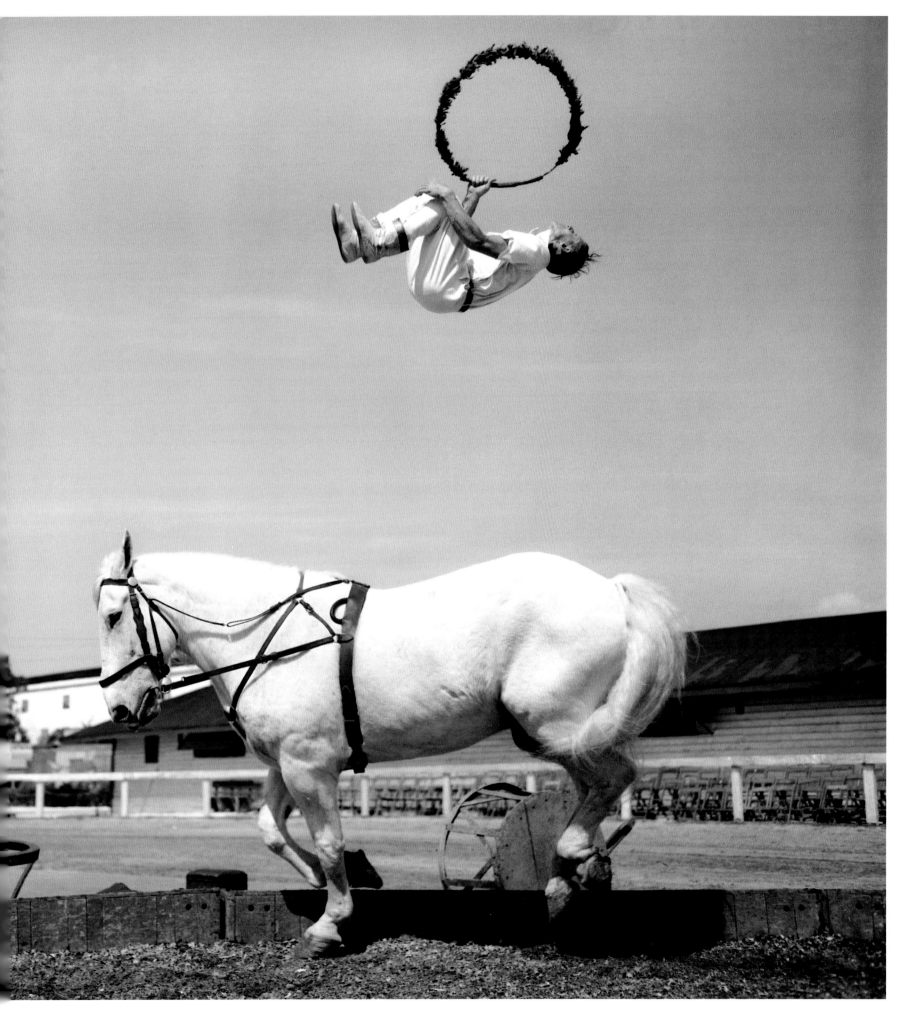

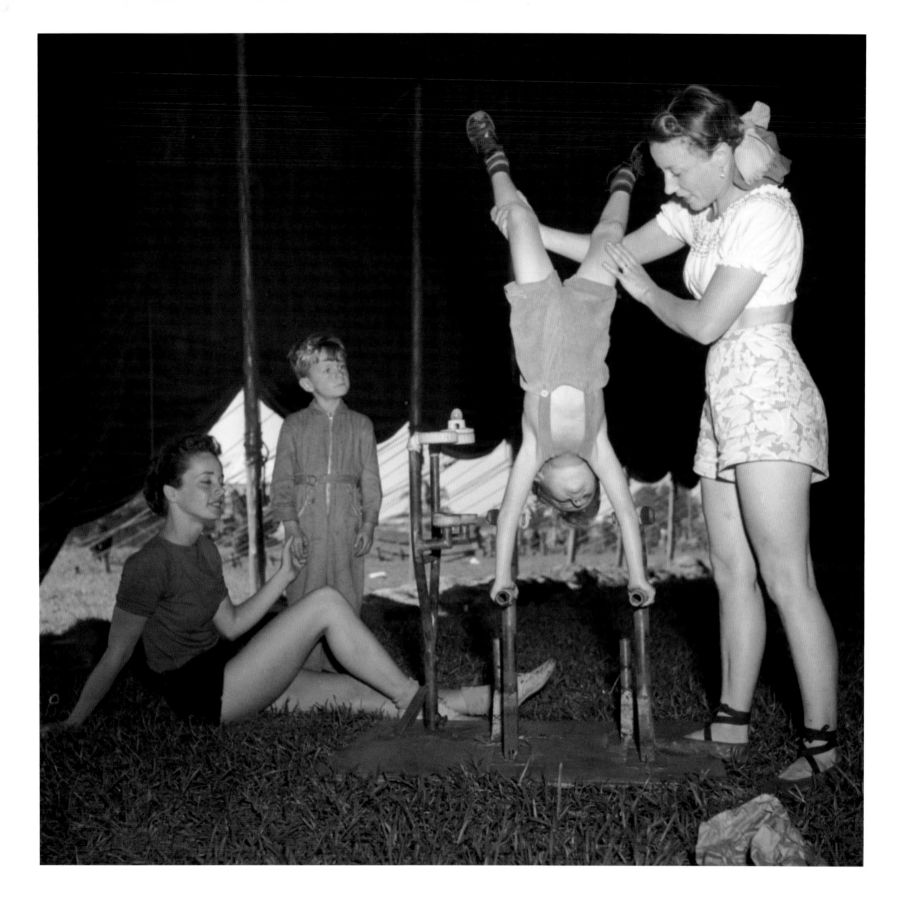

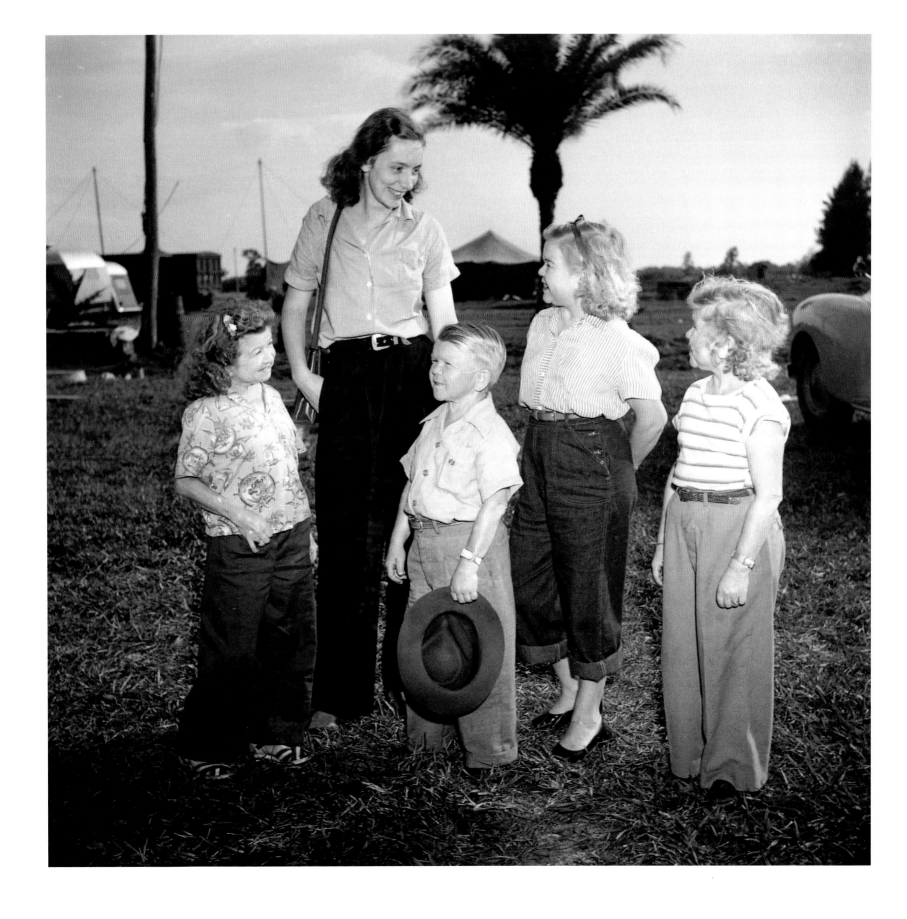

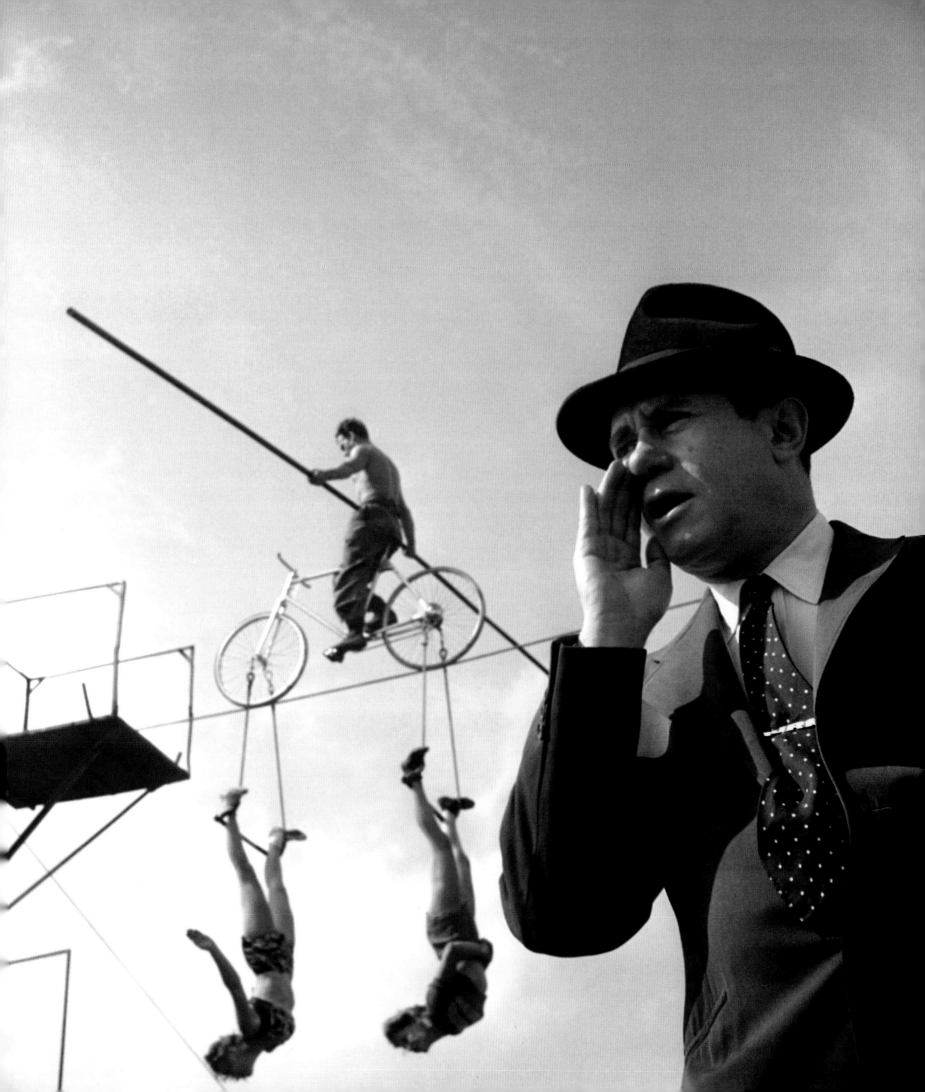

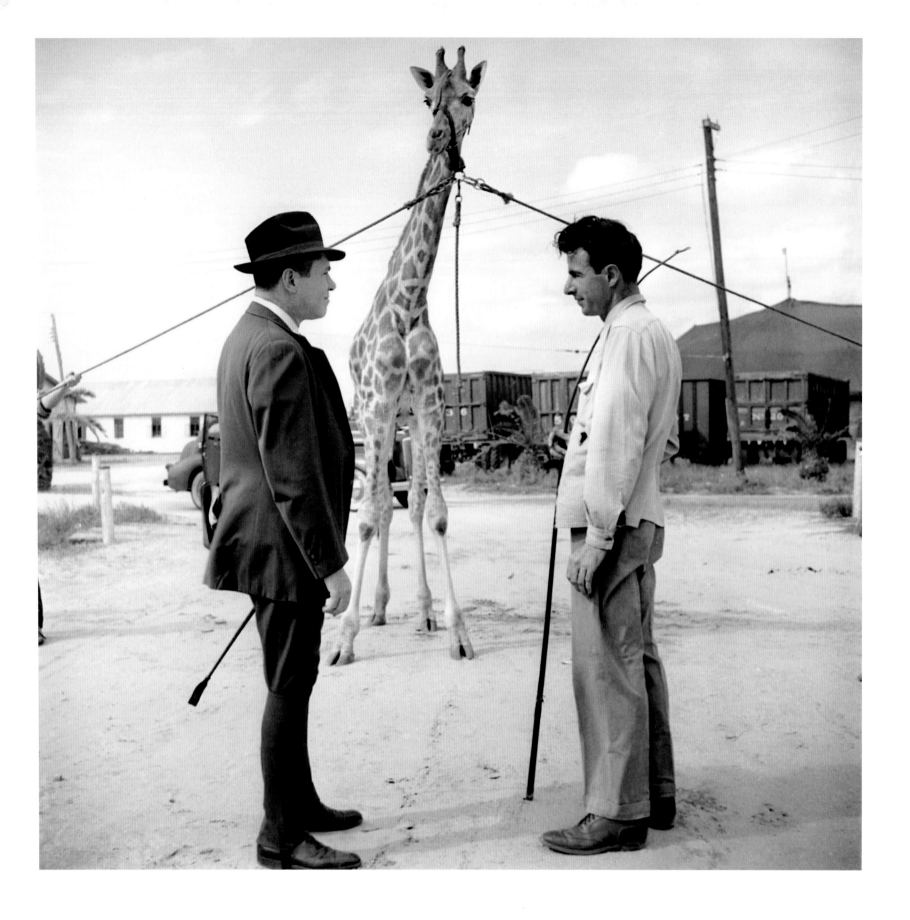

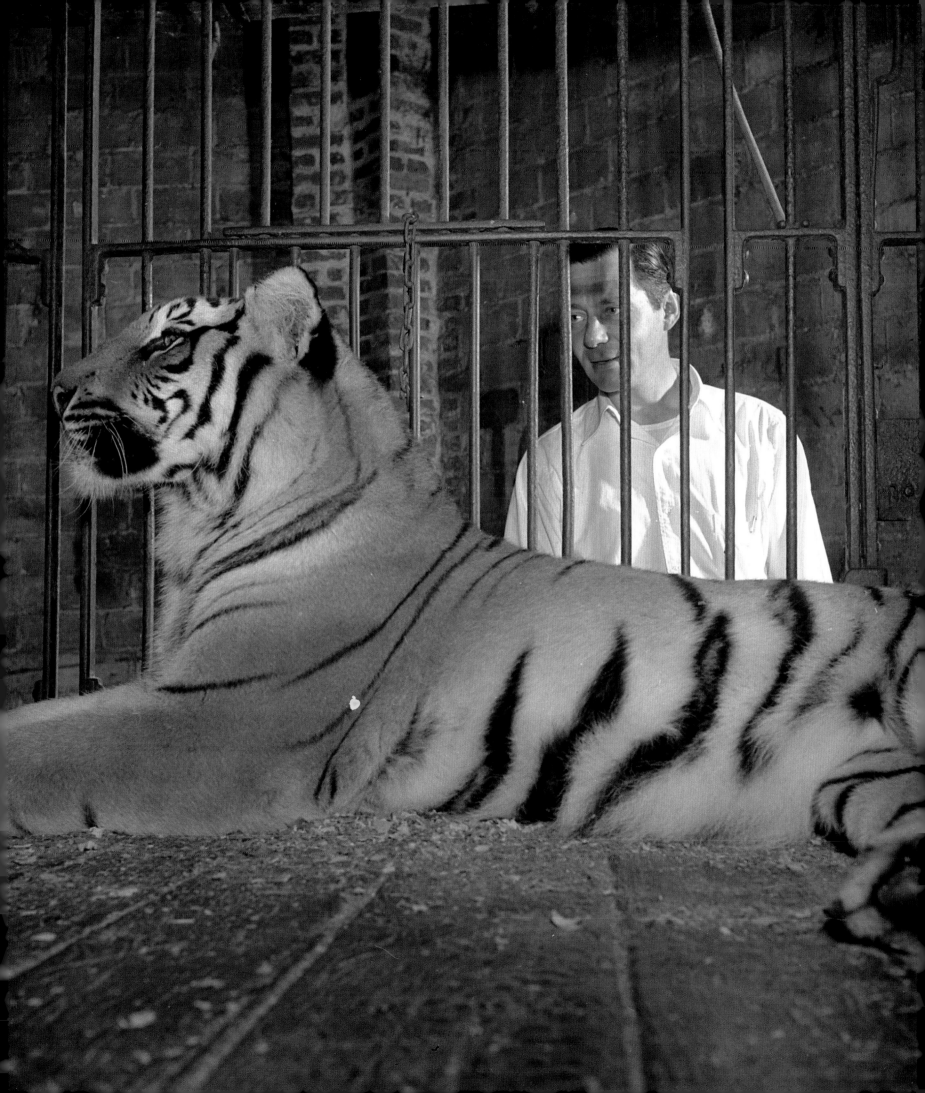

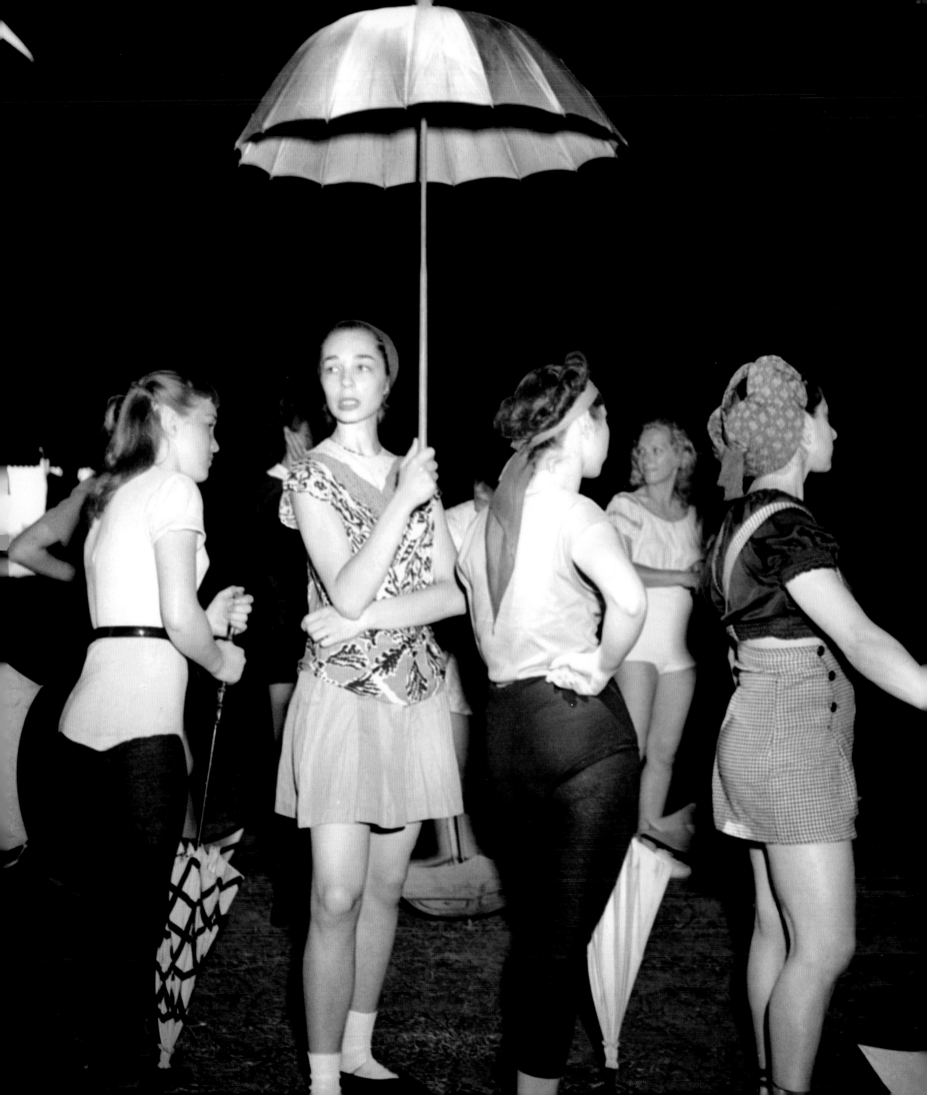

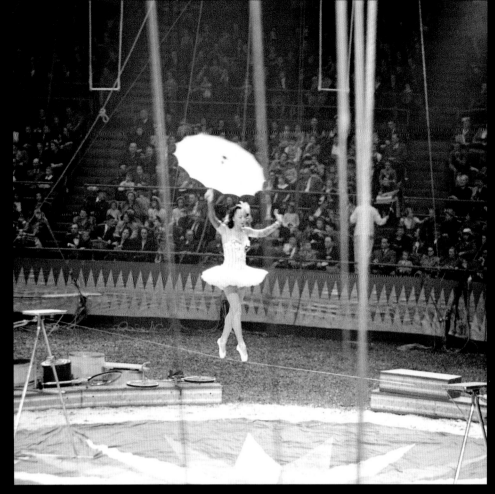

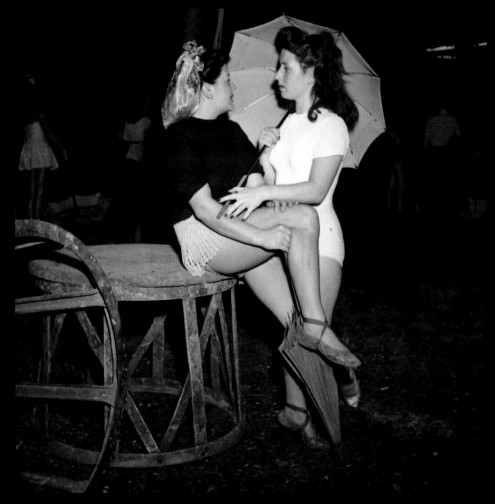

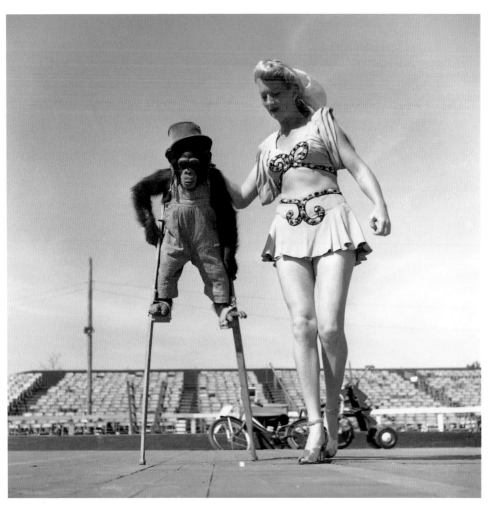

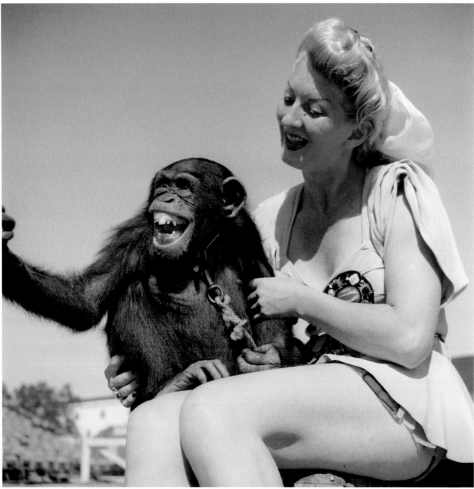

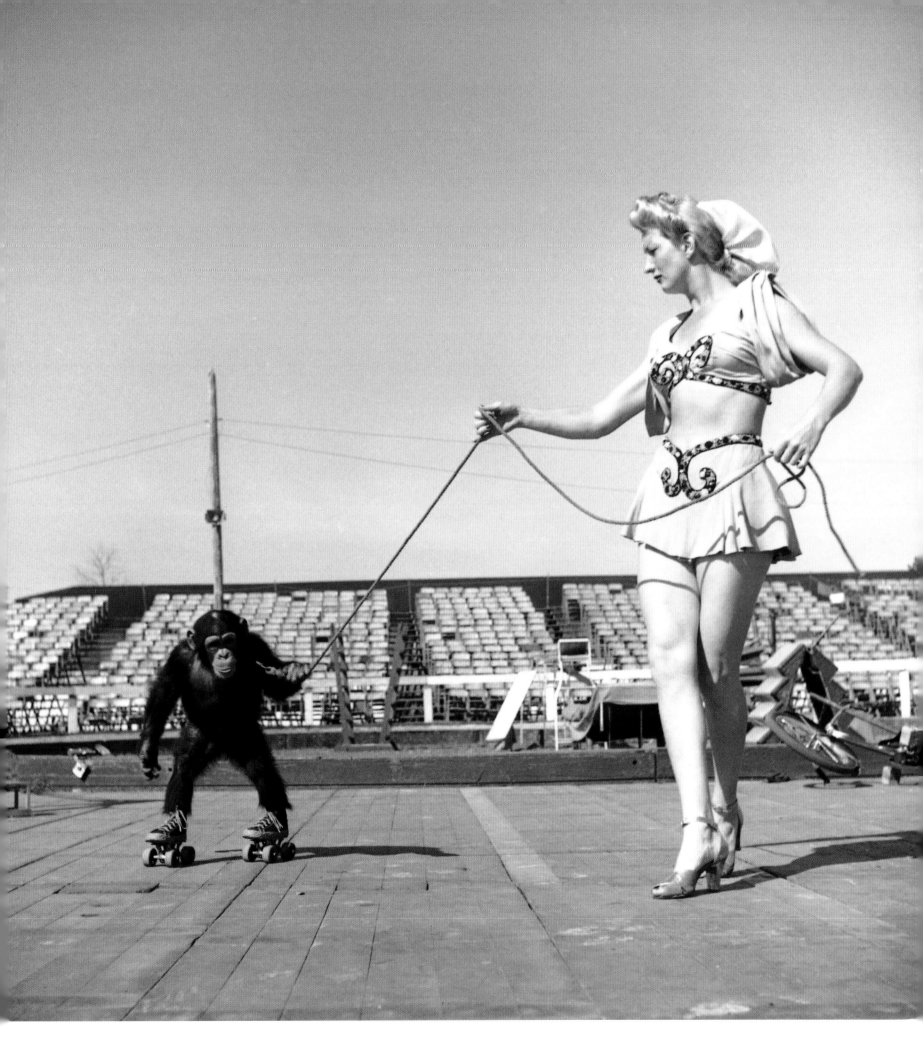

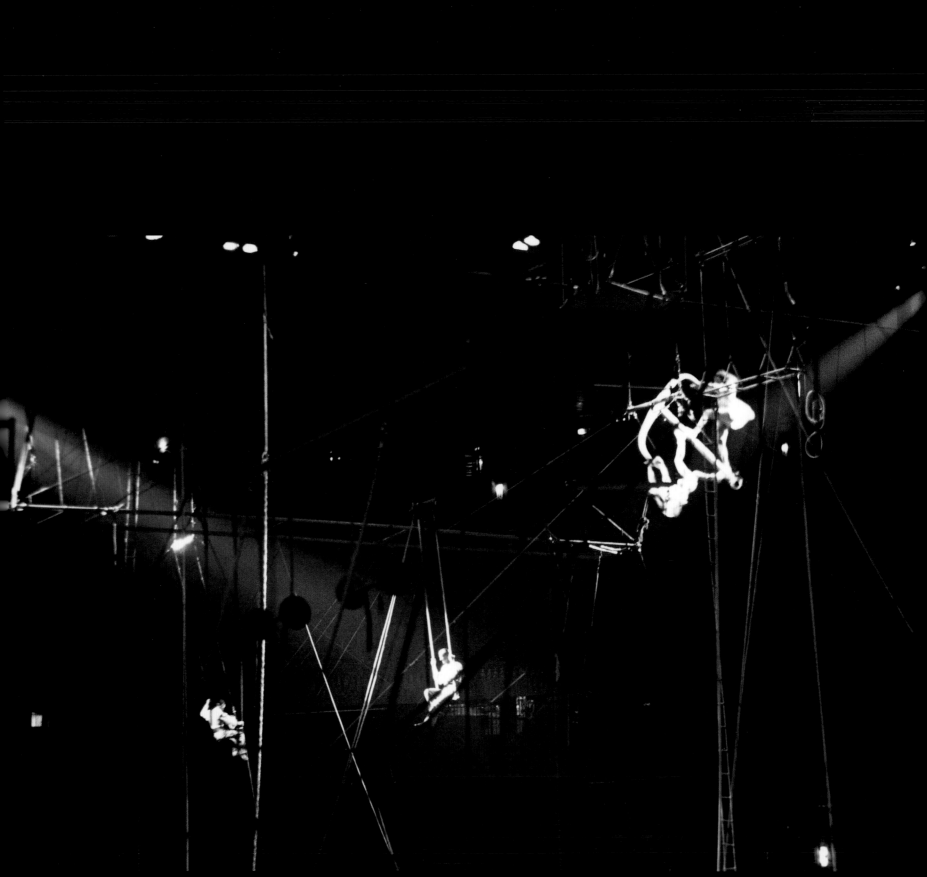

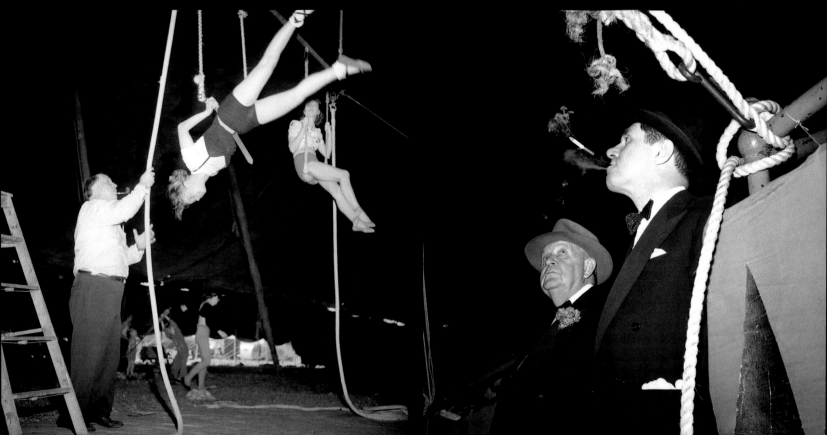

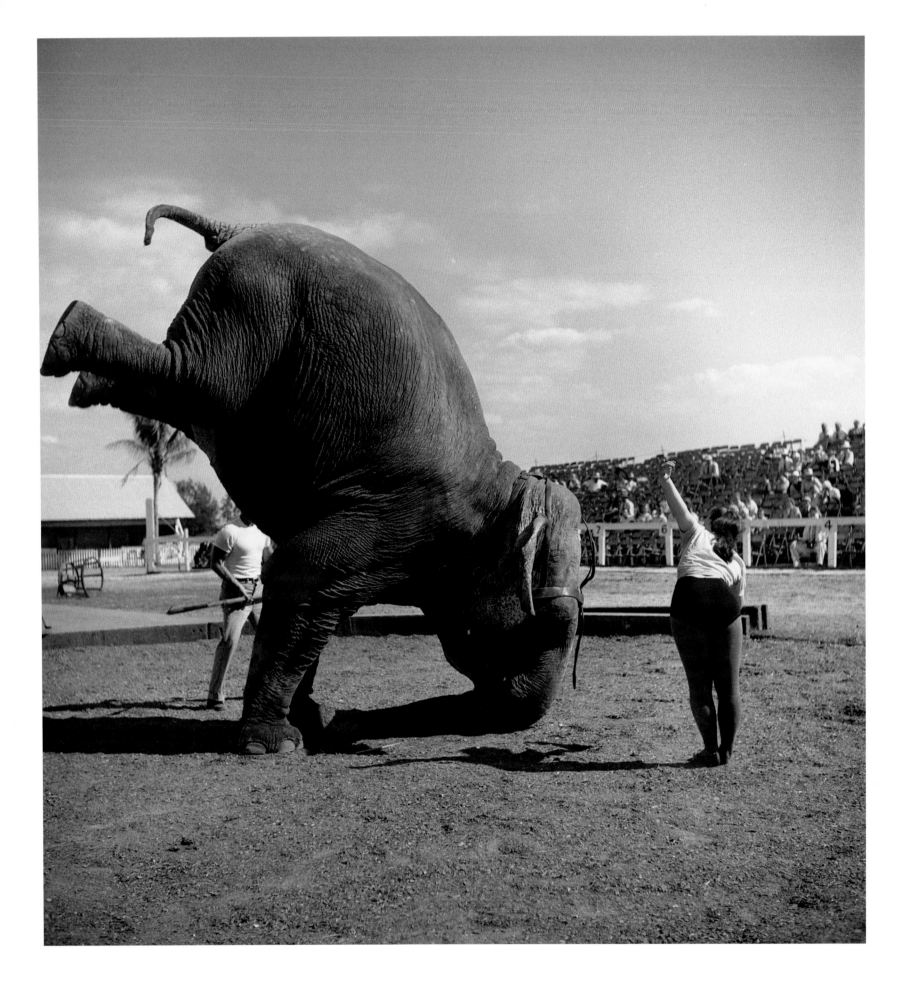

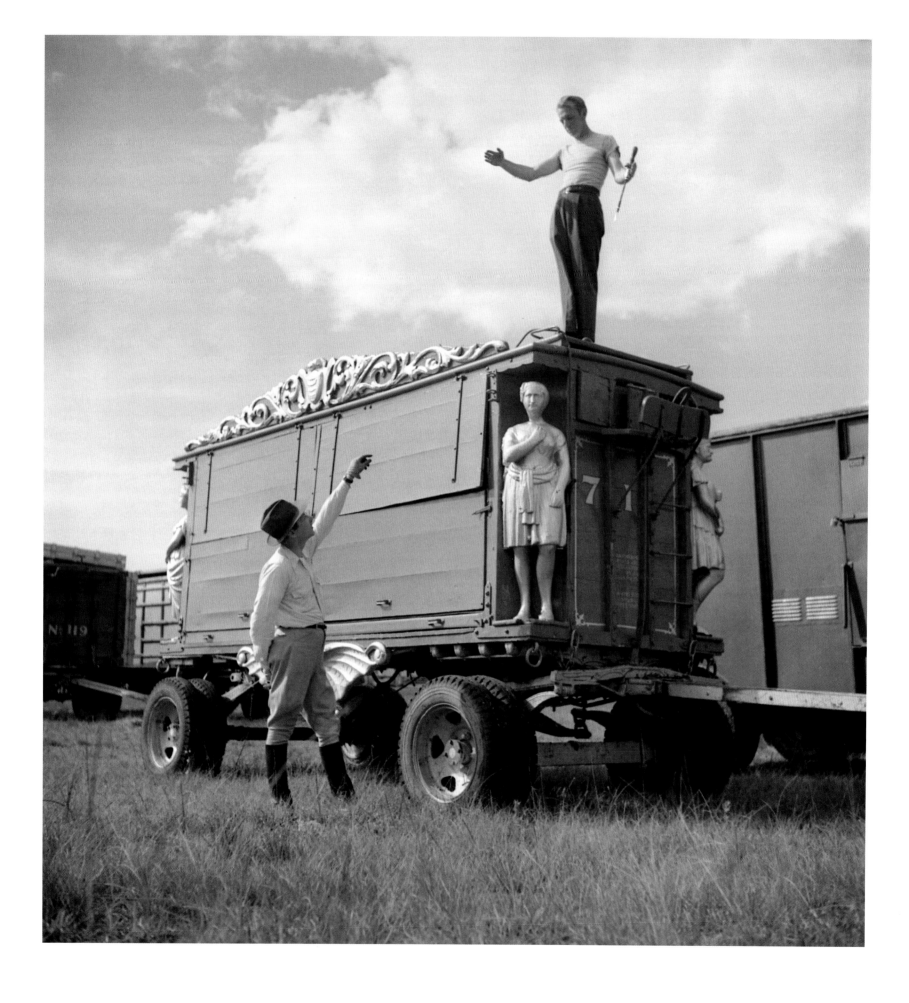

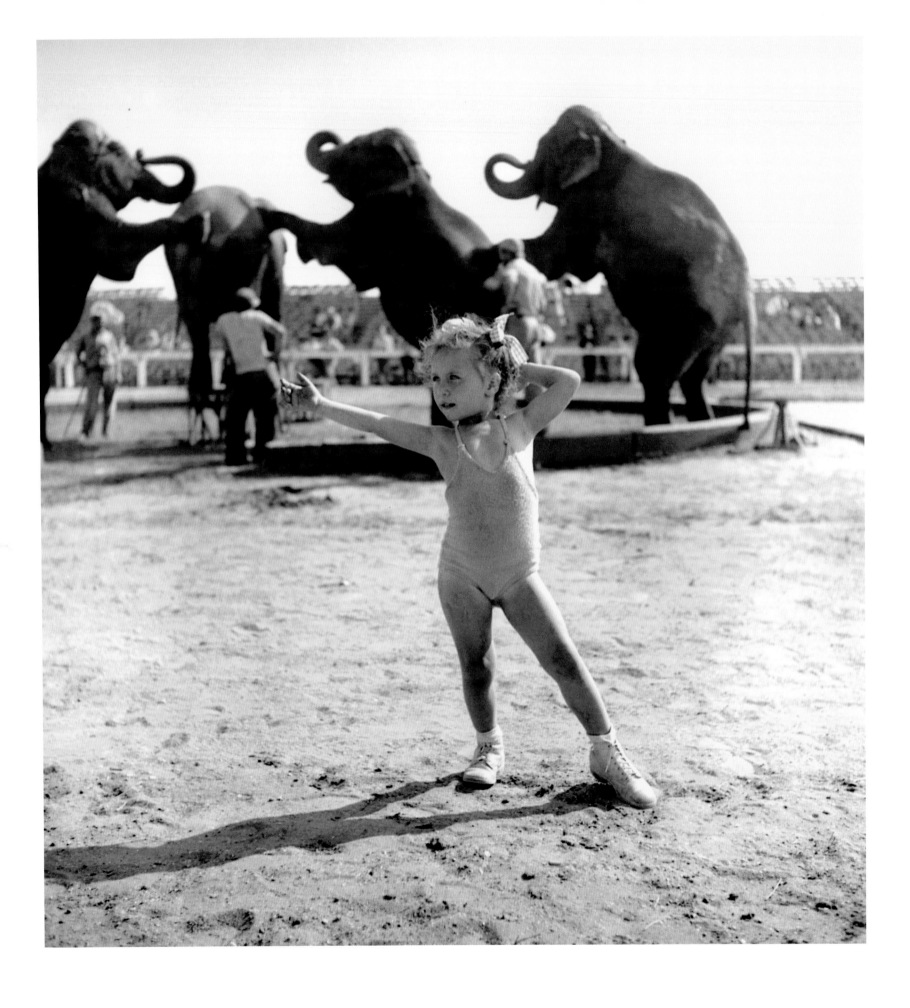

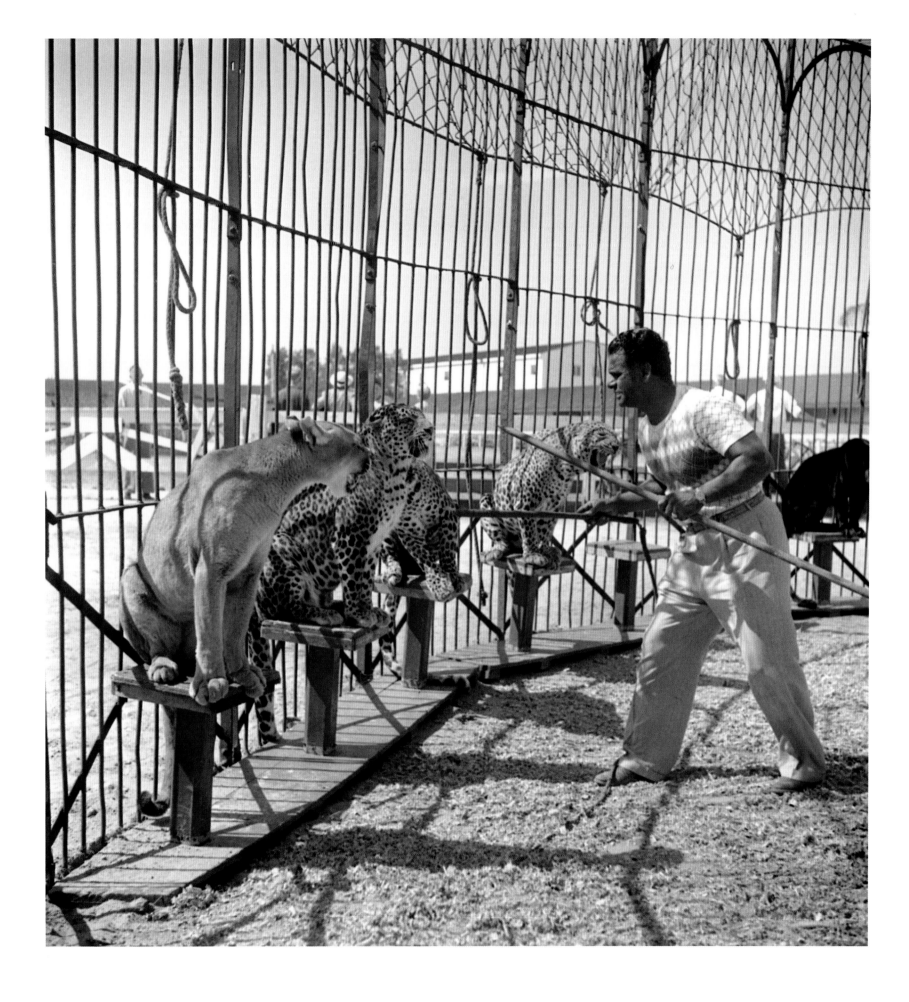

Jazz Is Hot Again
Dixieland in New York March 1950

One evening in 1949, George Lewis, a jazz musician from New Orleans, played a whole evening at Bop City Club in New York City: the long-forgotten jazz genre Dixieland was revived, and from then on, pieces like "High Society" and "When the Saints . . . " were heard again all over the country.

With its roots in funeral marches, spirituals, and parade songs dated from the mid-nineteenth century, Dixieland spread from the Vieux Carré in New Orleans to Chicago during World War I (not least thanks to Louis Armstrong), and then to New York. It was soon to be eclipsed by swing in the mid-1930s, and never to be heard again until the late 1940s, when jazz enthusiasts—purists, amateur dancers, and collectors alike—helped revive the style until its official rebirth on that evening of 1949.

By the 1950s, Dixieland's heroes—Old Satchmo, Jack Teagarden on trombone, George Lewis on clarinet, Phil Napoleon on the trumpet, and Art Hodes on piano—were touring again. Kubrick, a jazz enthusiast himself, portrayed these mostly black artists playing in stylish clubs that were attended by white people in suits and black tie. All dressed up themselves, the musicians seem to transmit a certain uneasiness, as if they were surprised by their revival, the sudden push into the limelight. Kubrick focuses on the musicians' expressive faces in a mise-en-scène of light and shadow that reads like a jazzy rhythm itself. When Kubrick portrays the musicians in their own informal setting, however, the photos convey a much more relaxed atmosphere, the lighting showing less dramatic contrast.

Years of worries and troubles had left their mark on the face of George Lewis's mother, included in Kubrick's study. Life had indeed been rough for these talented, hardworking artists who rarely could live off their music, so their music was rough, too. "And you don't want nothing smooth in it," declared George Lewis. Dixie smoothed the lifestyle of many music producers in the 1950s—while Kubrick prefigured in his photographs that profit of this New Orleans music rarely made it back home.

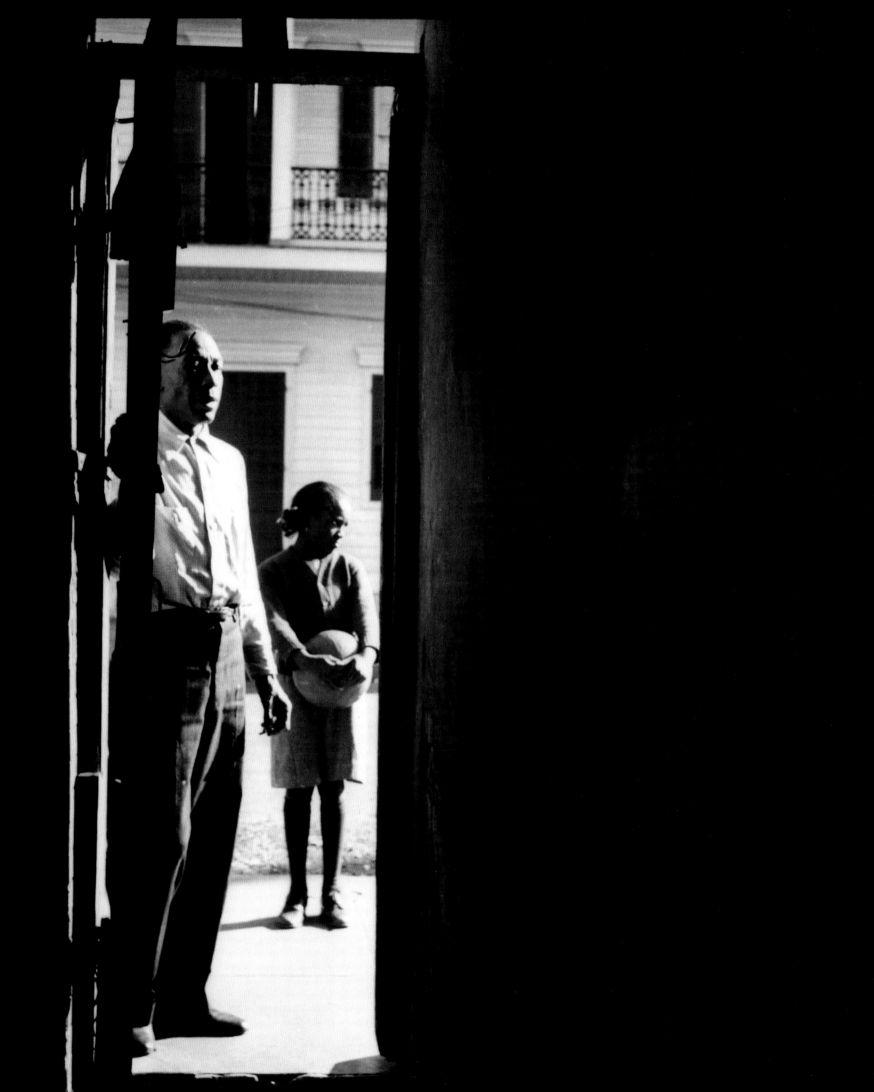

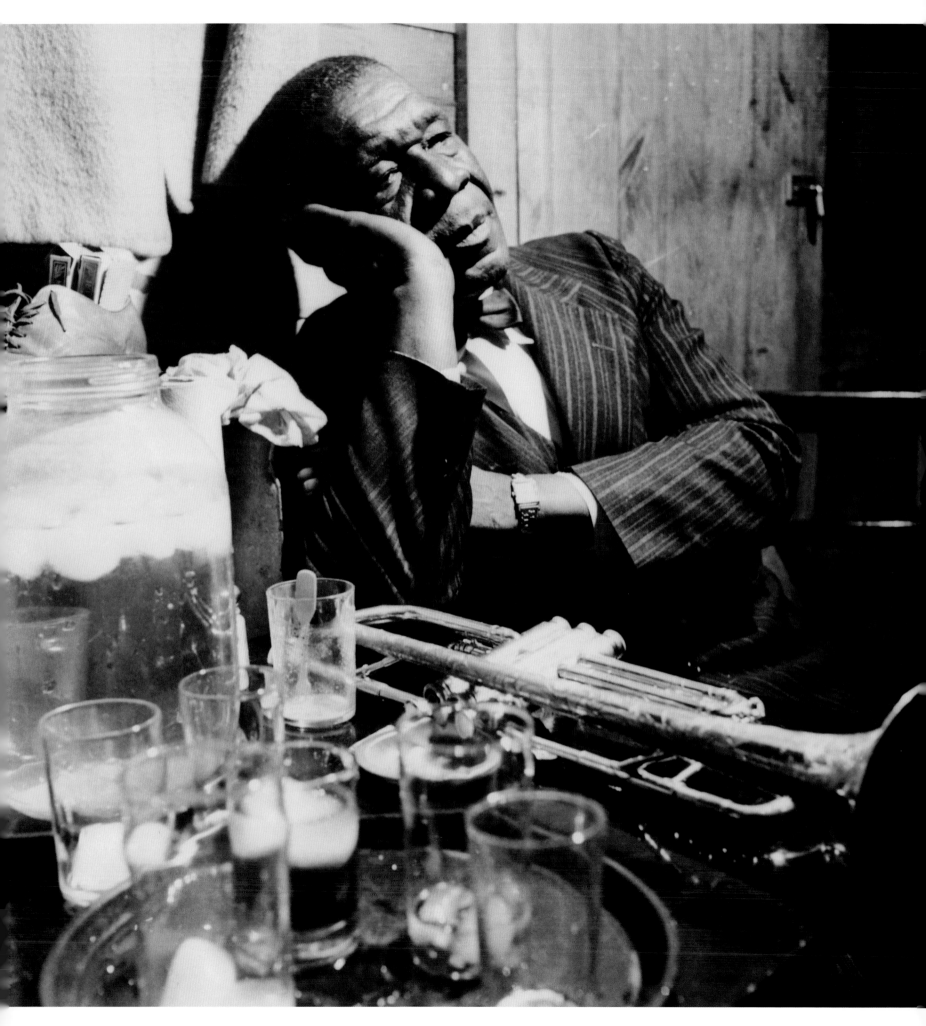

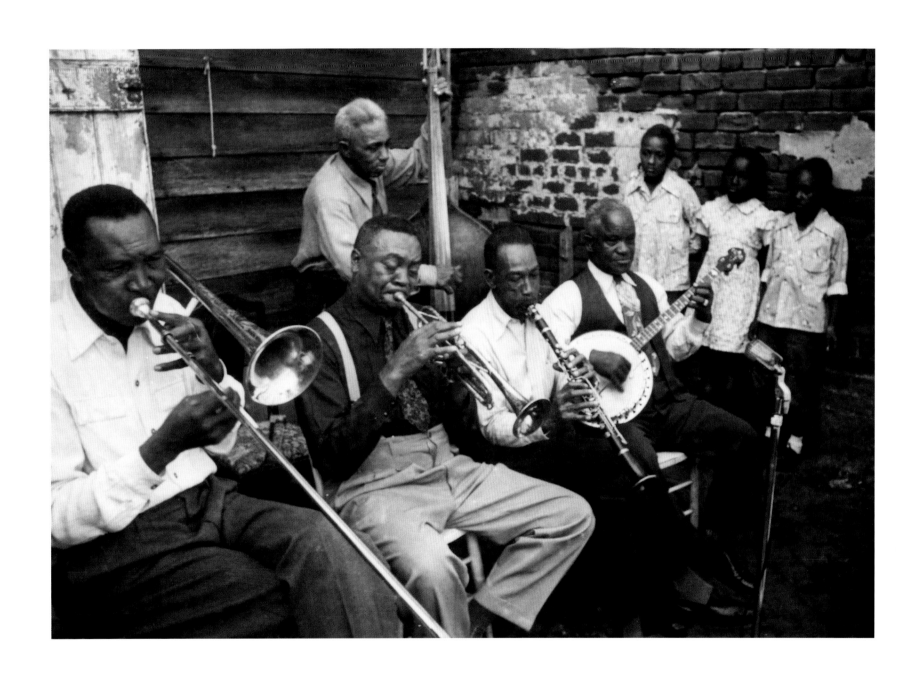

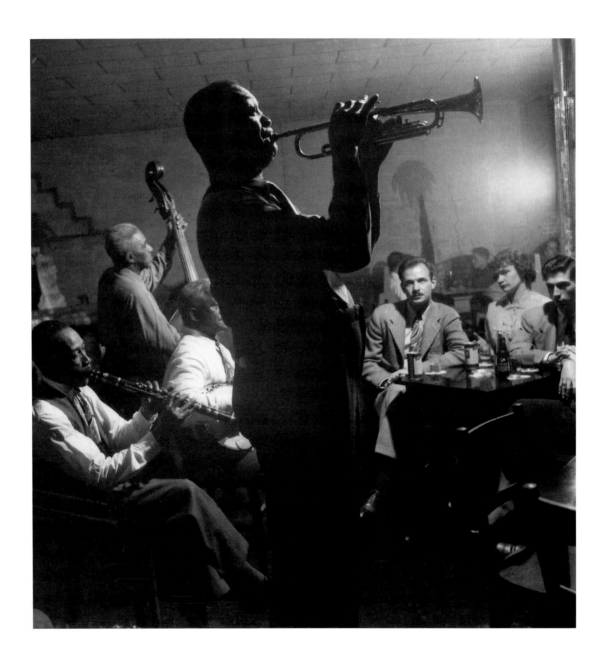

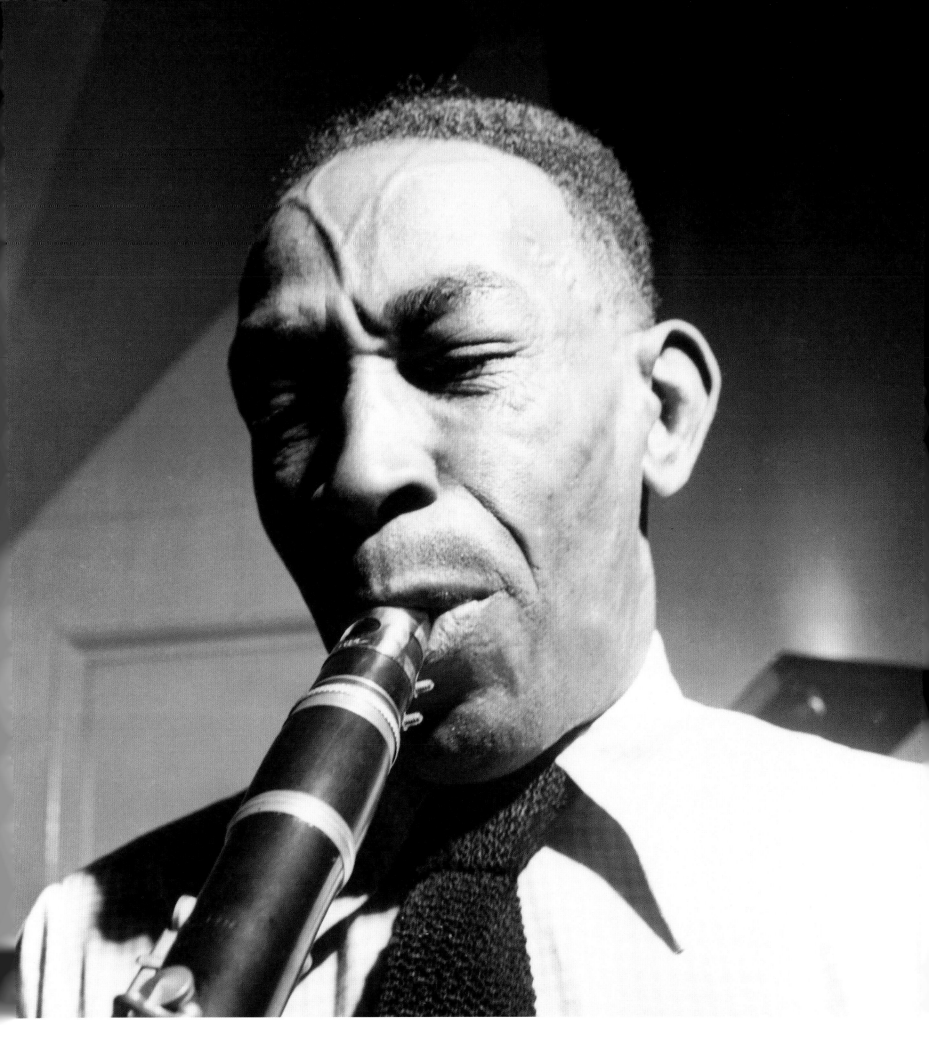

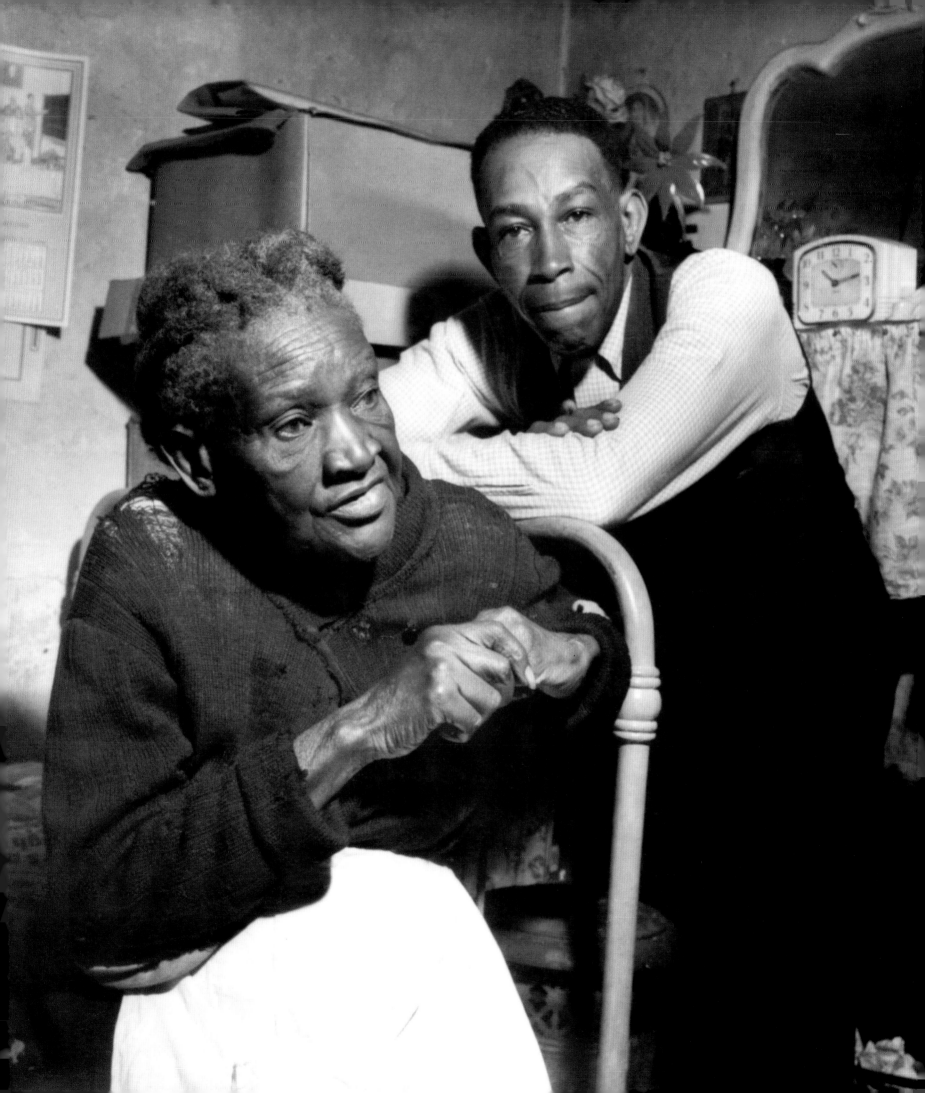

Framing a Showgirl's Daily Life March 1949

The threshold between private life and public image was the focus for Kubrick's photo story on Rosemary Williams, a showgirl who had promising good looks, though her career has left barely a trace. Kubrick closely observed the young actress off-stage, going about her daily life—out in public, with fellow performers, and all alone, applying makeup and contemplating herself like a modern Narcissa (although rather than falling in love with herself, she seems to be coolly checking whether her figure lives up to her profession's high commercial expectations). Whether she appears gregarious and provocative or focused and introspective, Kubrick's photographs of Williams reveal a life in which even the most intimate moments were consciously staged events.

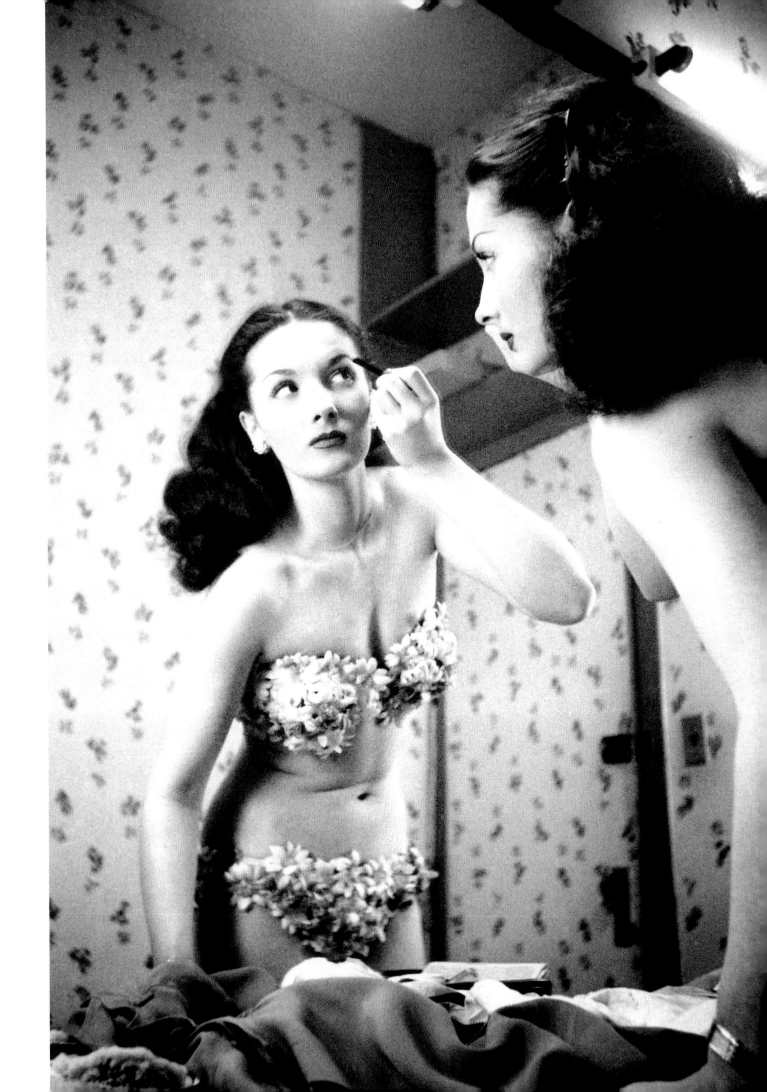

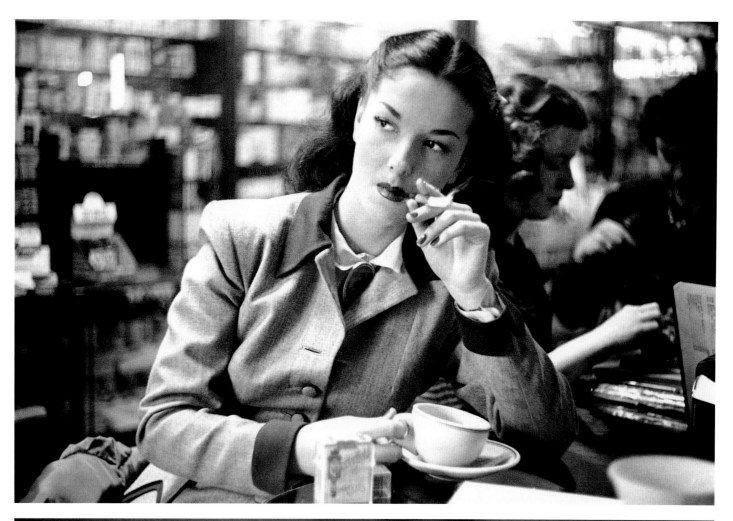

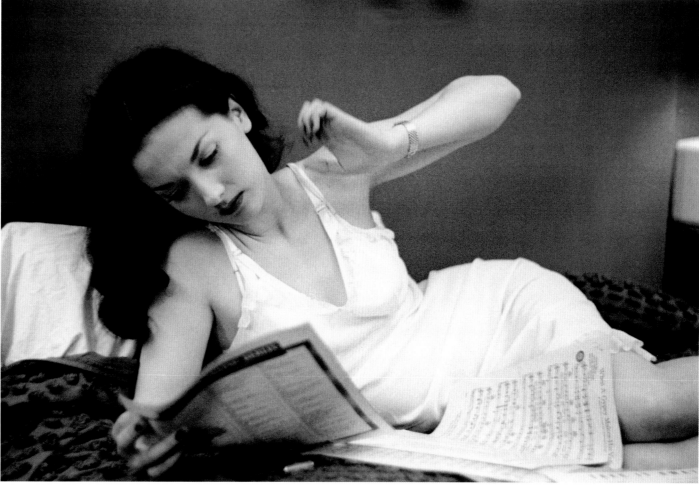

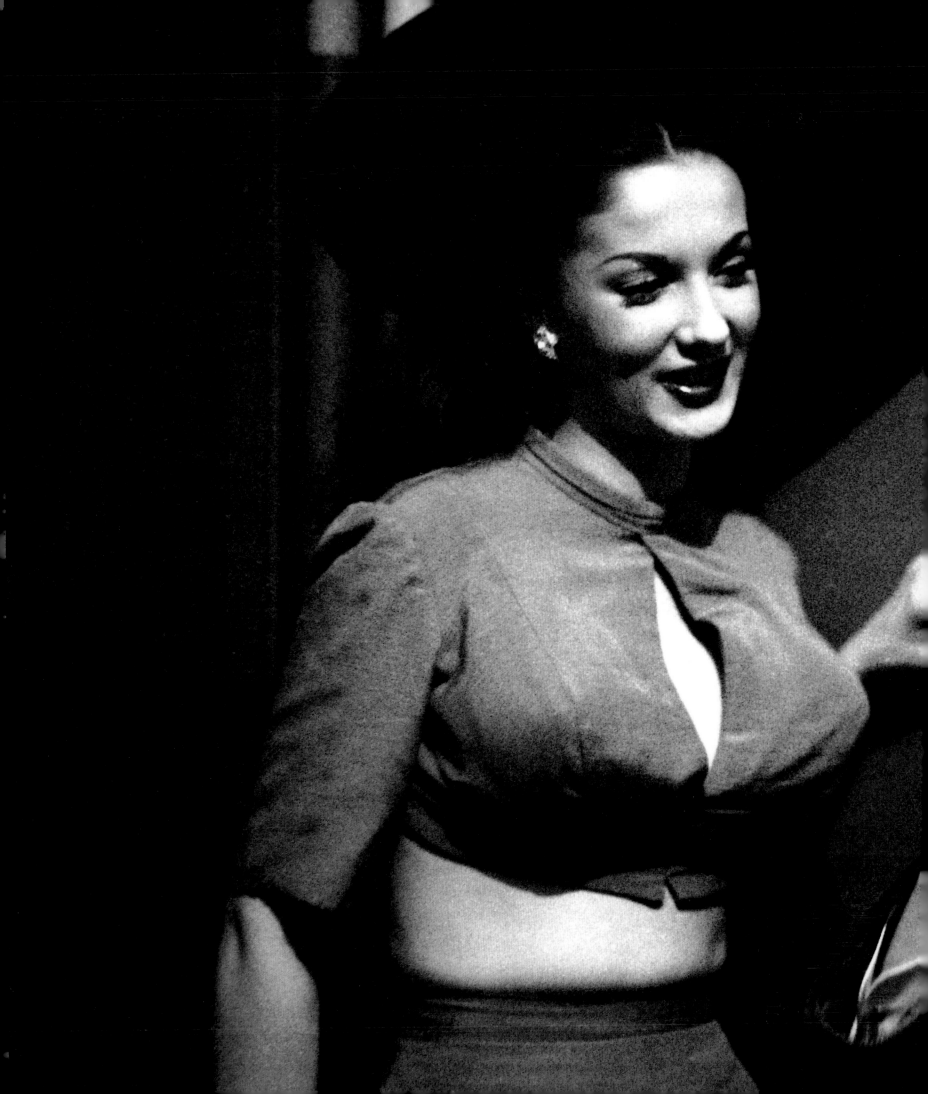

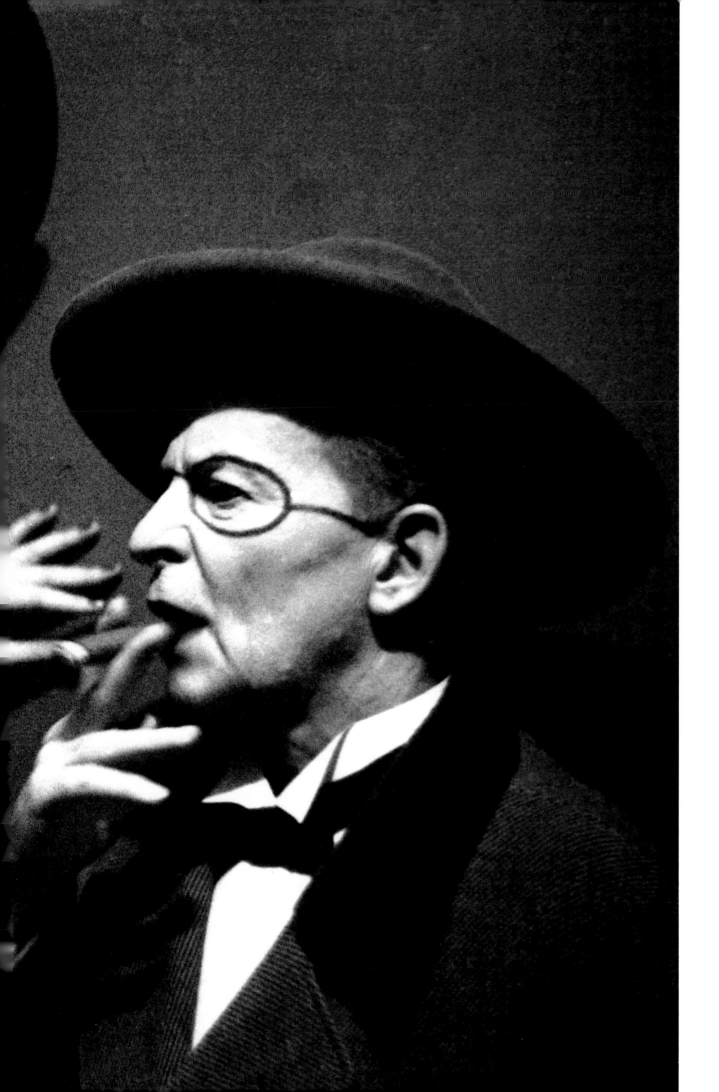

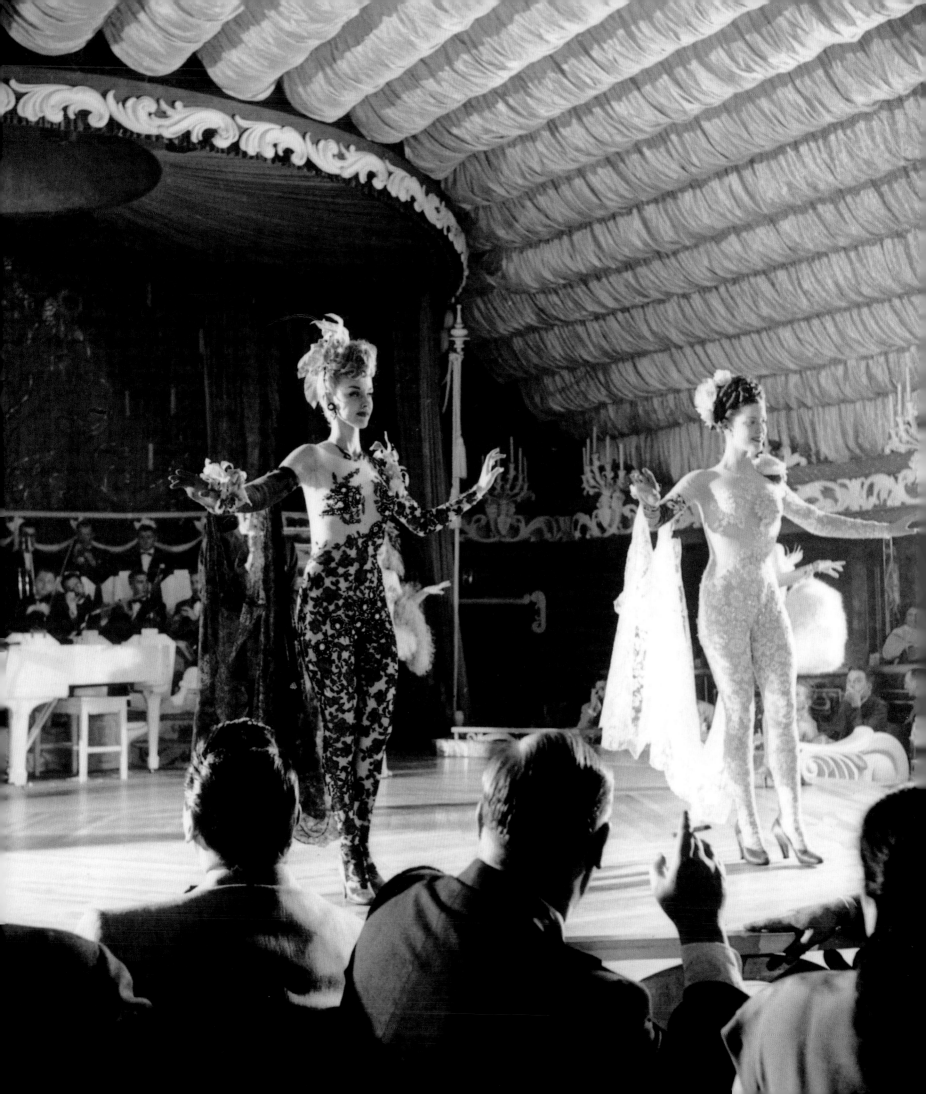

Showtime at the Copacabana December 1948

"Music and passion were always in fashion at the Copa" is a famous line that refers to Manhattan's legendary nightclub at 10 East Sixtieth Street, which opened in 1940 and soon became known for its excellent kitchen, exceptional music, and breath-taking floor shows. Postwar regulars included stars such as Dean Martin and Jerry Lewis, Frank Sinatra, Ella Fitzgerald, Nat King Cole, and Jimmy Durante, and its glittering nightlife even inspired a musical, which Marx Brothers producer Alfred E. Green turned into a screwball comedy of the same name in 1947 starring Carmen Miranda and Groucho Marx. The "Copa" eventually declined in popularity and finally closed in 1973 after a thirty-three-year run.

In this series of pictures, Kubrick concentrates less on the social aspect of the club than on staging backstage impressions with narrative impact. In his images of the Copa girls getting dressed, Kubrick reveals the pressures that go into presenting a facade of lightness and glamour—once again peeling back the surface to offer a glimpse at reality.

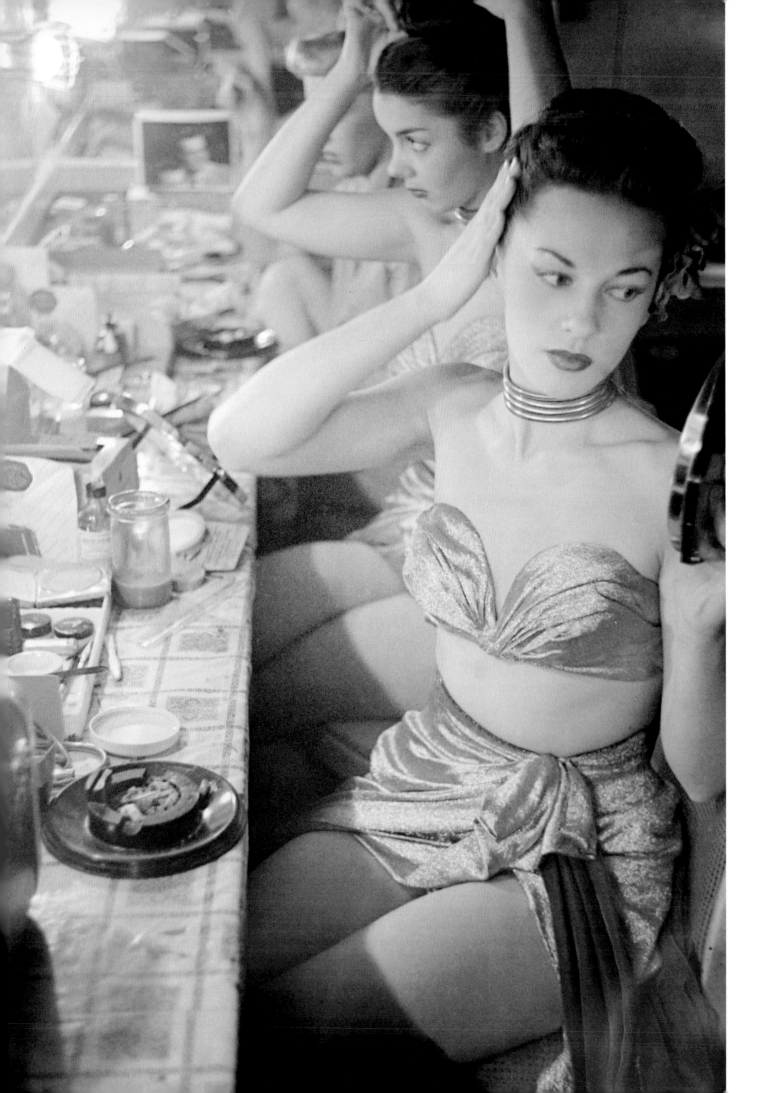

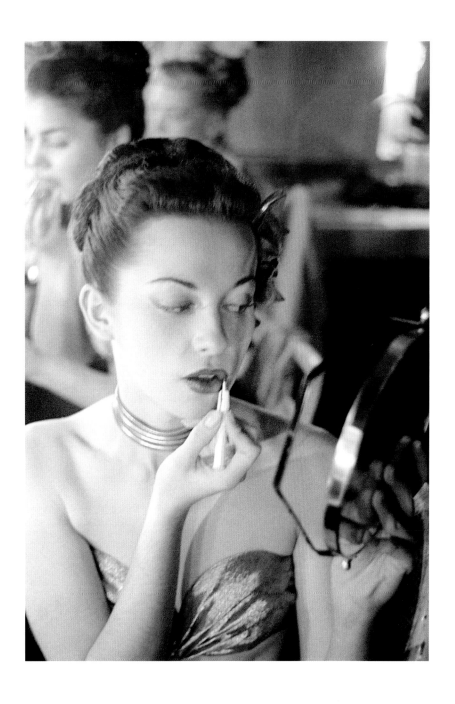

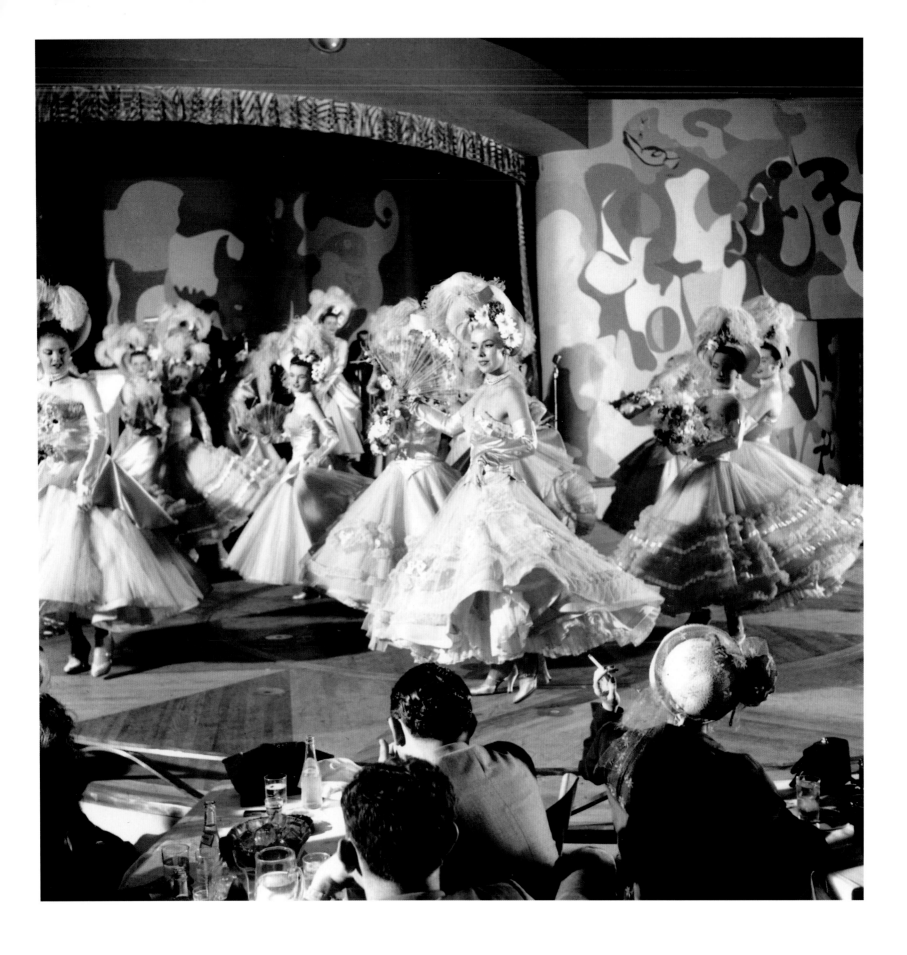

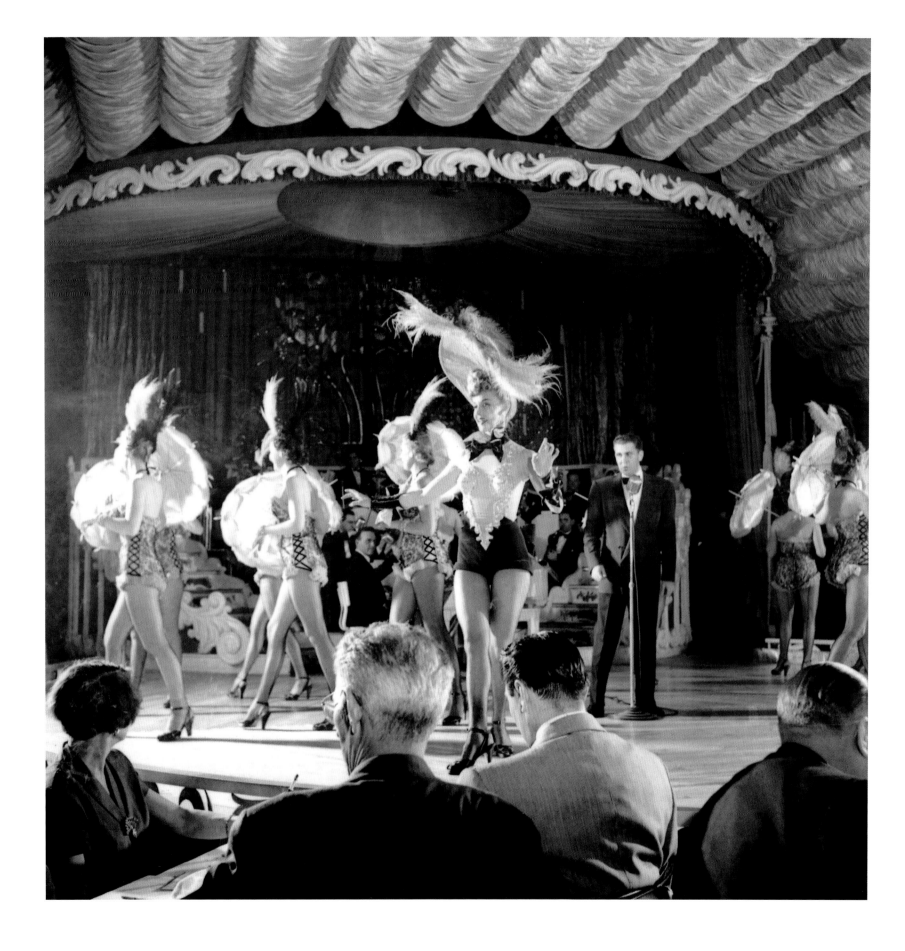

Dancing in *High Button Shoes* October 1947

In October 1947, Broadway was taken by surprise by the new musical *High Button Shoes*, which premiered at the New Center Theater and ran for 727 performances. A retro comedy set in 1913, *High Button Shoes* is a story of betrayal and failed hopes written by Stephen Longstreet and Jimmy Cahn with music composed by Jule Styne. Along with humorous antics and romantic lyrics, the musical featured staging that, as Kubrick's photos show, focused more on the clever manipulation of lighting and shadows than on an elaborate set design.

Seemingly inspired by such silent-movie figures as the Keystone Kops or Mack Sennet, this vaudeville shadow play stages good and looming bad in an ambiguous, intertwining rhythm. Kubrick serves to heighten the dramatic effects by featuring larger-than-life shadows created by the performers.

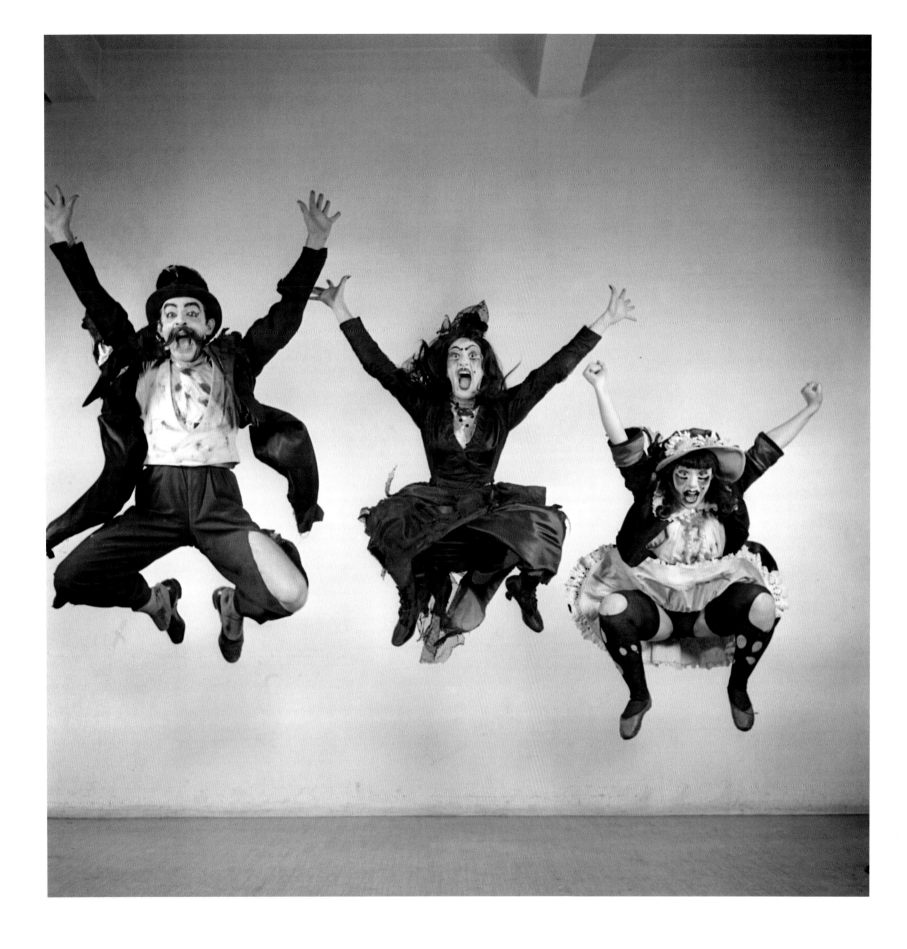

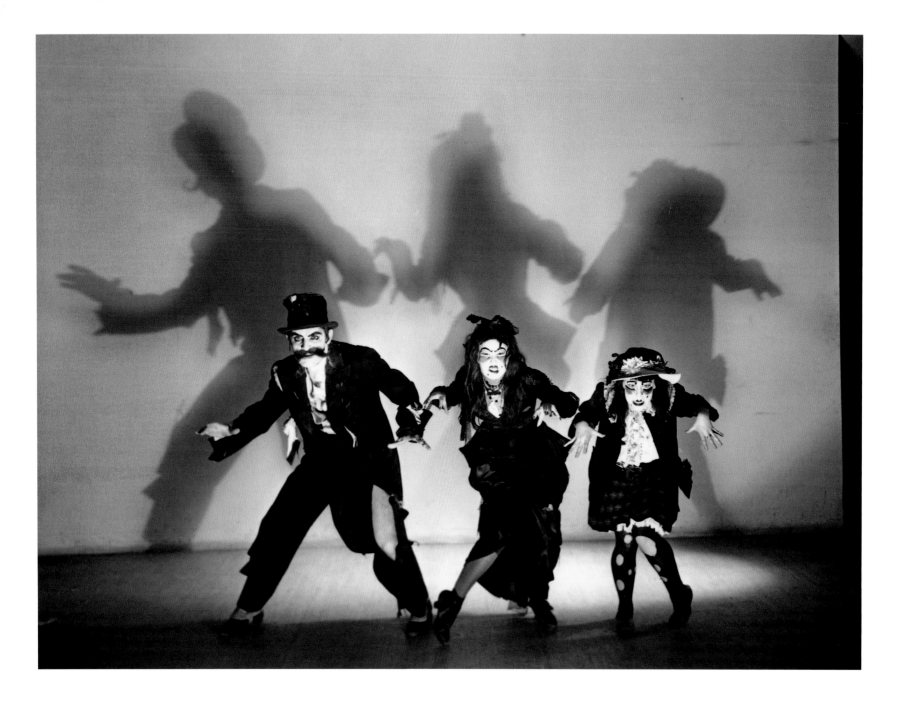

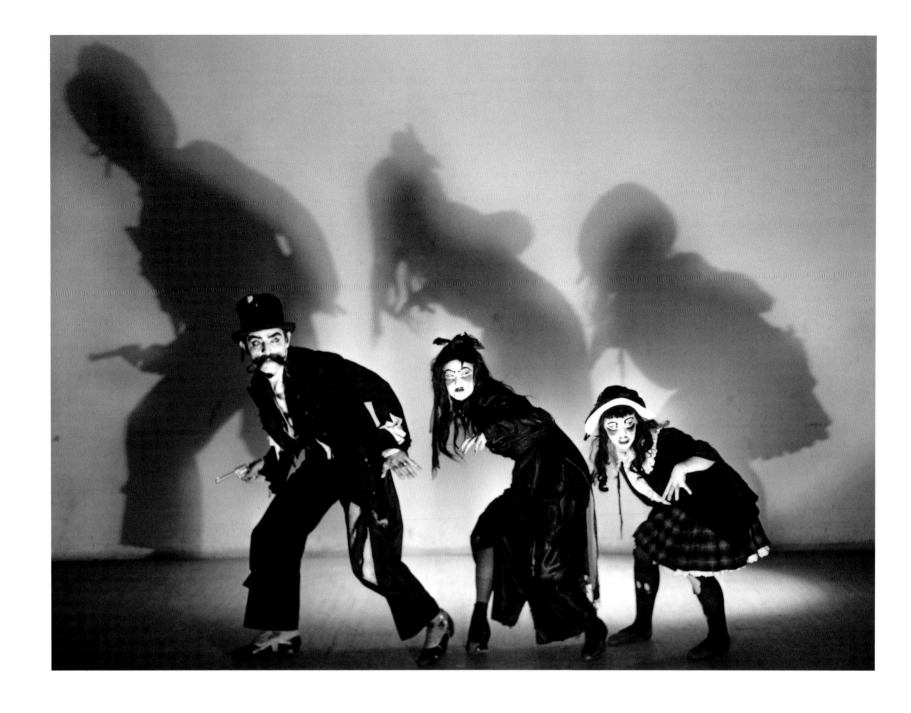

Shadows Speaking

One of the most revealing photographs Kubrick was able to shoot in the late 1940s can be seen in his series "Shadows Speaking." Shot during a theater performance, the photos depict players interacting with shadows that are created by people who are not in the camera's view.

Kubrick's photo-essay does not simply document what is happening on a stage that is filled with signs generated by "auteurs" outside the frame of reference. The young Kubrick actually allows himself to analyze the current theoretical status of photography through pictures of a dramaturgic event. It is light alone that acts as a source for the figure generated on the backdrop; shadows create the meaning of the staged dramatic situation. Thus the contextual element signified is generating the hermeneutics of a fictional scene.

These are the essential components of photography and cinema: light, shadows, and drama. As a photographer of the late 1940s, Kubrick already understood the power of semiotic processes. In these photographs, we can detect the creative potential of the nascent filmmaker.

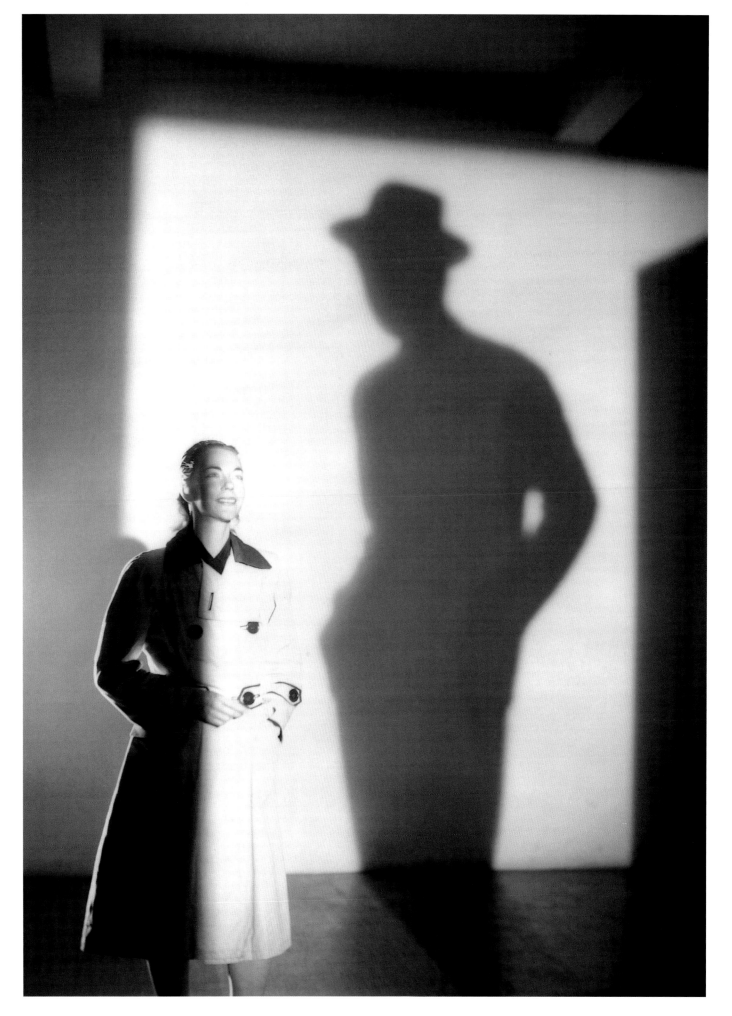

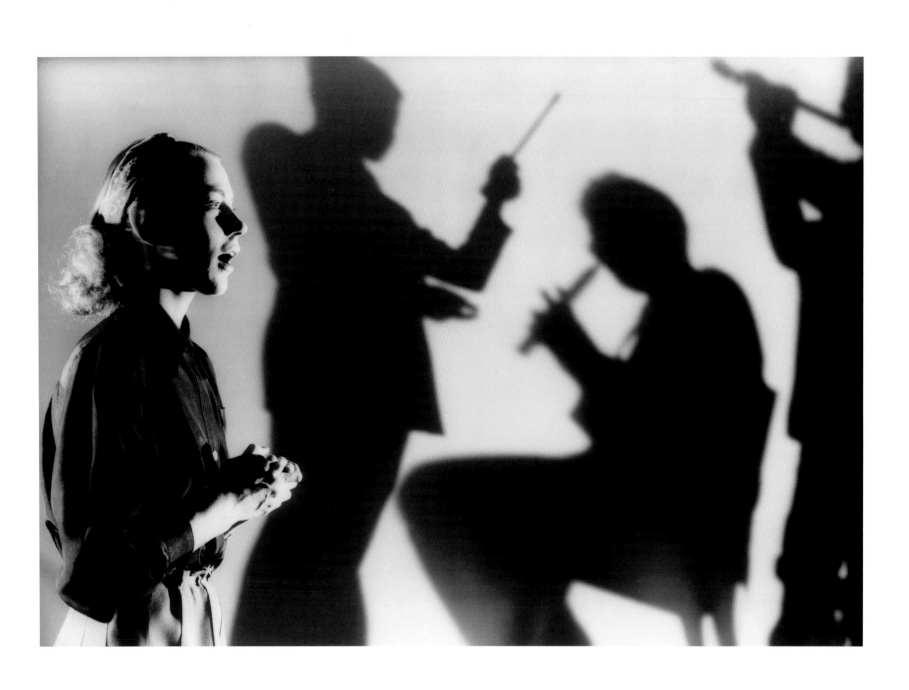

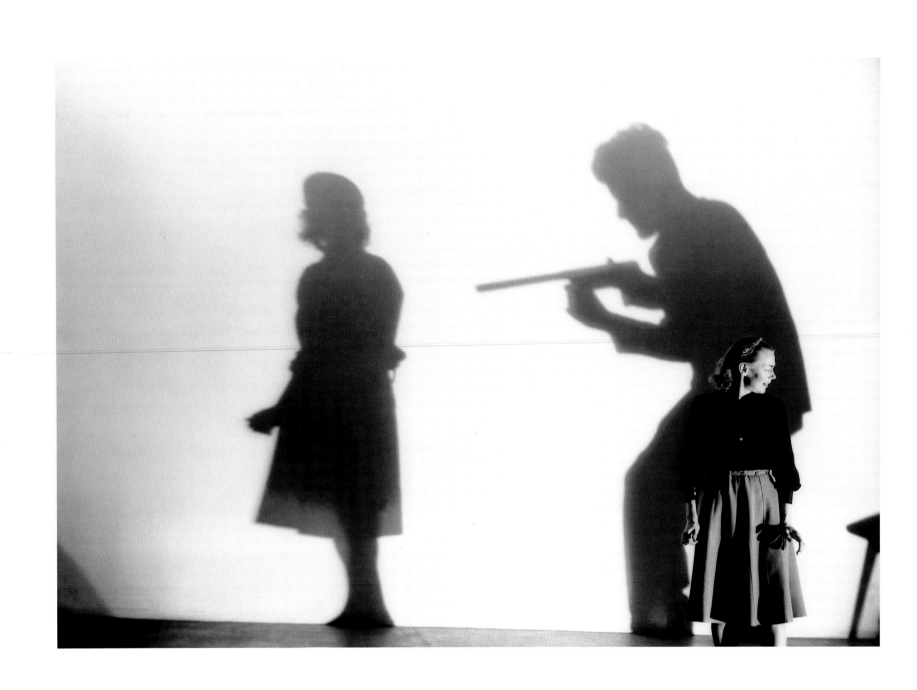

Traveling in Portugal May 1948

In May 1948, Kubrick traveled to Portugal on assignment. Instead of focusing on touristic commonplaces like churches and monuments, the resulting starkly sober photographs of everyday life in the archaic Portuguese fishing village of Nazare testify to the young photographer's respectful fascination with the people and their culture. Kubrick captured an essential human dignity in his subjects, an ability that filmmaker and press photographer Henri Cartier-Bresson famously deemed necessary for any photojournalist. Inspired by Cartier-Bresson, Kubrick gave credence to the older photographer's sage advice that "in order to 'give a meaning' to the world, one has to feel involved in what one frames in a viewfinder. This attitude requires concentration, discipline of mind, sensitivity, and a sense of geometry. It is by economy of means that one arrives at simplicity of expression."

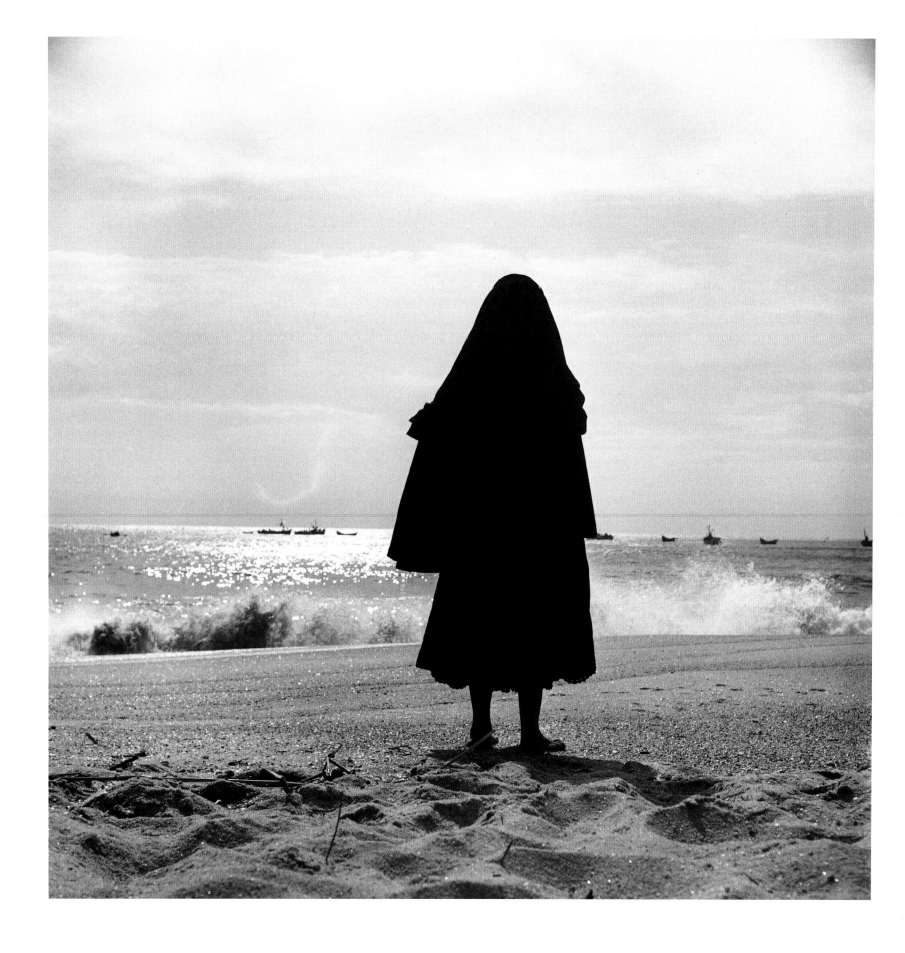

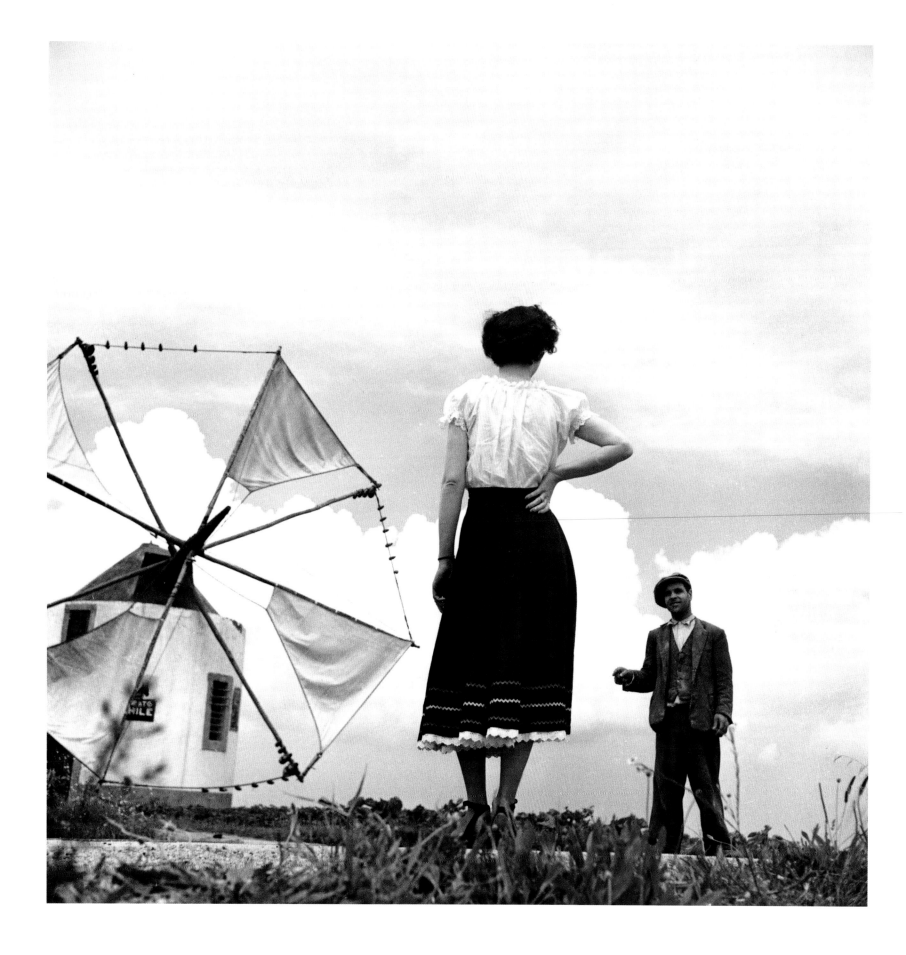

Aqueduct Racetrack
Hope, Despair, and Habit March 1947

Though it opened in 1894, the Aqueduct Racetrack only really flourished after 1940, when mutual stake betting was legalized and greater profits could be turned in thoroughbred racing. A minor facility at its inception, it eventually became the site of famous races like the Carter Handicap of 10 July 1944, which ended in a triple dead heat. After it was renovated in 1959, Aqueduct became the leading betting track in the United States until the 1970s, when offtrack betting was introduced.

When Kubrick shot his photo story, racing was on the verge of becoming the most popular American spectator sport. Instead of following the race itself, Kubrick concentrated on observing the spectators close-up, capturing the tension and excitement—as well as the frustration and disappointment—of individuals in the crowd, and even the workers sweeping up in the aftermath.

Kubrick further explored the world of the racetrack in his third feature film, *The Killing* (1956), about a racetrack heist. Kubrick's portrayal of a day at the track reveals a keen sense of individual pathos as well as the potential for mass hysteria that a public event on this scale could generate.

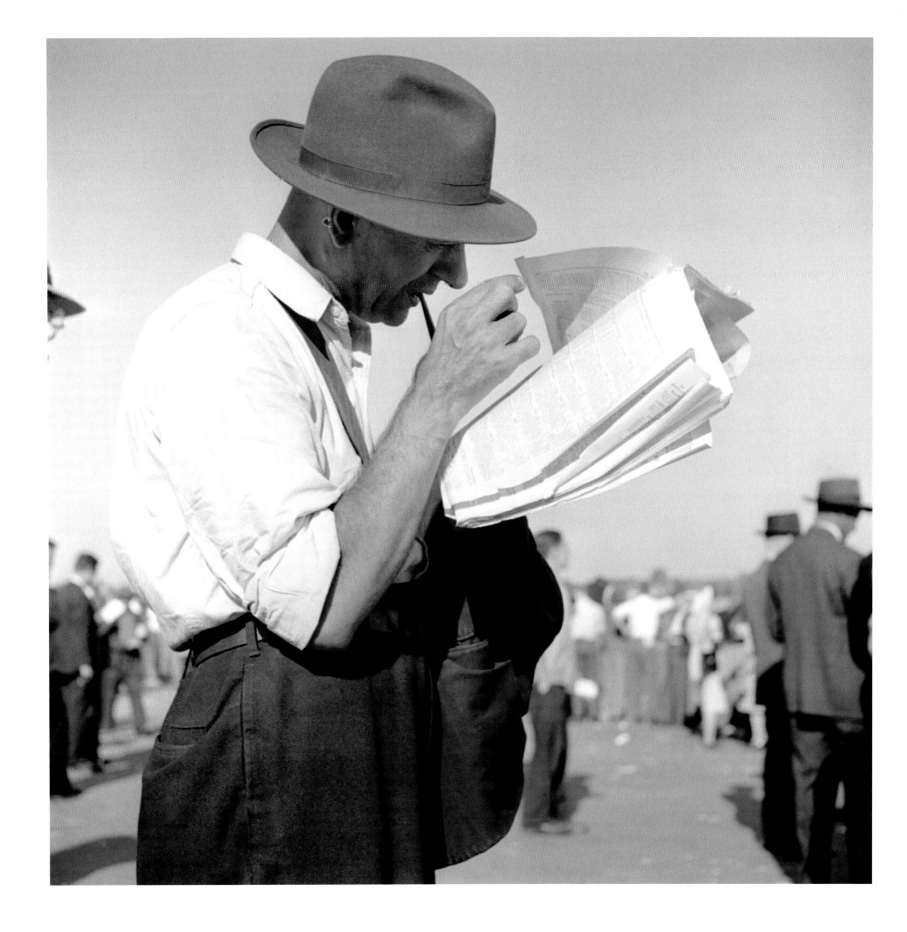

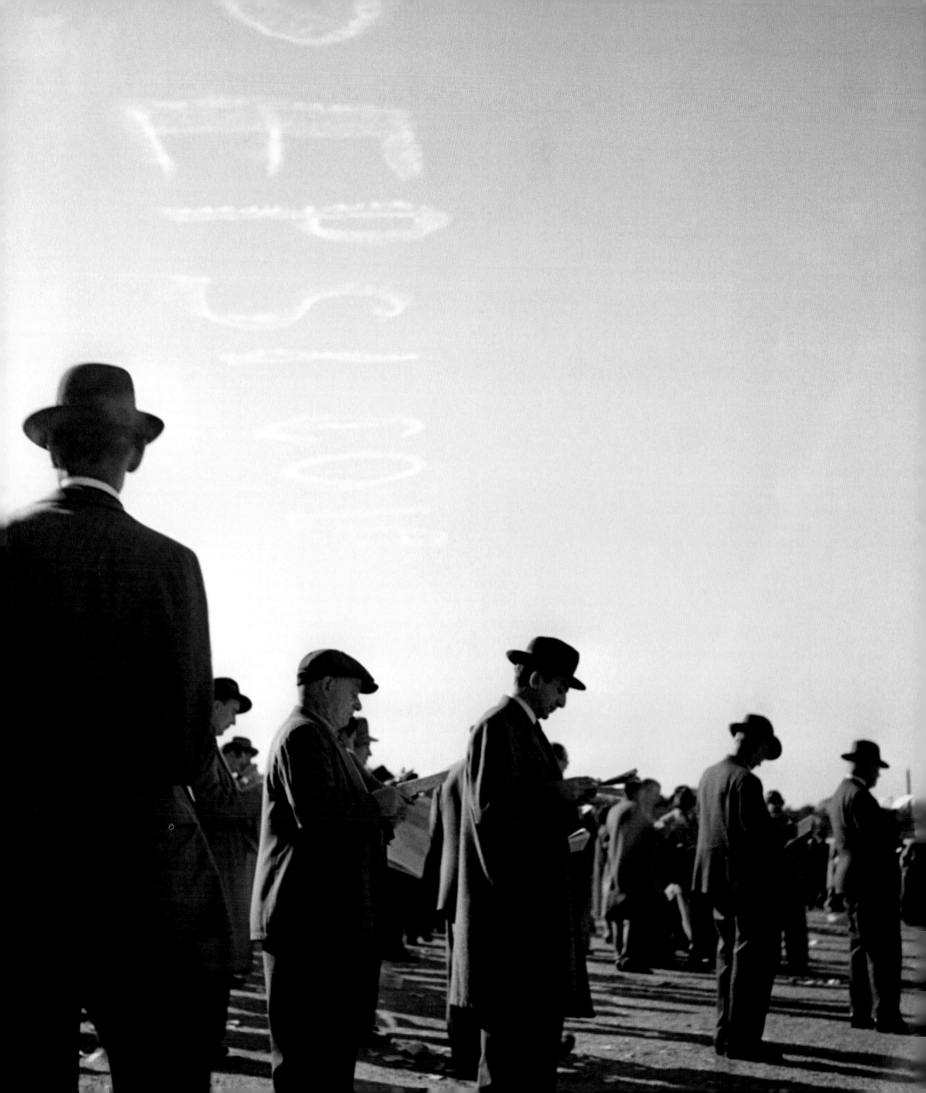

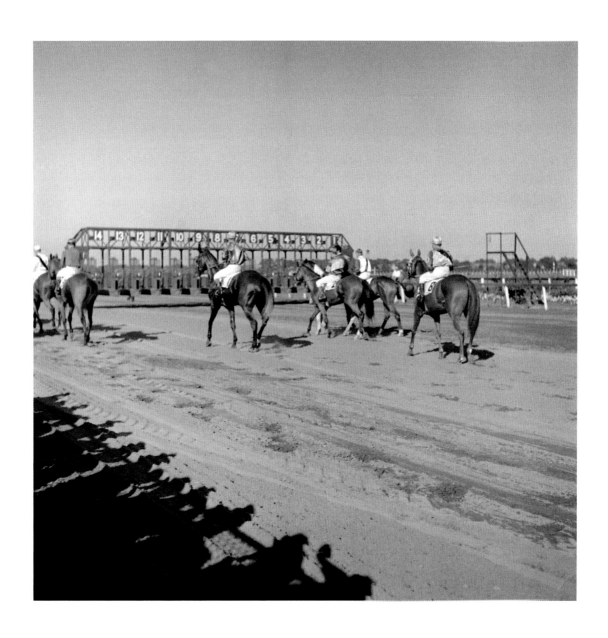

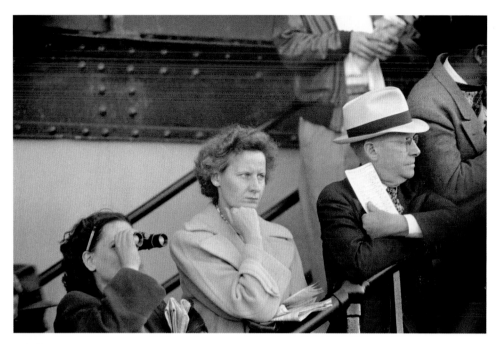

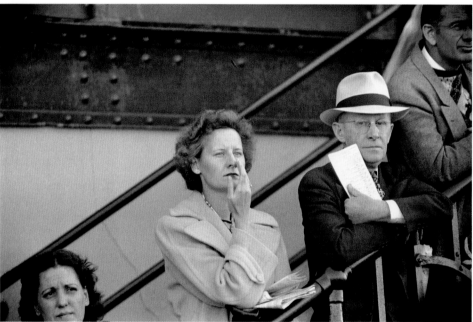

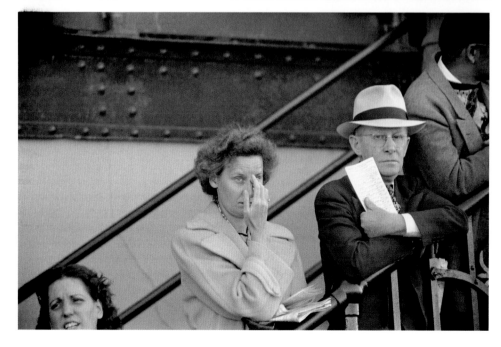

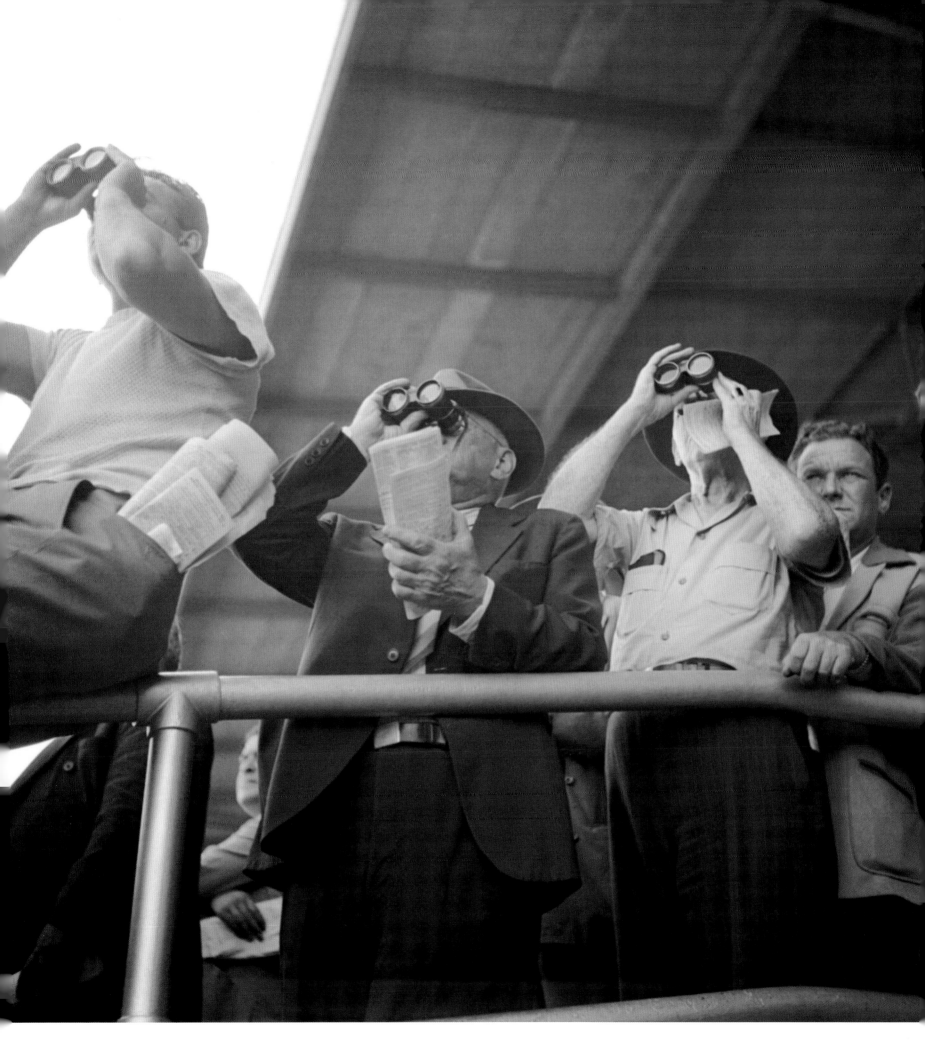

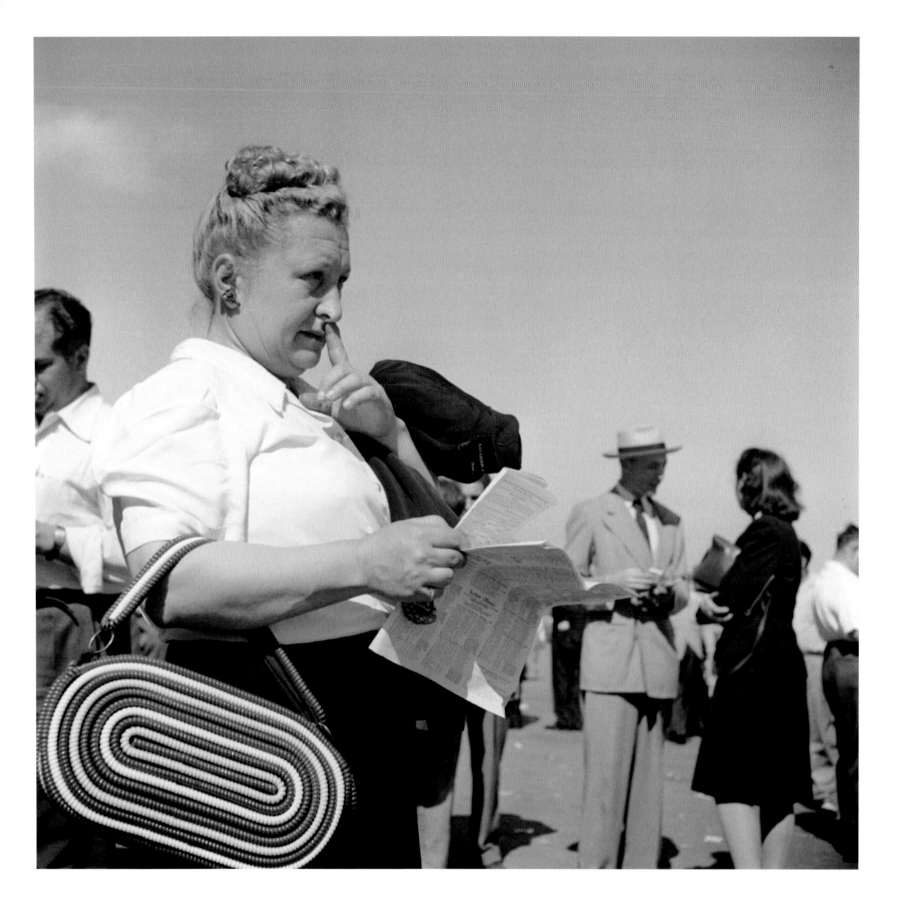

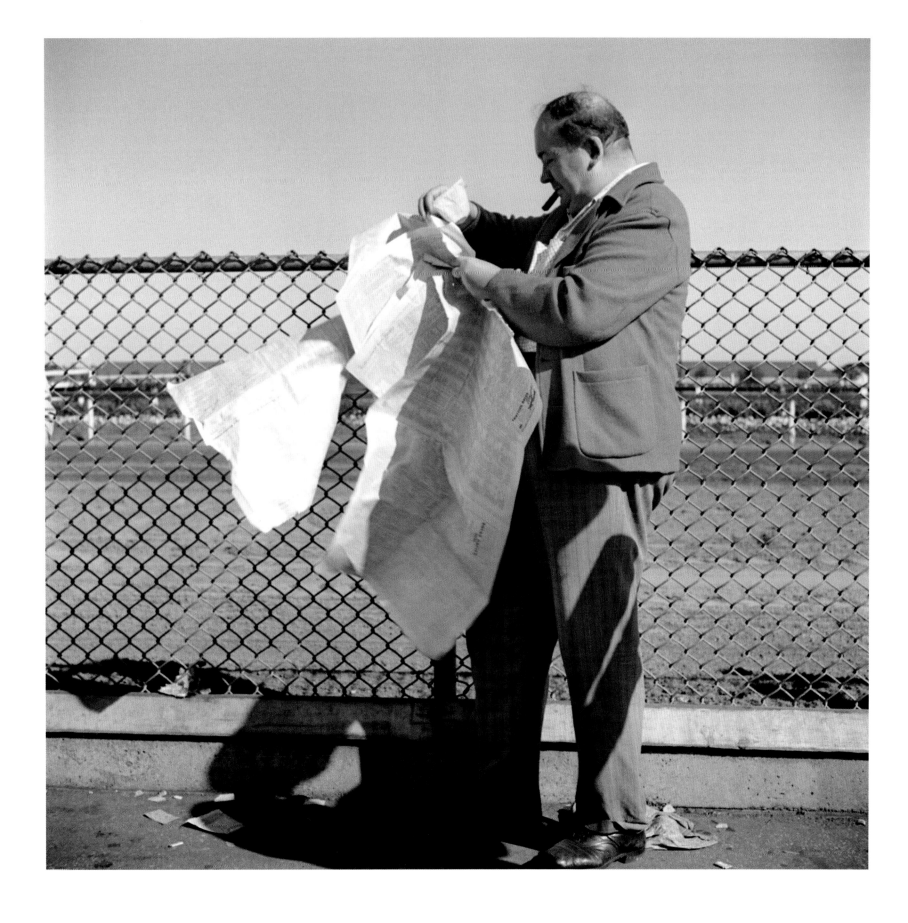

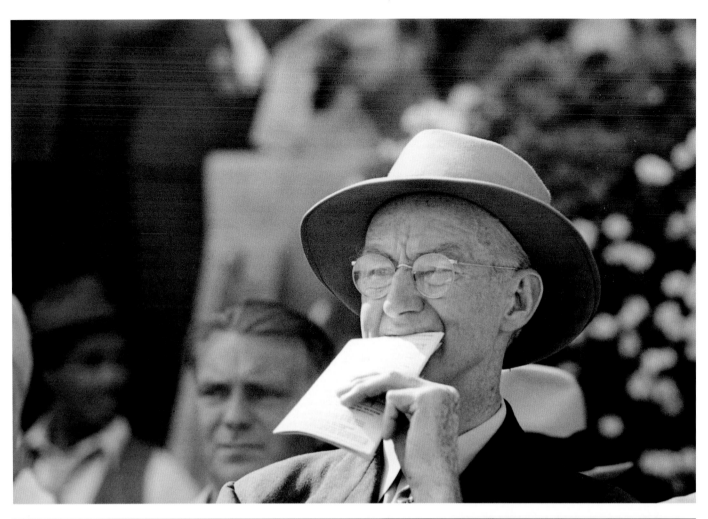

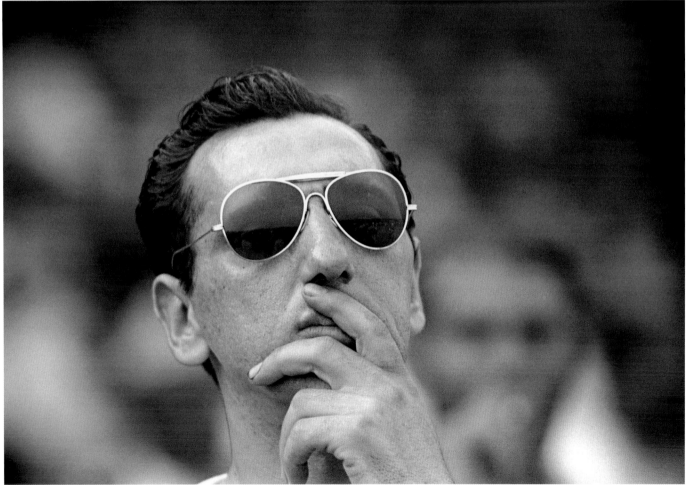

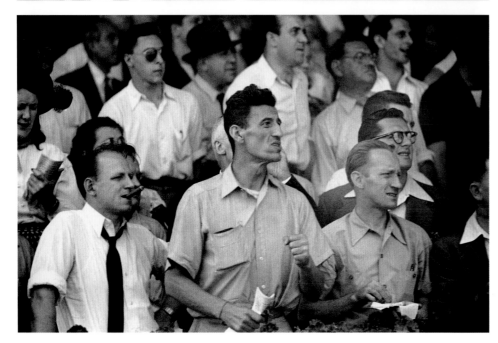

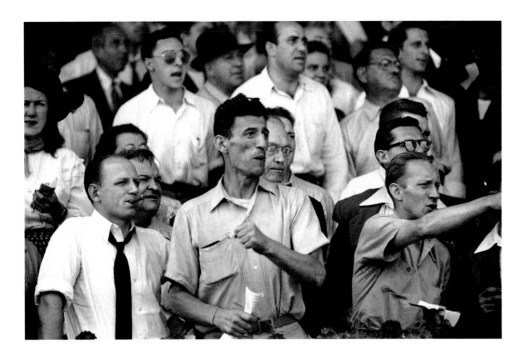

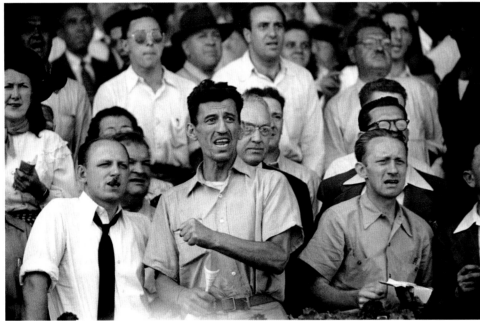

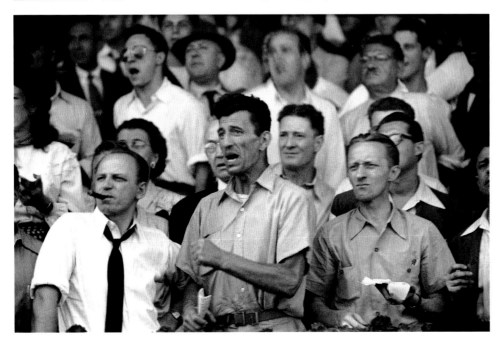

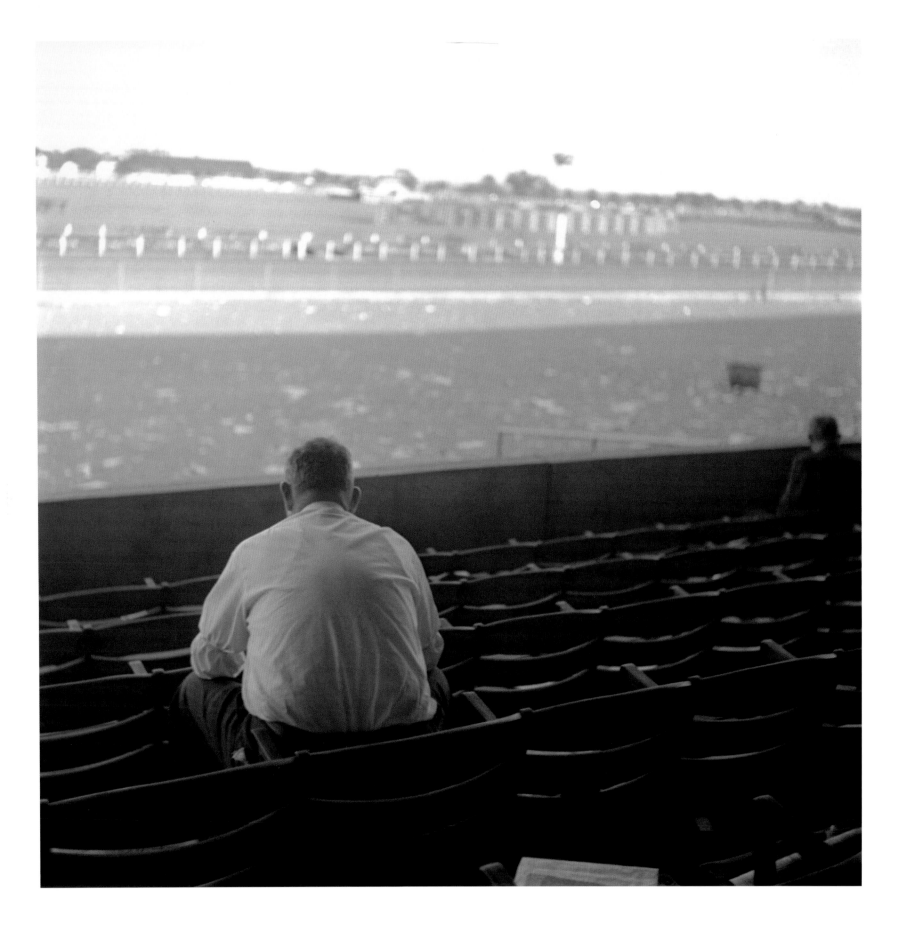

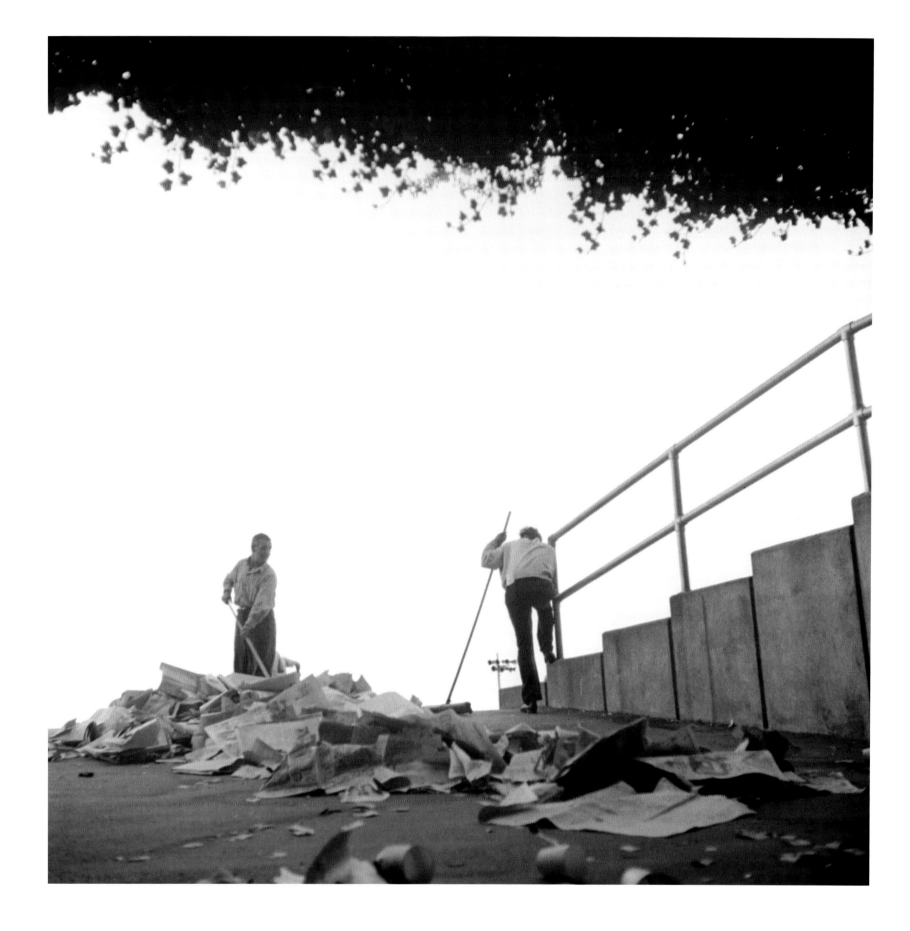

Amusements in the Palisades Park June 1946

The Palisades Amusement Park was located on the border of Cliffside Park and Fort Lee in New Jersey. Founded in 1898 as a trolley park, it grew steadily in attractions, adding roller coasters, theaters, and restaurants to an area of thirty-eight acres. In the 1930s, it even featured the world's largest salt-water pool.

When Kubrick visited the park, the main attractions were the Cyclone and the Giant Coaster, which lured visitors with skyrocketing thrills. To relay the strangeness and oversize dimensions of the place, Kubrick adopts a child's perspective, looking up at the Giant Coaster's enormous tracks, which are reduced to a pure line silhouetted against the sky like a Russian Constructivist's aesthetic experiment. Other photos depict such rides as the Comet sailing across the sky like a futuristic mode of public transport, as well as visitors playing ring-the-bell with a giant sledgehammer to prove their strength in front of a rapt (mostly female) audience.

But at an amusement park, watching is as important as participating. Kubrick captures the ambiguous nature of observation, which exists somewhere between personal projection and secure distance. He shows the fascination of amusement-park visitors in threshold moments as they pass from mundane reality into a wonderland that provides an easy escape from everyday life.

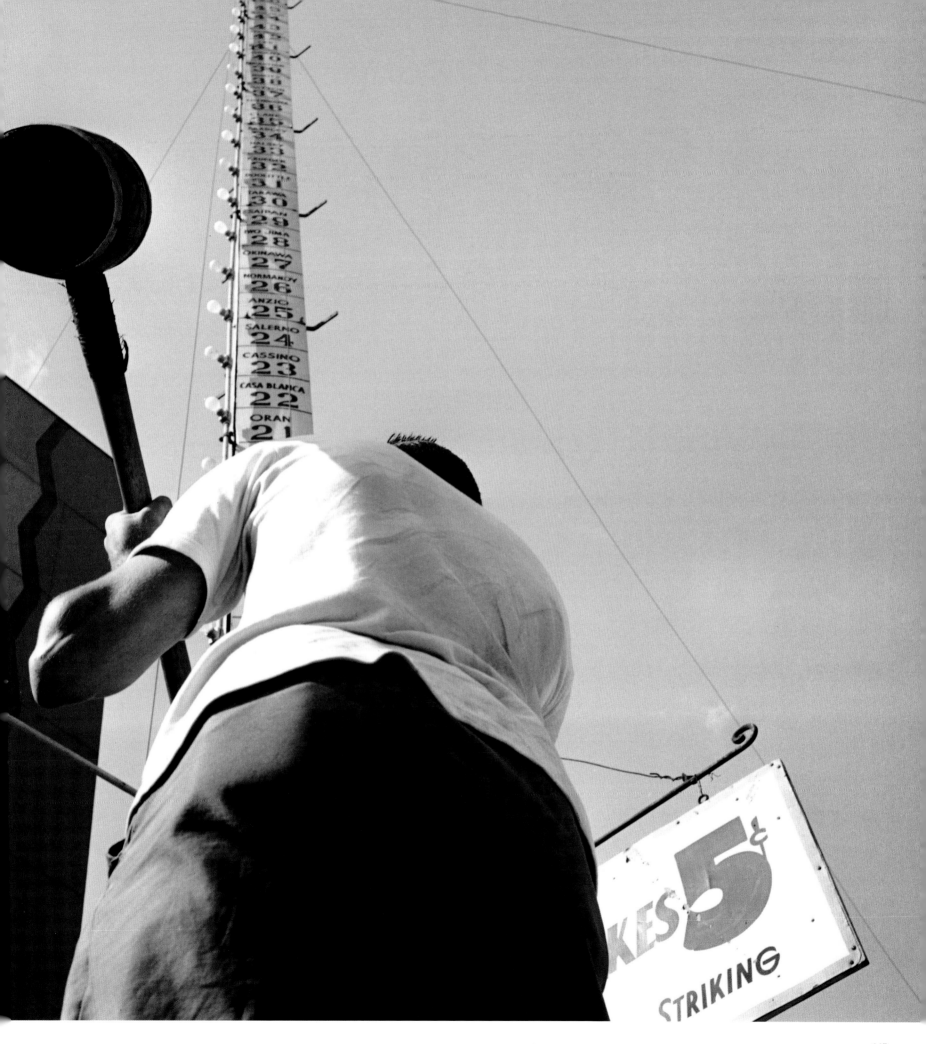

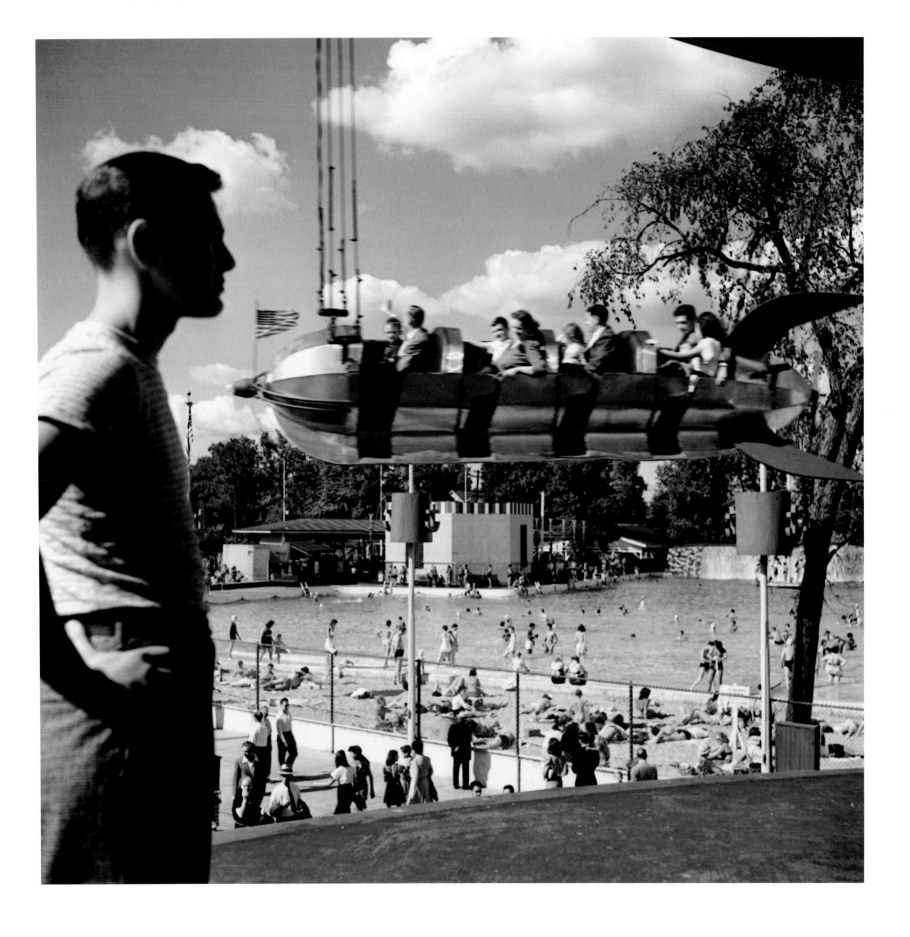

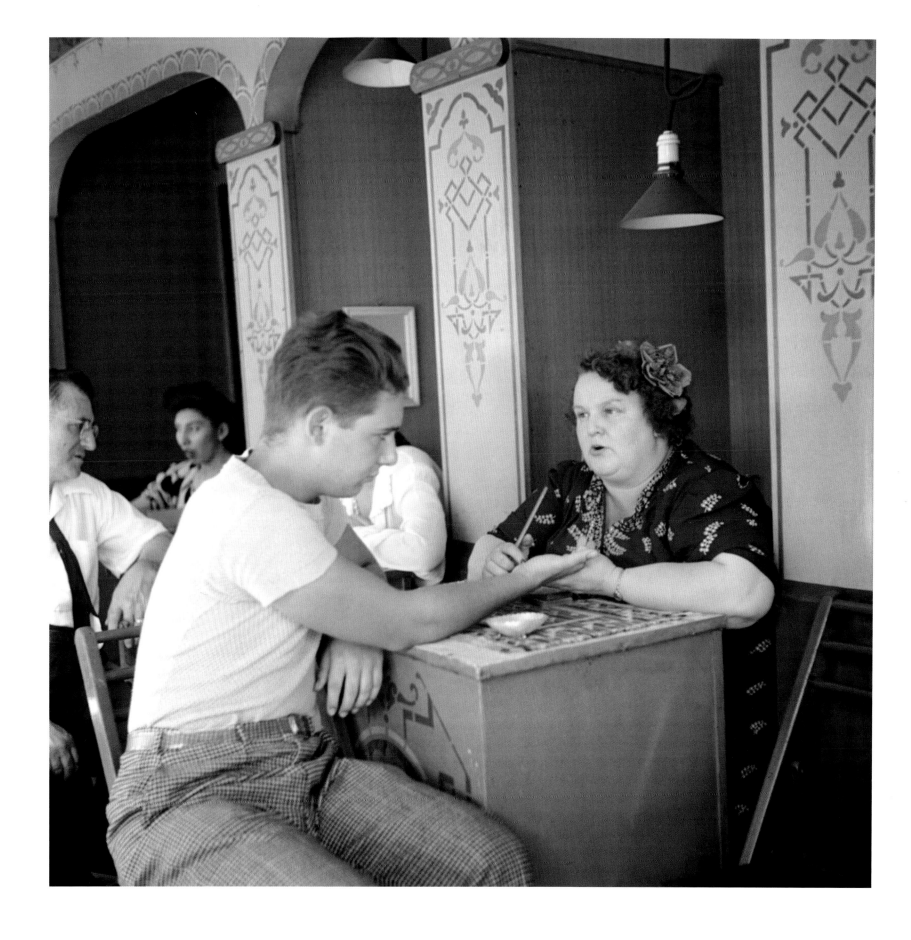

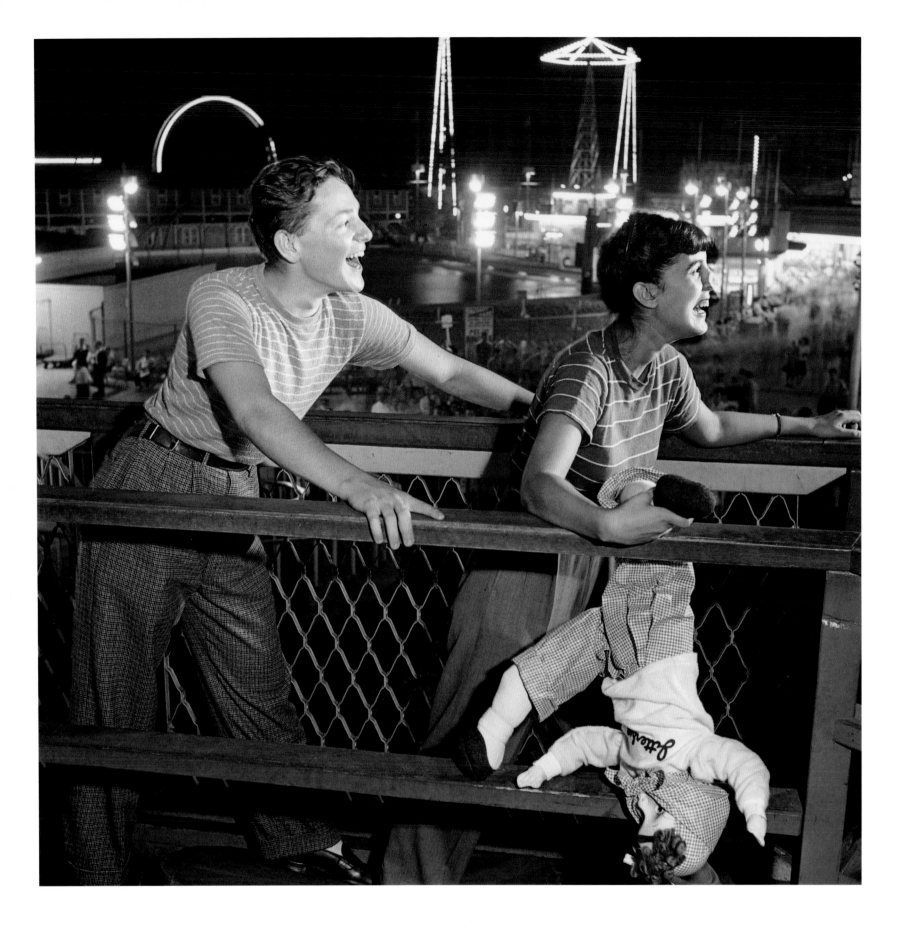

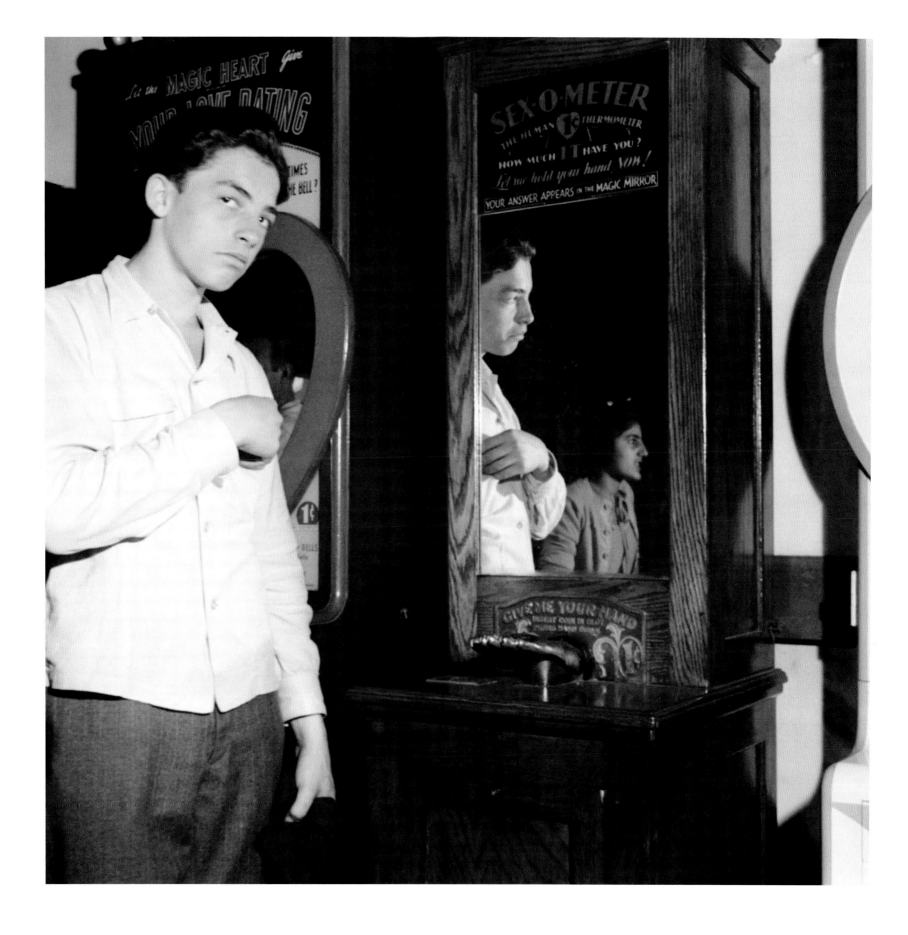

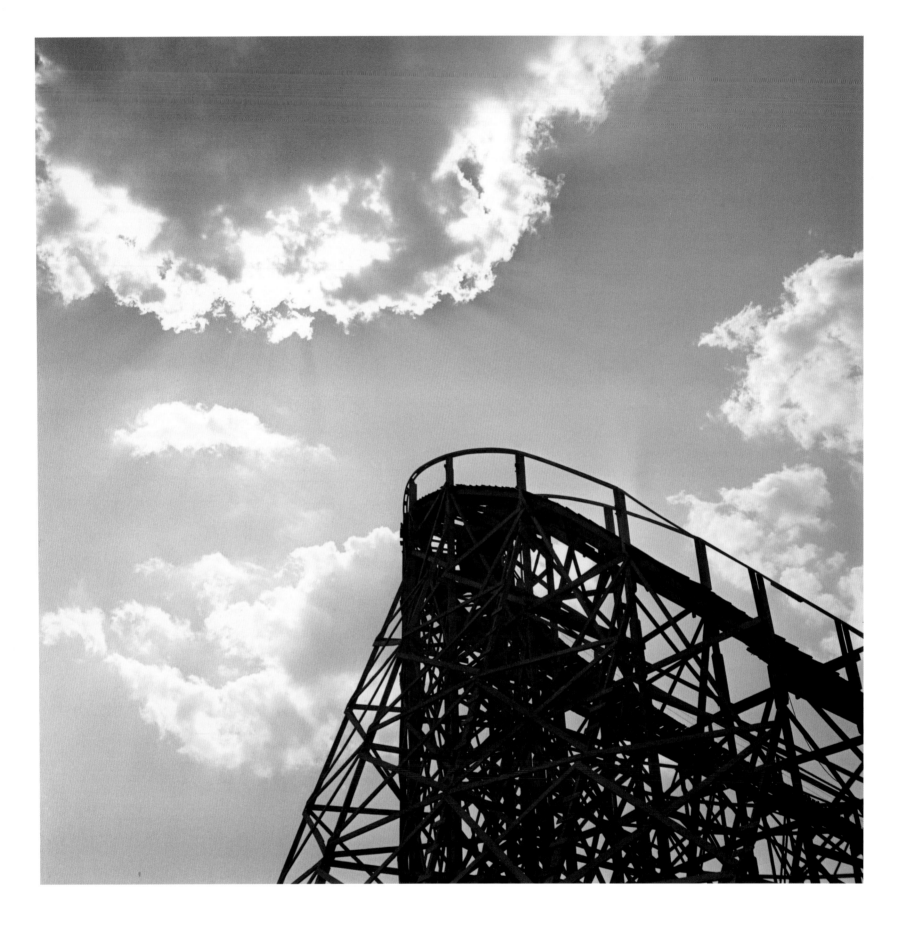

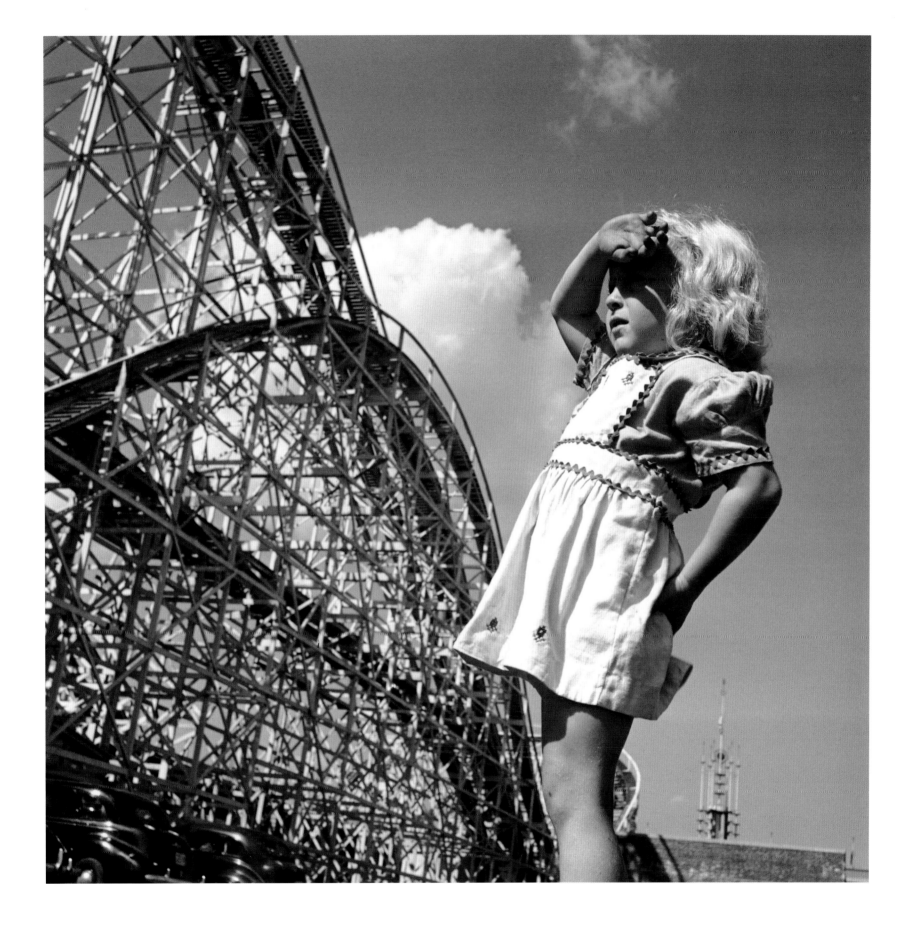

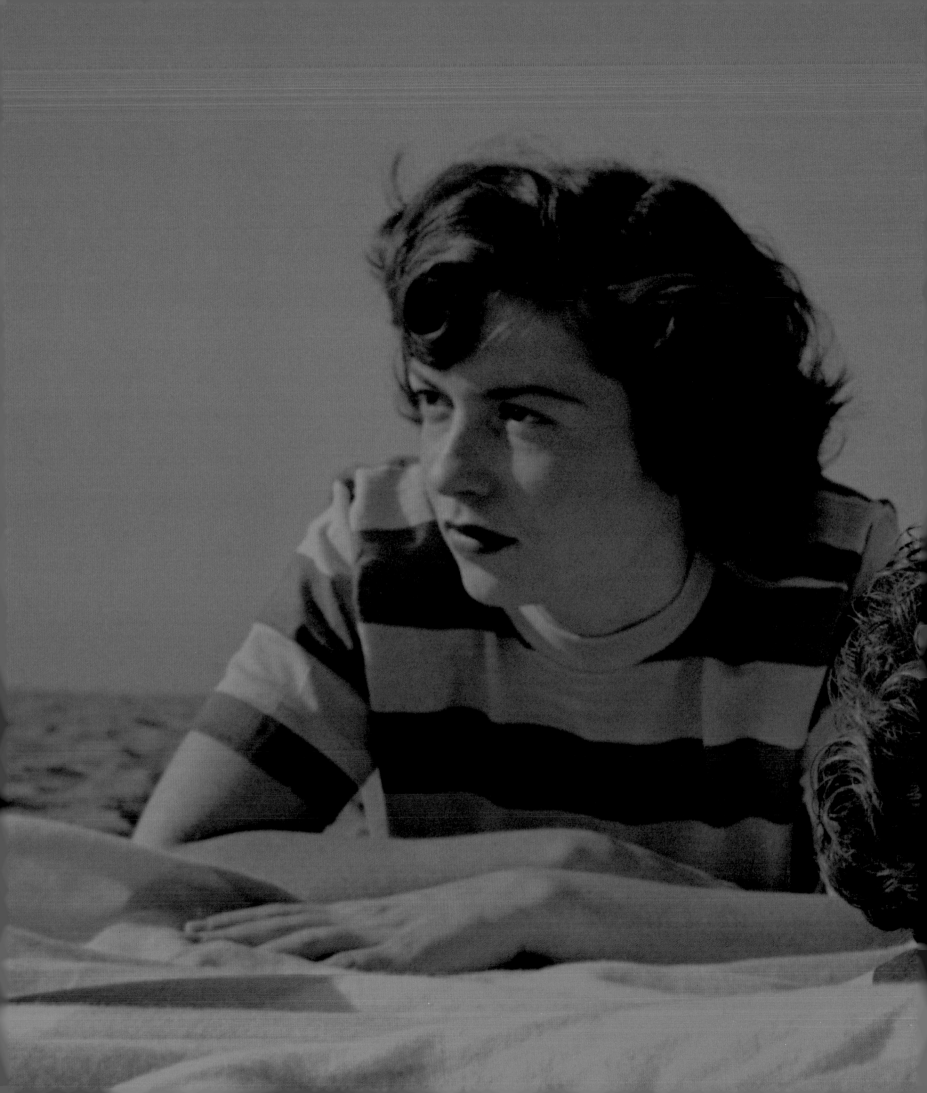

Celebrities

Intimate Scenes with Leonard Bernstein August 1949

The composer, conductor, pianist, teacher, humanitarian, and thinker Leonard Bernstein (1918–1990) was also an entertainer and an adventurous, playful spirit—one aspect that became a focus of interest for Kubrick when he shot this "home story" on the great American musician in 1949. By the time of this photo-essay, Bernstein was a household name, famous for being the first American appointed as music director of a major American orchestra, the New York Philharmonic.

Bernstein made his historic conducting debut at the age of twenty-five: with only a few hours notice, he substituted for Bruno Walter, who had taken ill, with the Philharmonic at Carnegie Hall. He was an instant success and made the front page of the *New York Times* the next day. Bernstein's engagement with music was legendary in New York, where he championed the work of American composers and wrote his own sym-phony compositions (*Jeremiah*, 1943), ballets (*Fancy Free*, 1946), and musicals (*On the Town*, 1944). Bernstein's social awareness made him a prominent target for the patriotic para-noia of the House Un-American Activities Committee, although he managed to avoid being blacklisted.

In this photo-essay, Kubrick manages to enter Bernstein's inner circle. He portrays a casual, family-like atmosphere filled with Bernstein and his friends enjoying sunbathing, horseback riding, TV watching, and joking around. Kubrick is able to bring the artists' expressive talents to the fore in a suite of narrative images. One sequence of images of Bernstein in swim trunks performing various scenes on a dock transcends the limits of a two-dimensional black-and-white frame and conveys more about his sense of musicality than portraits of the artist actually play-ing the piano.

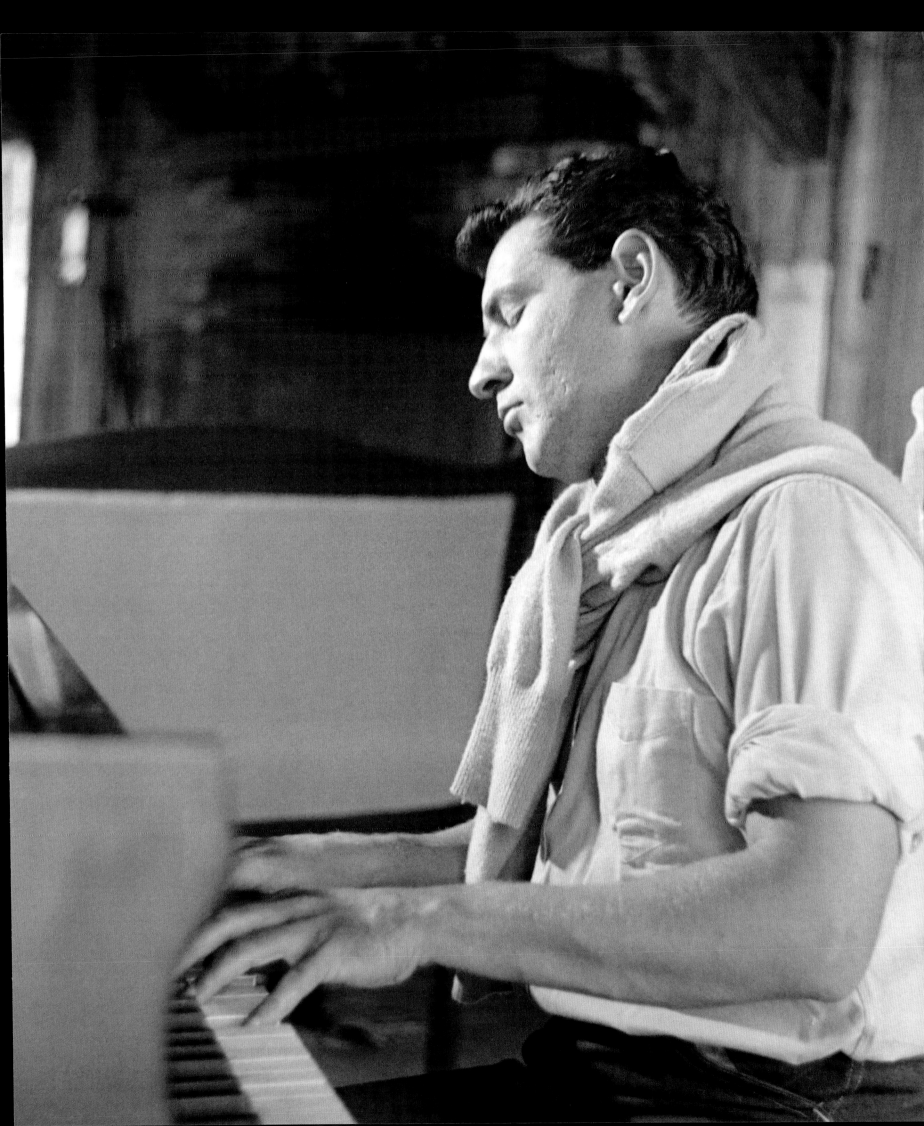

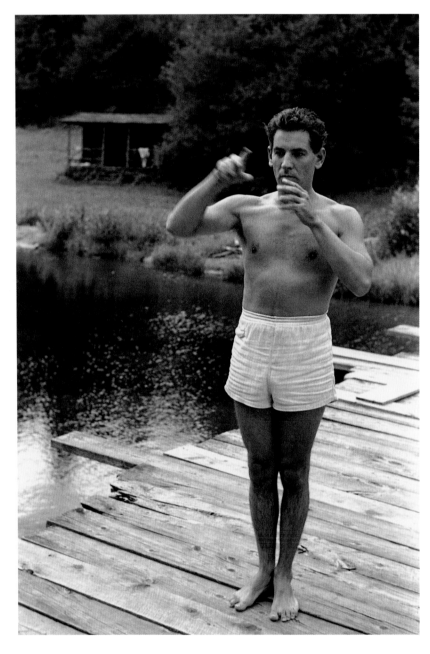
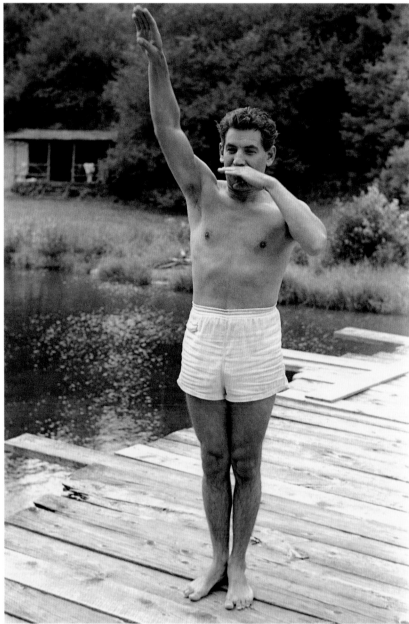

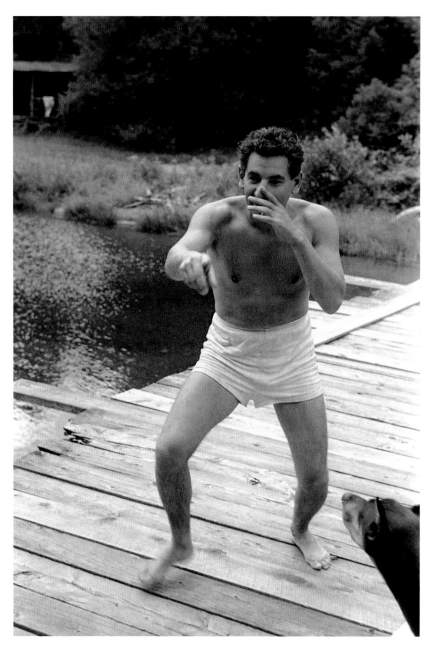
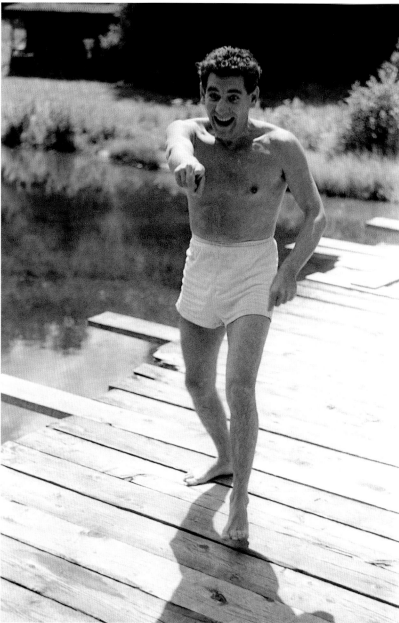

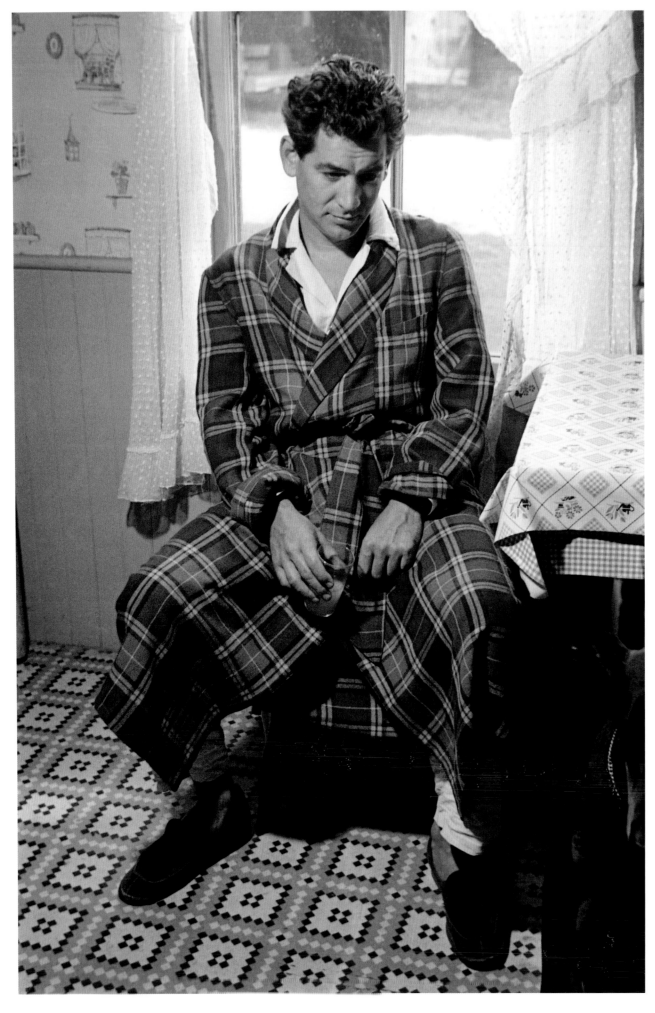

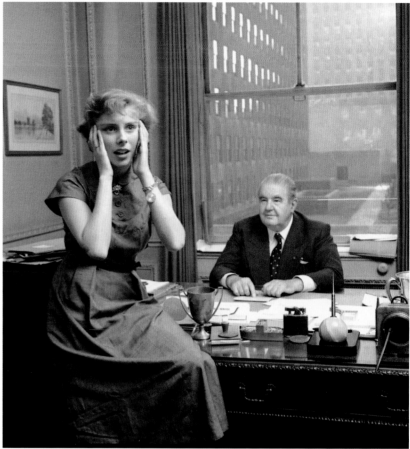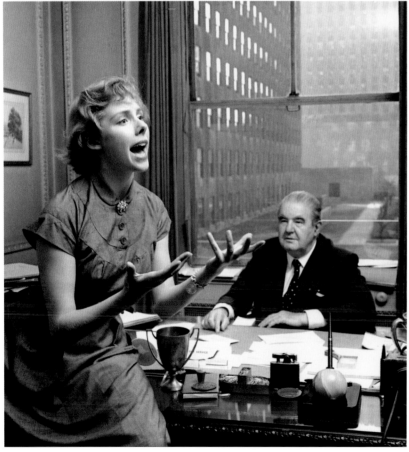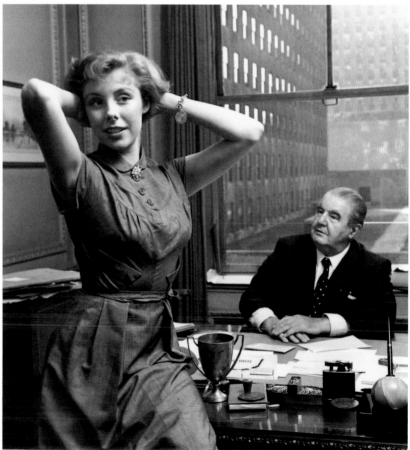

Dailies of a Rising Star
Betsy von Fürstenberg May 1950

Kubrick's unique way of dealing with fragments of reality and their compositions becomes apparent in a photo study of a teenage socialite and aspiring actress named Betsy von Fürstenberg, who was born to a German aristocratic father and an American mother. At age seven, von Fürstenberg was dancing at the New Yorker Center Theater and, at fourteen, was modeling in Paris, her pretty though unremarkable face adorning many magazine covers at the time.

At nineteen, when Kubrick visited von Fürstenberg for this shoot, she had long mastered her role as a model teenager and is shown at a party, in restaurants, and on the estate of affluent friends. Except for one scene in which she has fallen from her bicycle—an image obviously omitted from publication—there is rarely a picture that catches von Fürstenberg off guard, her self-conscious smile seemingly cemented to her face. It is in the composition of the fragments within the frame, however, that Kubrick hints at the shallowness of such a public existence.

In one photo, Kubrick features von Fürstenberg decoratively seated in a window frame reading a script. Kubrick manages to transform her pose into a delicate subversion of her own vain mise-en-scène by presenting an empty center space—a constructivist device he often used—that presented a plain view out the window. Here, the curtains are opening not onto her, the star, but onto the nothingness of the facade behind her.

In another picture featuring a party scene, von Fürstenberg is presented lounging on a love seat, her organza petticoat all but covering up the interested but neglected beau sitting to her left. A famous Picasso painting of the artist's studio mate Angel de Soto sitting in a bar hangs above the sofa, facing the viewer. The parallel expressions of the Spanish art student in the painting and the young socialite relay the uncomfortable truth that early accomplishments are rarely sustained into adulthood. Kubrick uses the painting as a mirror onto von Fürstenberg and as a visual challenge to the viewer.

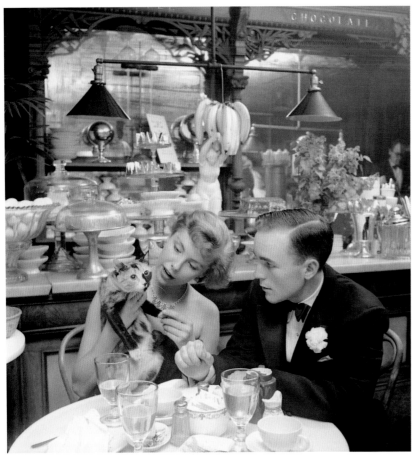
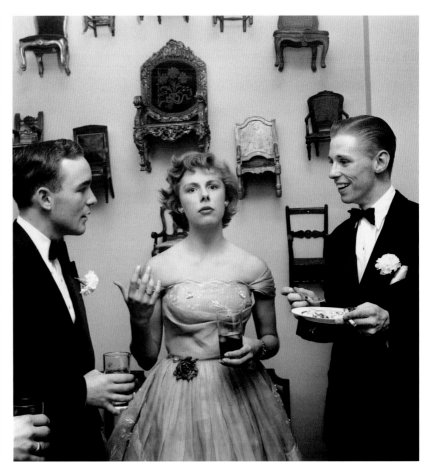
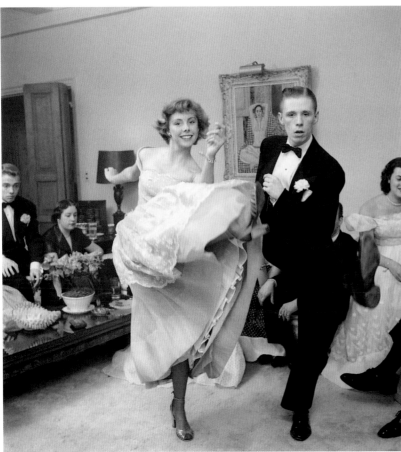
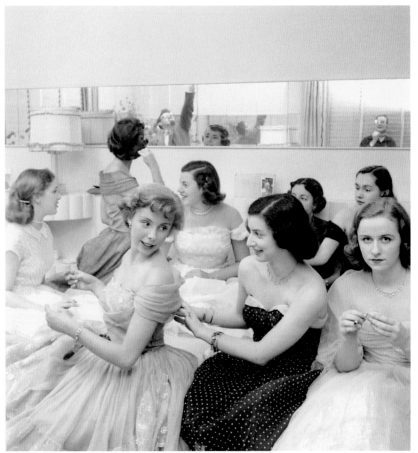

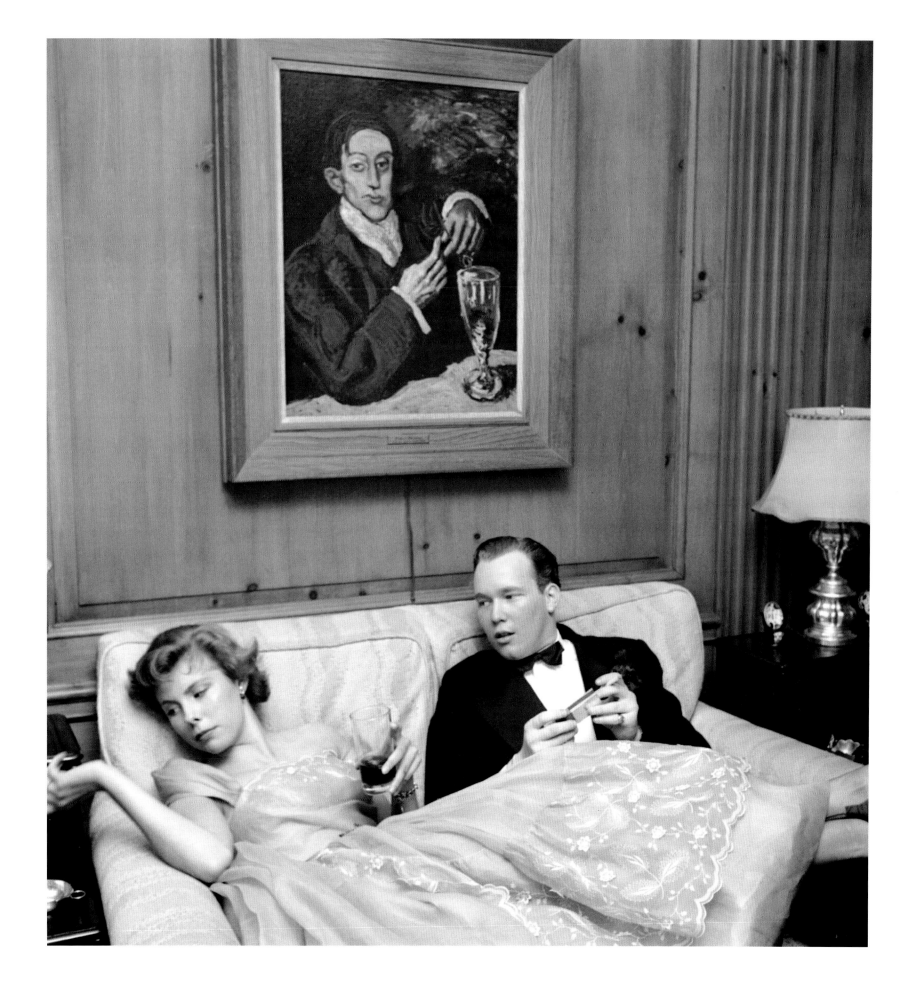

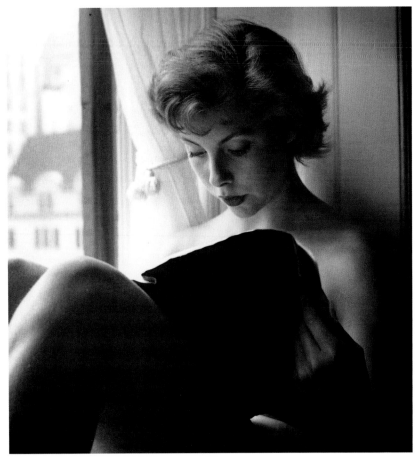
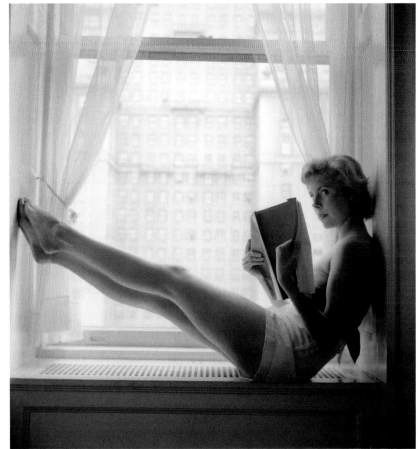
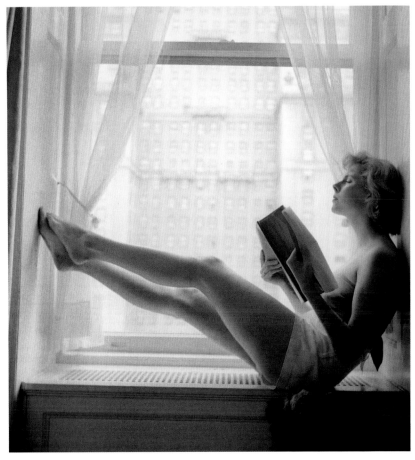
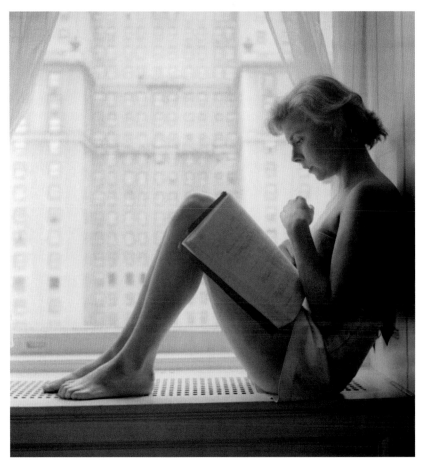

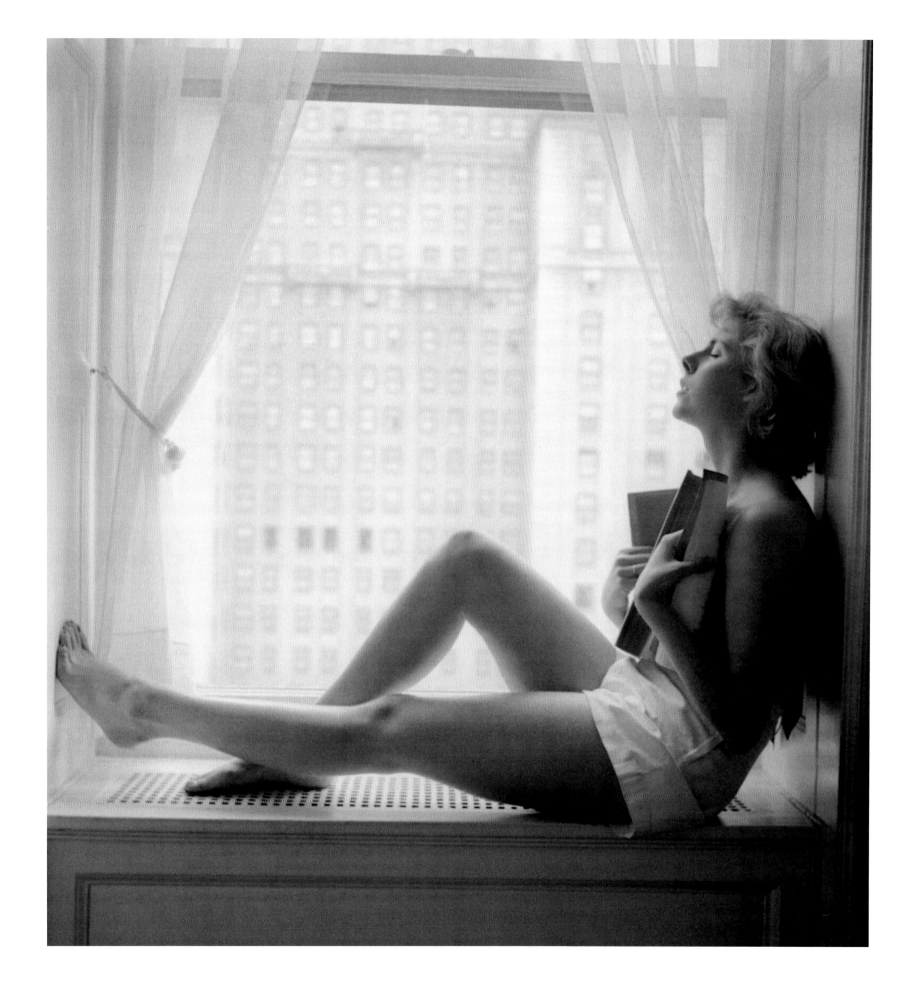

The Young Montgomery Clift
A Conflicted Soul March 1949

Kubrick's visit to Montgomery Clift's New York apartment is a typical example of how he used an official assignment to create his own subversive ideas of the public image. Clift was about twenty-eight years old and had just celebrated his first Hollywood success with *Red River*, a western starring John Wayne. Kubrick's notorious interest in the dialectics between image and personality becomes all the more vital in these photos of Clift, a quintessential young existentialist and myth incarnate.

Clift had been a precocious stage actor who, unwilling to bow to Hollywood's demands, had kept returning movie scripts for twelve years before conceding to appear in Wayne's western. Kubrick presents an intimate portrait of the enigmatic star, showing him dressed in boxer shorts or in a white T-shirt—still considered underwear before James Dean and Marlon Brando made it fashionable in the early 1950s. Acting the part of a loner in some pictures and as a warm family man in others, Clift reveals the staged facets of his image coined by the public.

Even when Kubrick takes a seat at the same table with Clift and focuses close-up on the actor's face, there is no eye contact. The shoot's sense of intimacy is clearly feigned, as is the actor's image as "the most wanted bachelor," announced in *Look*. Kubrick's study intuitively reveals the oscillating character of the tormented actor, who had chosen a life of roles and suffered secretly from having to conceal his homosexuality. Sadly, Clift would ultimately destroy himself through a combination of drink and drugs, dying of a heart attack at age forty-six.

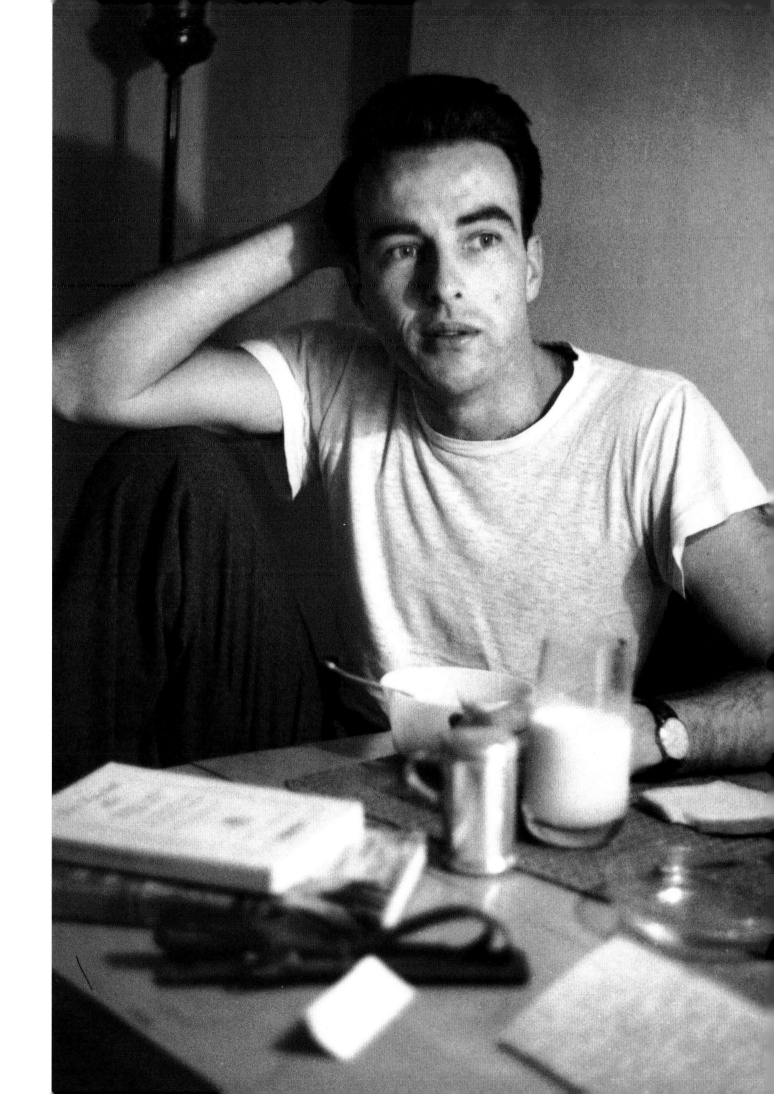

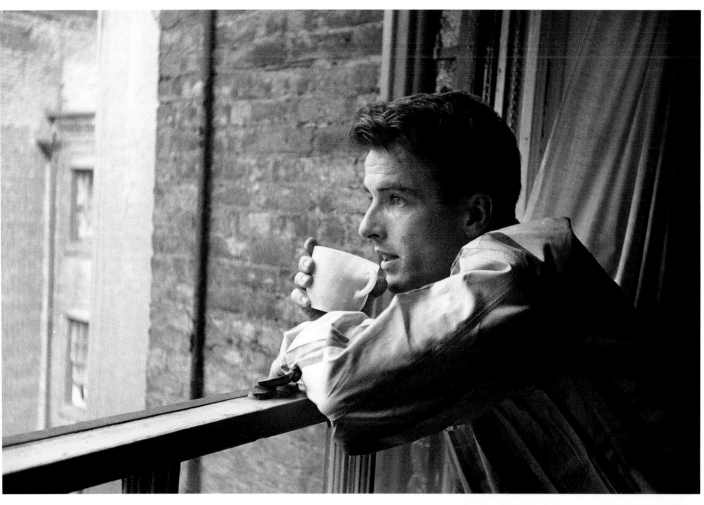

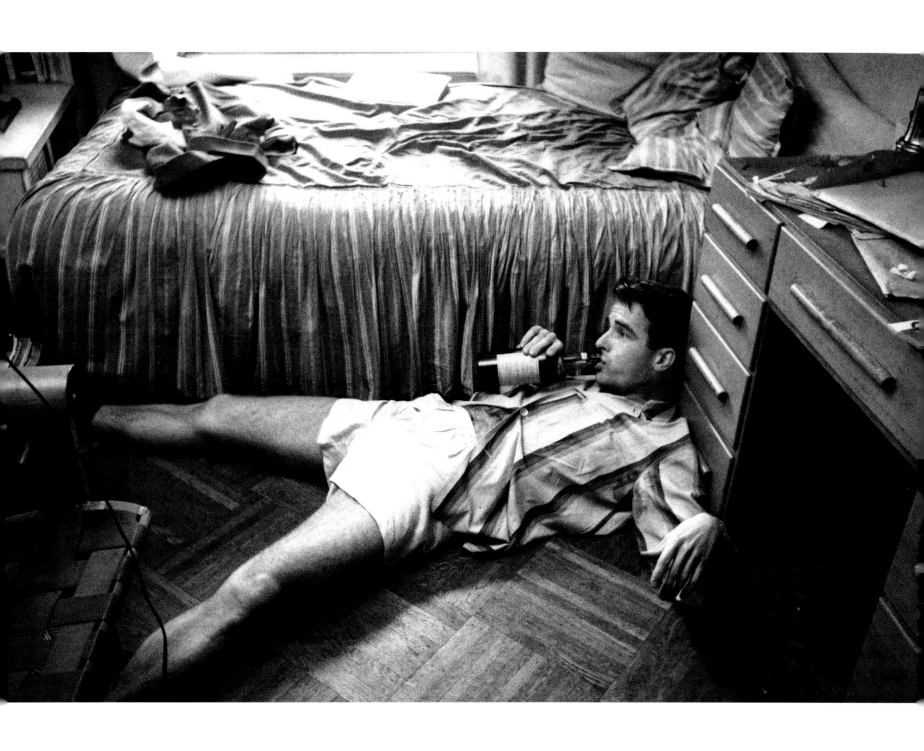

World Sport Boxing's Two Mythic Heroes
Rocky Graziano December 1949

"Boxing is our most controversial American sport," writes Joyce Carol Oates in her book-length essay *On Boxing* (1995). "It is the quintessential image of human struggle, masculine or otherwise, against not only other people but one's own divided self." This paradigm of the ambiguity of life and its continual battles fascinated Kubrick, who followed the careers of such boxers as Rocky Graziano, Joe Louis, Sugar Ray Robinson, and Jake LaMotta.

Graziano especially lived the quintessential American dream, having transformed himself from a troubled criminal youth on the gritty Lower East Side of Manhattan into a modern myth. Graziano fought between the welterweight and middleweight divisions but made his mark in 1945 when he knocked out welterweight contenders Billy Arnold and Al "Bummy" Davis. Graziano's three-fight series with middleweight champ Tony Zale defined his career. The three contests lasted a combined fifteen rounds and saw seven knockdowns.

It is striking how close the twenty-year-old Kubrick could get to the prizefighter, who was seven years his senior. He was even allowed to follow Graziano into the shower, although these scenes were omitted from publication. Even when Kubrick presents the champion in his deepest privacy, however, it all underscores the impression that Graziano is a public animal, entertaining even at that moment, with Kubrick directing him in his role.

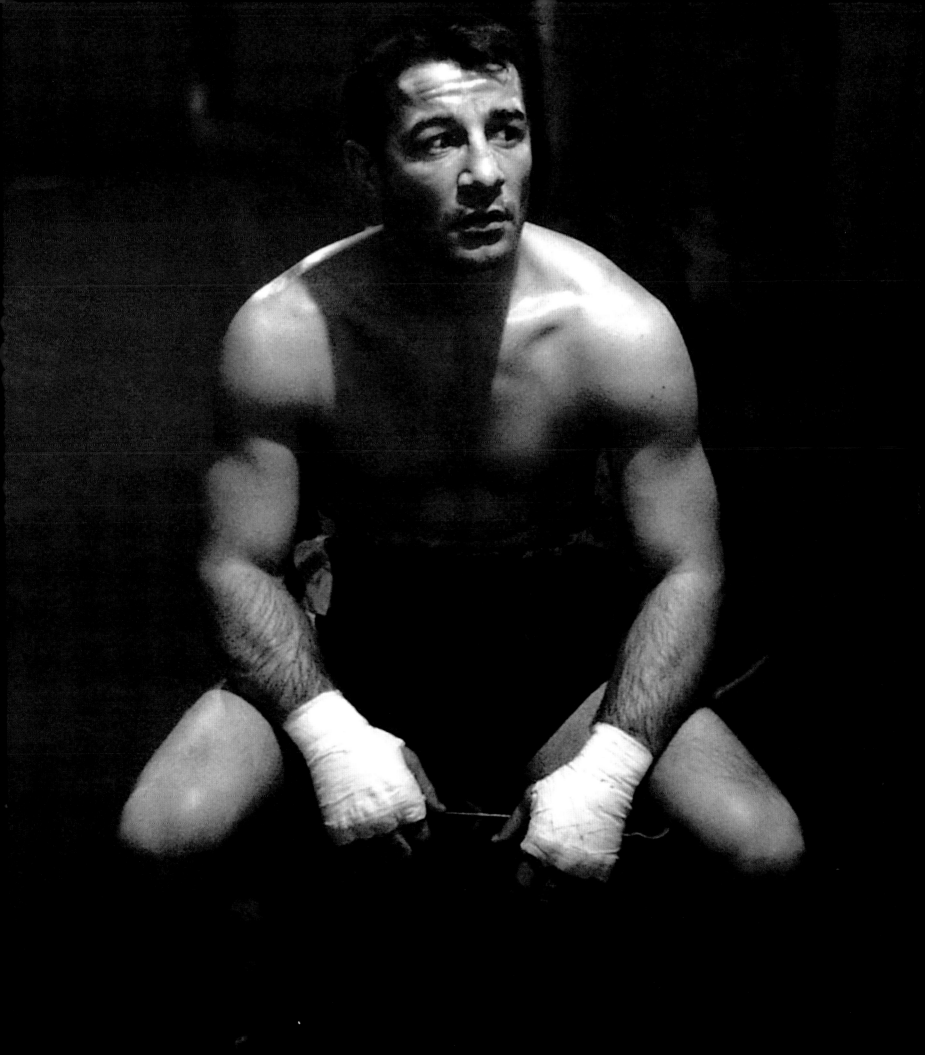

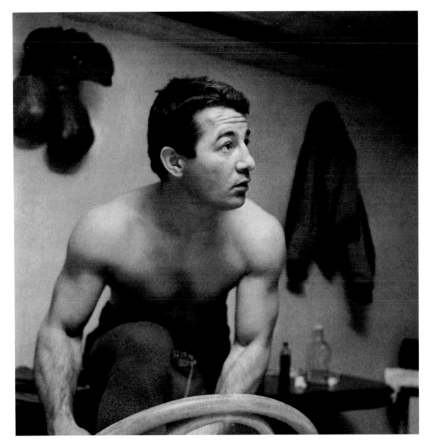
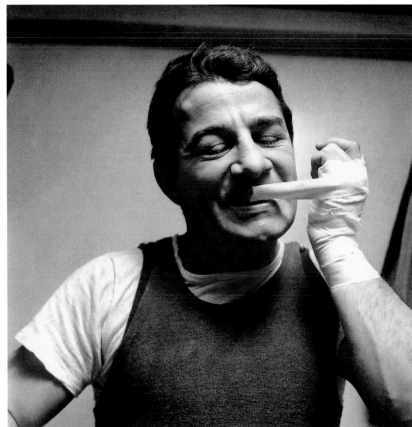
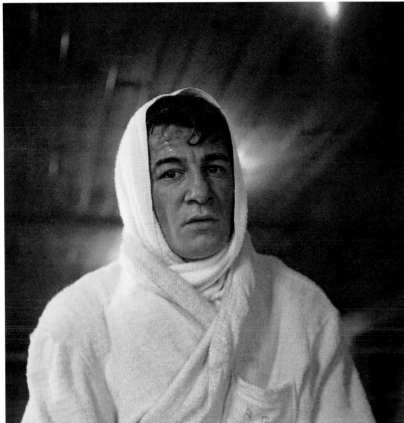
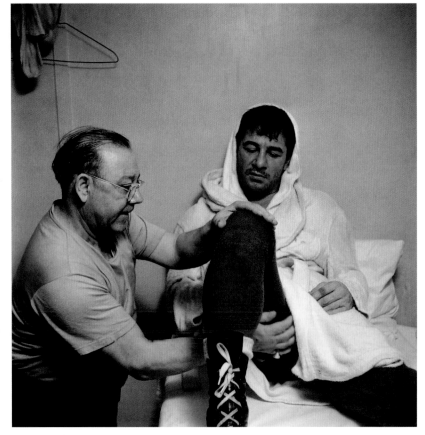

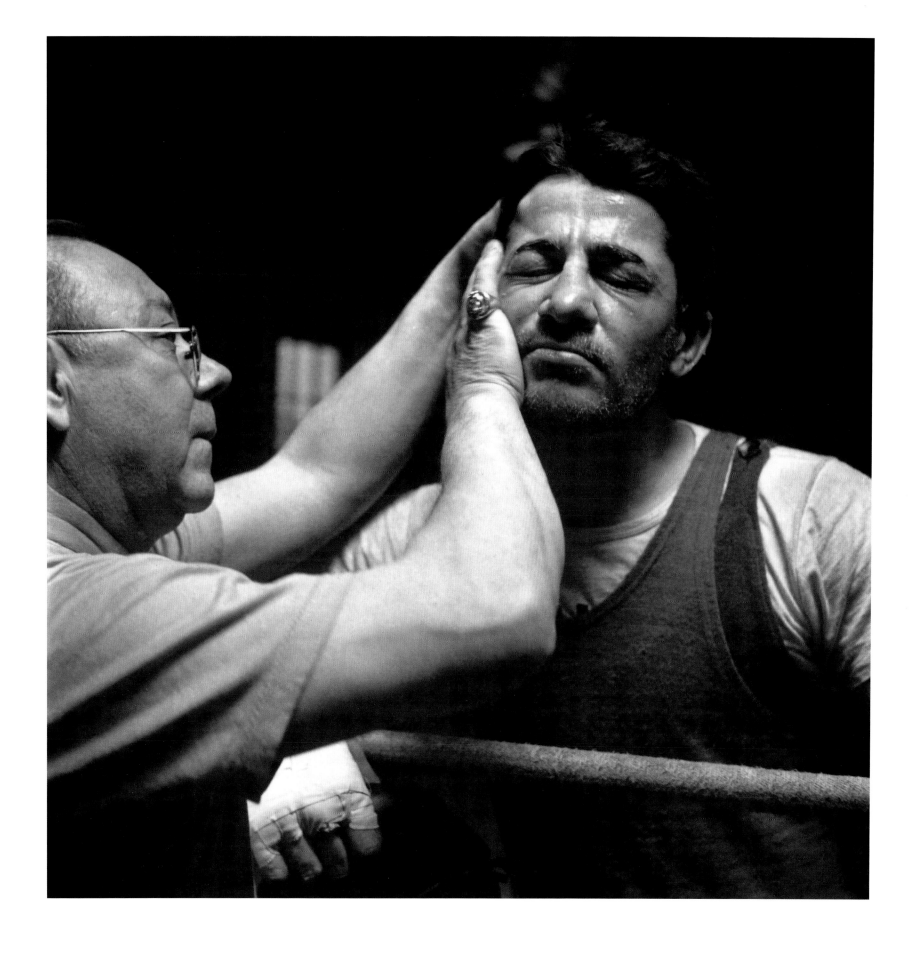

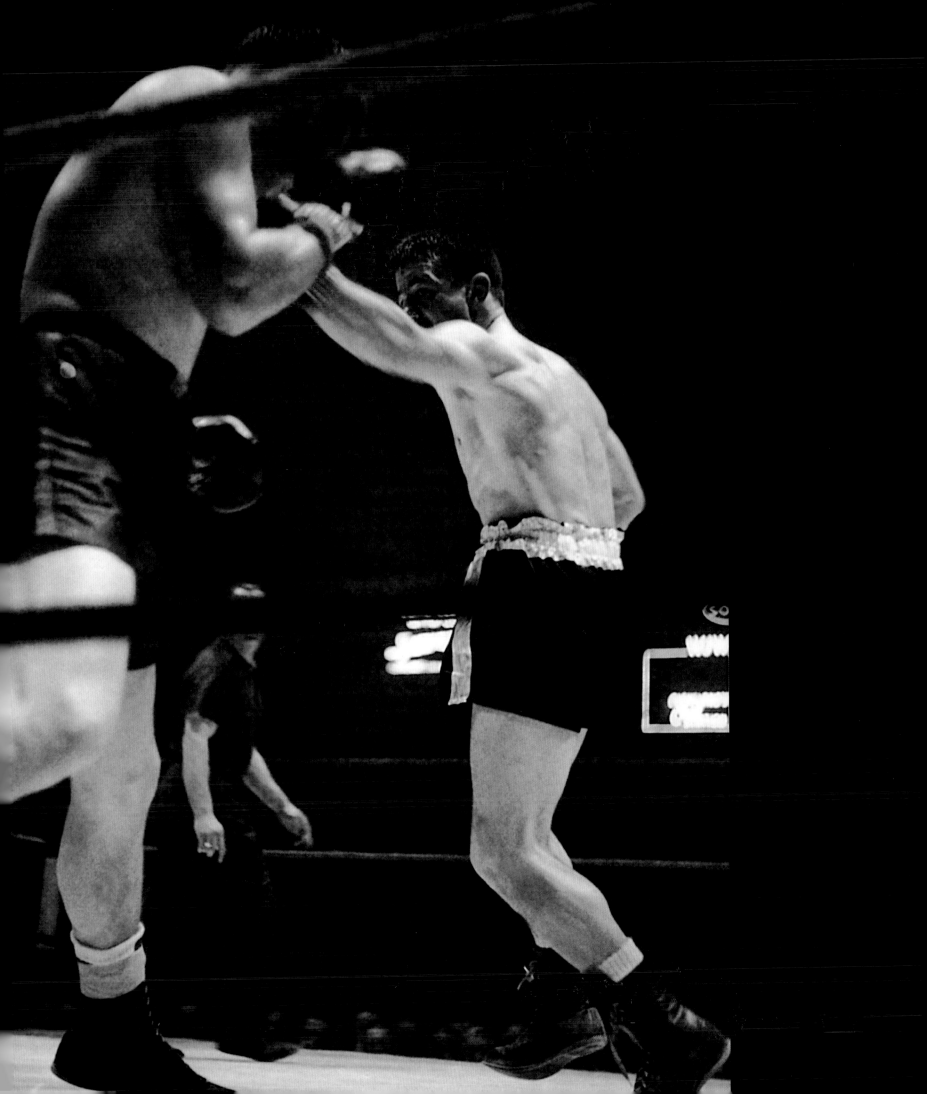

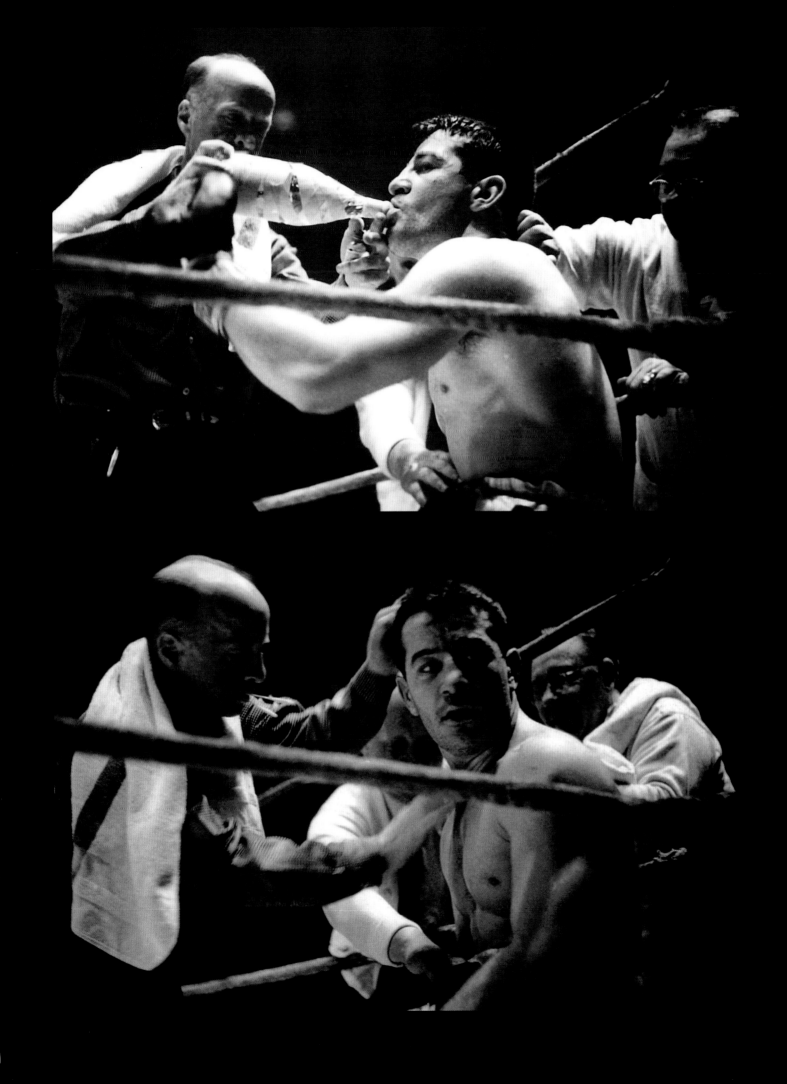

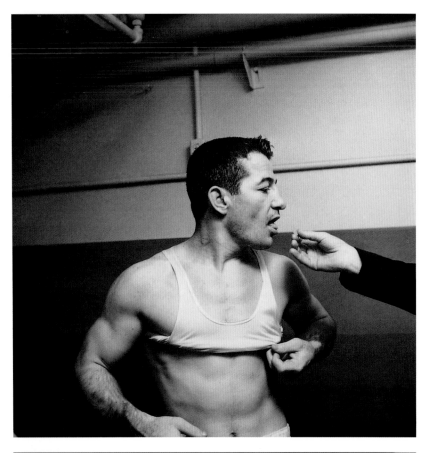
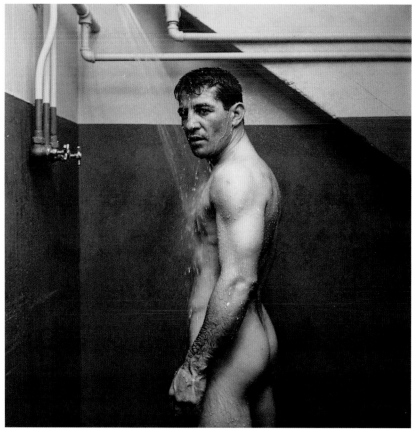
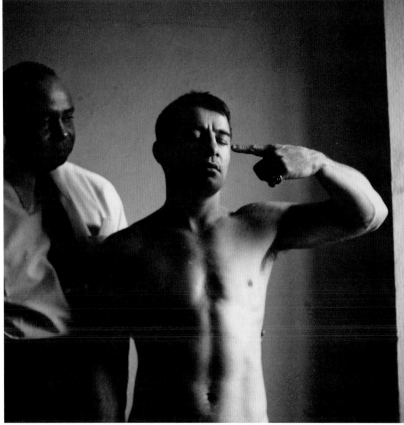
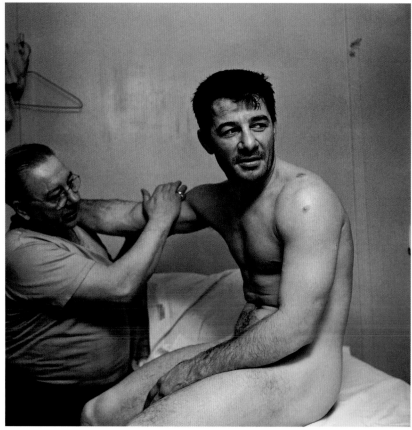

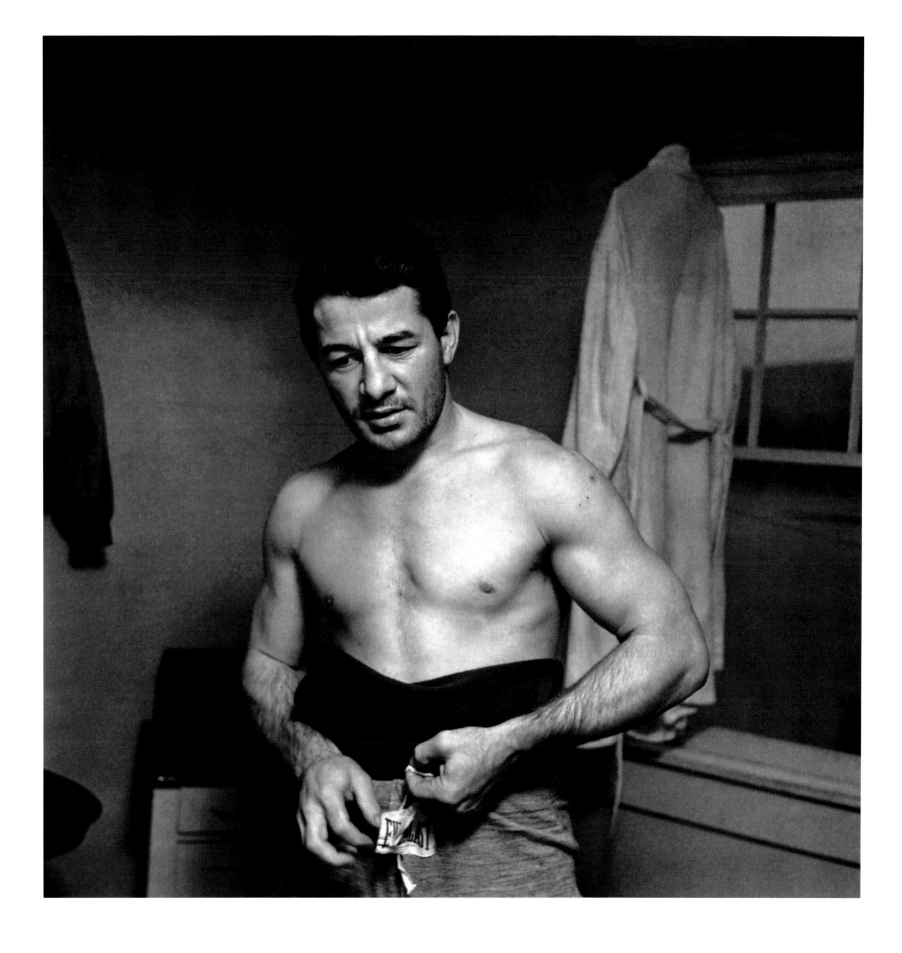

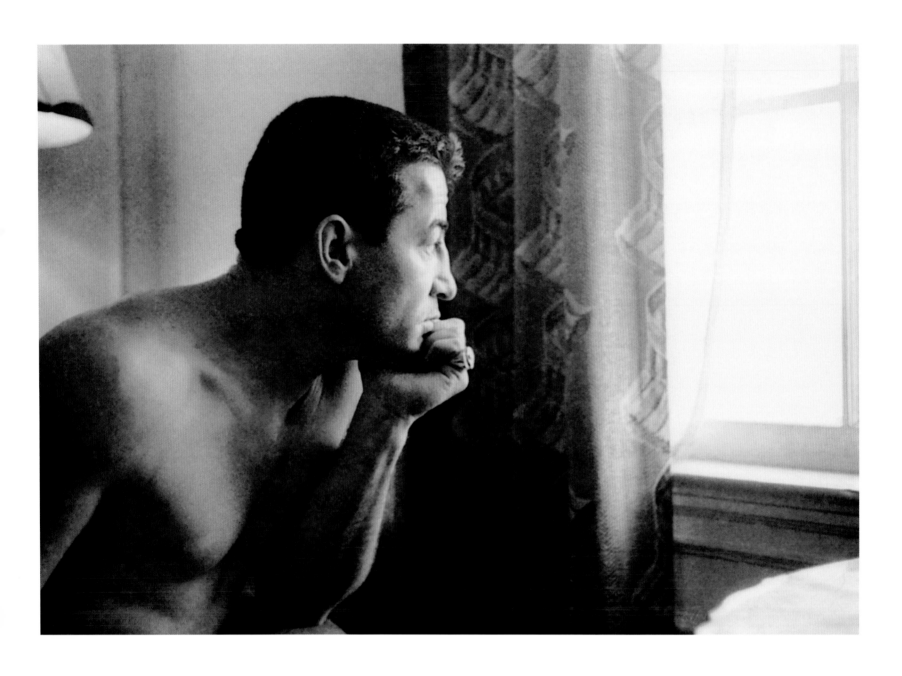

World Sport Boxing's Two Mythic Heroes: Rocky Graziano

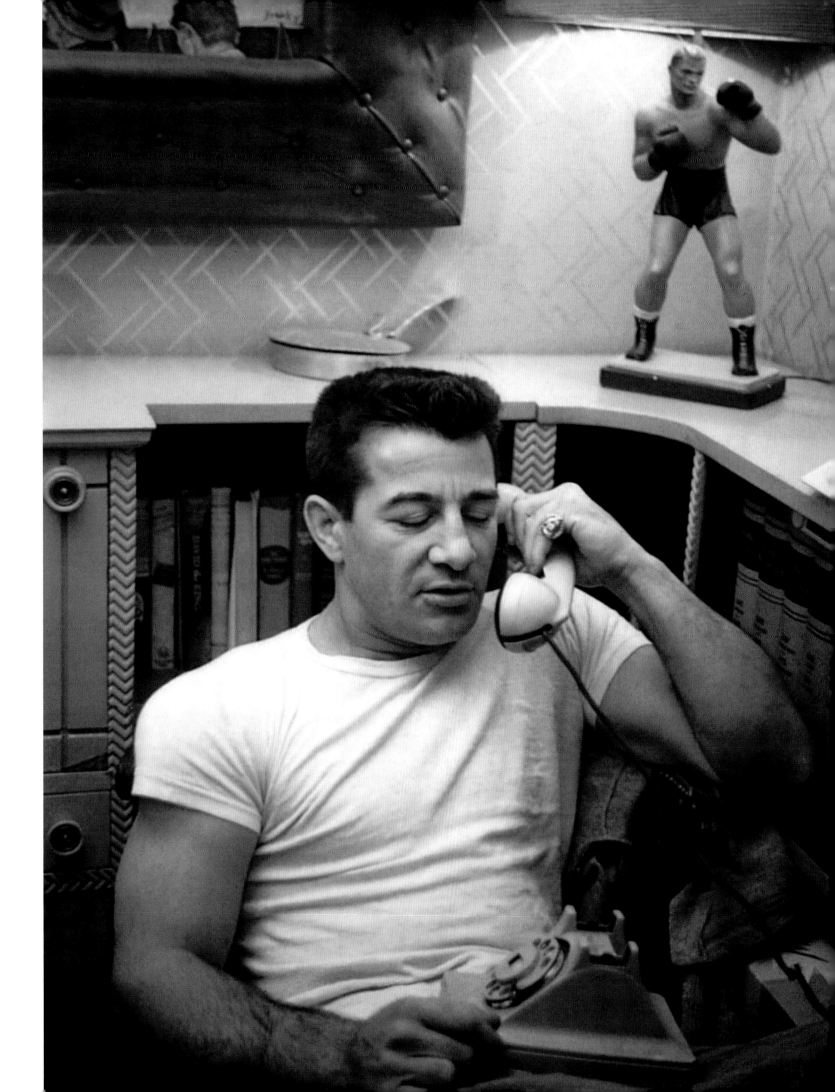

World Sport Boxing's Two Mythic Heroes
Walter Cartier October 1947

In his first study of a boxer, titled "Prizefighter Walter Cartier," Kubrick saw the dramatic potential in boxing and aimed to investigate the tension that exists between public and private life—in this case with the example of a handsome, promising champion who also happened to live in Greenwich Village.

Cartier had been boxing since he was young, giving exhibitions with his twin brother, Vincent, in country fairs in Connecticut. After serving in World War II, he started training to be a professional prizefighter. Kubrick's photo-essay provides a tour of the twenty-seven-year-old champion's private life, showing him meditating in a church, visiting the beach with friends, working out with the famous trainer Bobby Gleason, and fighting in the ring. At first glance it seems that Kubrick has access to the boxer's most intimate moments, but then it becomes clear that the photographer keeps reinstating a certain distance. When Kubrick focuses on a close-up of the boxer as he sits in church, he primarily transmits the inner tension of the

champion before the fight. Even in these private moments, we become aware that, ultimately, the boxer is a public object charged with high expectations and commercial interests.

In contrast, the fight itself is presented in such an intimate and direct way that it draws the viewer right into the ring. During a fight with Tony DeMicco at Jerome Stadium, Kubrick shoots from a low angle holding the camera beyond the ropes, capturing each drop of spit and sweat. *Day of the Fight*, Kubrick's first venture as a filmmaker, was made while he was still working as a photographer for *Look*, and starred Cartier. The sixteen-minute documentary reputedly came about when a friend of Kubrick's who worked with director Alexander Singer heard that his employer was paying $40,000 for eight- or nine-minute documentary shorts. Kubrick made *Day of the Fight* for $3,900 but was able to sell it to RKO for only $4,000.

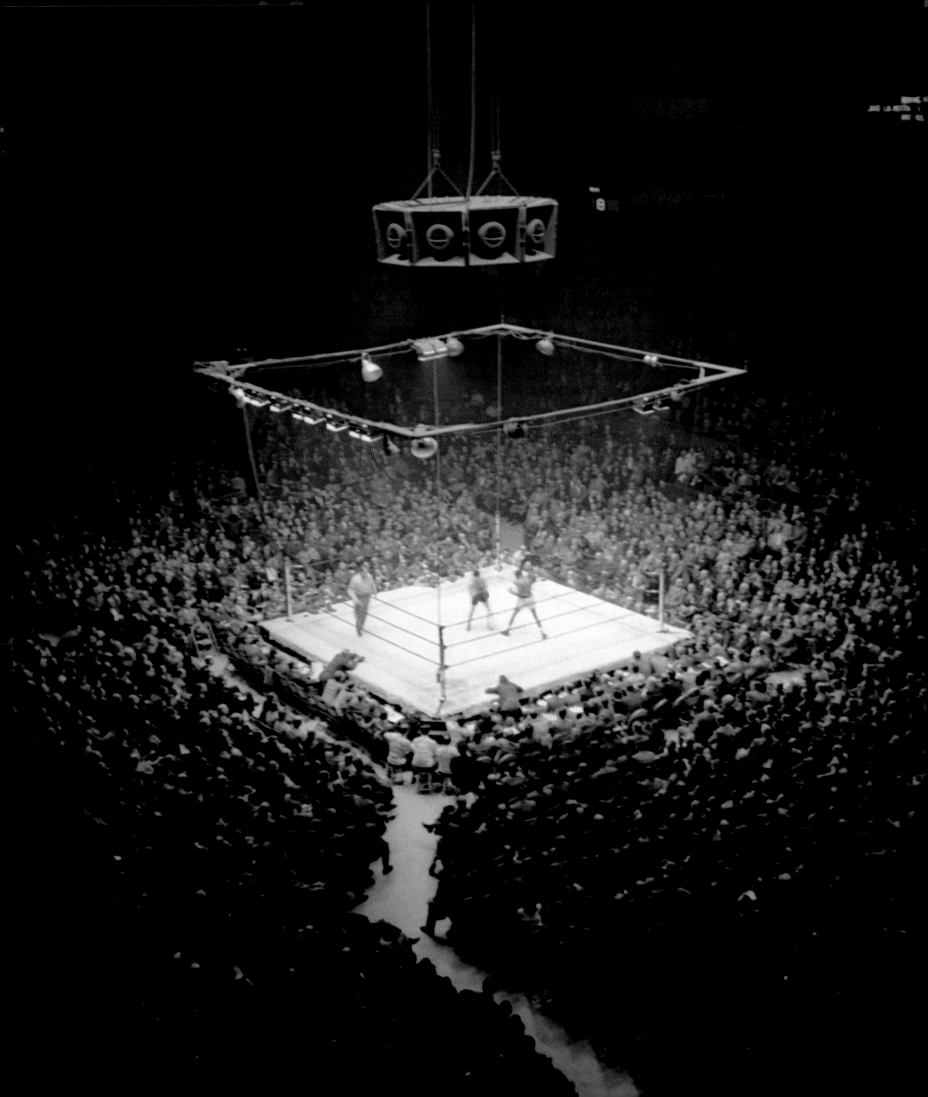

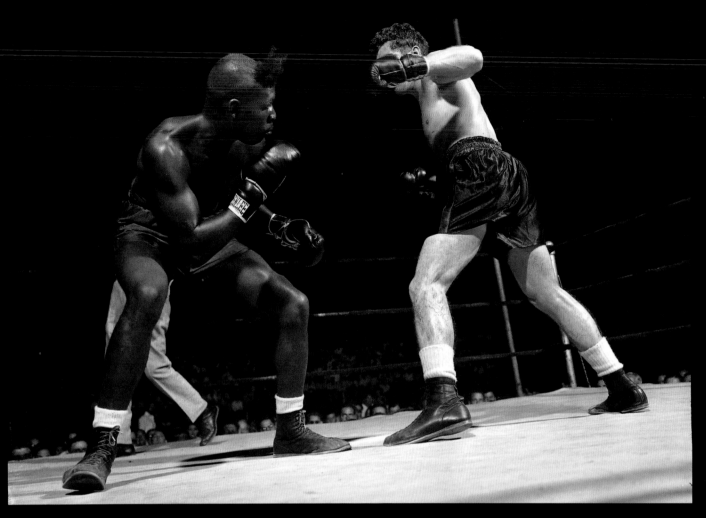

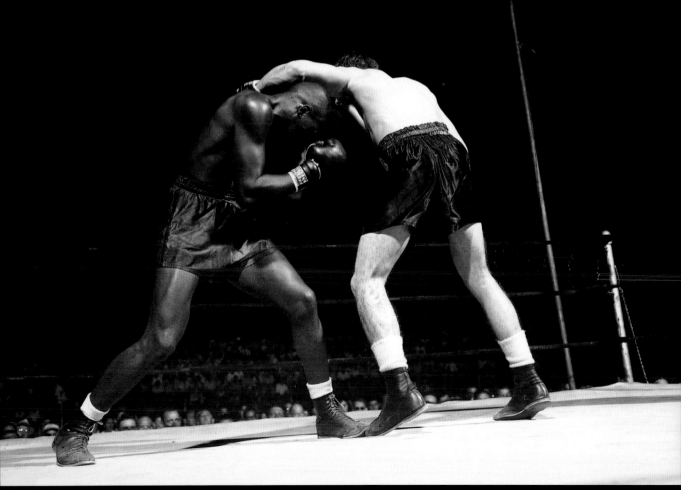

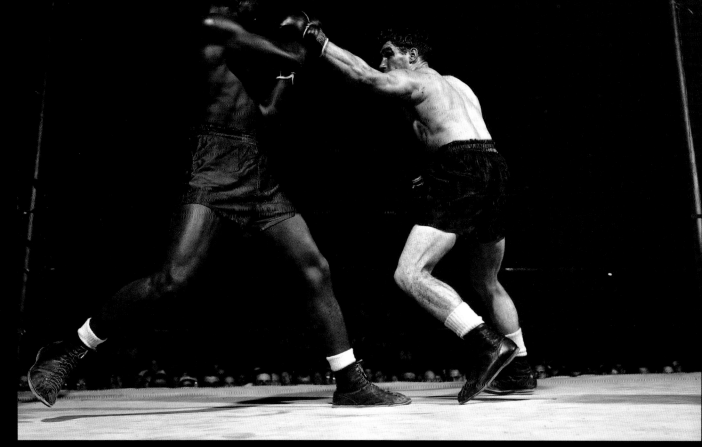

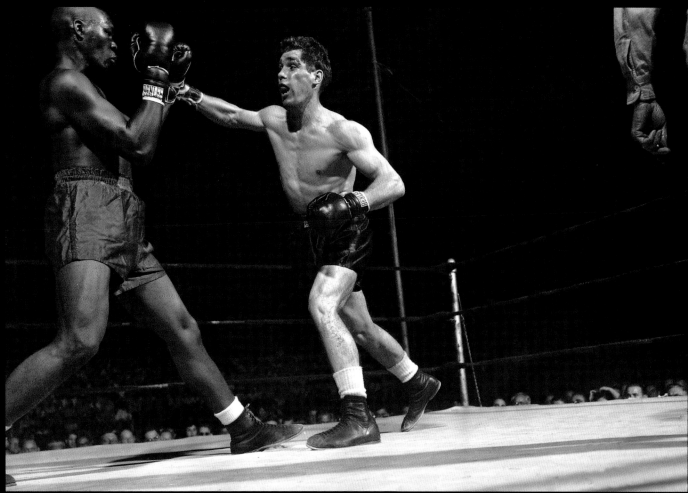

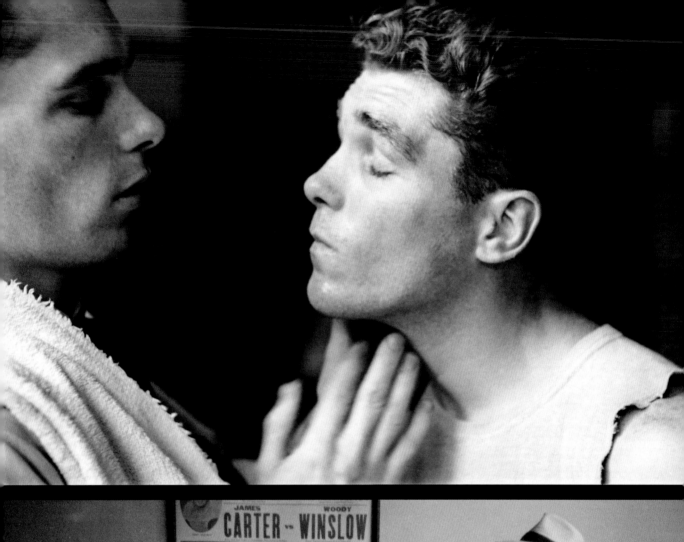
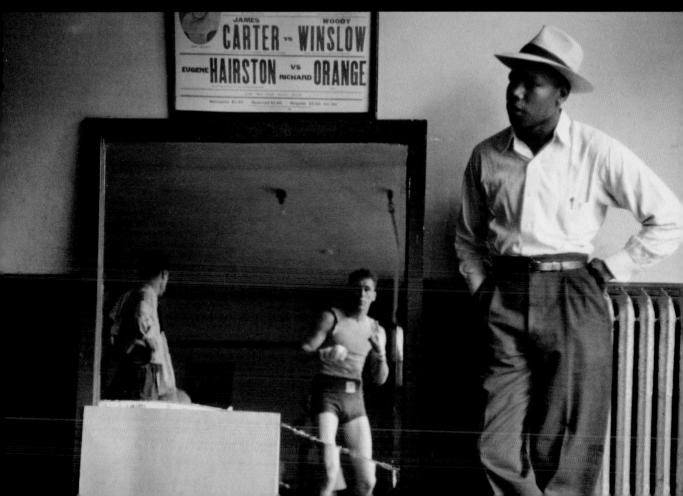

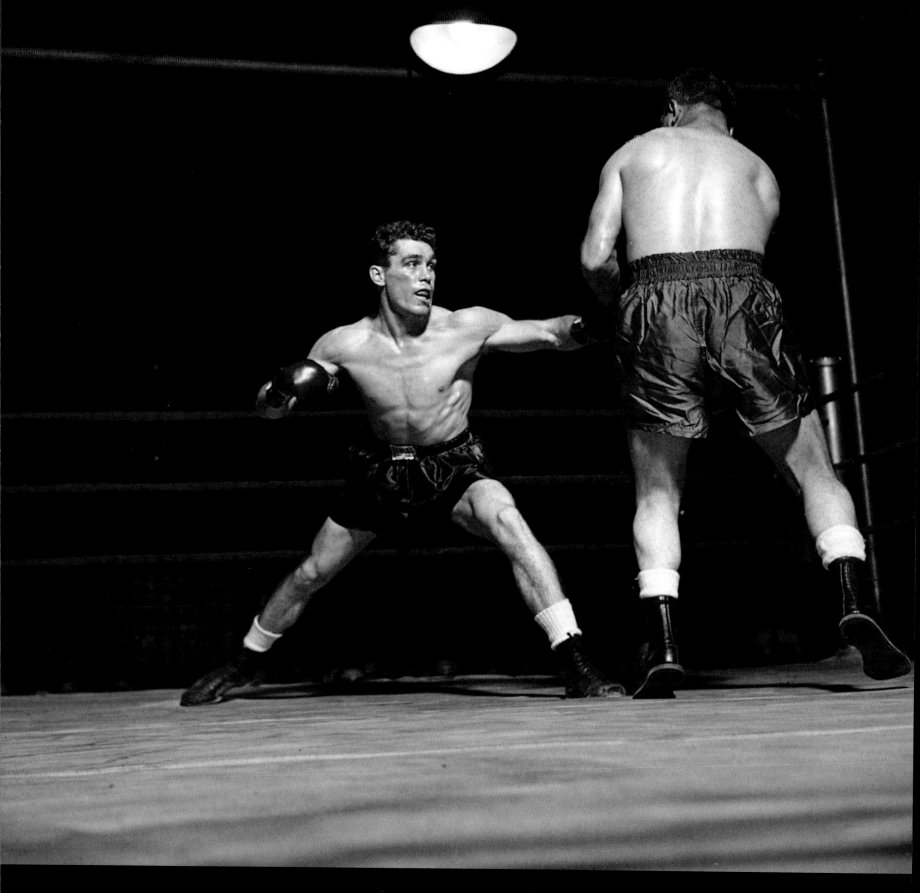

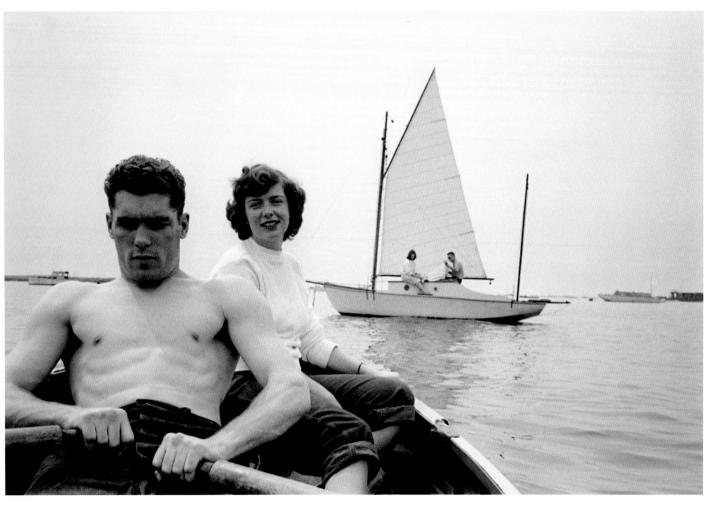

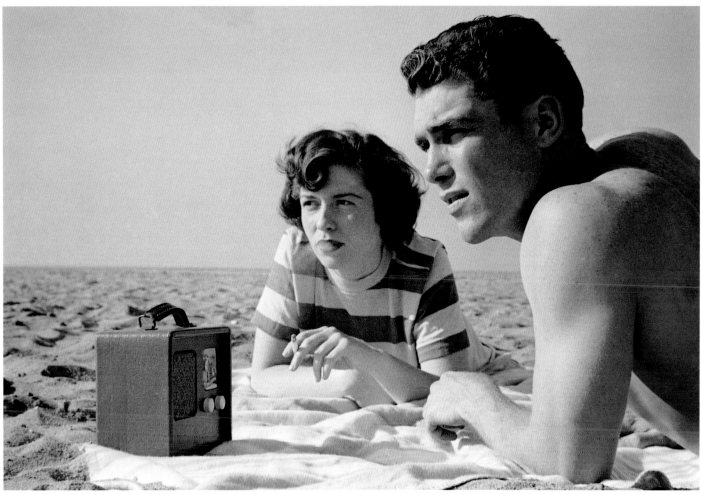

Human Behavior

Observing People Observing Monkeys May 1946

Kubrick's predilection for funny, almost satirical observation becomes apparent in a series of photos produced just one year after his first photo got published in *Look*. The images feature a rhesus monkey gazing into a crowd at the zoo, the camera following his perspective from inside the cage. The pictures make the onlooking people appear paradoxically "caged in"—a typical Kubrick way to question the issue of point of view. Kubrick's conflation of man and monkey would find fuller expression in the legendary "Dawn of Man" sequence of *2001: A Space Odyssey*.

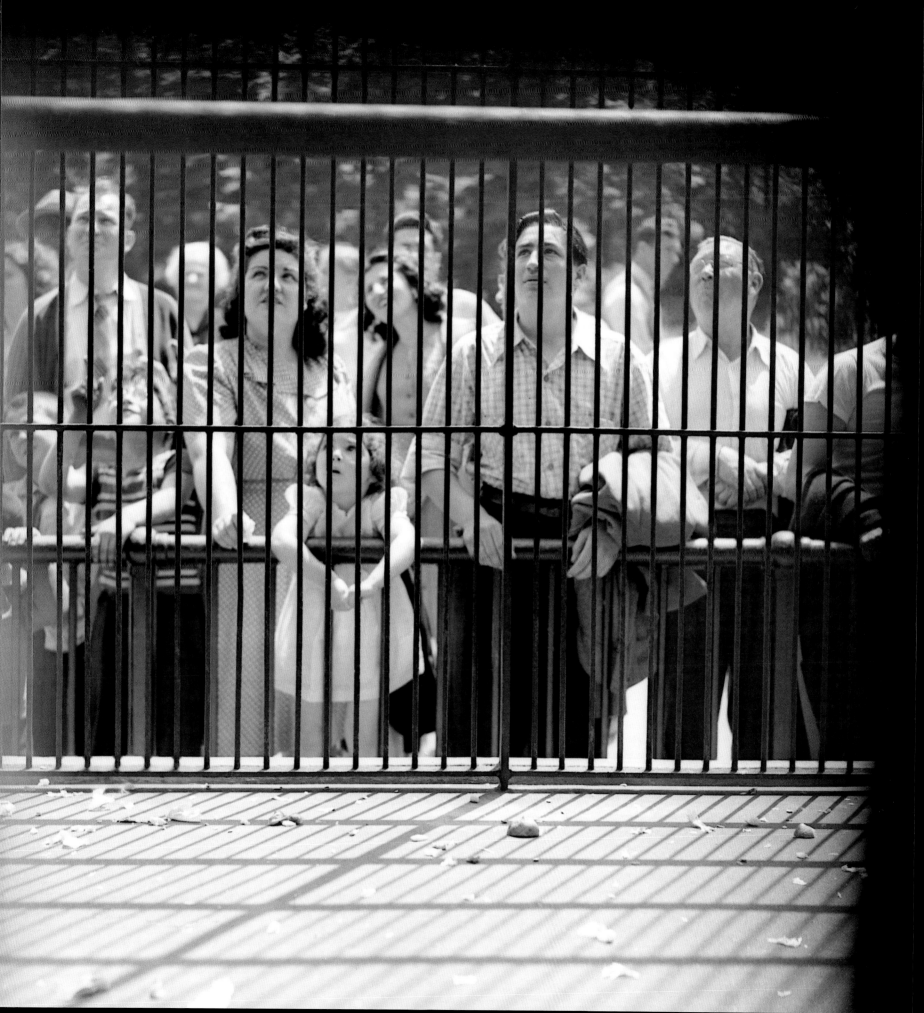

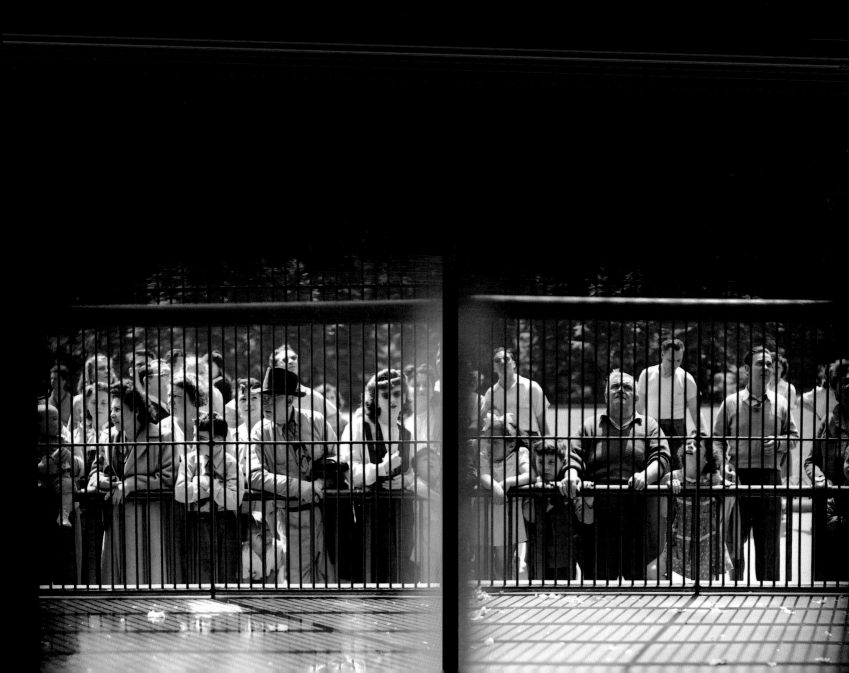

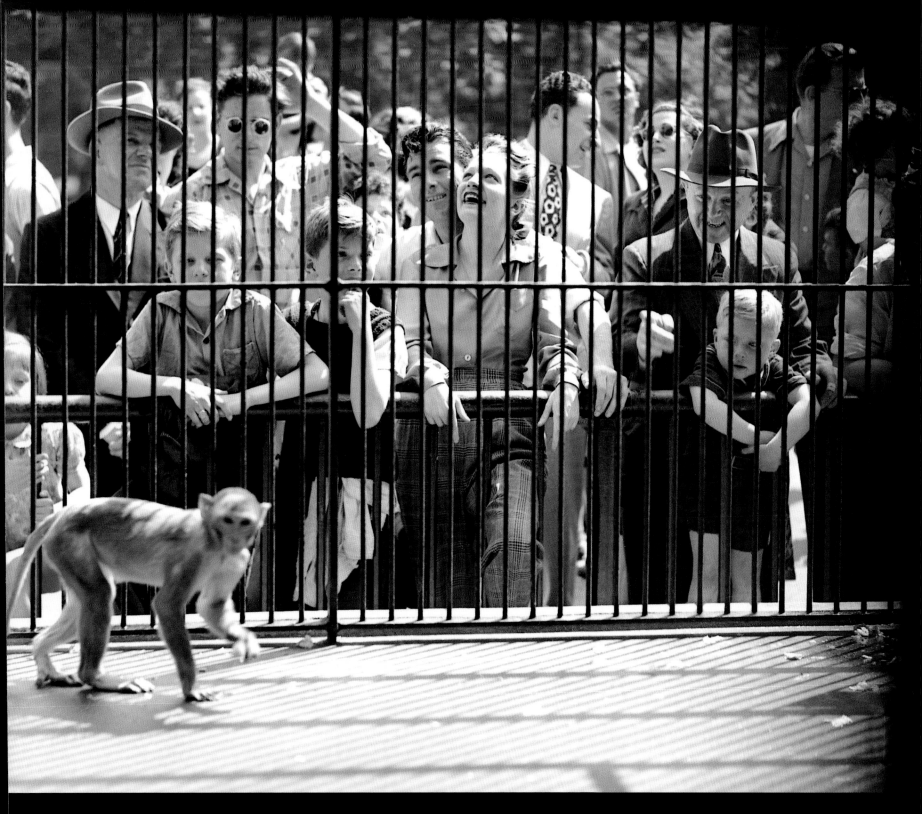

Looking at Art in New York Febuary 1947

While working for *Look*, whenever Kubrick had the chance to take pictures of an event intently watched by a crowd of people, he always directed his camera toward the spectators, seeking to document the expressions on their faces—the psychology of visual perception itself.

After fifty years, Kubrick's high school friend Bernard Cooperman still recalls the young photographer's method at a baseball game: "He just sat in front of a group of three of four kids facing the camera. They made faces at him and he just sat there until they finally forgot that he was there and he got great pictures. I realize now at that age he knew what to do."

In these photographs, Kubrick considered facial expressions in all their manifestations worth recording, whether concentrated and attentive, superficial and bored, or amused and enraptured. These images record what distinguishes photography as a visual medium in the eyes of the beholder: their subject is their own reception. This auto-reflection of an art form is an essential characteristic of modern art itself.

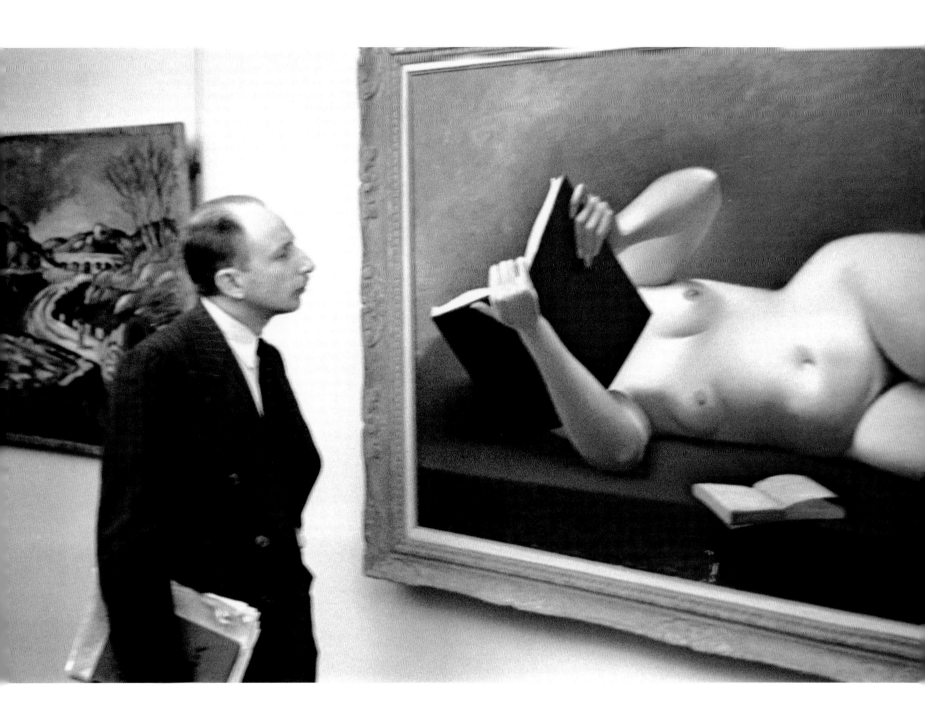

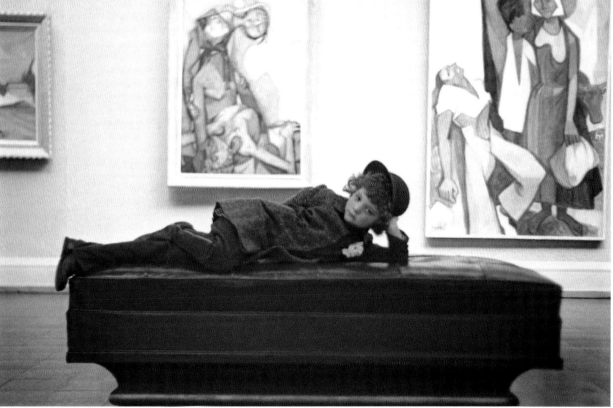

Dogs in the City August 1949

When taking a series of pictures of New York dogs, Kubrick was not satisfied with merely depicting the sheer variety of breeds living in the city's entirely unnatural environment. Like an anthropologist who reflects on his own cultural background when describing foreign customs, Kubrick cunningly shot from a dog's-eye view when portraying the pets with their owners. Without being the focus of his critical attention, the carefully chosen outfits of the ladies together with the hairstyles of their dogs are shown with a certain irony. Here, a slightly derisive photographic approach emerges that was to be harshly radicalized in the socio-documentary photography of the years to come by such artists as Diane Arbus, who knew Kubrick as a young man and often brought him along to Greenwich Village parties to play charades.

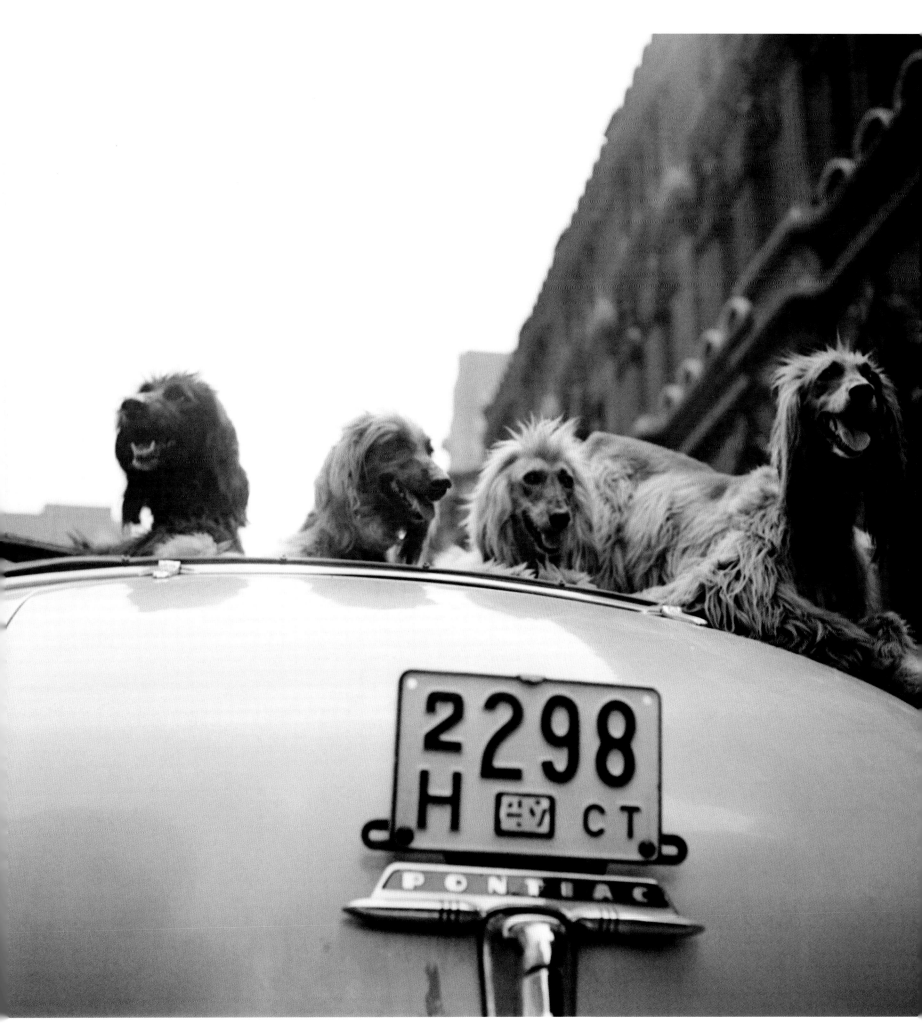

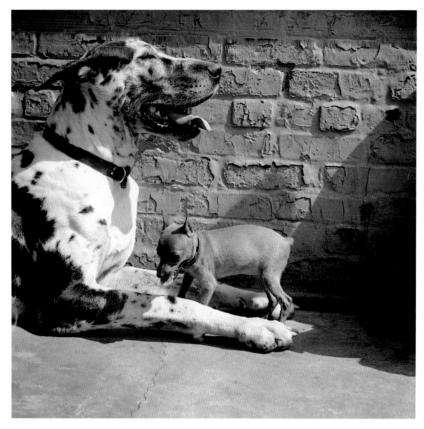
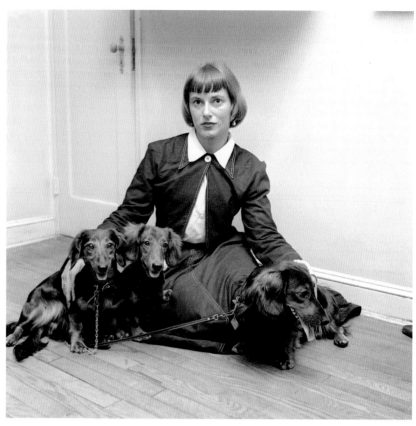
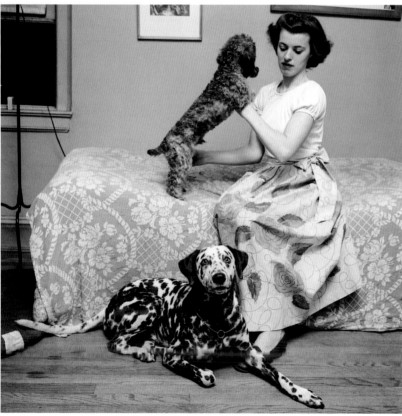
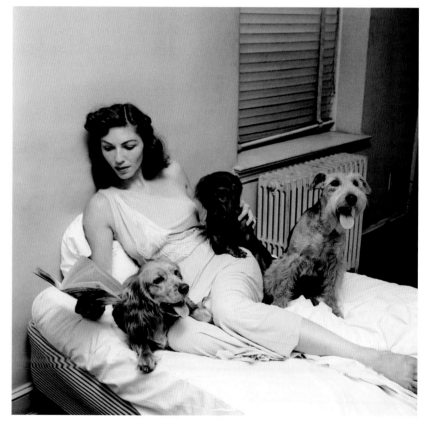

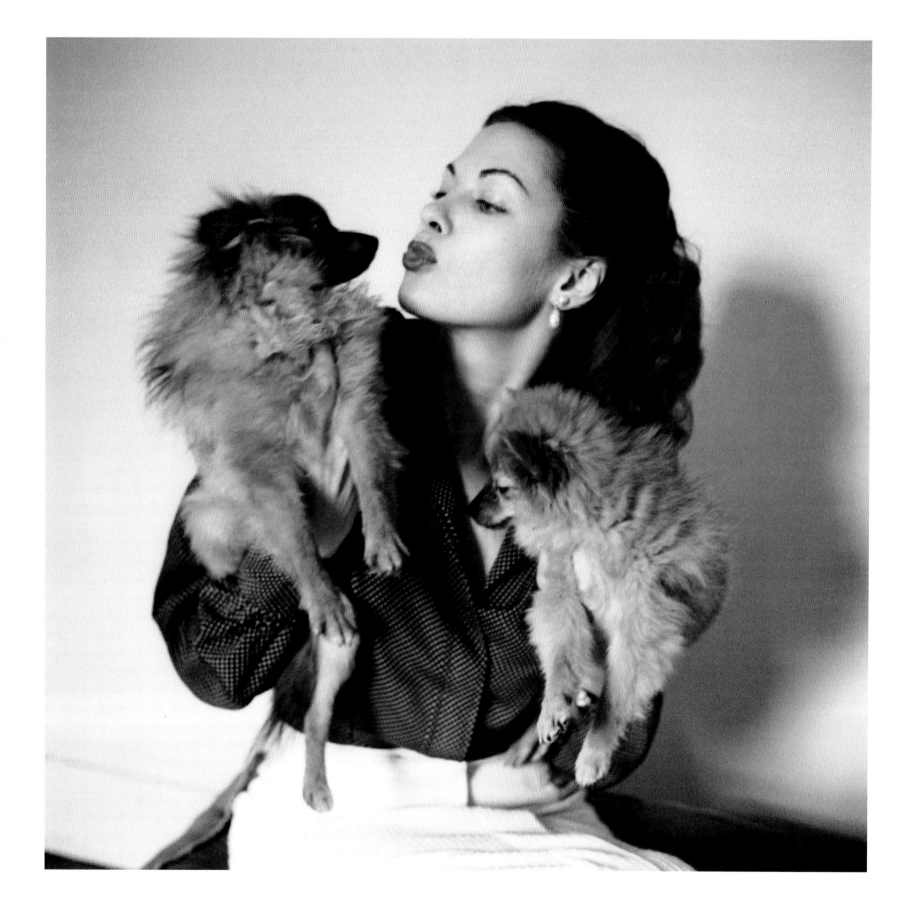

Observations on Park Benches May 1946

While painters in Paris or Vienna went to cafés—the focal points of social life to do character studies, New York artists had to resort to park benches. Photographers like Lewis Hine, André Kertesz, and Ben Shahn recorded the drama of unemployed, middle-age men condemned to momentary uselessness amid the city's frantic activity; as they sleep, read, or stare into space, their introspective glance is directed beyond the picture frame into terrible isolation, inviting the observer to experience time as slow-moving and virtually elastic.

Kubrick broke with this genre of park-bench pathos by training his attention on such subjects as two well-dressed business men having an animated conversation in which facial expressions and gestures perform a silent film of sorts.

206

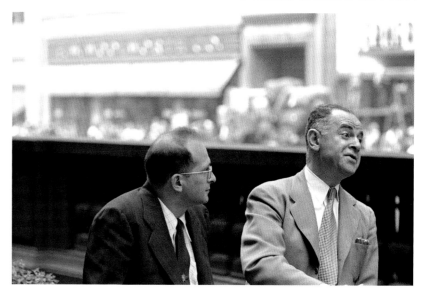

Personalities of the Circus March 1948

In his photo story on the Ringling Brothers circus in Florida, Kubrick was particularly fascinated with individual performers and showmen—people drawn to the exotic world of the circus whose distinct characters show in their proud posture or simply in their choice of an unusual pair of glasses.

Inspired by this world outside normal social conventions, Kubrick overcomes the stereotypical portrait; often shooting from below, he imbued his subjects with a larger-than-life quality that emphasized their quirkiness. In one image of the tattooed body of an old man, Kubrick transforms what would normally be perceived as freakish into beauty: skin becomes a canvas on which pony heads, swallows, and cherubs are artfully intertwined with a lavishly growing floral arrangement.

Kubrick's portraits of fringe society stood out against the relatively conservative context of the late 1940s—and prefigure the fascination with alternative living that would blossom in the 1960s.

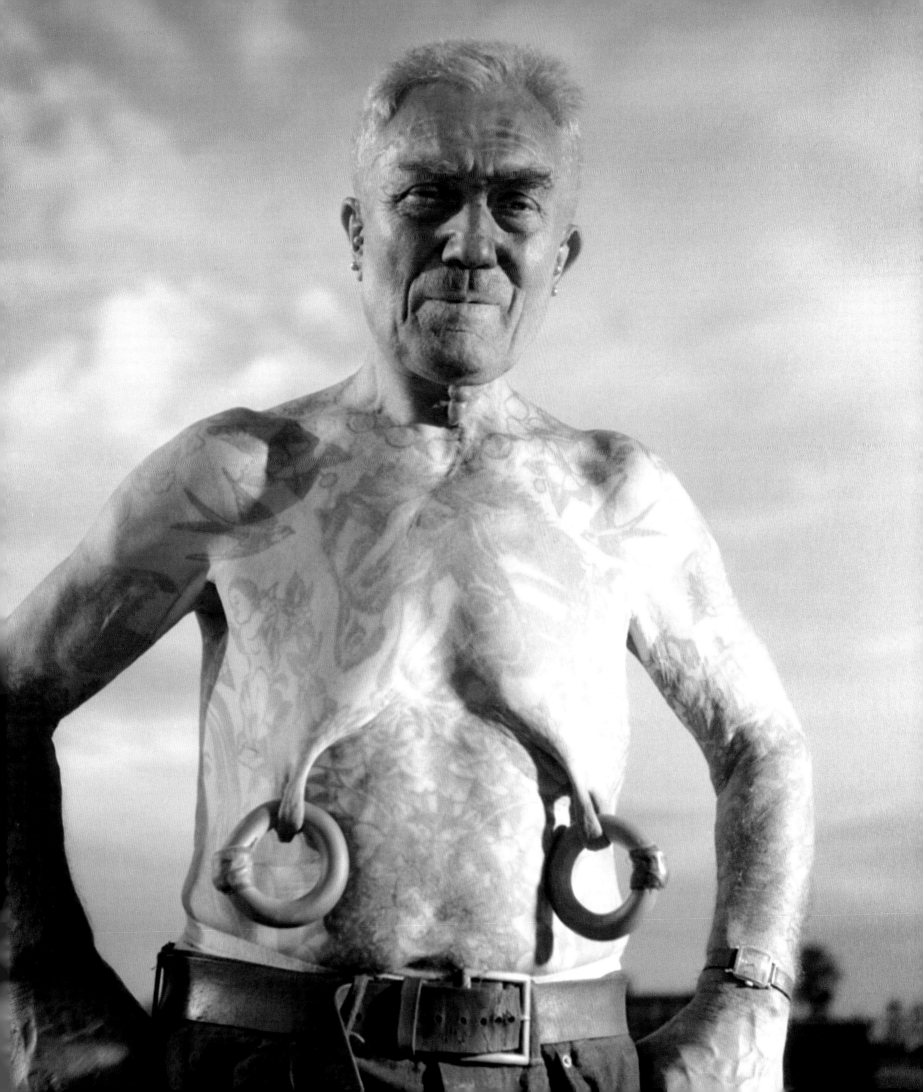

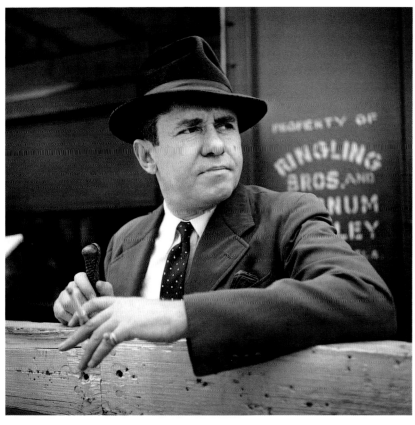

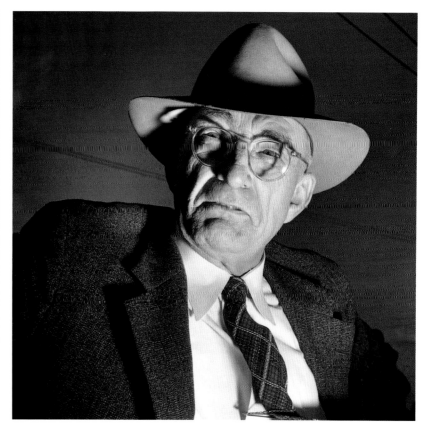

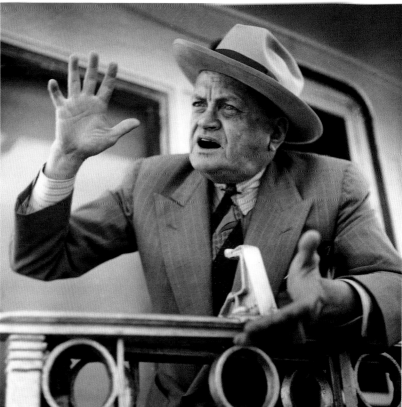

Scenes from a Handwriting Analysis Booth

June 1946

In these photographs, Kubrick closely and subtly observes a young serviceman and a young woman meeting for the first time, he being the customer and she the professional handwriting analyst operating a booth in an amusement park. Kubrick's photo story establishes an intimate narrative about how two people, presumably total strangers, start to take an interest in one another. These pictures clearly demonstrate the exceptional dramaturgic power of the young Kubrick, not only in the psychological insight he possessed, but also in his use of changing camera positions to capture different facets of the encounter as it unfolded, thus implying the elements of time and motion that he would more fully explore in later films.

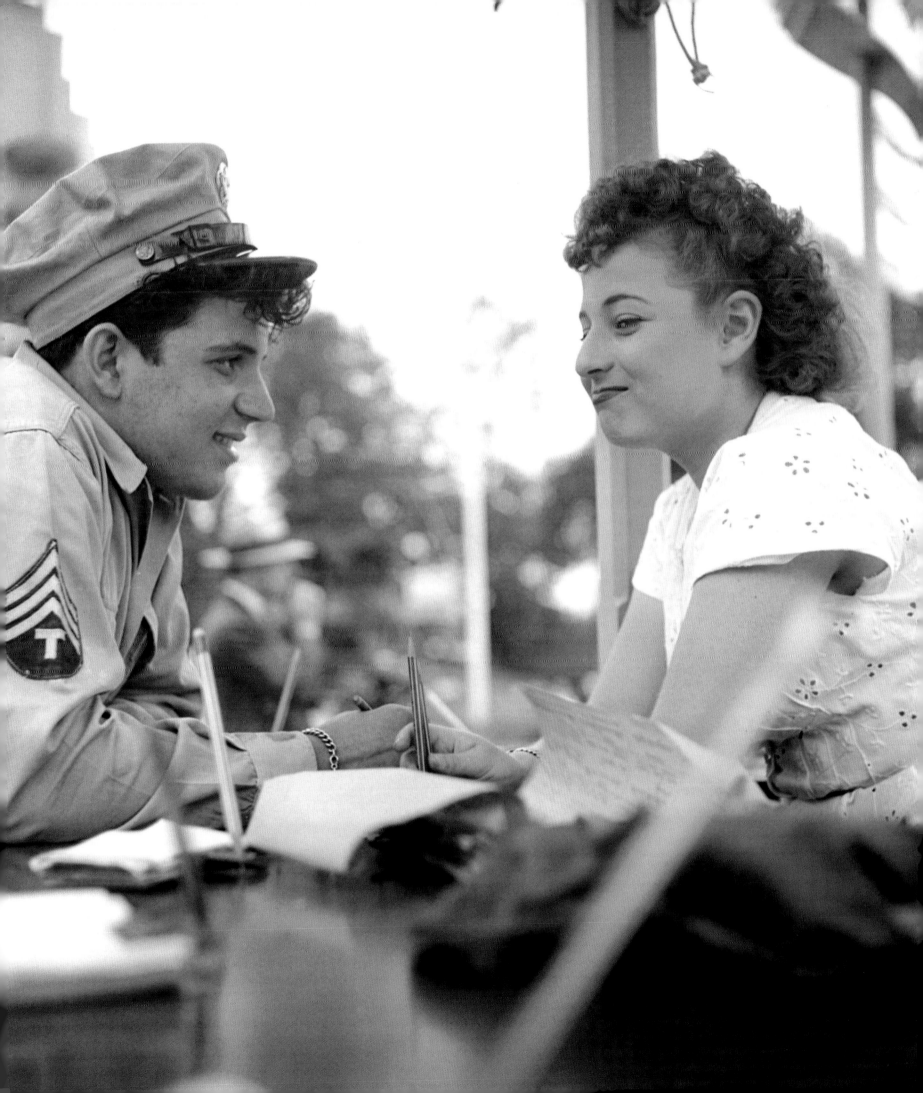

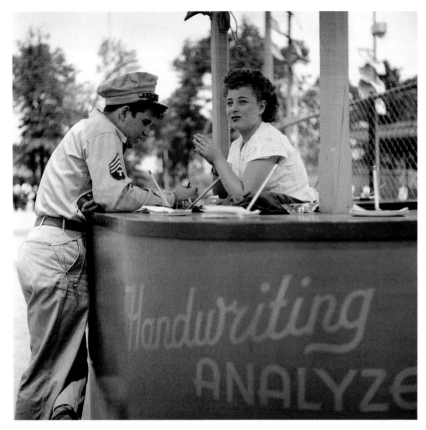
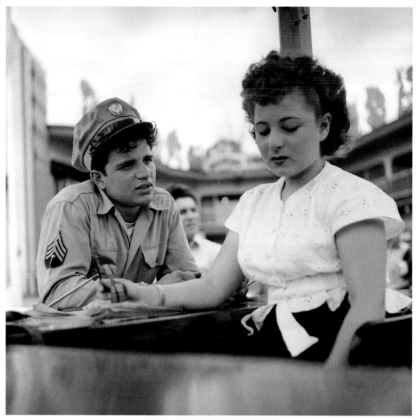
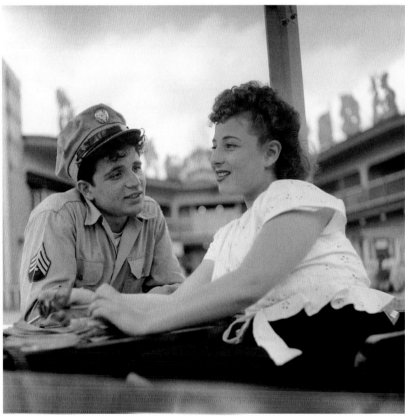
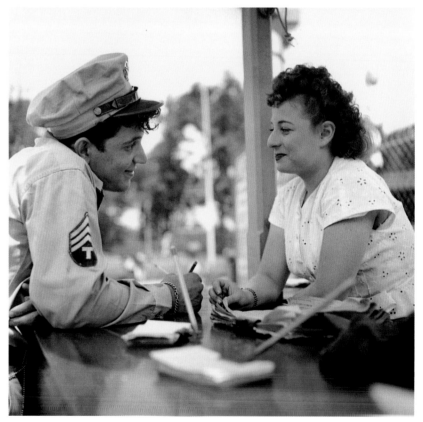

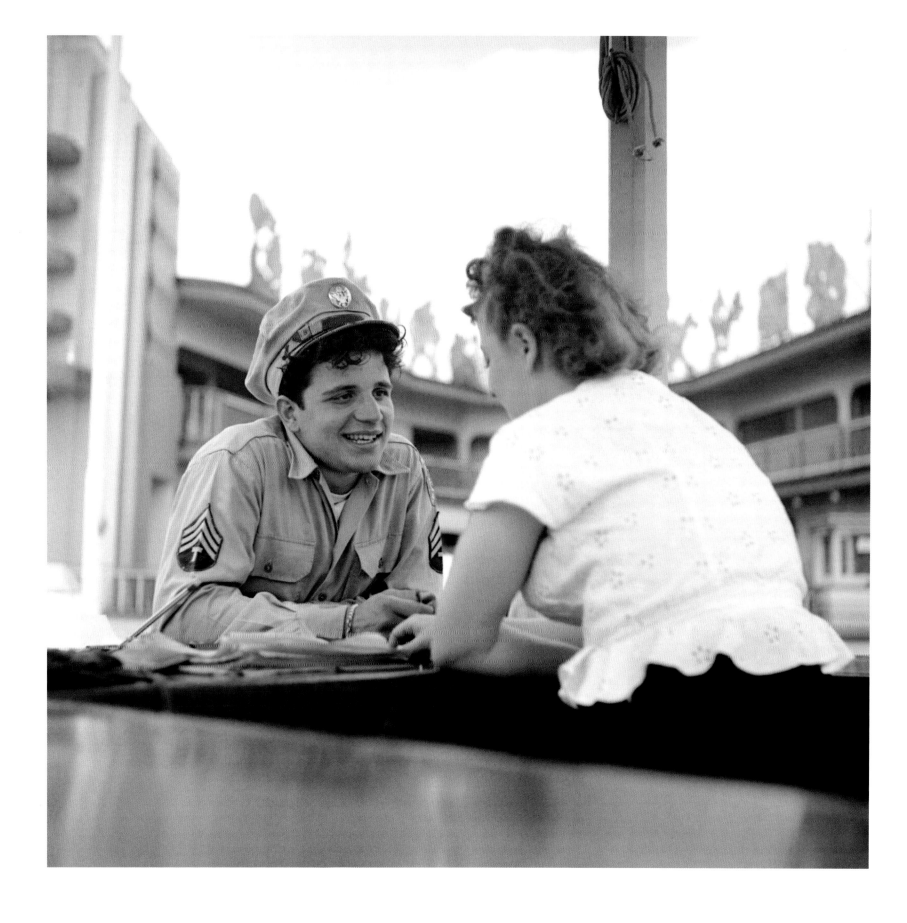

A Baby's First Time Facing a Mirror March 1947

In the personal stage of human development called "individuation," an important step is meeting oneself in the mirror for the first time. French psychologist Jacques Lacan first defined this experience as the "mirror stage" in a 1936 lecture that went on to be published in 1949.

In a March 1947 issue of *Look*, Kubrick presented a series on that exact phase, picturing a baby boy of approximately fifteen months placed in front of a mirror. At first, the little boy is greeting his supposed new playfellow, waving joyously at the mirror, only to be greeted in the same cheerful manner. When he leans into the mirror to have a closer look, the baby registers surprise at finding that the boy in the mirror has exactly the same idea. Kubrick observes the baby being thrown into confusion by the revelation that this is just an image of himself. In the final images, he breaks down and cries.

The confrontation with the other in one's own self is an archetypal experience that shapes the individual's attitude toward his surroundings and his fellow human beings. From then on, as Lacan suggests, one has to distinguish between the subjective Cartesian eye, appropriating the world, and the "other's gaze," questioning the subject's personal view. Photography itself can be considered a combination of eye and gaze—of subjective perspective and outer influence—in the shape of light. Thus, photography, in its technical composition, mirrors the individuality of any perception, questioning the "objectivity" of vision.

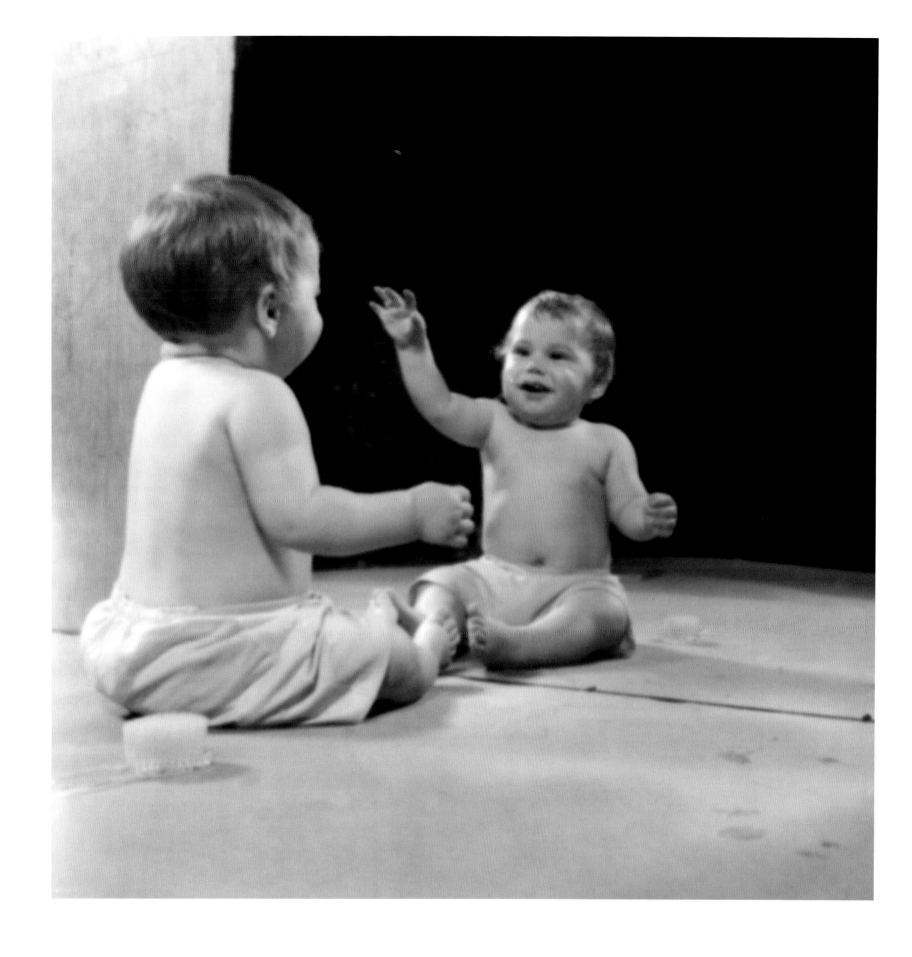

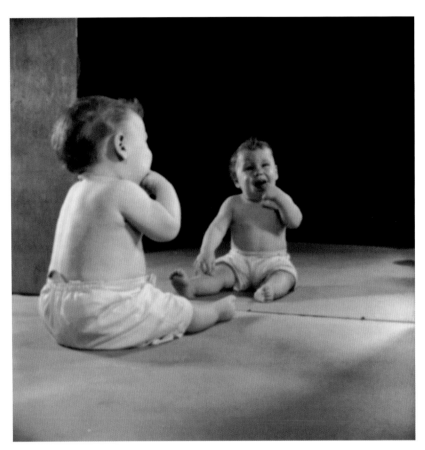
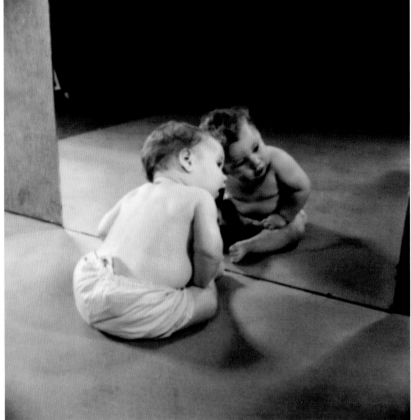

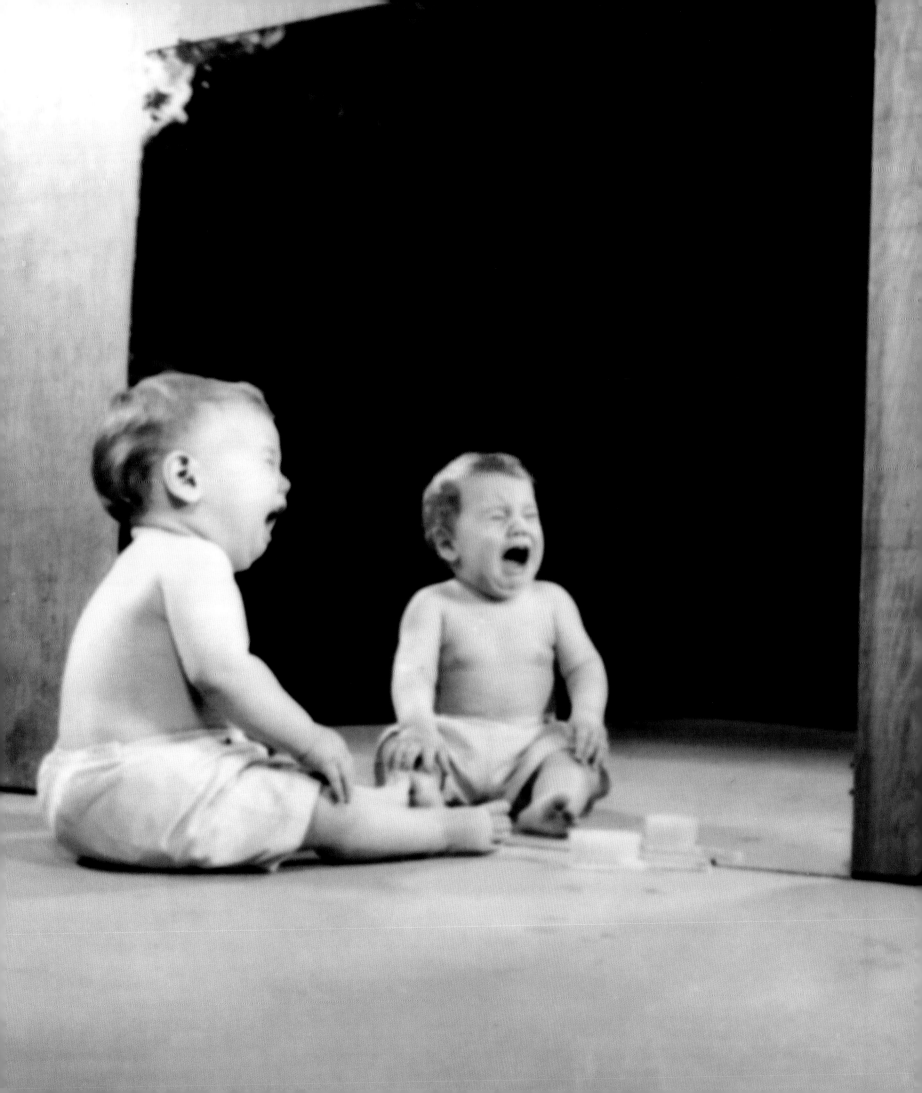

Columbia University in New York City January 1948

When Kubrick produced his photo study on campus life at New York's Columbia University, Columbia had developed into a major academic and commercial player. Founded as King's College in 1754, Columbia was predated only by Harvard University, the College of William & Mary, Yale University, and Princeton University. One reason for Kubrick's assignment was the appointment of the new head of the university, Dwight D. Eisenhower, who, five years later, would be elected the thirty-fourth president of the United States.

During Kubrick's two weeks on campus, he captured the atmosphere of the school, which was home to a number of renowned European faculty members. Columbia's physics department in particular had become famous for its decisive role in the development of the atomic bomb. Kubrick gives his personal interpretation of the nascent cold war arms race in a rather surrealist study of Columbia's nuclear physics research center. In this photo, Professor F. T. Booth, executive director, is portrayed together with two other engineers standing on the partly finished 2,500 ton, 400-million-volt cyclotron. The three men are presented like minor figures next to the gigantic engine; the perspective is that of a stage observed from a theater box. This view, as well as the inscription "Bethlehem" on all sides of the cyclotron, combines to create a starkly surreal impression.

Kubrick's approach to a subject that could involve the annihilation of mankind culminated in his 1964 satire, *Dr. Strangelove or: How I Learned to Stop Worrying and Love the Bomb*.

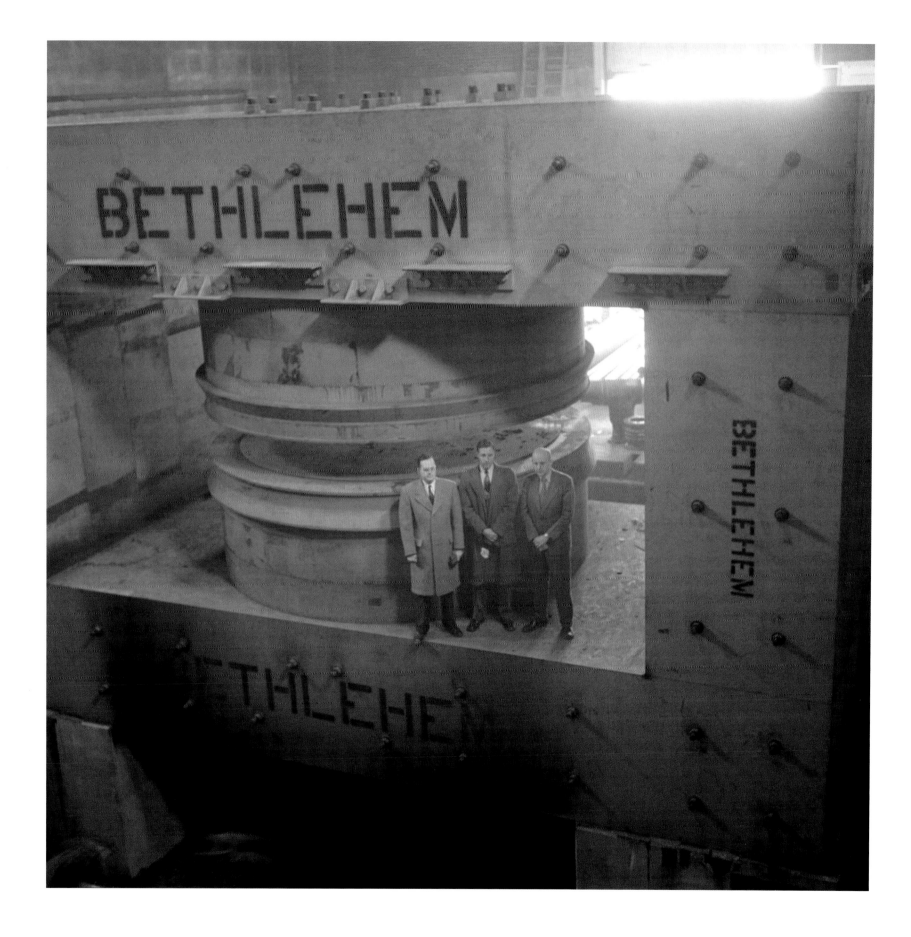

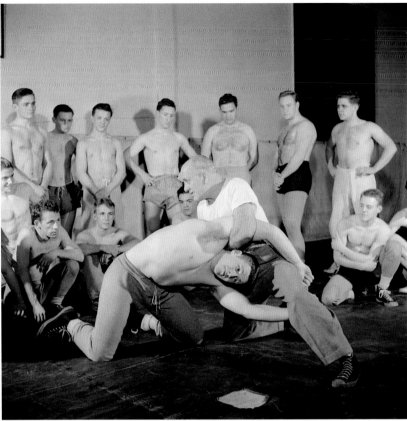

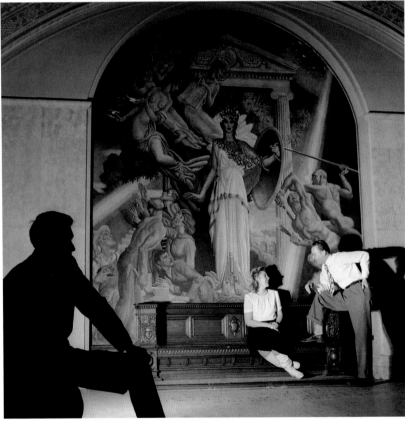

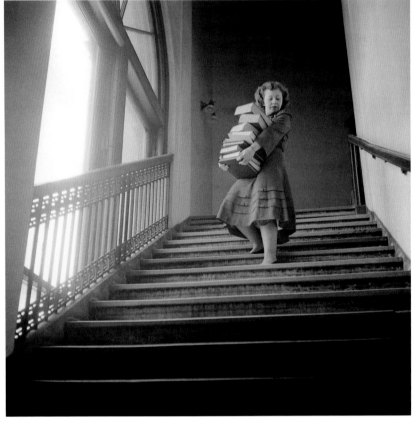

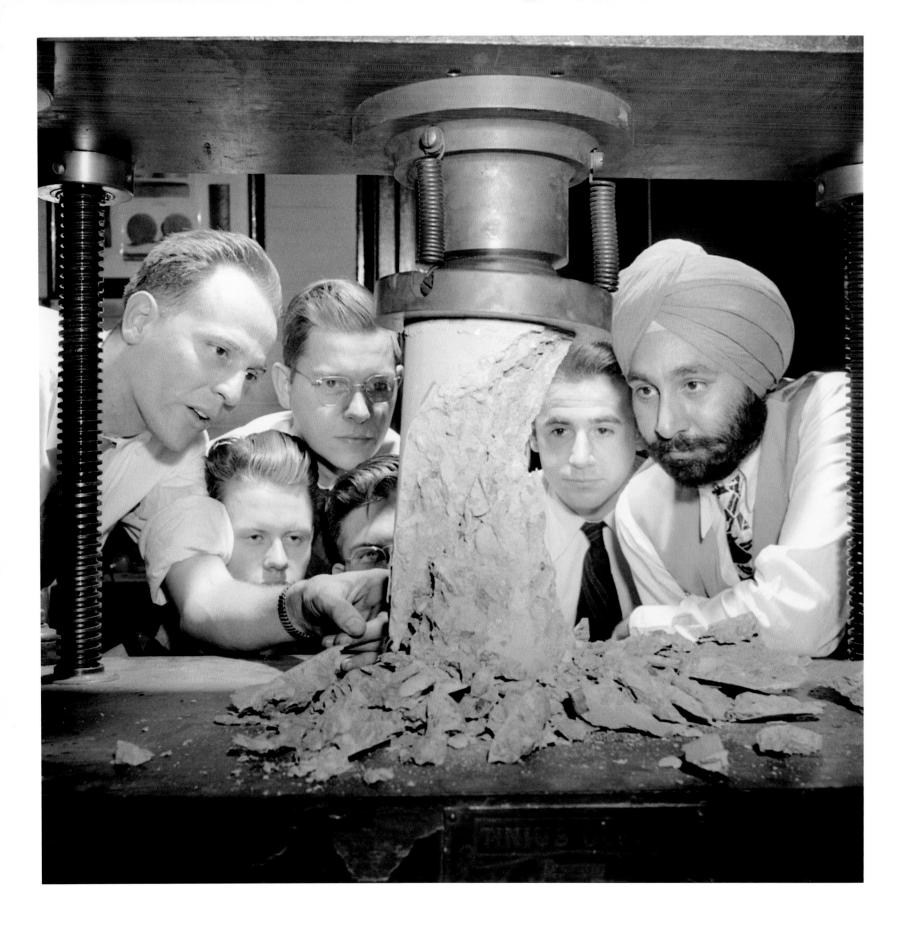

A Curious Event at the Natural History Station March 1947

Having been fascinated by Vsevolod Pudovkin's and other Russian filmmakers' cinematic and dramaturgic techniques, Kubrick applies the widely known alienation effect used in Constructivist photography and theater in staging a love scene in a deserted subway station near the Museum of Natural History.

In this photograph, Kubrick allows different levels of information to enter the scene that are psychological, semiotic, and cinematic in nature. The photo depicts a young couple—in actuality Kubrick's girlfriend and future wife, Toba Metz, and a school chum—on the platform of a subway station that is significantly identified with a sign that reads "Natural History." Kubrick has installed artificial lighting in order to heighten the scene's dramatic effects; his choice to reveal rather than conceal the light source and its technical apparatus is in line with theatrical methods of alienation that were used by such artists as Bertolt Brecht.

Evidence of such technique shows the young photographer's highly informed and aesthetically reflected concepts of photography and stage direction.

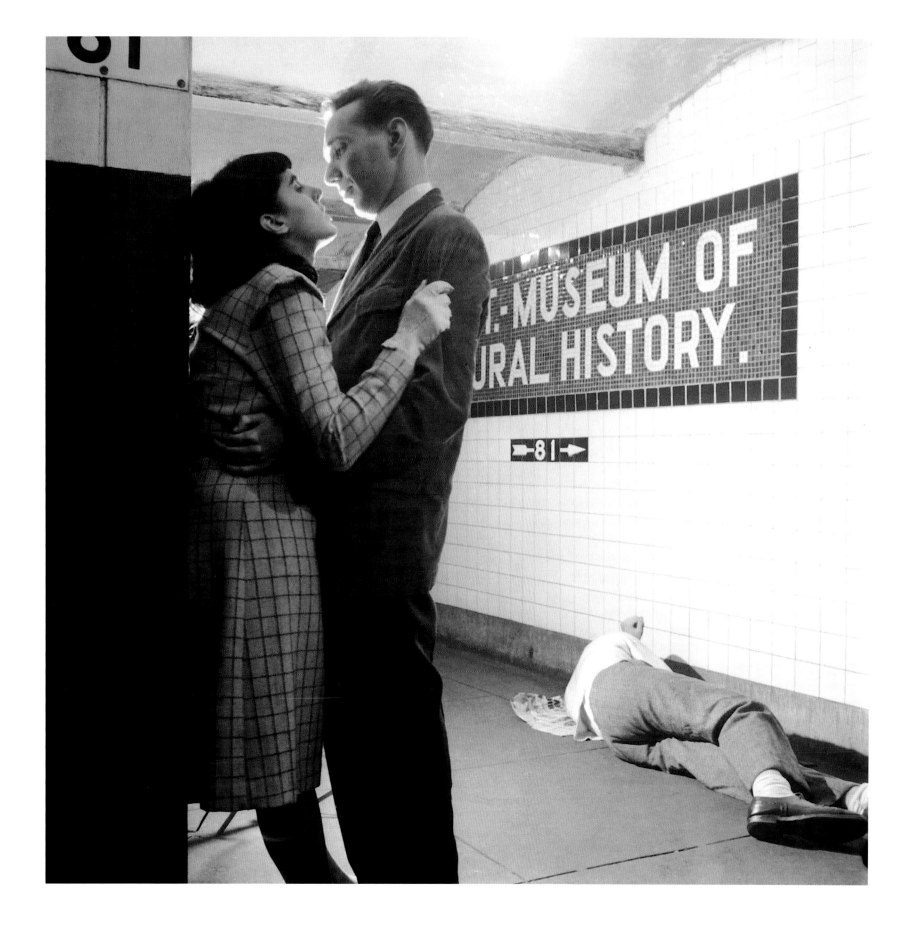

New York City Street Portraits

Characters are the material of drama and thus an essential component of how one forms a picture of any city. Even as a very young photographer, Kubrick was able to capture New York City's flair from his own distinct perspective. For these shots of New York's diverse inhabitants, Kubrick used highly unusual camera angles that were not in common practice in the late 1940s, when straight documentary photography was the aesthetic convention. With his creative angles, Kubrick is reminiscent of Robert Frank in the mid-1950s. The main characteristic trait of Kubrick's portrait photography, however, is in how he shows the psychological conditions of people while at the same time maintaining a detachment that enables the observer to make more intimate interpretations of character him- or herself.

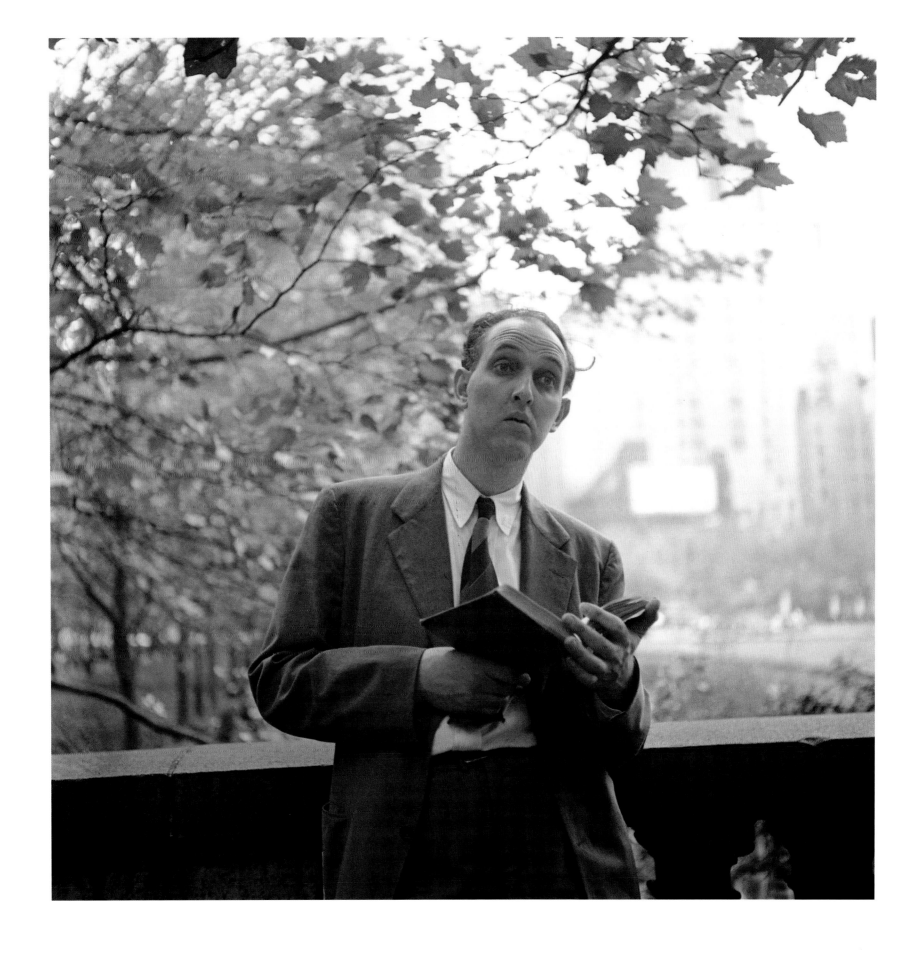

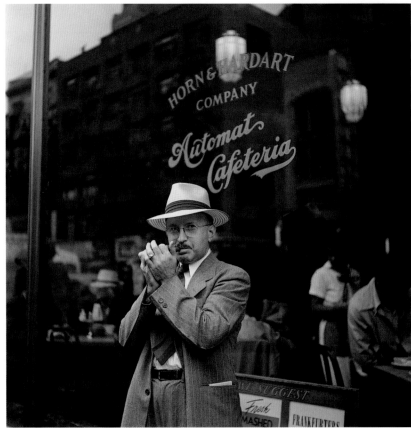

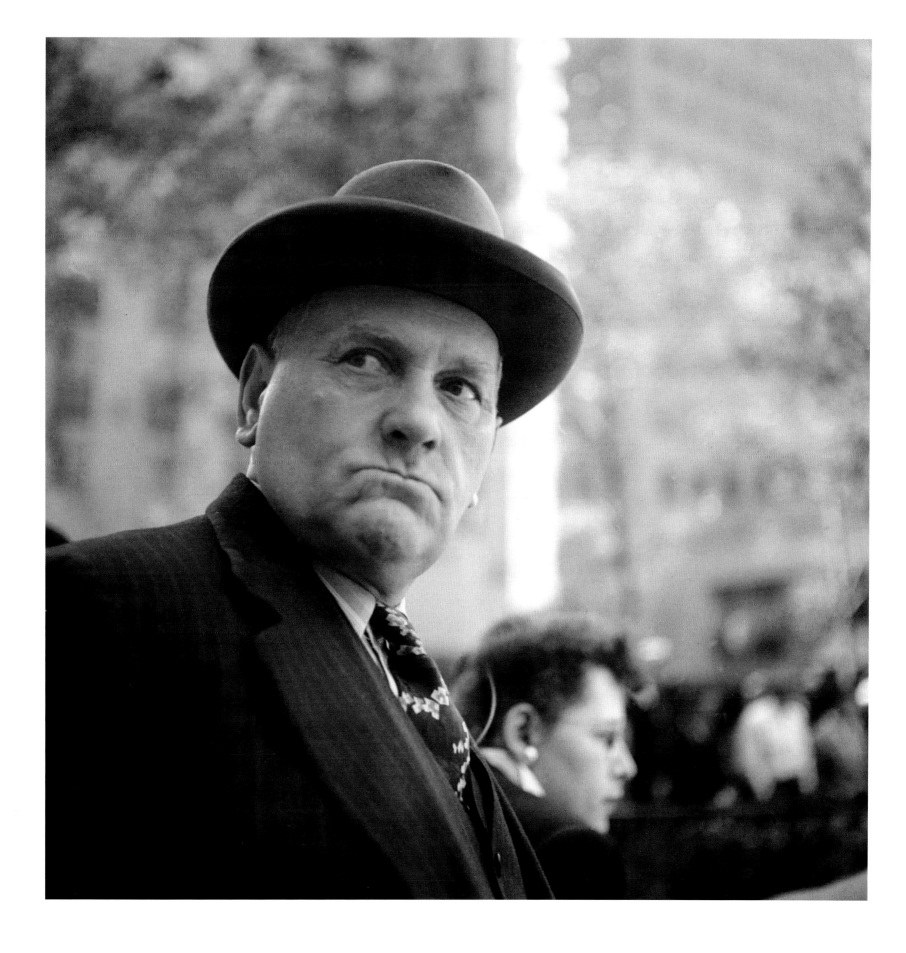

Artists in the New Center of the Art World 1948

Unnoticed by most of its postwar citizens, New York had become the new art center of the world. Fleeing the suffocating and life-threatening atmosphere of Nazi Europe, thousands of artists and their entourages—dealers, collectors, curators, and writers—came to New York. In 1948, the year of Kubrick's photo-essay of some of Europe's best-known émigrés, there were more than three hundred art venues in Manhattan alone.

In his photograph of George Grosz, Kubrick presents the painter of political and social satire dressed up in a business suit straddling a chair in the middle of a Fifth Avenue sidewalk next to a sign reading "No parking in this block." A close analysis of the photo reveals an ironic reference to Walker Evans's use of vernacular signs as well as a subversive social critique. Grosz may be wearing the garb of an all-American businessman, but Kubrick emphasizes the German painter's subversiveness through the absurdly seated position in the middle of the crowded street. Kubrick went so far as to wait for all passersby to show their backs to the camera, underscoring Grosz's singular position against the current of everyday life.

Another of Kubrick's portraits shows the Austrian-born artist Henry Koerner. Like many European émigrés, Koerner had escaped a world of horror when he fled Vienna in 1939, only to lose his parents and brother to the Nazis in the years to come. Kubrick captures Koerner's complex character by placing him in front of a wall pinned with preparatory drawings and a shelf that features a naked doll and three roses; arms crossed in front of him, Koerner stares boldly at the camera with a look of melancholy and amusement. Just three years earlier, Koerner had been the official court artist at the Nuremberg trials.

The artist Jacques Lipchitz also sat for the young photographer, who captured him sitting on a wooden box surrounded by the monumental sculptures that had earned him acclaim in Paris thirty years earlier. Lipchitz is the calm center of the image, while his work expresses a more tormented worldview.

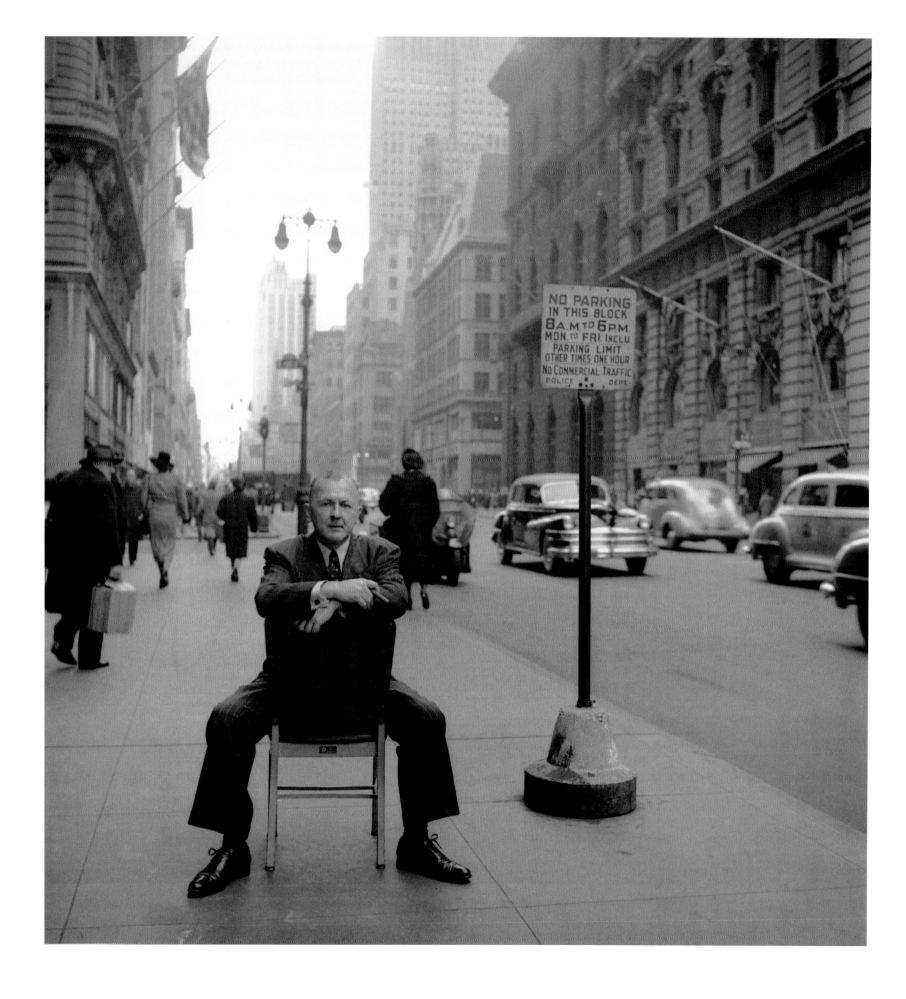

239

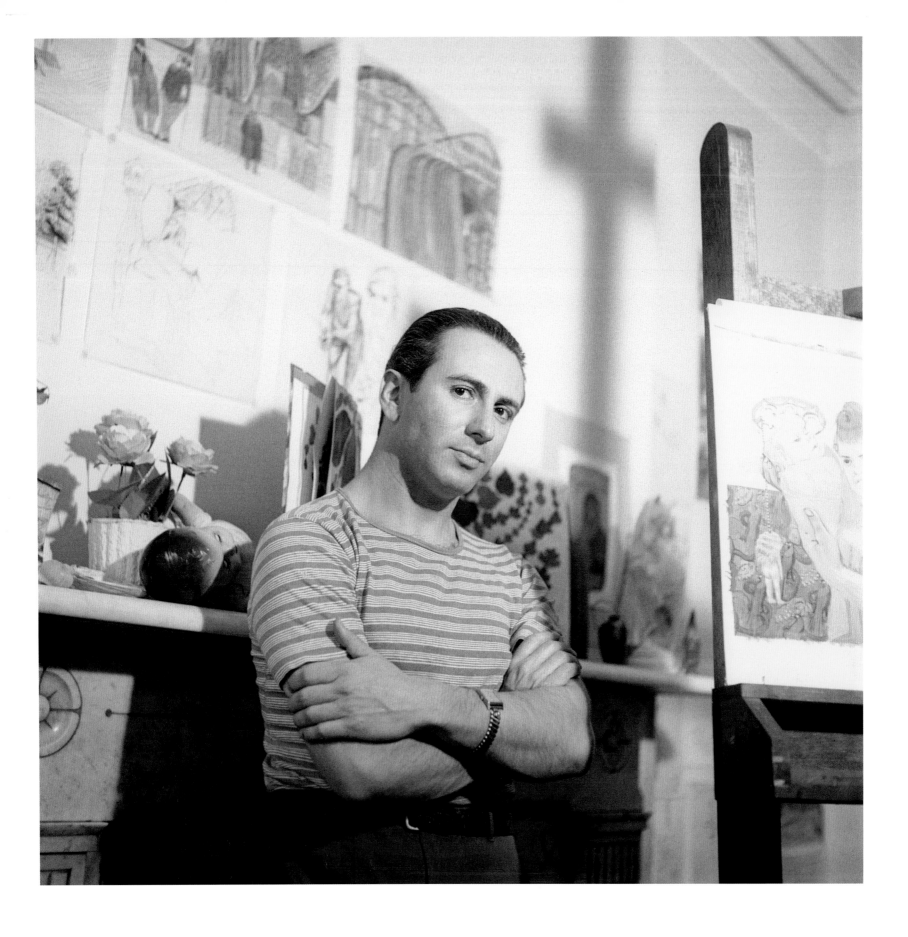

Stanley Kubrick: Inventor of Facts
by Petrus Schaesberg

Stanley Kubrick is a conceptual illustrator of the human condition.
—Steven Spielberg

A beautiful woman wearing nothing but a bikini and high heels sprawls idly on a bed beneath a sunlamp. A segmented mirror takes up the whole front and side wall of the spacious bedroom and reflects such a fragmented view that it is impossible to maintain a continuous perception of the space, much less a sense of orientation. On a second bed lies a suitcase, and on a shelf in front of the mirror there are bottles and glasses arranged as if in a still life. The grouped bottles combined with evenly spaced-out lamps accentuate a rhythmic order that is disturbed by flaring pinpoints of light and the glare of a less-than-decorative lamp in the foreground. In the far distance, in the depth of the mirror, we see the reflection of the woman's face protected by sunglasses in a double sequence.

This scene, taken from the beginning of Stanley Kubrick's film *Dr. Strangelove or: How I Learned to Stop Worrying and Love the Bomb* (1964), reveals a visual wealth that is typical of the director's sensibility, each element—whether object or gesture—contributing to its well-constructed significance. What could otherwise be considered a depiction of carefree pleasure is disturbed, its perception duplicated and darkened by a kaleidoscope of impressions that burden the eye (fig. 1).

What at first looks like the simple representation of a perfectly realistic situation turns out to be a subtly warped reproduction of reality, emphasizing the fundamental elements of the artistic medium of photography itself. Photography, by means of light and mirrors, captures an image of reality on film, which is then potentially endlessly reproducible. Certainly the lamp in the foreground and the mirror in the background are functionally legitimate objects. But they also represent the prerequisites of cinematography and photography. Like a painter who, beyond the mere portrayal of his subject, emphasizes the sheer sensual materialism of his art, Kubrick subtly points out his artistic means in order to disturb the illusory world. Unlike the obvious alienations employed by Bertolt Brecht,[1] however, this gentle reference is more like the ironic winking of a storyteller who lets his audience know that his eloquent embellishments cannot and should not be taken entirely at face value.

The confusion of lights and interlocking reflections aesthetically illustrates both the plot of the film and the formal relationship between cinematography and reality. The girl in the bikini has in fact already appeared in a previous scene, only this time in a photograph on the cover of *Playboy*, where she wears nothing but a bracelet and a copy of *Foreign Affairs*. The B-52 pilot who leafs through the magazine has just been ordered to drop his atomic load over the Soviet Union by the deranged General Jack D. Ripper. The very same woman is now comfortably stretched out on the bed. When the telephone rings in the hotel room, we learn that "Miss Scott" is not only the secretary of General Turgidson—who is offscreen in the bathroom—but also his mistress.

fig. 1: Stanley Kubrick, Dr. Strangelove or: How I Stopped Worrying and Learned to Love the Bomb, *1964.*

Her soft, friendly tone of voice suggests the relationship she fosters with the caller, a colonel, is not entirely platonic either. She passes on the message of a nuclear war to General Turgidson, who answers the call personally in his boxer shorts and an unbuttoned Hawaiian shirt. This network of structural references and allusions to sex and war blends into a recurring theme that finds its echo in names (de Sadeski, Ripper) and images (the sexually charged refueling of the B-52 bomber in midair during the title sequence). For Kubrick, sex and the lust for power became a means of mirroring the menacing climate of the cold war.

Ever since the visual arts first applied themselves to the representation of reality, the mirror has been used as a metaphor. Early-twentieth-century photographers like Brassaï incorporated mirrors into their work as a kind of complex comment on the aesthetics of the artistic medium itself. Kubrick's personal penchant for mirror play extends from his early 1947 photo essay "A Baby's First Look into a Mirror" to his last movie, *Eyes Wide Shut* (1999), which was advertised by a picture of Nicole Kidman looking meaningfully into a mirror moments before being kissed by Tom Cruise.

Kubrick always sought to hold up a mirror to his audience by maintaining a supposed documentary accuracy. On the occasion of the film's fortieth anniversary, Fred Kaplan explained at length in the *New York Times* why *Dr. Strangelove* is not only a brilliant satire but also a remarkably specific and fact-based guide to some of the oddest, most secretive chapters of the cold war. Kaplan ends his essay with a comment by Daniel Ellsberg, a consultant to the Defense Department, who said after seeing the film for the first time in 1964: "That was a documentary."[2]

Kubrick took great pains to structure his films in such a way that depth, complexity, and variety would be enhanced—not diminished—by multiple viewings. Consequently, initial reviews of his films tended to be restrained; only later in his career would

his work be critically acclaimed for its stylistic and conceptual denseness and the virtually flawless craftsmanship that Kubrick, being self-taught, had acquired with passionate enthusiasm.

By all accounts, Kubrick was fascinated by photography and filmmaking at an early age. Growing up in a working-class neighborhood in the Bronx in a family of Austrian Jewish immigrants, he exhibited a bright and lively intelligence, although he was thoroughly indifferent about his performance at school. A biographical documentary called *Stanley Kubrick: A Life in Pictures* by Jan Harland—his brother-in-law and long-standing executive producer—shows pictures of the ten-year-old Kubrick at play. Scenes showing the young boy posing, dancing, goofing off, and tormenting his sister are strangely elucidating. They reveal a playful and imaginative nature given to a degree of excess—all characteristics that the director would retain throughout his life.

Kubrick developed a true passion for the movies that went beyond a mere pastime. Twice a week he went to see a double feature at his local movie theater. In 1939 the Museum of Modern Art had started showing both European and American films from its vast film library, where outstanding movies from 1895 on had been systematically archived. The perseverance and single-mindedness of Kubrick's visits to the cinema verged on the obsessive.

Photography was also a passion for Kubrick, who carried his camera with him everywhere he went in search of new subjects. One picture in particular—taken on 12 April 1945, the day that President Roosevelt died—would set the course of his career. The photograph's formal elegance and classical composition contribute to its emotional effect. The vendor's head is surrounded by newspapers—entirely framed by print like the photographs on one of the front pages dangling directly above him—thus creating the impression of a picture within a picture. Framed in such a way, the old man is no longer just a news agent but a symbol representing the nation's grief and uncertainty, the photograph elevated to allegory. Already at the age of seventeen, Kubrick knew how to poetically intensify a picture by strictly formal means that were well within journalistic conventions—a fact that also served to increase its documentary value.

In *Eyes Wide Shut*, Kubrick includes a sly allusion to his first published photograph.[3] During his nocturnal odyssey through New York, Dr. Bill Harford (Tom Cruise) is followed by a stranger. In order to catch a glimpse of his pursuer, Harford stops at a kiosk and buys a newspaper headlined "Lucky To Be Alive." Considering Kubrick's reputation for precisionist mise-en-scènes—not to mention the reminiscent setting of a New York newsstand—this subtle reference is probably more than just coincidence. Given that Kubrick died only one week after the first official screening of *Eyes Wide Shut*, this ironic allusion seems a little eerie.

While Kubrick-the-director composed his films during the 1960s with a visual style that, according to film historian Thomas Allen Nelson, "lends an unfamiliarity to the real and an empirical life to the surreal,"[4] back in the 1940s the young photographer

fig. 2: Stanley Kubrick, Untitled, *1947–48.*

sought to enrich his pictures dramaturgically. In a conversation with the French film critic Michel Ciment, Kubrick described his photographic work as training for his real vocation. "It was tremendous fun for me at that age," Kubrick recalled, "but eventually it began to wear thin especially since my ultimate ambition had always been to make movies. Photography certainly gave me the first step up to movies. To make a film entirely by yourself, which initially I did, you may not have to know very much about anything else, but you must know about photography."[5]

One of the several hundred photographs that Kubrick took at New York's Columbia University in 1948 serves to illustrate how deliberately he arranged his pictures. In one of Columbia's great halls, Kubrick placed a man and a woman beneath a mural. Their position against the wall echoes the painting's composition, which is filled with Greek mythological symbols surrounding a stoic Athena, the goddess of war and wisdom. On the bench beneath Athena the woman chats animatedly with the man, who stands with his foot on the bench, body leaning toward her in the same sweeping pose as the nude allegorical figures behind him. The left foreground reveals the shadowy outline of another man who remains obscured in darkness but completes the picture's composition.

Kubrick photographically interprets the rays of light depicted in the mural that symbolize knowledge, in a literal sense: the term "photograph" is a compound of the Greek words *photos* (light) and *graphein* (to write). The strong shadows cast by the figures create a dramatic, almost sinister effect that is more

fig. 3: Henry Koerner, Subway, 1947–48.

typically used to create suspense in crime thrillers, especially in film noir movies of the time such as *Dark Passage* from 1947, which Kubrick undoubtedly saw in his avid moviegoing years. Through careful composition, Kubrick manages to transform a rather harmless scene into a dramatically charged tableau—first defined by the eighteenth-century philosopher and encyclopedist Denis Diderot as "an arrangement of characters on the stage, so natural and true that, if it were painted realistically, it would also please me on canvas."[6] Kubrick's choice of using a painting as a backdrop as well as a compositional template illustrates his unusually advanced understanding of the nature of realism in photography. His complex formal intertwining of an essentially documentary approach with dramatic means is atypical for the artistic context of the time.

Kubrick always identified himself as an artist of moral integrity—a self-conception that must have been shaped considerably by the meetings and conversations he had with Henry Koerner, George Grosz, and Jacques Lipchitz, three artists he portrayed for *Look* in 1946. Although very different in their background and style, all three shared the same fate of forced emigration and the same conviction: to reveal the dangerous undercurrents and moral corruption of society in their work. After arriving in New York, in 1941, Lipchitz created sculptures that were influenced by the fascist horrors of Europe as well as by his escape from Paris just before the Nazi invasion. Bearing such names as *Rape of Europe, Flight, The Rescue, Arrival,* and *Road of Exile,* Lipchitz's work vividly expressed the existential shock the artist had suffered.

Kubrick must have also listened raptly to the stories of Grosz and Koerner, whose hometown, Vienna, Kubrick was certainly familiar with through his grandparents. Grosz had so viciously criticized the society and politics of the Weimar Republic through paintings of war and moral corruption that the Nazis declared

him "cultural bolshevist No. 1." Koerner's eyewitness account of the persecution of the Jews, the horror of concentration camps, and the devastation of bombed-out cities more than likely had sown the first seeds of a film project that was postponed shortly before its realization in 1995. Kubrick's film, titled *The Aryan Papers,* was to be based on the autobiographical novel *Wartime Lies* by Louis Begley, an account of the escape and rescue of a Jewish boy from the Nazis.

Koerner's inconceivable grief over the annihilation of his entire family and the loss of his home country found expression in his artwork, which presented an understandably acrid view of humanity (fig. 3).[7] Only someone who had become a stranger in his own culture could devise such cutting scenarios that were not mere figments of the imagination but made up of actual fragments of reality. (While living and filming in England after *Lolita,* Kubrick's own geographic detachment from the US might have helped to develop his razor-sharp satirical view on the cold-war reality of his home country.)

Koerner's visual language was at the time inspired by Ben Shahn, whom he had first met at the Office of War.[8] As a painter and one of the most eminent Farm Security Administration photographers, Shahn was setting the tone for a New York movement of representational artists who took up distinctly sociopolitical topics in order to draw attention to the bitter lot of those Americans hit by the Depression and the programs of the New Deal.[9] Unemployment, poverty, racial discrimination, and political injustice feature in their paintings and photographs.

Already in the 1930s, the artistic intention of Shahn's pictures clearly differed from a mere journalistic recording of fact. In his 1938 essay "Documentary Approach to Photography," the photo historian Beaumont Newhall noticed a particularly sociopolitical approach to documentary photography in the work of Shahn and Walker Evans that aimed for what he termed "a dramatic presentation of fact." According to Newhall, such work was "more closely allied to the French *documentaire* as developed by Emile Zola."[10] Newhall, who had been instrumental in setting up the Department of Photography at the Museum of Modern Art, compared this specific form of photography to the socially committed works of the French novelist, whose aim had been a transformation of reality determined by his own temperament.

Rather than Zola, however, Evans and Shahn aspired to emulate the tradition of the nineteenth-century French social satirist Honoré Daumier. In a 1940 issue of the magazine *PM's Weekly,* the documentary filmmaker and photographer Ralph Steiner published press photographs next to Daumier's drawings, thus illustrating Evans's claim that photographers should take up Daumier's themes.[11] It was in this sociocritical context of the 1940s that Kubrick artistically matured.

Although after World War II, the so-called social realism of Grosz, Koerner, and Shahn became aesthetically marginalized—gradually superseded by gestural and nonrepresentational art—

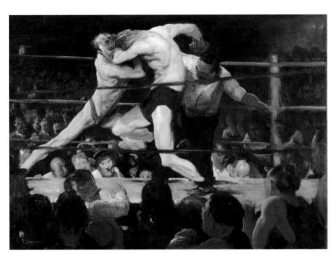

fig. 4: George Bellows, Stag at Sharkey's, *1909.*

their matters of concern became represented even more credibly by the quickly developing media of film and photography. Directors such as Elia Kazan (*Panic in the Streets, On the Waterfront*) embedded sociopolitical themes in their movies, as did photographers of the 1950s as diverse as Diane Arbus and W. Eugene Smith. These artists defined photography as an active, practical reaction to reality—not just its mere image or reflection.

Martin Scorsese's precisely and carefully crafted scenes in *Raging Bull*, which capture the forced atmosphere of the Copacabana nightclub, bear such a startling resemblance in composition and camera angle to a series of photographs that Kubrick took of the Copacabana that the latter may well have served as a model. In Scorsese's biopic of the boxer Jake La Motta, the aggressive intensity of this middleweight champion is shown best in scenes set at the Copacabana. Until the late 1950s, the Copacabana was considered New York's most glamorous nightclub; however by 1980, when Scorsese shot his film, it had already been closed down for seven years. In order to set his work apart from other films about boxing produced in the late 1970s and also to evoke an atmosphere that corresponded with his memories of the period, Scorsese decided to shoot in black and white. "We had an idea of making the film look like a tabloid," Scorsese said, "like the *Daily News*, like Weegee photographs."[12]

Raging Bull not only provides an account of La Motta's autobiography but also endeavors to revive an era that had been reproduced and documented in thousands of magazine photographs like Kubrick's. The play between fact and fiction becomes even more complex, as the fight sequences are interspersed with supposed family movies shot in color with a hand-held camera. It is because of the alleged historical authenticity of these images that a confusing illusion of documentary familiarity is established that resembles so much of Kubrick's photo-essays of a day in the life of boxer Walter Cartier.

The strange symbiosis of boxing and nightclubs—both places where tensions escalate into fighting—fairly obsessed Kubrick throughout his early career. As a record of the past, photography is able to capture the ephemeral climax of a fight better than words. During a boxing match, everything can change within seconds, and a written account of the action is insufficient to relay the tension and excitement of the moment. Boxing was a topic covered by countless American artists and authors in the early twentieth century. The culturally curious Kubrick would have been exposed to such work as Thomas Eakins's *Between the Rounds* (1899), which was featured in the Museum of Modern Art's 1944 "Art in Progress" show, or George Bellows's 1909 *Stag at Sharkeys* (fig. 4). Kubrick devoted two *Look* photo-essays to the boxing champions Walter Cartier and Rocky Graziano, made Cartier the subject of his first, twenty-minute documentary, *Day of the Fight* (1951), and chose a boxer protagonist for his first full-length feature, *Killer's Kiss* (1955). Joyce Carol Oates once wrote of the implicit homoeroticism of boxing: the fighters stripped to the waist, oiled and sweating; the fights that resemble half dancing, half mating; the hard, desperate clinches like embraces. Sometimes after a fight, Rocky Graziano would even kiss his opponent.[13] Normally the eroticism of fighting might be considered a side issue, but in the films and photo-essays of Kubrick and Scorsese, it becomes essential to the plot, with the elaborate choreography of the fight mirrored in the protagonists' various love affairs. Oates finds parallels between boxing and pornography, as both elevate the breaking of social taboos into public spectacle. In both cases, the observer is turned into a voyeur.

This compulsion to watch makes up some of the most fascinating moments in *Killer's Kiss*. Whether it is the protagonists' introspective glances into a mirror, their getting undressed, or the involuntary arousal evoked by watching boxing on TV, Kubrick unfolds a voyeuristic spectrum that in the end incorporates all the psychological states of a staged theatrical performance. Although Oates notes that "the obvious difference between boxing and pornography is that boxing, unlike pornography, is not theatrical,"[14] a film about boxing inevitably converts the boxing ring into a stage, as does a photographic essay of such an event. Interestingly, the first motion picture featuring "actors" was a boxing exhibition staged by Thomas Edison as early as 1894. If the sociologist Daniel Bell calls photography an inherently American form of self-presentation, boxing seems to be a fitting metaphor for the structure of American society.

Photographs have made all classes of people aware of how they and others live, whether perceived as still images in printed publications or as moving pictures on cinema screens. As photo historian Naomi Rosenblum remarks: "It is the descriptive aspect of camera work that has been the medium's defining characteristic over the past century and a half."[15]

Beyond the Looking Glass: Kubrick and Self-Reflectivity
By Alexandra von Stosch

Who am I? How do I see myself? How am I perceived? These key questions of individuation and perception are core to Kubrick's work as an artist and photographer. The beginning of the last century witnessed an unparalleled paradigm shift in notions of reality and perception.[1] Einstein's theory of relativity and quantum physics introduced the idea that reality need no longer be defined by linear, teleological development. Process and experiment became tools to question mimesis and gave rise to new, nonrepresentational visual models. In the 1940s and 1950s—thanks in large part to European immigrants in the US—modes of perception became central issues in literature, linguistics, and the fine arts, provoking a new kind of self-reflectivity. It was in this social and cultural context that Stanley Kubrick first became engaged as a professional photographer.

Eleven years after the French psychoanalyst Jacques Lacan first presented his famous discourse on the mirror stage of human development, Kubrick shot a photo-essay for *Look* magazine depicting a baby boy experiencing himself in a mirror for the first time.[2] Simple as they may seem, these photos open a vast discourse on the nature of perception and, consequently, the modern worldview. In his seminal 1962 essay *The Open Work*, the writer-philosopher Umberto Eco declares that "It is less the task of the Arts to fathom the world, but to produce *complements* of it, autonomous forms adding to those already existing, revealing their own intrinsic rules and personal life."[3] An analysis of Kubrick's photographic approach shows that the young photographer created not only complementary models of reality but independent models of it as well—echoing philosopher Hans Blumenberg's assertion that "The art work does not want to *mean* something, it aims to *be* something."[4]

A rarity in Kubrick's photo-essays, this series follows a linear narrative, suggesting a causal chain of experiences. The number of various takes of the same scene hints at an extended process of experimentation and selection. Devoid of a distinguishing external identity, the infant turns into a surrogate for any baby and therefore comes to represent a universal human experience. This neutral appearance also serves to foil the baby's ability to immediately identify with his own reflection in the mirror. Lacan describes the mirror stage as the experience of encountering oneself in the mirror as a total stranger—an early intimation of self-alienation that evokes the nineteenth-century poet Arthur Rimbaud's 1871 decree "JE est un autre."[5] Twentieth-century existentialists like Albert Camus and especially Jean-Paul Sartre dwelled on this attitude, reaching the renowned verdict that "Hell is other people."[6] (Of course, with Lacan, one is tempted to add, "If the other people are hell, then I am also hell—to myself and to others.")

A precise description of Kubrick's staged mirror event gives an idea of each single step of self-realization that leads to this self-alienation. This sequence is characteristic of Kubrick's photographic style in that neither he nor his camera can be seen in the mirror, even though he shoots the sequence at the same low perspective as the baby's in order to enhance the viewer's identification. No camera points distractingly to the technical process of image generation. Instead, Kubrick reflects the complexity of identity confusion not only for the baby in front of the mirror but also for the viewer.

The first picture in the sequence shows a baby, about one year old, sitting in front of a mirror leaning on the ground. The scene is taken from behind and from the right, allowing the spectator a straight view onto the mirrored image. With the left hand, the little boy waves enthusiastically to himself, obviously expecting to have found a new playmate. It is important to note that the active, greeting figure is, indeed, presented in the mirrored image, as the spectator cannot see the front baby's left arm. Thus, Kubrick creates the impression of two independent figures—a stylistic device essential for a reading in Lacanian terms. It shows how Kubrick deliberately stages the event. In the second picture, the baby fiddles intensively with a brush, only to be copied by his equally frowning counterpart. In the third picture the baby reaches close to the mirror offering his brush to his new friend; strangely enough, his mirror-comrade does exactly the same. In the fourth picture, the baby tentatively retrieves the brush as if to test his opposite and carefully scrutinizes his right hand in the mirror. In the fifth picture, his amazement at the copied behavior becomes obvious, and, bewildered, he puts his right fist into his mouth. In the sequence's final photo, irritation takes over, and the baby resigns himself to confusion and disappointment in a loud, open-mouthed cry. The caption in *Look* tellingly reads: "It's beyond me, and I want no more of it. Mom—get me out of this fast."

In Kubrick's photo-essay, the mirror becomes the threshold in which the self is represented as the other. The irritation in the last picture reflects the jarring experience of stepping beyond oneself through the mirror, of transcending one's consciousness. In this archetypal pictorial narrative, Kubrick questions common ideas of self-representation and the accurate depiction of reality. He also illustrates that the congruence of reality and its representation—as claimed by figurative arts and especially by documentary photography—turns out to be impossible to realize. Only the question of the process of perception remains as relevant.

Lacan's mirror stage is a concept of identity based on a projected anticipation of the own body's wholeness as represented in the mirror.[7] While observing himself in the mirror, the baby, aged six to eighteen months, experiences the anticipation of an aspiring identity. But the mirror being a deceptive tool, this process is always accompanied by fear of loss of that identity, by the threat of self-alienation. According to Lacan, the mirror stage also describes a concept of intersubjectivity by characterizing the dual relationship essential for the imaginary, or prelingual, stage of development. It is about the intermediation of the "I" through the other, in this case through the mirror image.

Lacan distinguishes two modalities of the self: the "I," which represents language and the subconscious, and the "me," which stands for the image and the realm of the imagination.

Lacan's theory recognizes that man suffers a double alienation from his origin. The "me" part of the self does not abolish the imaginary identification with its own reflection or identification with another's image on entering the language-oriented order. Instead, it experiences a cleavage, a going-back-and-forth between the imaginary and the lingual in the process of development.

Lacan is also relevant in tracing the process of perception in Kubrick's photographs. In 1973, based on his studies on the mirror stage, Lacan published a lecture series he had given nine years earlier titled *Four Fundamental Principles of Psychoanalysis*, in which he defines a process of perception that stems from the distinction between the "eye" and the "look."[8] The eye stands for physical seeing and is related to a Cartesian way of viewing—and dominating—the world. The look, on the other hand, refers to experiences from the outside—what Sartre meant by the influence of the other. When we experience ourselves in a first encounter with a mirror as somebody completely different, we experience an early, painful split in identity; we feel exposed to a "stranger's" look. In the illusion, the mirror is transcending the subject-object duality, because, looking into the mirror, we experience ourselves as objects, just as others perceive us.

Lacan introduces another possible response: desire. The archetypal experience of discrepancy in the mirror signifies the feeling of deprivation, leading to a pursuit of entirety. This desire to unite with the "other" finds its vehicle in the look. Thus Narcissus, seeing his reflection for the first time in the water, falls in love with his own image and forever aspires to merge with it.[9]

Brassaï, the Romanian photographer who lived and worked in Paris from the early 1920s, came to fame through his photographs of Parisian night life.[10] Together with the American expatriate writer Henry Miller, he strolled through Paris as a flaneur—the incarnation of the modern, hypersensitive metropolitan soul—and documented what critic Susan Sontag characterized as its "dark seamy corners, its neglected populations, an unofficial reality behind the façade of bourgeois life that the photographer 'apprehends,' as a detective apprehends a criminal."[11]

With an eye for the marginal, Brassaï photographed the detritus of urban existence—from stones on the street to graffiti on walls.[12] For Brassaï, "a picture worked much more as a spiritual construction, an invention, than as a found object."[13] In this way, Brassaï's approach relates directly to Kubrick and his pictorial compositions.

One of Brassaï's favorite stylistic methods was to use mirrors.[14] In his photographs, the real event—inevitably staged and observed in a bar or brothel—is revealed only in a mirror, thus

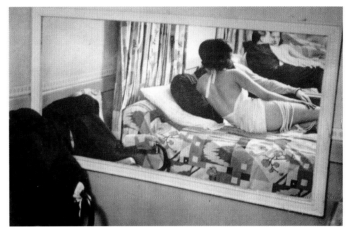

fig. 1: Brassaï, Chez Suzy, *1932.*

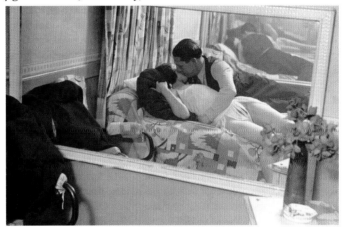

fig. 2: Brassaï, Chez Suzy, rue Grégoire-de-Tours, *1932.*

enhacing the voyeuristic aspect of the medium, making the spectator a witness to intimate acts revealed only at certain angles and seemingly by accident. On the other hand, these mirrored images, in their multiperspectivity, show a "twisted" way of representing reality.

A series of pictures staged in 1932 in a nightclub/brothel called Suzy on the Rue Grégoire-de-Tours illustrates this well. Tellingly, the photographer himself never appears in the mirror, indicating an elaborate planning of the frame. Two pictures taken in a bedroom featuring two opposite mirrors show a couple on a bed—a man and a woman—whose silhouette is seen only from behind in the first picture. From the reflection in the opposite mirror, it becomes clear that the fully clothed man is lying next to the scantily clad woman in a position that mirrors hers (fig. 1). The scene seems expressly staged, evoking an erotic tension that serves as an introduction to the next picture. In the second mirror-within-a-mirror picture, the photographer recedes even more (fig. 2). Now, the camera is fixed on the first

mirror, which shows the woman surrendering to her partner's kiss as she lies on her back with him leaning over her. The second mirror reveals only the man's back, which echoes the woman's figure in the first picture: another mirrored situation.

The ensuing spatial confusion takes the spectator straight into the bedroom in the position of a peeping Tom. As in Kubrick's mirror pictures, the highest possible identification is reached with the viewer, although distance is also stressed. Both photographic and mirror frames confront the spectator with his insurmountable remoteness from the event. In this simultaneous presentation of desire and its frustration, Brassaï and Kubrick maximize the photographic dilemma to the hilt.

Brassaï set forth to create his idea of reality within an infinite play of mirrored substitutes, although he never stopped searching for congruence with a universal, permanent element. In distinction, Kubrick emphasizes splits and fragments of a reality that can be grasped only as an ever-changing kaleidoscope—never as an absolute expression. As a rule, his compositions allow for several different perspectives and readings and are designed to enable an expansion of the field of perception.

The intentional interplay of fictional and documentary elements in Kubrick's work reveals what philosopher Vilém Flusser has termed an "intersubjective" point of view:

The photographer is looking for a point of view from which another one (the beholder) can see the world just as he is seeing it himself. He is searching neither for an "objective perspective" (which obviously cannot exist in photography) nor for a subjective one (the machine making sheer subjectivity obsolete), but for an intersubjective one. [. . .] Photographs are frozen views of the world, created while looking for intersubjectiviy—they are views that can be shared with others.[15]

This has ramifications for the photographer as well as the viewer as they navigate the world. Kubrick goes even further than Flusser when he states that "To try to fasten any responsibility of art as the cause of life seems to me to have the case put the wrong way around. Art consists of *reshaping* life but does not create life or cause life."[16] Obviously, in his intersubjective perspectives, Kubrick is interested in opening various possibilities of self-perception to the viewer. Here, photography turns from a "document" into a means of experience that can change our consciousness, the very way we deal with our given reality.

Photography offers a new view onto the figurative world, not a "copy" of reality. Traces of the outer world (look) intertwine with imaginary, variable facets (eye). In fact, the tension between eye and look, Lacan's double pyramid of perception, seems to reproduce within the photographic process. On the one hand, we are dealing with a secured construction of perception, suggesting to the subject a reassuring idea of identity. This subjective perspective is transferred onto the objective lens of the camera. On the other hand, the photo is made possible only through the exterior effect of the light, realized independently from the photographing subject: photography as "writing with light."

This effect of light, however, appears less "enlightening," but rather as an illusion: it is the negative inscription of things on a film, a "mirror writing" of sorts, which can be read only in a change of position for the other's perspective. Yet, photography, originally, set forth to create a surrogate for the insatiable desire for identity and totality, to ease Narcissus's longing. It was to satisfy the urge to view. This irresolvable ambiguity between eye and look, between subjective viewfinder and objective light, intrinsic to the photographic medium, perfectly caters to Kubrick's ideas of a facetry of perspectives, reflecting his modern worldview.

In many ways, Kubrick's photographs of the baby serve as a mirror itself of the mirror stage. The fact that Kubrick never appears in the mirror opens another level of reception. As the viewer identifies with the events that take place in the mirror, he is also immediately aware of a diachronic discrepancy. The "informed" viewer is quite aware that the "other" in the mirror is actually the baby himself. The pictures do, however, present two figures, each offering different information. Only the baby's reflection reveals what the baby actually looks like, since what we see directly is only his back. Obviously, Kubrick satisfies the timeless desire for wholeness, as formulated by both Freud and Lacan: in the complementarity of the image of the "real" baby with his mirror image, the viewer gets a much more complete idea than from a common photographic frame.

Of course, the mirror as a trick to overcome two-dimensionality is an old artistic gimmick that was commonly used by mimetic painters as diverse as Jan van Eyck and Diego Velázquez. Mirrors represent the introduction of another level of information or reality but also symbolize illusion and deception, as they can only point to this new dimension rather than make it real. This transcending act, in fact, is up to the eye of the beholder. The mirror turns out as a visual stylistic means and a metaphor for intersubjective communication.

In Kubrick's version of the mirror stage, this stylistic means becomes especially powerful. The spectator, seemingly so much smarter than the baby, observes with great amusement the various stages of the baby's communication with his mirror image. But Kubrick subverts the "natural" authority of the viewer, because he makes the spectator face a mirror in manifold ways. Confronting him with his own archetypal experience via the photographic medium—considered early on as a *speculum mundi*[17]—Kubrick also shows him the origin of his alienation. He unveils a psychological wrong that has been successfully suppressed by the self-conscious adult. Finally, he makes the beholder question the autonomy of the Cartesian, world-appropriating subject.

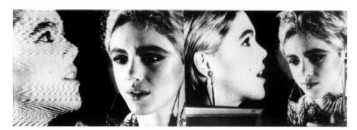

Fig 3: Andy Warhol, Outer and Inner Space, *1965.*

A further interpretation of the issue of "self-reflectivity" is at the core of Andy Warhol's *Outer and Inner Space*, made in 1965, which shows Factory "superstar" Edie Sedgwick in a two-reel split screen video and film installation (fig. 3). The installation's right screen shows two close-ups of Sedgwick—a profile of her on the left and a full-frontal view on the right in which she seems to be speaking animatedly to someone out of the pictorial frame. In the left screen it becomes clear through Warhol's pulled-out perspective that these images in fact depict Sedgwick watching herself act on video. The effect is as if the viewer were in a hall of mirrors. It is only through the revelation of the left screen that the viewer begins to understand what is going on and gets insights into Sedgwick's self-perception. Warhol illustrates the time lag of life and the consciousness of experience—the dialectics of outer and inner space, of public and private experiences. These are issues that Kubrick found himself reflecting on time and time again, especially in his photo-essays of post-war celebrities—both real ones like Leonard Bernstein and Rocky Graziano and would-be ones like Betsy von Fürstenberg.

Such moments of diachrony and spatial dialectics are frequent in the photographic medium, and especially in the artistic interpretation staged by Kubrick in his early photographs. In Kubrick's photography, dealing with memorized time and reflecting one's own perception prove key moments for the genuinely human process of individuation. As in Warhol's video presentation, the beholder has to perform an additional connotation, asking himself: How do I act? How am I perceived? How do I perceive (myself)?

Notes

Rainer Crone

1. Siegfried Kracauer, *Theory of Film: The Redemption of Physical Reality* (London: Oxford University Press, 1960), pp. 18–19.
2. Hubertus von Amelunxen, "Imaginäre und reale Blickpunkte zu Stanley Fotostories," in Rainer Crone and Petrus Schaesberg (eds.), *Stanley Kubrick Still Moving Pictures: Fotografien 1945–1950* (Regensburg: Schnell & Steiner/Edition Iccarus, 1999), pp. 13–17. English translation by the author.
3. *Theory of Film*, p. 30.
4. Susan Sontag, *On Photography* (New York: Picador USA/Farrar, Straus & Giroux, 2001), pp. 119–120.
5. Ibid., p. 63.
6. Taken from a 1960 interview with Robert Emmett Ginna, reprinted in the *Guardian*, 16 July 1999.
7. *On Photography*, p. 121. Italics by the author.
8. In 1961, Kubrick noted: "The most influential book I read at that time was Pudovkin's *Film Technique*. It is a very simple unpretentious book that illuminates rather than embroiders. It certainly makes it clear that film cutting is the one and only aspect of films that is unique and unrelated to any other art form. I found this book much more important than the complex writings of Eisenstein."
9. Fredric Jameson, *Brecht and Method* (London/New York: Verso, 1998), pp. 99–101.
10. W. Hecht, J. Kopf, W. Mittenzwei, and K.-D. Mueller (eds.), *Grosse kommentierte Berliner und Frankfurter Ausgabe* (Berlin/Frankfurt am Main: Aufbau/Suhrkamp, 1989–1998). English translation by the author.
11. *Brecht and Method*, pp. 109–110
12. See John Baxter, *Stanley Kubrick: A Biography* (New York: Carroll and Graf Publishers, 1997), p. 27.
13. See Walker Evans, "Subway Portraits," *Harper's Bazaar*, March 1962.
14. *Brecht and Method*, pp. 109–110.
15. See "A veteran photographer at 19, Stanley makes up for youth with zeal," *Look*, 11 May 1948, reprinted in *Stanley Kubrick Still Moving Pictures*, p. 12.
16. Vincent Lobrutto, *Stanley Kubrick: A Biography* (New York: Donald I. Fine Books, 1997), p. 53.
17. Diane Arbus biographer Patricia Bosworth hints that the uncanny appearance of the two murdered Grady girls in Kubrick's film *The Shining* might have been inspired by that famous Arbus photo of the twins. See *Stanley Kubrick: A Biography*, p. 444, and Patricia Bosworth, *Diane Arbus: A Biography* (New York: Knopf, 1984).
18. See Roland Barthes, *La Chambre claire: Note sur la photographie* (Paris: Cahiers du Cinéma, Gallimard, Seuil, 1980), p. 71: "In that space, being in general unified, sometimes (but all too seldom), a 'detail' attracts my attention. I have a feeling that its single presence is changing my way of reading (the image), that I am looking at a new photo, which has gained, in my view, a higher value. This 'detail' is the punctum (pointing toward me)." English translation by the author.
19. *Brecht and Method*, p. 107.
20. *Sight and Sound*, 1961, p. 14.

Petrus Schaesberg

1. See Rainer Crone's essay in this book, "Kubrick's Kaleidoscope: Epic Pictures as Parables," p. 7.
2. Fred Kaplan, *The New York Times*, 10 October 2004, p. 21.
3. For Kubrick's manifold allusions to his own work in his movies, see Ralf Michael Fischer, "Pictures at an Exhibition," in *Stanley Kubrick* (Frankfurt am Main: Schriftenreihe des Deutschen Filmmuseums, 2004), pp. 168–83.
4. Thomas Allen Nelson, *Kubrick: Inside a Film Artist's Maze* (Bloomington: Indiana University Press, 1982), p. 85.
5. Michel Ciment, *Kubrick* (New York: Holt, Rinehart and Winston, 1984), quoted in *Stanley Kubrick: A Biography*, p. 53.
6. Denis Diderot, "Entretiens sur le fils naturel," in Paul Vernière (ed.), *Oeuvres esthétiques* (Paris: Garnier Frères, 1968), p. 88. English translation by the author.
7. See Edith Balas, *The Early Work of Henry Koerner* (Pittsburgh: Frick Art and Historical Center, 2003), and *Unheimliche Heimat: Henry Koerner 1915–1991*, with an introduction by Joseph Leo Koerner (Vienna: Österreichische Galerie Belvedere, 1997).
8. *Unheimliche Heimat*, p. 14.
9. See Deborah Martin Kao, Laura Katzman, and Jenna Webster (eds.), *Ben Shahn's New York: The Photography of Modern Times* (Cambridge, Massachusetts: Fogg Art Museum, Harvard University, 2000).
10. Beaumont Newhall, "Documentary Approach to Photography," *Parnassus*, March 1938, p. 3.
11. See Deborah Martin Kao, "Ben Shahn and the Public Use of Art," in *Ben Shahn's New York*, pp. 39–73.
12. Mary Pat Kelly, *Martin Scorsese: A Journey* (New York: Thunder's Mouth Press, 1991), p. 125.
13. Joyce Carol Oates, *On Boxing* (Garden City, New York: Dolphin/Doubleday, 1987), p. 30.
14. Ibid., p. 106.
15. Naomi Rosenblum, "Documentary Photography: Past and Present," in Denise Miller, *Photography's Multiple Roles* (New York: Museum of Modern Art, 1998), p. 85.

Alexandra von Stosch

This essay is based on the doctoral thesis "Stanley Kubricks Bildwelten: Untersuchungen zu seinen frühen Photographien 1945–1950," Munich University, 2004.

1. See Thomas S. Kuhn, *The Structure of Scientific Revolutions* (Chicago: University of Chicago Press, 1962).
2. Lacan borrowed the notion of the mirror stage from psychologist Henri Wallon. On 3 August 1936, Lacan held his first lecture on the topic at a psychology congress in Marienbad, Germany, and presented it again in Zurich in 1949 in a slightly changed version. See Jacques Lacan, "The Mirror Stage as Formative of the Function of the I as Revealed in Psychoanalytic Theory" [1949], in *Écrits: A Selection* (London: Tavistock Publications 1977). See also Jacques Lacan, *The Four Fundamental Concepts of Psychoanalysis (The Seminar of Jacques Lacan, Book 11)* (New York: W.W. Norton & Company, 1998).
3. Umberto Eco, *The Open Work* (Cambridge, Massachusetts: Harvard University Press, 1989), p. 46.
4. Hans Blumenberg, "Nachahmung der Natur," in *Wirklichkeiten in denen wir leben* (Stuttgart: Reclam, 1993), p. 93. English translation by the author.
5. Excerpted from a May 1871 letter that Rimbaud wrote to his friend Georges Izambard: "It's wrong to say *I think*: one should say *I am thought*. Forgive the pun. I is someone else." See Wyatt Mason (ed.), *I Promise to Be Good: The Letters of Arthur Rimbaud* (New York: Modern Library, 2003), p. 27.
6. Jean-Paul Sartre, *Huis clos* [1944] (Paris: Gallimard, 1972), p. 41. English translation by the author.
7. Following World War II, Lacan's psychoanalytic concepts were widely discussed in Europe and the United States, mostly in connection with Freudian ideas. A revival of his theories could be observed in the 1970s, when interdisciplinary "theory" discussions developed in the US that were based on studies of such French thinkers as Lacan, Barthes, Jacques Derrida, and Michel Foucault.
8. See *The Four Fundamental Concepts of Psychoanalysis*.
9. See Ovid, *Metamorphoses* III, 339–510.
10. Brassaï, *Paris after Dark* (London: Batsford Gallery, 1933).
11. Susan Sontag, *On Photography* (New York: Picador, 1990), pp. 55–56.
12. Graffiti was the subject of Brassaï's first one-person photography show in 1956 in New York, "Language of the Wall," at the Museum of Modern Art. Brassaï had previously shown work in several New York group shows, including "Photography 1839–1937 at MoMA (1937); "French Photographers" at the Photo League (1948); and "The Family of Man" at MoMA (1955). All of these exhibitions would have given Kubrick the opportunity to famliarize himself with Brassaï's work.
13. Alain Sayag and Annick Lionel-Marie, *Brassaï* (Vienna: Albertina/Verlag Christian Brandstätter, 2003), p. 15. English translation by the author.
14. On Brassaï's mirror images see Craig Owens, "Photography *en abyme*," in *Beyond Recognition: Representation, Power, and Culture* (Berkeley: University of California Press, 1992).
15. Vilém Flusser, "Umbruch der menschlichen Beziehungen," in Stefan Bollmann and Edith Flusser (eds.), *Kommunikologie* (Frankfurt am Main: Fischer, 1998), p. 187. English translation by the author.
16. See Kubrick's interview with Penelope Strick and Philip Houston, *Sight & Sound*, spring 1972, p. 63.
17. At its inception, photography was called "Daguerre's mirror": See Richard Rudisill, *Mirror Image: The Influence of the Daguerreotype on American Society* (Albuquerque: University of New Mexico Press, 1971).

Selected Readings

On Stanley Kubrick

Ciment, Michel.
Kubrick: The Definitive Edition.
New York: Faber & Faber, 2001.

Crone, Rainer, and Petrus Schaesberg, eds.
Stanley Kubrick Still Moving Pictures: Fotografien 1945–1950.
Regensburg: Schnell & Steiner/Edition Iccarus, 1999.

García Mainar, Luis M.
Narrative and Stylistic Patterns in the Films of Stanley Kubrick.
New York: Camden House, 2000.

Ghezzi, Enrico.
Stanley Kubrick.
Florence: Il Castoro Cinema, 1977.

Howard, James.
The Stanley Kubrick Companion.
London: B.T. Batsford, 2000.

Kilb, Andreas, Rainer Rother et al., eds.
Stanley Kubrick.
Berlin: Dieter Bertz-Verlag, 1999.

Kirchmann, Kay.
Stanley Kubrick: Das Schweigen der Bilder.
Bochum: Schnitt der Filmverlag, 2001.

Kubrick, Christiane.
Stanley Kubrick: A Life in Pictures.
London: Little, Brown & Co., 2002.

LoBrutto, Vincent.
Stanley Kubrick: A Biography.
New York: Donald I. Fine Books, 1997.

Nelson, Thomas Allen.
Kubrick: Inside a Film Artist's Maze.
Bloomington: Indiana University Press, 1982.

Phillips, Gene D.
Stanley Kubrick: Interviews.
Jackson: University Press of Mississippi, 2001.

Phillips, Gene D., and Rodney Hill.
The Encyclopedia of Stanley Kubrick:
From Day of the Fight *to* Eyes Wide Shut.
New York: Checkmark Books, 2002.

Seesslen, Georg, and Fernand Jung.
Stanley Kubrick und Seine Filme.
Marburg: Schüren Presse-Verlag, 2001.

Walker, Alexander.
Stanley Kubrick Directs: A Visual Analysis.
New York/London: W.W. Norton & Co., 2000.

On subjects pertaining to Kubrick's early photography

Cowles, Gardner.
Mike Looks Back: The Memoirs of Garner Cowles, Founder of Look *Magazine*.
New York: G. Cowles, 1985.

Greenough, Sarah.
Subways and Streets.
Washington, DC: National Gallery of Art, 1991.

Grosz, George.
A Little Yes and a Big No.
New York: Dial Press, 1946.

Jenks, Chris.
"Watching Your Step: The History and Practice of the Flâneur."
In *Visual Culture*, pp. 148–57. New York: Routledge, 1995.

Kao, Deborah Martin, Laura Katzman, and Jenna Webster, eds.
Ben Shahn's New York: The Photography of Modern Times.
Cambridge, Massachusetts: Fogg Art Museum, Harvard University, 2000.

Köhler, Thomas, ed.
Constructed Realities: The Art of Staged Photography.
Munich/Zurich: Kunstverein München e.V./Edition Stemmle, 1995.

Kozloff, Max.
New York: Capital of Photography.
New York/New Haven: The Jewish Museum/
Yale University Press, 2002.

Lacan, Jacques.
The Four Fundamental Concepts of Psychoanalysis
(The Seminar of Jacques Lacan, Book 11).
New York: W.W. Norton & Company, 1998.

Laguardia, Robert.
Monty: A Biography of Montgomery Clift.
New York: Morrow/Avon, 1978.

Lee, Anthony W., and John Pultz, eds.
Diane Arbus: Family Albums.
New Haven/London: Yale University Press, 2003.

Livingston, Jane.
The New York School Photographs 1936–1963.
New York: Stewart, Tabori and Chang, 1992.

Moholy-Nagy, László.
Vision in Motion [1947].
Chicago: Paul Theobald and Company, 1961.

Montier, Jean-Pierre.
Henri Cartier-Bresson: Seine Kunst, Sein Leben.
Munich: Schirmer/Mosel, 1995.

Müller-Pohle, Andreas.
"Photography as Staging."
European Photography 34: German Stagings (April/May/June 1988)

Oates, Joyce Carol.
On Boxing.
Garden City, New York: Dolphin/Doubleday, 1987.

Pudovkin, Vsevolod I.
Film Technique and Film Acting.
London: Vision, 1954.

Rudisill, Richard.
Mirror Images.
Albuquerque: University of New Mexico Press, 1971.

Sontag, Susan.
On Photography.
New York: Picador USA/Farrar, Straus & Giroux, 2001.

Tupitsyn, Magarita.
Alexander Rodtschenko: Das Neue Moskau.
Munich: Schirmer/Mosel, 1999.

Weegee.
Weegee: Naked New York.
New York: Te Neues, 1997.

Filmography

Kubrick himself withdrew all short films—as well as his first feature, Fear and Desire—*from distribution.*

Day of the Fight (1950–51)
Kubrick's first documentary short film shows a day in the life of middleweight champion Walter Cartier, whom he had already portrayed in a photo series for *Look* magazine. Kubrick accompanies him from rising in the morning to fighting in the evening. He wins by knockout: a typical workday for Walter Cartier. *Director, editor, screenplay, camera: Stanley Kubrick; narrator: Douglas Edwards; distribution: RKO; running time: 16 minutes, b/w.*

Flying Padre (1950–51)
This documentary short describes the life of Fred Stadtmueller, the pastor of a rural parish in New Mexico. In order to deal with great distances, Stadtmueller uses a small airplane. The camera accompanies the pastor during his workday as he buries a farmer, raises canaries, and saves an ailing baby with his airplane. *Director, editor, screenplay, camera: Stanley Kubrick; distribution: RKO; running time: 9 minutes, b/w.*

The Seafarers (1953)
This study of the life of sailors follows them in their daily routine aboard ships and on the docks. The short film shows the workers in a port tavern, reporting for work, and fulfilling their consigned chores, and emphasizes the importance of union membership. *Director, editor, screenplay, camera: Stanley Kubrick; commissioned by the Atlantic and Gulf Coast District of the Seafarer's International Union; running time: 30 minutes, color.*

Fear and Desire (1951–53)
In a fictitious war, Lieutenant Corby (Kenneth Harp), Sergeant Mac (Frank Silvera), and the two privates Fletcher (Steve Coit) and Sidney (Paul Mazursky) find themselves behind enemy lines after a plane crash. They are attacked by two enemy soldiers but manage to overwhelm them. Later they take a girl (Virginia Leith) hostage. Sidney, his nerves increasingly weakening, is supposed to watch her. When he tries to rape her, she escapes and is shot by him. Sidney flees in panic into a forest. His comrades, after having successfully attacked an enemy command post and killed the soldiers, escape by plane. Only wounded Mac picks up the now insane Sidney. *Production company: Stanley Kubrick Productions; producers: Stanley Kubrick, Martin Perveler; distribution: Joseph Burstyn Inc.; director: Stanley Kubrick; screenplay: Stanley Kubrick and Howard O. Sackler; editor: Stanley Kubrick; running time: 68 minutes, b/w.*

Killer's Kiss (1955)
The boxer Davy Gordon (Jamie Smith) is sitting in the waiting room of Grand Central Station reflecting on the events of the past few days. He has fallen in love with his neighbor Gloria (Irene Kane), who works at the "dance bar" Pleasureland. After his defeat in an important boxing match, Davy comes home, and sees through the window the nightclub owner Rapallo (Frank Silvera) molesting Gloria. Davy comes to Gloria's help. Both decide to leave New York for Seattle. Gloria quits her job with Rapallo, who, full of jealousy, wants to kill Davy and abducts Gloria. After a long chase across New York, Davy kills Rapallo. When he finally enters the train platform, Davy finds Gloria: the beginning of a new life. *Production, screenplay: Stanley Kubrick and Howard O. Sackler; director, editor: Stanley Kubrick: distribution: United Artists; running time: 67 minutes, b/w.*

The Killing (1955–56)
Freshly out of prison, the petty criminal Johnny Clay (Sterling Hayden) plans his next heist. Together with the cashier George Patty (Elisha Cook), the barkeeper O'Reilly (Joe Sawyer), the corrupt policeman Kennan (Ted DeCorsia), the sniper Nikki Arane (Timothy Carey), the baseball catcher Maurice (Kola Kwariani), and the alcoholic Marvin Unger (Jay C. Flippen), Clay wants to rob the racetrack ticket office, which is worth about two million dollars. The heist is a success until the sniper gets shot by the police. While splitting the plunder, the thieves are interrupted by gangster Val Cannon (Vince Edwards), the lover of Sherry (Marie Windsor), the unsatisfied wife of Patty. Patty is shot by Cannon but manages to drag himself home and kill his wife before he dies. Clay can escape with the money and wants to leave town together with his fiancé, Fay (Coleen Gray). But at the gangway of the airport, the suitcase with the money opens up by accident, and all the bills fly in the propeller wind of an airplane. *Production company and distribution: United Artists; producers: James B. Harris and Alexander Singer; director: Stanley Kubrick; screenplay: Stanley Kubrick, based on the novel* Clean Break *by Lionel White; running time: 84 minutes, b/w.*

Paths of Glory (1957)
In 1916, along the trenches of the front line between German and French troops, General Broulard (Adolphe Menjou) persuades General Mireau (George Macready) to agree to a suicide commando. The assault is directed by Colonel Dax (Kirk Douglas), whose troops advance only slowly. Mireau orders Captain Rousseau (John Stein) to shoot his own soldiers. Rousseau refuses. The assault is a fiasco. To cover it up, Mireau has three men court-martialed for cowardice. Dax takes over the hopeless defense of the men. They are sentenced to death and executed, even though Dax told Broulard about Captain Rousseau's rightful refusal of orders. Now, Mireau himself comes under scrutiny, and Colonel Dax is chosen as his successor. But Dax declines and is sent back to the front lines. *Production companies: Harris-Kubrick Productions, Bryna Productions; producer: James B. Harris; distribution: United Artists; director: Stanley Kubrick; screenplay: Stanley Kubrick, based on the novel of the same name by Humphrey Cobb; running time: 87 minutes, b/w.*

Spartacus (1959–60)
The rebellious slave Spartacus (Kirk Douglas) is bought by Batiatus (Peter Ustinov), a Roman salesman from Libya, and is handed over to a gladiator school near Capua. There, Spartacus falls in love with the beautiful slave Varinia (Jean Simmons), who is sold to the patrician senator Marcus Crassus (Laurence Olivier), visiting the school with his minion Glabrus (John Dall). Crassus demands a show fight to death, which Spartacus wins. Shortly afterward, Spartacus escapes with his comrades and successfully leads the slave army against the Roman forces. Spartacus meets Varinia again. Antonius (Tony Curtis), the favorite slave of Crassus, joins Spartacus. Crassus is waiting in Rome for a good moment to grasp power. Gracchus (Charles Laughton), the leader of the plebeian party and his ally Julius Caesar (John Gavin) oppose him. Fighting against an overwhelming mass of Roman soldiers, the slaves are defeated. Antonius and Spartacus are supposed to fight to the death. The winner, Spartacus, is crucified, but just before his death Varinia shows him his son, who is born a free Roman citizen. *Production company and distribution: Bryna Productions for Universal Pictures; producers: Kirk Douglas and Edward Lewis; director: Stanley Kubrick; screenplay: Dalton Trumbo, based on the novel of the same name by Howard Fast; running time: 184 minutes, color.*

Lolita (1960–62)
Humbert Humbert (James Mason) is a British professor of literature who rents a summer room in a New Hampshire house owned by the widow Charlotte Haze (Shelly Winters). He feels strongly attracted to her adolescent daughter, Lolita, and marries Charlotte in order to be closer to the teenager. Charlotte discovers the whole truth by reading Humbert's diaries. She runs out of the house in despair and is fatally hit by a car. Humbert takes Lolita out of her summer camp without telling her immediately about her mother's death. Lolita seduces Humbert, and both start a road trip across the country. Humbert constantly feels persecuted by a stranger, the writer Quilty (Peter Sellers). One night, Lolita just disappears. Years later she writes Humbert that she is pregnant and married to a young worker. Humbert visits Lolita to try to persuade her to come with him. She refuses to and tells him that during all the time they had been together, she had a love affair with Quilty. Humbert finds Quilty and shoots him. Humbert goes on to prison and dies from a heart attack. *Production company: Seven Arts/Anya/Transworld; distribution: Metro-Goldwyn-Mayer; producer: James B. Harris; director: Stanley Kubrick; screenplay: Stanley Kubrick and Vladimir Nabokov, based on the novel of the same name by Nabokov; running time: 152 minutes, b/w.*

Dr. Strangelove or: How I Learned to Stop Worrying and Love the Bomb (1963–64)
At the peak of the cold war, General Ripper (Sterling Hayden), the mentally disturbed commander of the air-force base Burpelson, is obsessed by a communist conspiracy and orders a B-52 attack on the USSR. Only Ripper knows the secret code to call off the attack and cuts the base from any exterior communication. When President Muffley (Peter Sellers) hears about it, he calls the Soviet ambassador de Sadesky (Peter Bull) into the war room of the Pentagon. Against the advice of general Turgidson (George C. Scott), who suggests a full-fledged atomic war, Muffley orders the assault of Burpelson, and Ripper commits suicide. Captain Mandrake (Peter Sellers) cracks the secret code that enables the recall of the bombs; however, pilot T.J. King Kong (Slim Pickens) is still able to fulfill his mission. Muffley is told in a telephone call that the Soviet president plans an atomic backlash with a "Doomsday Machine" if his country is attacked. Muffley calls for the advice of Dr. Strangelove (Peter Sellers), a former Nazi, who tells him that a few selected people can survive a hundred years in secured underground bunkers. Meanwhile, King Kong rides his bomb, which

explodes in a gigantic atomic mushroom cloud. *Production company: Hawk Films Ltd.; producer: Stanley Kubrick; distribution: Columbia Pictures; director: Stanley Kubrick; screenplay: Peter George, based on his novel* Red Alert; *running time: 95 minutes, b/w.*

2001: A Space Odyssey (1968)
At the dawn of time, a clan of herbivore apes struggles daily in rough surroundings for food and water. One morning, the group is suddenly awoken: in front of their cave, the apes find a strange black monolith. One of them, Moonwatcher, learns to use a bone as a tool and weapon. The herbivores turn carnivores. After having killed a member of an enemy group, Moonwatcher throws the bone into the air. In the year 2001, the American scientist Dr. Heywood Floyd (William Sylvester) is on his way to the moon. There, a strange black monolith of unknown origin has been discovered, sending radiation toward Jupiter. Floyd and his American colleagues set off for the excavation location. When they assemble in front of the monolith for a group photo, a loud warning signal is heard. Eighteen months later, the gigantic spaceship Discovery is on its way to Jupiter. Aboard are the astronauts David Bowman (Keir Dullea) and Frank Poole (Gary Lockwood), as well as three colleagues in a hibernaculum. The spaceship is controlled by the supercomputer HAL 9000, which alone knows the reason for the mission. When HAL mistakenly reports the failure of an antenna control device, Poole and Bowman are afraid that HAL is pursuing ideas that might not be totally congruent with his programming. When Poole tries to reinstall the control device, HAL stops the oxygen supply. The crew dies, but with a trick, Bowman saves himself through an emergency air lock and manages to pull out all of HAL's memory blocks. When Discovery approaches Jupiter, the monolith reappears, and Bowman is sucked into a tunnel of light and colors. Finally, he finds himself in a strangely lit rococo chamber. Going through several metamorphoses, he ages and eventually looks back on earth as a newly born Starchild: an embryo looking from a shiny amniotic sac seems to smile. *Production company and distribution: Stanley Kubrick Productions Ltd. for MGM; producers: Stanley Kubrick, Victor Lyndon; director: Stanley Kubrick; screenplay: Stanley Kubrick and Arthur C. Clarke, based on Clarke's short story "The Sentinel"; running time: 141 minutes, color.*

A Clockwork Orange (1971)
England in the near future: Alex DeLarge (Malcolm McDowell) and the Droogs—his three friends Dim (Warren Clarke), Pete (Michael Tarn), and Georgie (James Marcus)—attack a homeless man (Paul Farrell) and brawl with a rivaling gang called the Billyboys. They invade the house of the writer Mr. Alexander (Patrick Magee) and rape his wife (Adrienne Corri). After having killed a woman (Miriam Karlin) in another incident, Alex is captured by the police and sentenced to fourteen years in prison. He agrees to submit himself to a new type of shock therapy—the so-called Ludovico-Program—installed by the new Home Secretary. Afterward, Alex can no longer stand violence and the sound of Beethoven's music. Now homeless himself, Alex is attacked by other tramps and battered by his former Droogs, who have become policemen. He seeks refuge with Mr. Alexander, who, for revenge, and in order to counter the government therapy, uses Beethoven's music to drive Alex to attempt suicide. Public opinion changes on the Ludovico-Program, and Alex survives, reversed in a hospital visit into his former self. The home secretary offers him a job, thereby having the state sanction Alex's reclaimed capacity for violence. *Production company and distribution: Polaris/Hawk for Warner Bros.; producer, director: Stanley Kubrick; screenplay: Stanley Kubrick, based on the novel of the same name by Anthony Burgess; running time: 137 minutes, color.*

Barry Lyndon (1975)
Barry Lyndon (Ryan O'Neal) falls in love with his cousin Nora Brady (Gay Hamilton) and challenges Captain Quin (Leonard Rossiter), Nora's fiancé, to a duel in eighteenth-century Ireland. Barry believes he has killed Quin and flees. Without any means, he has to enter the army. He participates in the Seven Years' War and hears by Captain Grogan (Godfrey Quigley) that he did not kill Quin. Barry deserts the army but is captured by Captain Potzdorf (Hardy Krüger), who forces him to enter the Prussian army. Barry gets the mission to spy on his fellow Irishman Chevalier de Balibari (Patrick Magee), a gambler, whose trust he wins. At the gaming table, he meets the rich Lady Lyndon (Marisa Berenson) who marries him after the death of her husband (Frank Middlemass). He adopts her name. But Barry betrays her, making his stepson Lord Bullington (Leon Vitali) his worst enemy. After the death of his own small son, he alienates himself more and more from his wife, who tries to commit suicide. Lord Bullington hurts Barry Lyndon in a duel and is forced to leave England. Production company: Hawk/Warner Bros.; distribution: Warner Bros.; producers: Stanley Kubrick, Jan

Harlan; director: Stanley Kubrick; screenplay: Stanley Kubrick, based on the novel of the same name by William Makepeace Thackeray; running time: 187 minutes, color.

The Shining (1980)
Struggling writer Jack Torrance (Jack Nicholson) takes a job as the caretaker of the Overlook Hotel in Colorado, which is closed for the winter months. Jack hopes to be able to work on his novel. Stuart Ullman (Barry Nelson), the hotel director, informs him that the former caretaker Grady had killed his wife and his two daughters in 1970 and committed suicide, as he could not stand the isolation of the place. Nonetheless Jack moves in with his wife, Wendy (Shelley Duvall) and his little son, Danny (Danny Lloyd), who has the "shining"—a capacity for supernatural perceptions, as the cook Hallorann (Scatman Crothers) immediately finds out. He, himself sensitive to supernatural powers, warns Danny about room 237. As the weeks go by, Jack becomes more and more irritable. In the ballroom of the hotel, he talks to the imaginary barkeeper Lloyd (Joe Turkel), whom he recognizes as his predecessor Grady. Meanwhile, Danny keeps having visions: He sees the twin Grady daughters (Lisa and Louise Burns). Jack opens the door to room 237, where he observes a woman (Lia Beldam) as she is taking a bath. When he embraces her, he sees in the mirror that he is holding a dead body in his arms. Jack becomes increasingly violent with his family, and his mental state grows more and more disturbed. Danny gets in touch with Hallorann, who comes to the hotel and gets killed by Jack. Danny and his mother hide in the snowy maze in front of the hotel, while Jack freezes to death in a snowstorm. The final scene shows a photo of a formal ball in the Overlook, featuring a smiling Jack—in the year 1921. *Production company: Peregrine/Hawk/Warner Bros.; producers: Stanley Kubrick, Jan Harlan, Robert Fryer; director: Stanley Kubrick; screenplay: Diane Johnson and Stanley Kubrick, based on the novel of the same name by Stephen King; running time: 146 minutes, color.*

Full Metal Jacket (1987)
During the Vietnam War, in the training camp of the US Marines on Parris Island, the new recruits are getting their heads shaved. Their cruel trainer Sergeant Hartman (R. Lee Ermey) keeps insulting them. His favorite target is the overweight Private Pyle (Vincent D'Onofrio), who cannot cope with the mental and physical requirements. But finally, even Pyle finishes the hard training camp. On the evening after the graduation ceremony, Joker (Matthew Modine) discovers Pyle with a loaded rifle, the "Full Metal Jacket." When Sergeant Hartman joins them, Pyle shoots him first, then himself. The second half of the movie changes setting to Da Nhang in Vietnam. Joker has become a war correspondent for *Stars and Stripes* magazine. He and his colleague Rafterman (Kevyn M. Howard), a photographer, are sent to the city of Hué, where they witness a mass funeral for Vietnamese civilians. Not far from Hué, they are ambushed by a Vietnamese sniper who turns out to be a twelve-year-old girl. She fires on Joker but is hit by Rafterman. Against the wishes of the others, Joker gives her the final coup de grâce. *Production company: Warner Bros.; producer, director: Stanley Kubrick; screenplay: Stanley Kubrick, based on the novel* The Short-Timers *by Gustav Hasford; running time: 116 minutes, color.*

Eyes Wide Shut (1999)
Kubrick's final film focuses on Dr. Bill Harford (Tom Cruise), who jeopardizes his marriage to Alice (Nicole Kidman) by exploring the demimonde of New York City. Early in the movie, Alice confesses to Bill a sexual fantasy she had the previous summer about a young naval officer to whom she felt attracted. Angry and jealous, Bill leaves the apartment and engages in a nightmarish odyssey, the climax of which is a grotesque masked ball in a spooky mansion on Long Island. A black mass and orgy are being held, and Bill is inevitably exposed as an intruder. He fears for his life but is saved by a masked prostitute who is later apparently sacrificed on his behalf. The following night, the sinister Victor Ziegler (Sydney Pollack) informs Bill that he had been spotted at the orgy and warns him of invading the secret rituals of the upper class. He coolly informs him that the prostitute had died of a drug overdose rather than from the supposed sacrifice. Still not sure what is fantasy and what is reality, Bill returns home to resume his marital life. He finds a mask on his bed and confesses the deeds of the past twenty-four hours. His wife suggests a pragmatic solution to their respective erotic evasions, real or imaginary: having sex. *Production company and distribution: Warner Bros.; producer, director: Stanley Kubrick; screenplay: Stanley Kubrick and Frederic Raphael, based on the novella* Rhapsody: A Dream Novel *by Arthur Schnitzler; running time: 159 minutes, color.*

Index

Author Acknowledgments Photo Credits

I am foremost indebted to Amanda Renshaw, Editorial Director of Phaidon Press, for her enthusiastic involvement in helping to select the photographs presented in this book from the 12,000 negatives Kubrick produced between 1945 and 1950. Her critical and intuitive eye was much appreciated and very helpful. My thanks go to Richard Schlagman, the Publisher of Phaidon Press, for his genuine enthusiasm and support for this publication. I would also like to thank my friends and former Ph.D. students Alexandra Gräfin von Stosch—with whom I wrote, with great enjoyment, the texts introducing the photo-essays—and Petrus Schaesberg for their continuously invaluable assistance in all aspects of research and production of this book. Schaesberg particularly was intensely involved in the research as my coeditor.

My special thanks go to Josh Weiss of Spectra Photo/Digital, a generous sponsor of this project, and to Kevin Mutch of POD publishing, who have been extremely supportive with their time and services in bringing out the quality of the negatives as they now appear in the book. Likewise, I am grateful to Lawrence Beck, a photo-artist who has helped me in many ways in this project.

Above all, I extend my thanks to the Museum of the City of New York, in particular to Bob Shamis, curator of Prints and Photographs; Sarah Henry, deputy director; Marguerite Lavin, head of Rights and Reproductions; and Eileen Morales—all of whom have been helpful at every given moment. Dan Leers, assistant to the curator of Photographs, has been working on the *Look* archives for the past two years and was always ready to help. Mary Ison and Erica Kelly at the Photo and Print Division of the Library of Congress always assisted in the best way possible. My thanks also go to my longtime friend Charles Cowles, who has supported my research and this publication wholeheartedly. Of course, the permission that the late Stanley Kubrick himself gave me in 1998 to research, exhibit, and publicize his photographs deserves a special mention, as does the Stanley Kubrick Estate.

I would also like to thank Andrew Marks, who spent a whole month of his summer researching the museum's archives with me and produced a truly scholarly spread sheet for all the stories Kubrick created in his years at *Look*. Simularly, Carola Wiese, my doctoral student from Munich, was helpful with this project in many ways. My agent Andrew Wylie and his associate Jeff Posternak have always been helpful and I am grateful to them. I would like to mention Phaidon's New York office, which was always ready to provide any assistance. Finally, I am indebted to Andrea Codrington, whose special sensitivity to literature and imagery was of great assistance in the final stages of the project.

This book is dedicated to my longtime friends Mera and Donald Rubell.

Phaidon Press Limited
Regent's Wharf
All Saints Street
London N1 9PA

Phaidon Press Inc.
180 Varick Street
New York, NY 10014

www.phaidon.com

First published 2005
© 2005 Phaidon Press Limited

All images reproduced by kind permission of
the Museum of the City of New York, except
for images on pp. 30–43; 98–105; 126–131; and
218–221, by kind permission of The Library
of Congress.

ISBN 07148-4438-1

A CIP catalogue record for this book is available
from the British Library.

Designed by Angus Hyland/Pentagram
Printed in China